PENGUIN CLASSICS

LIVES OF THE ARTISTS

Volume II

GIORGIO VASARI was born in 1511 at Arezzo in Tuscany. While still a boy he was introduced to Cardinal Silvio Passerini who put him to study in Florence with Michelangelo – who later became a close friend – then with Andrea del Sarto. He left Florence when his patron, Duke Alessandro, was assassinated, and wandered round Italy filling his notebooks with sketches; it was during this period that he conceived the idea of the *Lives*. By now, in his thirties, Vasari was a highly successful painter and when his *Lives* were published they were received enthusiastically. He returned to Florence in 1555 to serve Duke Cosimo who appointed him architect of the Palazzo Vecchio. After a grand tour of Italian towns he published the revised and enlarged edition of his *Lives* in 1568. Vasari spent the rest of his life in a glow of self-satisfaction and public recognition, and in 1571 he was knighted by Pope Pius V. He died in 1574.

GEORGE BULL is an author and journalist who has translated six volumes for the Penguin Classics: Benvenuto Cellini's *Autobiography*, *The Book of the Courtier* by Castiglione, Vasari's *Lives of the Artists* (two volumes), *The Prince* by Machiavelli and Pietro Aretino's *Selected Letters*. He is also Consultant Editor to the Penguin Business Library. After reading history at Brasenose College, Oxford, George Bull worked for the *Financial Times*, McGraw-Hill *World News*, and for the *Director* magazine, of which he was Editor-in-Chief until 1984. His other books include *Vatican Politics*; *Bid for Power* (with Anthony Vice), a history of take-over bids; *Renaissance Italy*, a book for children; *Venice: The Most Triumphant City*; and *Inside the Vatican*.

GIORGIO VASARI

LIVES OF THE ARTISTS

—— · ——

VOLUME II

A SELECTION TRANSLATED BY

GEORGE BULL

PENGUIN BOOKS

Penguin Books Ltd, Harmondsworth, Middlesex, England
Viking Penguin Inc., 40 West 23rd Street, New York, New York 10010, USA
Penguin Books Australia Ltd, Ringwood, Victoria, Australia
Penguin Books Canada Ltd, 2801 John Street, Markham, Ontario, Canada L3R 1B4
Penguin Books (NZ) Ltd, 182–190 Wairau Road, Auckland 10, New Zealand

This translation first published 1987

Filmset in Monophoto Bembo

Made and printed in Great Britain by
Richard Clay Ltd, Bungay, Suffolk

CONTENTS

—— · ——

For Stephanie and Philip

INTRODUCTION

—— · ——

In the first edition of Vasari's *Lives*, published in 1550, the biography of Michelangelo was the only one of a living artist. The whole book, beginning with Cimabue, born about 1240, led up to the climax of the life of the greatest artist of the age, whose works in painting, sculpture, and architecture were cited to demonstrate the basic Vasarian thesis that the rebirth or Renaissance of the arts of design in the thirteenth century had led through three progressive stages to the excellence that had made the art of Vasari's own time 'even more glorious than that of the ancient world'.

Michelangelo, Vasari wrote in his Preface to Part Three of the *Lives*, had triumphed not only over artists of the ancient world but over Nature itself,

which has produced nothing, however challenging or extra-ordinary, that his inspired genius, with its great powers of application, design, artistry, judgement, and grace, has not been able to surpass with ease. He has shown his genius not only in painting and colouring (in which are expressed all possible forms and bodies, straight and curved, tangible and intangible, accessible and inaccessible) but also in the creation of sculptural works in full relief, and his fruitful and inspiring labours have already spread their branches so wide that the world has been filled with an abundance of delectable fruits, and the three fine arts have been brought to a state of complete perfection.

In 1550, Michelangelo at seventy-five, toiling in Rome chiefly as the supreme architect of the Basilica of St Peter's and finishing the frescoes in the Pauline Chapel of the Vatican, was still to produce magnificent work before his death in 1564, including poignant religious drawings and sonnets,

the noble Pietà for his own tomb, with his self-portrait, and
the tragic, almost abstract Rondanini Pietà. Michelangelo
had misgivings about the slant in Vasari's account of his
early days as an apprentice artist, and his dealings with the
della Rovere family over the uncompleted tomb of Pope
Julius II. (He encouraged his assistant, Ascanio Condivi, to
write a fresh life, putting straight, as he saw it, his relations
with his original teacher, Ghirlandaio, and his financial deal-
ings over the monument to Julius.) To Vasari, all the same,
Michelangelo dedicated a complimentary sonnet ('*Se con lo
stile o coi colori avete*'), with the barest sarcastic hint of his
misgivings over Vasari's account of his own career, com-
menting that the biographies transcended Vasari's efforts to
rival nature as a painter by their ability to bring artists back
to life and endow them and himself with eternal life.

Michelangelo's approval of the *Lives*, which originally
sprang from a famous meeting of literary men in Rome in
the mid-1540s, the additional information yielded by the
Condivi biography – with its stringent criticism of Vasari –
and the growing intimacy between Michelangelo and
Vasari, would alone have prompted Vasari to prepare a
fresh edition of the book to which he had in any case
promised, in its conclusion, to add a supplement dealing
with new facts as they came to light, and still living artists
whose work was important enough to justify inclusion.
Moreover, the success of the enterprise in terms of esteem
and undoubtedly also of sales (though the number of copies
printed is unknown) provided a strong incentive to Vasari,
with the eager help of many friends and correspondents, to
revise and expand the book. It grew from two volumes of
about 300,000 words to three volumes of over half a million
words, covering about 160 lives, including several groups of
artists. Responding especially to suggestions from his close
Florentine friend and contemporary, the scholarly, well-
connected Vincenzo Borghini, prior of the Foundling Hos-
pital (Ospedale degli Innocenti), he cut back and sometimes
left out many of his sermonizing introductions. But after

extensive travelling and note-taking, he added some more detail about particular works of art, and many lengthy anecdotal digressions, making the narrative more sprawling but agreeably more variegated and surprising.

A few of the *Lives* of the first edition were omitted from the second and some opinions revised. Vasari had to seek a new printer (Giunti, in Florence); it was a sign of the times that his first printer, a Fleming known as Lorenzo Torrentino by the Italians, had to withdraw to Piedmont after apparently running foul of the Roman Inquisition. The most dramatic change was the inclusion of the *Lives* of so many living artists, which may have made the plan of the work less blatant but yields rich material for an understanding of the development and theory of mid-Cinquecento art, the period of transition from Renaissance to Mannerist styles. Among the living or only recently dead artists whose *Lives* appear in the second edition of 1568 – including in this translated selection, Jacopo Pontormo, Lorenzo Lotto, Giulio Romano, Francesco Salviati, and Jacopo Sansovino – was Giorgio Vasari himself.

VASARI'S LIFE AND WORKS

The description of 'The works of Giorgio Vasari, painter and architect of Arezzo', the last of the *Lives*, is a very human document of ambition and affection, chiefly establishing Vasari's credentials as one of those people knowledgeable about the arts – the *cognoscenti* to whom he often appeals to back his judgement in the course of the *Lives* through birth, upbringing, practice, and dedication. As we learn in his *Life* of Salviati, his father, Antonio, made sure that Giorgio learned as a boy how to draw, as well as recite Latin verse, and was encouraged by his relation, Cardinal Silvio Passerini, to send him to Florence in 1524 where he claims (doubtfully) to have studied under Michelangelo, and then the painter Andrea del Sarto and the sculptor Baccio Bandinelli. His lifelong association with the Medici

family began when he first arrived in Florence and was set to study with the two illegitimate Medici boys, Ippolito and Alessandro, whose fathers, respectively Giuliano and Lorenzo, are immortalized by Michelangelo's Medici tombs in San Lorenzo. Luca Signorelli he remembered as an old kinsman visiting the Vasari home in Arezzo and telling the eight-year-old Giorgio to 'learn, learn'. His early professional friendships included Francesco Salviati and Rosso. When he went in 1530 to Rome in the train of Ippolito de' Medici, now a cardinal, he seems to have experienced a fresh upsurge of enthusiasm for his vocation as an artist, after several years of family upsets and personal setbacks, partly caused by political turmoil in Florence and Rome during 1527 to 1530. In the Rome of the Medici Pope, Clement VII, he would recall in his own life story, he was stimulated by competition with other young artists, and striving for glory,

decided that I would spare no toil, discomfort, vigil, or effort to achieve this end. And so after I had resolved this, there was nothing important in Rome at that time, or in Florence later, or in other places where I lived, which in my youth I did not draw; and not only paintings but also works of sculpture and architecture, ancient and modern.

In Florence, working for Ottaviano de' Medici and then Duke Alessandro, Vasari began a career as court painter, his first decorative work being scenes for the Medici Palace from the life of Julius Caesar, begun by Giovanni da Udine. He began to form his own workshop to combat local competition for the decorative work commissioned for the visit of the Emperor Charles V in 1536.

After the murder of Duke Alessandro by his mad kinsman, Lorenzino, Vasari, remaining for some time after in a state of shock, came to learn 'how much more helpful to study are gentle quietness and decent solitude than the noise of the piazzas and the courts'. His travels away from Florence, to Bologna, Rome, Arezzo, Camaldoli in the Casentino, Venice, and Naples, brought him commissions ranging

from wall and ceiling paintings for monks, especially of the Olivetan Order, to an altarpiece for the family chapel of the banker, Bindo Altoviti, to stage designs for a Venetian festival in which his fellow Aretine, the licentious and brilliant Pietro Aretino, had an interest. During these years, he gained the background knowledge and practical experience that would be indispensable to his writing and fostered the vital friendship with Michelangelo that reshaped his own artistic career after he was forty and marked the genesis of the influential theme of the *Lives*. In 1542, he painted a Deposition from the Cross for Bindo Altoviti in Rome which 'for its grace, did not displease the greatest painter, sculptor, and architect of our own times, and perhaps of all times past . . .' So then, while in Rome, Vasari

did many services for Michelangelo, and also asked him his opinion of all my works, and out of his goodness he was very kind to me; and having seen some of my designs, he therefore successfully advised me to dedicate myself afresh and with better method to the study of architectural matters, which perhaps I would not have done, had that most excellent man not said to me what he did, which modesty forbids me to repeat.

In Rome, Vasari won one of his grandest commissions ever from Cardinal Farnese, for the frescoing of the great hall in the Palazzo della Cancelleria, with flamboyant scenes from the life of the Farnese Pope, Paul III. The cardinal was in a hurry, and the painting was claimed to have been completed in a hundred days. (And it looks it, Michelangelo is supposed to have said drily.) And the same cardinal, about the time Vasari was painting the hall, in 1546, asked Vasari the question that led to his writing the *Lives*. At a supper party of friends, Vasari wrote, perhaps dramatizing and embroidering a more protracted process, after they had discussed the collection of painters of famous men made by the bishop, biographer and historian, Paolo Giovio,

as we went from one thing to another, as usual in conversation, Monsignor Giovio said that he had always had a strong wish, as was still the case, to add to the museum and to his book of eulogies

a treatise which should discuss the subject of illustrious men con-
cerned with the art of design from Cimabue to our own times.
Enlarging on this, he convincingly demonstrated that he had great
knowledge and judgement as regards the matters of our arts. But
in truth, he was content to deal in generalities, and not go into fine
details; and often when chatting about the craftsmen in question,
he confused their proper names, and what they were called, and
their places of birth and their works, and did not tell things exactly
as they had been but by and large. Then when Giovio had finished
his discourse, the cardinal turned to me and said: 'What do you
say, Giorgio; would not this be a grand and splendid project to
work on?' 'Splendid,' I replied, 'most illustrious Monsignor, if
Giovio were helped by whomsoever from the profession to sort
things out, and to tell him how they really stand; and I say this
because, though his speech was surely marvellous, he changed and
confused many things with each other.' 'Well then, you yourself,'
added the cardinal, urged by Giovio, Caro, Tolomei, and the
others, 'you could make him a summary and properly arranged
list in chronological order of all the craftsmen and their works; and
your arts will thus receive an additional benefit from you.' And
this, even though I knew it was beyond my powers, I gladly
promised to do, as best I could.

Before he left Rome in October 1546 to paint an altar-
piece of the Last Supper for the nuns of the Murate, the
house of an enclosed Order in Florence, Vasari had studied
all the notes and papers he had been making since boyhood,
shown them to Giovio, and bowed to the pleadings of his
literary friends to undertake the splendid project himself.
By the end of 1547, though he did several oil paintings as
well, he had progressed far enough with the *Lives* to trans-
cribe a fair copy.

In January 1550, the year of publication of the *Lives*,
Vasari married Niccola Bacci, from Arezzo, nicknamed
Cosina, in what proved to be a childless but by all appear-
ances a tranquil marriage, and which gave him someone to
look after his houses in Arezzo (where her kitchen can be
seen today, and a portrait of her by Vasari as one of the
Muses), and later in Florence, helping to entertain his many

friends and visitors. During these years Vasari spent most of his time executing oil paintings with religious or classical themes, chiefly, as he liked to emphasize, for his circle of good friends.

Cosimo de' Medici, son of the great *condottiere*, Giovanni delle Bande Nere, and fourth-generation descendant of Lorenzo, brother of the elder Cosimo, *pater patriae*, according to Vasari was anxious for him to have the *Lives* printed as soon as possible by the ducal printer. The glorification of Tuscan art in the *Lives*, and their generally appreciative references to the patronage of the Medicis, would naturally appeal to the future Grand Duke of Tuscany.

In 1550, too, Cardinal del Monte, the man who had encouraged a rather reluctant Vasari to marry, and who had alerted him in Florence to be ready to come to Rome, was elected Pope Julius III. One of Vasari's immediate commissions from him was a painting of the Conversion of St Paul. He recorded this rather disingenuously.

As a variation on what Buonarroti had done in the Pauline Chapel, I made St Paul, as he himself writes, a young man, who after having fallen from his horse is being led blind by the soldiers to Ananias . . . In this work, whether for the narrowness of the site, or whatever reason, I did not entirely satisfy myself, although it did not perhaps displease others, and particularly Michelangelo.

But Vasari became disillusioned with the Pope's willingness to use his services and at last found his true *métier* as artist in residence to Duke Cosimo who had always kept closely in touch with him.

In 1555, after spending time with the Duke's permission on his own affairs at Arezzo and a fresco painting in Cortona, he moved with all his family to Florence. The house he took in 1557 still stands in Borgo Santa Croce. He was forty-four, with nearly twenty years ahead of him to spend on the 'great and continuous labours' to which Duke Cosimo responded with 'magnanimous generosity', in the form, so gratifying to the Tuscan soul, of houses (in Florence

and the country), offices (including that of chief magistrate at Arezzo), favours granted for his relations, and sabbatical leave when Vasari felt tired. In 1571, after he had decorated some chapels in the Vatican for Pope Pius V, the erstwhile shepherd and inquisitor, austere and ascetic reformer, Vasari's honours were augmented by the award of a knighthood of the Golden Spur of the Order of St Peter, bringing with it a pension, a golden chain and medal, and a white horse.

Vasari wrote in his own autographical pages that he could truthfully say he had always executed his own paintings, inventions and designs: 'I do not say with very great speed, but to be sure with incredible facility and without laboured effort.' His output for Duke Cosimo, for the whole of Florence, and his home town Arezzo, was prodigious.

In the late 1550s and 1560s, one of his main concerns was the Palazzo Vecchio, whose earlier history he describes in the *Life* of Michelozzo. He carried out important structural alterations for what had become Duke Cosimo's residence, raising the ceiling of the Sala dei Cinquecento by about twenty-six feet. He then embarked on the grandiose propaganda exercise of painting the hall's walls and ceilings with scenes from the history of Florence, delighting to show off in his own work the fecundity of images for which he found Raphael so praiseworthy; Vasari would be excused all his failures when people saw his pictures:

the great variety of subjects of war by land and sea, cities besieged, batteries of artillery, assaults, skirmishes, the building of cities, public deliberations, ancient and modern ceremonies, triumphs and so much else that, apart from anything else, the sketches, designs, and cartoons for all this work required enormous time; and this is not to mention the nudes, in which the perfection of our arts consists, or the landscapes . . .

There were about forty great scenes, he recalled wonderingly, some of them in pictures twenty feet square, with huge figures and a plethora of styles.

More to modern taste were Vasari's competent and elegant architectural works in Florence in the 1560s, notably the Palazzo degli Uffizi, the new wing of administrative offices for the Duchy of Tuscany, stretching in restrained grandeur from the Palazzo della Signoria to the Arno, a brilliant feat of engineering, and now housing the Archivio dello Stato, as well as Italy's most important art collection. Its construction, Vasari wrote, with the fascinating passageway connecting it with the Pitti palace and garden across the river (which was completed in five months though people thought it would take five years), was 'the most difficult and the most dangerous' he had ever undertaken.

The Purpose of the Lives

After reflecting that it 'would take too long to recount in detail all the many other pictures, innumerable designs and models and masquerades' that he had done, Vasari rounded off the account of his own life with a tribute to Duke Cosimo (who was to die before him). He added a message for his fellow craftsmen in design – *'L'autore agli artefici del disegno'* – in which he apologized for possibly having been a little prolix in his writing here and there, made the important critical point that his judgements on artists were delivered in the light both of the standards of their own times and also of modern demands, and acknowledged the debt owed to the writings of Lorenzo Ghiberti, Domenico Ghirlandaio and Raphael (for the last two, no source is known unless Vasari meant the famous letter to Leo X). He concluded by saying that he had written the *Lives* as a painter, as best he knew how, in the language he spoke, namely Florentine or Tuscan, and scattering technical terms throughout, in order to be understood by craftsmen, by the artists for whom the book was principally intended.

The purpose of the *Lives* was complex, for Vasari and his contemporaries were complicated people living in a very sophisticated age; they were above all didactic, aimed at

inspiring and instructing painters, sculptors, and architects. Vasari's own works, especially his architecture but also, despite many lapses, some of his paintings, such as the portraits in his own homes, or the Conversion of St Paul for its vivacity and feeling, were generally competent and at least of important interest as historical documents. His criticism as an art historian rested on a sure grasp of techniques, about which he wrote excellently in his original introduction to the *Lives*, and on his firsthand knowledge of the ideas and practices of many of the contemporary artists whose *Lives* he added for the second edition.

These additions went along with other changes, some mentioned above, which included, for example, ending the second part of the *Lives* instead of with Perugino, with Signorelli, who died in 1521 and, Vasari said, was someone who

with a grounding in drawing, and especially of nudes, and showing graceful invention and composition in his scenes, opened the way for the majority of craftsmen to the final perfection of the art of design, to which those who followed were then able to add the crown . . .

Thus despite the exuberance with which Vasari extended and embellished it, his original, soaring vision of the arts still permeates the second edition of the *Lives* from which those in this translation are taken.

The first volume of my own translation of Vasari (Penguin Books, 1965) includes twenty of the *Lives* and Vasari's Prefaces to the three parts into which they were divided to mark the stages of development of the arts. The selection begins with Cimabue and ends with Titian, and it includes the biography of Michelangelo (abridged). This additional selection is similarly divided into three parts, respecting the progressive scheme of Vasari's historical masterpiece.

Belonging to Vasari's first period are Nicola and Giovanni Pisano, and Duccio.

In this first and oldest period, [Vasari observed,] the three artists

evidently fell a long way short of perfection and, although they may have shown some good qualities, were accompanied by so much that was imperfect that they certainly do not deserve a great deal of praise. All the same, they did mark a new beginning, opening the way for the better work which followed; and if only for this reason I have to speak in their favour and to allow them rather more distinction than the work of that time would deserve if judged by the strict rules of art.

To represent the second period I have translated seven additional *Lives*, from Andrea del Castagno and Domenico Veneziano to Perugino. Following Vasari's theory of art history,

In the second period there was clearly a considerable improvement in invention and execution, with more design, better style, and a more careful finish; and as a result artists cleaned away the rust of the old style, along with the stiffness and disproportion character-istic of the ineptitude of the first period. Even so, how can one claim that in the second period there was one artist perfect in everything, producing works comparable in invention, design, and colouring to those of today? Who at that time rendered his figures with the shadows softly darkened in, so that the lights remain only on the parts in relief, and who achieved the perfora-tions and various superb finishings seen in the marble statues executed today?

These achievements [Vasari continued] certainly belong to the third period, when I can say confidently that art has achieved everything possible in the imitation of nature and has progressed so far that it has more reason to fear slipping back than to expect ever to make fresh advances.

To represent this period I have translated another ten of the *Lives* from Piero di Cosimo to Sansovino. This choice amply illustrates Vasari's constantly reiterated belief that 'it is inherent in the very nature of these arts to progress step by step from modest beginnings and finally to reach the summit of perfection': without doubt the most influential general theory of art ever propounded.* Despite this,

* Quotations from the Preface to Part Two of the *Lives of the Artists*, (Penguin Books, 1965).

historians have long since broken down Vasari's grand
simplicities, finding infinitely more crosscurrents in the
development of the fine arts over the period from Giotto
to Michelangelo than he could discern or imagine; not
just Mannerism, for example, but several varieties of
Mannerism. The idea of progress in art has also lost favour.
None the less, Vasari's assumptions and judgements are still
enormously influential, whether expressed in generalities
about styles and periods or ratings of particular schools and
artists.

The *Lives* translated in this volume provide further
material to illustrate Vasari's theoretical position as the most
influential art historian of all time. But the theory was not a
strait-jacket. Most of the *Lives* also show how Vasari's sup-
positions did not inhibit often exceptionally shrewd obser-
vation and judgements, even of artists and schools offending
what he saw as the correct standards of *le cose moderne*. A
good example of this can be seen in the *Life* of Pontormo
about whom Vasari learned so much from his friend, and
Pontormo's pupil, the Medici court painter Bronzino. Vasari
more or less ignored the influence of what has come to be
called International Gothic – the elegant, joyful, courtly art
of the late-fourteenth and fifteenth centuries – on Italian
artists such as Pisanello and Gentile da Fabriano. On the
other hand, he was very aware of the later Northern
influence (what he called the German style) on Italian
artists, especially through the new medium of copperplate
engraving.

In the case of Pontormo he saw rightly enough, though
he did not like what he saw, that the imitation of Dürer was
a profound break with the classical ideals of the Italian
Renaissance. Through Vasari's descriptions of the works
of Rosso, Parmigianino and Pontormo, we can see the
emergence of a new style whose elements he observes and
critically describes, though without understanding the im-
plications for his simplistic view of modern art as the summit
from which there can only be a decline. Continuing

exploration by art historians of the stylistic problems of the period covered generally start and often end with Vasari's *Lives*.* Even though his Tuscan obsession with the import-ance of design in art, and the lack of the chance to familiarize himself with Venetian painting, prejudiced him against it, his appreciation of Venetian colouring and brushwork was genuine and perceptive. The catholicity of Vasari's ap-preciation of art, again, is demonstrated by his remarkably sympathetic attitude towards techniques running counter to his academic instincts, often with revolutionary implica-tions: from the spontaneity and creative fury which he admires in, for example, Giulio Romano and Rosso, to the roughly finished work of Donatello.

Vasari was, in fact, if sometimes careless, extremely observant both of the details in works of art (such as, in sculpture, the difference between a Greek nose and a Flo-rentine nose, which he refers to in his technical introduction to the *Lives*) and of the existence and strength of certain styles, notably the Byzantine (Greek), Gothic (German) and High Renaissance (Modern). His way of looking at things was highly Italian and Tuscan, formed not only by the developing culture of the age in which he lived – humanist, mercantile, religious, courtly, and competitive – but by the very air itself. The light and shade in Italy and the contours of the land are among the factors which account for the age-old Italian mastery of design and obsessive sense of visual beauty. 'Beautiful' is the most-used adjective in Vasari, applicable to all forms and combinations – from horses in flight to helmets, beards, grottoes, rocks, fire, moonlight and bright sunshine, he said in the life of Raphael – but especially to the nude, of which Michelangelo was the supreme exponent and whose rediscovery and artistic exploitation was perhaps the most creative force in the Renaissance from the lone St Sebastians and rare studies of

* The best starting-point for study of Vasari's relationship with Man-nerism and early Baroque styles is still Walter Friedlaender's *Mannerism & Anti-Mannerism* (New York, 1957).

the early Quattrocento, Donatello's David and the Venuses, *putti* and superb studies from life of late-fifteenth-century Florentine art, to the fully realized High Renaissance drawings and, lastly, Michelangelo's powerful and alarming figures in the Last Judgement. Finally, as an art historian Vasari is a fascinating part of the organic process he is describing in the *Lives*, nailing his colours to classicism at the beginning with his definitions of the vital, classical and primarily architectural qualities of rule, order, and proportion, yet coming to produce one of the best succinct definitions of a Mannerist style as 'a grace in the figures that exceeds exact measurement', and in the *Life* of Pontormo especially, providing a richly suggestive study of artistic tension and change.

Erwin Panofsky * has given Vasari credit for establishing the fundamental change during the Renaissance in general attitudes towards classical antiquity; and for paradoxically 'confronting' and producing a stylistic characterization of Gothic art 'impossible in the Middle Ages and possible in the North only many centuries later'. Panofsky also admiringly discusses, in his essay on the first page of Giorgio Vasari's *Libro* – his album of drawings – what he calls Vasari's 'bold and beautiful structure' for the analysis of the development of art in the Renaissance. The refinement and promulgation of the 'myth' of the rebirth of the arts and their rise to perfection is Vasari's outstanding achievement. The more one looks at Vasari's expression of this myth, the more subtle it appears.

Vasari the writer has been called the ideal invisible companion in Italy, or indeed anywhere when Renaissance art is on show. He is also, however, an unexpectedly stimulating companion not just to the art of the Renaissance but to its general culture. As far as political power and wars are concerned, one must go elsewhere: to Da Porto, Guicciardini, Machiavelli. Typically in, for example, the *Life* of Salviati,

* See 'The First Page of Giorgio Vasari's *Libro*', in *Meaning in the Visual Arts* (1955).

who spent some time at the French court, one of Vasari's rare mentions of the wars of France was the throw-away comment that Salviati returned to Italy: *'Essendo quel re occupato in alcune guerre . . .'* – the king being occupied in some wars . . . But his casual remarks can be historically illuminating, even when they do not stray far from the topic of art and the artists. His terse statement that Sansovino, asked by Pope Paul III to return to Rome from Venice to take charge of St Peter's, refused on the grounds that he would not swap life in a Republic for life under an absolute ruler (*'non era da cambiar lo stato del vivere in una repubblica a quello di ritrovarsi sotto un principe assoluto'*), says a great deal about the appeal and status of Venice in the mid sixteenth century and the attitudes that fed the myth of Venice.

There are richer pickings for the historian in the copious allusions throughout the *Lives* to many interesting social phenomena which include the standing of art dealers; pageantry and the fine arts used for the glorification of the ruler and the *patria*; the diffuse classicizing tendencies in public life; the diverse and changing relationships between artist and patron; and the evolution of moral and religious beliefs and behaviour over several centuries. In, for example, the description of Piero di Cosimo's bizarre contribution to the Florentine carnival of 1511, with its medieval undertones, echoes of classical Rome and Medicean symbolism, a corner of the veil on the psychologically astonishing society of Renaissance Florence is lifted in a wonderfully suggestive way.

Above all, however, the *Lives* are a quarry for significant examples of relationships from the dawn of the Renaissance to the age of the Counter-Reformation between craftsmen and artists, and society in general. With Nicola and Giovanni Pisano we feel ourselves still in the world of the almost anonymous medieval artisans; with Sansovino in the world where the artist has emerged as socially eminent and individually distinctive, conscious of the princely status, the

'divine' qualities, of his exemplars such as Raphael and Michelangelo. The critical reader of Vasari, at this point, will not need reminding that the *Lives* were partly designed to propagate ideas of the artist as someone providentially born with a vocation from heaven, entitled to high recognition, remuneration, and respect. The sources which he used and embellished were extremely varied, from the *Commentarii* of Ghiberti (for Trecento art in Florence and Siena) to the verbal recollections of artists he knew in his youth, and the not always accurately noted evidence of his own eyes. We need to read Vasari with constructive suspicion. He was not only sometimes inaccurate in factual details. Like Cellini's *Autobiography*, which Vasari's first edition influenced, the *Lives* were shaped by the urge to supply models of great artists' origins, behaviour and working methods.

Vasari's Literary Style

Modern art historians are quite fiercely divided over Vasari's reliability as a critic, though all acknowledge his influence and insight. For all his occasionally hurried and repetitive writing, he possessed remarkable literary talent and a genius for expression in two particular areas. First, he is a masterly delineator of character, through vivid description and anecdote (and, as in the outstanding instance of Michelangelo, the reporting of conversation), written pungently and economically. In the *Lives* which follow, a riveting example of this is the pen portrait of Piero di Cosimo. Second, he has the rare facility of being able to express the subject-matter and achieved effects of works of art in words which convey to the reader the emotions aroused in the spectator. Prime examples of this are Vasari's description of Palma Vecchio's *Tempest at Sea* and Giulio Romano's *Fall of the Giants*. His language, like Cellini's frequently a torrent of words, is often brilliant in conveying states of mind, physical realities, and the comic interludes of life, as in, for example, respectively Salviati's misanthropic melancholy, or, in the *Life* of Perugino, the loveliness of a tranquil convent and its

garden, or the antics of Rosso's amorous Barbary ape. What he writes about Giulio Romano's painted figures can often be applied to Vasari's own words: '*E nel vero sono fatte con mirabile arte e ingegno, avendo Giulio saputo far si, che oltre al parer vive (cosi hanno rilievo) ingannano con piacevole veduto l'occhio umano.*' They are composed with marvellous skill and intelligence, and they deceptively bring people to life under the eyes of the reader.

On the hall ceiling of his own house at Arezzo, among the scores of paintings on walls and ceilings, Giorgio did some pictures of the Gods and of the Four Seasons. As you go round the hall, he says in the story of his own life, at one moment Fortune seems to be above Merit and Envy and at another, Merit is seen to be above Envy and Fortune. Despite his anxiety to please and to do things for people, Vasari ran into a good deal of envy from fellow craftsmen in his own lifetime, often based on the spirit of *campanilismo* or local pride and prejudice, and he has been roughly handled from time to time by modern art historians. But from where most of them sit today, it looks as if Vasari's Merit has triumphed over Envy and Fortune.

TRANSLATOR'S NOTE

For this selection of translations from the *Lives*, Professor Peter Murray has again provided 'Notes on the Artists' which correct some of Vasari's attributions and prejudices, and say where important surviving works are to be found. As in my earlier volume, I have generally not corrected Vasari's inaccuracies throughout, but have given correct dates, where known, of birth and death at the head of each *Life*, and given personal names and place names in the forms current today, in English versions where this is usual.

The selection of *Lives* again was influenced by the importance with which the artists concerned are regarded today, as well as by Vasari, and also by the wish to do justice to Vasari's plan for the *Lives* as a book in which he wanted to distinguish between 'the good, the better, and the

best' and show how the arts progressed 'to the perfection evident in the finest and most celebrated modern works'.

As I was finishing this translation, I had the rare opportunity to study the ceiling of the Sistine Chapel from scaffolding devised more or less on the same lines as Michelangelo had used and to appreciate the revelation being given by the cleaning process to Michelangelo's highly skilled technique as a colourist in traditional Florentine *buon fresco*. The 'rediscovery' of Michelangelo also makes the reading of Vasari a fresh experience, not least when it comes to the *Lives* of near contemporaries such as Pontormo and Rosso, whose achievements can be more clearly seen to have sprung from Michelangelo's brilliant dissonances and innovations.

The edition I have chiefly used for the translation is that of Carlo Ragghianti (Milan, 1945). The massive edition edited by Paola Barocchi and R. Bettarini, in course of publication, gives the texts of Vasari's first and second editions (Florence, 1966–). The standard annotated Italian edition is that of Gaetano Milanesi (Florence, 1878–85).

The late Betty Radice encouraged me to undertake this translation, partly to satisfy her personal curiosity about some of the artists whose names were missing from the first volume, and I recall her brisk interest and professional standards with gratitude. Professor Peter and Linda Murray have patiently helped me to solve many problems, especially with regard to the vocabulary of art, and I consulted them (and Professor Sir John Hale) in making the selection. Sir Michael Quinlan, with Anthony Brook, has again produced some elegant translations for me of many Latin epitaphs recorded by Vasari. I am grateful for the encouragement, in addition, of Paul Keegan, as editor of the Penguin Classics; and the assistance of my daughters, Jennifer and Catherine, in typing the book and putting it on computer.

George Bull
Pimlico, 1986

PART ONE

——— · ———

LIFE OF

NICOLA AND GIOVANNI PISANO

——— · ———

*Sculptors and architects, 1220/5–1284? and
c. 1245/50–after 1313*

HAVING discussed drawing and painting in the life of
Cimabue, and architecture in that of Arnolfo di Lapo,* in
this life of Nicola and of Giovanni Pisano I shall deal with
sculpture, and also with the very important buildings which
they created. For their works in sculpture and architecture
certainly deserve to be celebrated not only as truly great
and magnificent, but also as very well conceived, because
both when working in marble and when building, they
very largely shed the old Byzantine style with its clum-
siness and bad proportions and displayed better invention
in their scenes and gave their figures more attractive atti-
tudes.

Now Nicola Pisano found himself under some Greek
sculptors who were working on the figures and other carved
ornaments of the Duomo at Pisa and of the church of San
Giovanni, on the occasion when, among the many marble
spoils brought back by the Pisan fleet, were discovered some
ancient sarcophagi which are today in the Campo Santo of
that city and among which was an especially fine example
with a carving of the hunting by Meleager of the boar of
Calydon, in a style that was most beautiful, as both the nude

* In fact Arnolfo di Cambio, pupil of Nicola Pisano and designer of
Florence Cathedral.

and the draped figures were skilfully executed and perfectly designed.* This sarcophagus was placed by the Pisans for its beauty on the façade of the Duomo opposite San Rocco over the principal door on that side, where it served for the coffin of the mother of Countess Matilda, if the words which we read cut in the marble are true:

Anno Domini M.CXVI. IX^a Kl'as Augusti obiit Dña Matthilda felicis memoriae comitissa, quae pro anima genitricis suae Dominae Beatricis comitissae venerabilis in hac tumba honorabili quiescentis in multis partibus mirifice hanc dotavit ecclesiam. Quarum animae requiescant in pace.

And then:

Anno Domini MCCCIII. sub dignissimo operario Burgundio Tadı occasione graduum fiendorum per ipsum circa ecclesiam supradictam tumba superius notata bis translata fuit, nunc de sedibus primis in ecclesiam, nunc de ecclesia in hunc locum, ut cernitis, excellentem.†

On considering the excellence of this work, which pleased him enormously, Nicola strove with such diligence and zeal to imitate its style and that of some other good sculptures carved on those ancient sarcophagi that, before long, he was judged to be the best sculptor of his time. And in those days, no other sculptor since Arnolfo had been held in any esteem in Tuscany save for the Florentine sculptor and architect, Fuccio, who built Santa Maria sopra Arno in Florence in the year 1229, putting his name over the door. Fuccio also made for the church of San Francesco in Assisi the marble

* Meleager, according to Homer, was one of the Argonauts and ruler of Calydon, whose kingdom was ravaged by a giant boar (which he hunted to death) after he had annoyed Artemis, the daughter of Zeus.

† In the year of Our Lord 1116, on the twenty-fourth of July, there died the Countess of Matilda of happy memory, who endowed this church magnificently in many ways in memory of her mother, the revered Countess Beatrice, who rests in this tomb of honour. May their souls rest in peace. And then: In the year of Our Lord 1303, under the most worthy officer of works Burgundio Tadi, because steps were to be made around the aforesaid church the tomb noted above was twice moved – first from its original site into the church, then from the church into the admirable place where you now behold it.

tomb of the Queen of Cyprus with many figures and with her own portrait in particular, showing her seated on a lion, to convey the strength of mind of this woman, who after her death left a large amount of money for the building to be finished.

Nicola, then, made himself known as a far better master than Fuccio, and he was called to Bologna in the year 1225, after the death of St Dominic Calagora, founder of the Order of Friars Preachers, to make the Saint's tomb in marble. So having come to an agreement with those in charge of it, he made it full of figures in the manner that can still be seen today and handed it over completed in the year 1231, winning the highest praise as it was held to be an outstanding work and the best piece of sculpture done up to that time. In a similar manner, he did the model for the church and for a large part of the convent.

Afterwards, when Nicola returned to Tuscany, he found that Fuccio had left Florence. Having gone to Rome at the time Frederick was being crowned emperor by Honorius, from Rome Fuccio went with Frederick to Naples, where he finished the Castel Capuano, now called Vicaria, which houses all the city's law courts, and the Castel dell'Ovo, and where he also built the towers; and he made the gates on the river Volturno for the city of Capua, a walled park for fowling, near Gravina, and another at Amalfi for winter hunting, as well as many other things which, for the sake of brevity, I shall not describe.

Nicola, meanwhile, had stayed in Florence where he was occupying himself not only with sculpture but also with architecture through the buildings which were then being put up, incorporating some good design, throughout Italy, and especially in Tuscany. So he worked not a little on the fabric of the abbey of Settimo, left unfinished by the heirs of Count Ugo of Brandenburg, like the other six abbeys, as I have said. And although a marble epitaph on the campanile of the abbey says: *Gugliel. me fecit,*★ it can none the less be recognized from the style that the work was carried out

★ *Guglielmo* (d'Agnello) *made me.*

with Nicola's advice. Then about the same time, at Pisa, Nicola did the old Palazzo of the Anziani, which has now been pulled down by Duke Cosimo, who has used a part of the old building to erect there the magnificent palace and convent of the new Order of the Knights of St Stephen, following the design and model of the painter and architect Giorgio Vasari of Arezzo, who has adapted the old edifice as best he could to suit the modern style.

Nicola similarly made many other palaces and churches in Pisa where he was the first, ever since good methods of building had been lost, to introduce the practice of resting buildings on foundations of piers, with arches raised over them, having first sunk piles under the piers. For when it was done otherwise, the base would crack and then the walls always collapsed, whereas, as experience shows, sinking piles always makes a building safe and secure. The church of San Michele di Borgo of the monks of Camaldoli was also designed by Nicola.

But the most beautiful, the most ingenious and the most fanciful work of architecture that Nicola ever did was the campanile of San Nicola at Pisa, where the Augustinians live. For it is octagonal on the outside and yet the interior is round, with a spiral staircase winding to the top, leaving free space in the middle like a well; and from every fourth step rise columns supporting arches which slant as they follow the curve; and because of the structure of the vaulting over the arches, on the way to the top of the building from the ground one can always see those who are climbing the stairs, and those ascending can see those who are still on the ground, while those half-way can see both those above them and those below.

This fanciful invention with the employment of better method, more correct proportions and more ornamentation, was subsequently adapted by the architect Bramante to the Belvedere in Rome for Pope Julius II, and by Antonio da Sangallo, on the orders of Pope Clement VII, to the well at Orvieto.

NICOLA AND GIOVANNI PISANO　　　5

But to return to Nicola (who was no less excellent a
sculptor than he was an architect): on the façade of San
Martino in Lucca, under the portico over the door on the
left as you enter the church, he did the existing Deposition
of Christ from the cross, carved in marble in half relief, full
of very diligently executed figures, and with the marble
undercut and everything finished in such a way that he gave
those who formerly practised sculpture with very laboured
effort the hope that there must soon arrive someone who
would assist them still more with greater facility.

Nicola, in the year 1240, also did the design for the church
of San Jacopo at Pistoia where he set to work in mosaic
some Tuscan masters who executed the vault of the niche.
And this, although at the time it was regarded as being
difficult and costly, today moves us more readily to laughter
and pity than to wonder, and all the more so because its
disorder sprang from the lack of design which was evident
not only in Tuscany but throughout Italy, where many
buildings and other things being completed without method
or design made known the poor intelligence of the men of
that time no less than the way they were squandering untold
riches, for the reason that they had no masters to carry
through for them anything they did in a good style.

So then, through the work he did in sculpture and archi-
tecture, Nicola went on winning more fame than any of
the sculptors and architects who were working at that time
in the Romagna, as can be seen from Sant'Ippolito and San
Giovanni at Faenza, from the Duomo at Ravenna, from
San Francesco, and from the houses of the Traversari lords
and the church of Porto, as well as at Rimini from the
fabric of the Palazzo Pubblico, the houses of the Malatesta
family, and from other buildings, which are all far worse
than the old edifices then being made in Tuscany. And what
has just been said about the Romagna can also be truthfully
said about part of Lombardy. Look at the Duomo at Ferrara
and the other buildings put up by the Marquis Azzo, and it
will be recognized how true this is and how different they

are from the Santo at Padua, built from Nicola's model, and from the church of the Friars Minor at Venice, both of which are greatly honoured and most magnificent.

In Nicola's time there were many who were moved by a praiseworthy spirit of envy to apply themselves to sculpture with more zest than ever before, and particularly in Milan, where many Lombards and Germans competed on the fabric of the Duomo, and then dispersed through Italy in the wake of dissensions that arose between the Milanese and the Emperor Frederick. These craftsmen then started to compete with each other, in marble as well as in building, and they produced some good work.

The same happened in Florence, after people saw the work of Arnolfo and of Nicola, who, while the little church of the Misericordia was being built to his design on the piazza of San Giovanni, made there in his own hand a marble scene of Our Lady and St Dominic, with another saint between them, as can still be seen on the exterior of the church.

In Nicola's time, the Florentines began to pull down many towers made earlier in a primitive style* throughout the city, in order that they should cause less harm to the people, when, as so often, there were affrays between Guelphs and Ghibellines, and for greater public security. And it seemed to Nicola that it would prove very difficult to destroy the tower of the Guardamorto, which was on the piazza of San Giovanni, since the walls had been made so well bonded, that it could not be demolished just with pickaxes, especially as it was very high; so he cut on one of the sides into the base of the tower and stopped up the gap with wooden props, three feet in length, which were then set on fire; after they had been consumed, the building then collapsed and was almost entirely shattered, and this was held to be so useful and ingenious for its purpose that it has subsequently come into general use as the easiest way of rapidly demolishing any building as and when the need arises.

* Vasari describes the towers' style as *barbara*.

Nicola was present when the foundation of the Duomo of Siena was laid, and he designed the church of San Giovanni in the same city; then having returned to Florence in the same year as the Guelphs, he designed the church of Santa Trinita and the nuns' convent at Faenza which has been demolished in our day to make the Citadel. Then when he was called back to Naples, in order not to abandon his business in Tuscany, he sent there his pupil Maglione, a sculptor and architect, who afterwards in the time of Conradin * made the church of San Lorenzo at Naples, finished part of the Piscopio, and made there some tombs in which he boldly imitated the style of his master Nicola.

Meanwhile, in the year 1254, when they came under the Florentines, the people of Volterra summoned Nicola to enlarge their Duomo, which was small in size, and although it was very misshapen he gave it a better form and made it more magnificent than before. Then having finally returned to Pisa, he made the marble pulpit of San Giovanni, working on it with the utmost diligence so as to leave his native land a memorial of himself; and carving among other things the Last Judgement, he included many figures which, if not perfectly designed, were at least finished with infinite care and diligence, as one can see. And because it seemed to Nicola, as was true, that he had done work deserving of praise, he carved these lines of verse at the foot:

Anno milleno bis centum bisque trideno
Hoc opus insigne sculpsit Pisanus.†

Moved by the fame of this work, which pleased not the Pisans alone but whoever saw it, the people of Siena commissioned Nicola to make for their Duomo the pulpit from which the Gospel is sung, at the time Guglielmo Mariscotti was praetor. In this, Nicola did many scenes

* Conradin or Conrad V (1252–68) was the last German king of the Hohenstaufen dynasty, supported by the Ghibelline (or Imperial) faction in Italy in conflict with the Pope and his Guelf supporters.
† In the year one thousand two hundred and sixty [Nicola of] Pisa carved this splendid work.

from the life of Jesus Christ, deserving high praise for the figures they contain, which were accomplished with great difficulty and stand out in relief all around the marble.

Similarly Nicola designed the church and convent of San Domenico for the lords of Pietramala, who had it built; and at the entreaty of Bishop Ubertini, he restored the parish church of Cortona, and founded the church of Santa Margherita for the Franciscans on the highest spot in the city.

Because of these works Nicola's fame increased continuously, and, in the year 1267, he was called by Pope Clement IV to Viterbo where, among many other things, he restored the church and convent of the Friars Preachers. From Viterbo he went to Naples, to King Charles I, who, having routed and killed Conradin on the plain of Tagliacozzo, had built there a most sumptuous church and monastery in which he had buried the countless numbers who had been killed on the day of battle, and for whose souls he then ordered prayers to be offered up by crowds of monks day and night. And King Charles was left so satisfied with this building that he honoured and rewarded Nicola very generously.

From Naples, Nicola went back to Tuscany where he spent some time on the fabric of Santa Maria at Orvieto; and working in company with some Germans, for the main façade of the church he made some figures in the round, and notably two scenes of the Last Judgement, showing Paradise and Hell. And just as in Paradise, as beautifully as he possibly could, he showed the souls of the blessed in their restored bodies, so also in Hell he showed devils in the strangest imaginable shapes, all intent on tormenting the souls of the damned. In this work, to his great credit, he surpassed not only the Germans who were working there, but also himself. And since he did very many figures and exerted himself so very hard, this work has won nothing but praise up to our own times by those who have possessed no better judgement in sculpture.

Among other children, Nicola had a son called Giovanni who, since he always followed his father and applied himself under his teaching to sculpture and architecture, in a few years became not only equal but in some matters superior to his father. So, being now an old man, Nicola retired to Pisa to live there quietly, leaving his son to look after everything. Then when Pope Urban IV died in Perugia, after he was sent for, Giovanni went there and made for the pontiff a marble tomb, which, together with that of Pope Martin IV, was demolished when the Perugians extended their bishop's palace, so that only a few remains are now to be seen, dispersed throughout the church.

At the same time, the Perugians, through the ingenious application of a friar of the Silvestrines, had brought a huge volume of water through leaden conduits from the mountain of Pacciano, two miles distant from the city; and Giovanni Pisano was commissioned to make all the ornaments for the fountain, both in bronze and also in marble. So he put his hand to it and made basins on three tiers, two in marble and one in bronze: the first was put over twelve flights of steps, on twelve sides; the next on top of some columns rising from the level of the first basin, and thus in the middle; and the third, of bronze, up above supported by figures with griffins in the middle, also bronze, pouring water on every side. And as Giovanni considered he had executed the work very well indeed, he put his name to it. About the year 1560, the arches and conduits of that fountain, which cost 160,000 gold ducats, being found to be in great part damaged and ruined, to his no small credit a sculptor of Perugia, Vincenzio Danti, without rebuilding the arches, which would have been very expensive, very ingeniously restored the flow of water to the fountain just as it was before.

After he had finished this work, Giovanni desired to see his old, ailing father once again, and so he left Perugia to go to Pisa; but passing through Florence he was made to stop there to apply himself along with others to the construction

of the water-mills on the Arno, which were being made at San Gregorio near the Piazza de' Mozzi. But finally he received the bad news of his father's death, and so he went on to Pisa, where because of his talent he was welcomed with honour by the whole city, with everyone rejoicing that after the death of Nicola, Giovanni inherited his talents as well as his property.

And when the occasion arrived to put him to the test, their opinion of him proved not in the least bit mistaken. For when there were some things to be done in the small but very ornate church of Santa Maria della Spina, they were commissioned from Giovanni, who having set hand to the work, with the help of some of his young men, brought many of the ornaments of that oratory to the perfection we see today. Indeed, as far as can be judged, the work he did must in those days have been thought miraculous, all the more so as in one figure he portrayed Nicola from life as competently as he could. When they saw this, the Pisans, who a long time before had agreed and resolved to make a burial ground for all the inhabitants of the city both noble and plebeian, so as not to fill the Duomo with tombs, or for some other reason, charged Giovanni with building the Campo Santo which is on the square of the Duomo, towards the walls. With good design and considerable judgement, he completed the edifice in the style, with the marble ornaments, and to the size, that we see today. And as no account was taken of the expense, the roof was made of lead; and outside the main door we see these words carved in the marble: *A.D. MCCLXXVIII. tempore Domini Federigi archiepiscopi Pisani, et Domini Tarlati potestatis, operario Orlando Sardella, Iohanne magistro aedificante.**

After this work was finished, in the same year 1283, Giovanni went to Naples where, for King Charles, he made the Castel Nuovo of Naples; and to extend and make it

* A D 1278, in the time of the Lord Federigo as archbishop of Pisa and the Lord Tarlati as governor, Orlando Sardella being officer of works and Giovanni master builder.

stronger, he had to demolish many houses and churches, and in particular a convent belonging to the Franciscans, which was then rebuilt still bigger and more magnificent than it had been, far away from the castle and with the name of Santa Maria della Nuova.

After work on these buildings had started and was well advanced, Giovanni left Naples to return to Tuscany; but when he reached Siena, not being allowed to proceed any further, he was commissioned to make the model for the façade of the Duomo of that city, which was subsequently built from his model very richly and magnificently.

Then in the year 1286, when the bishop's palace at Arezzo was being built to the design of the Aretine architect, Margaritone, Giovanni was brought from Siena to Arezzo by Guglielmino Ubertini, bishop of that city, and he made the marble panel of the high altar, full of carvings of figures, of foliage, and of other ornaments, distributing throughout the work some things in fine mosaic, and enamels laid on silver plates and let into the marble with great diligence. In the middle is the figure of Our Lady holding her Son, and to one side Pope St Gregory (whose face is the portrait of Pope Honorius IV taken from life); and on the other side is St Donatus, bishop and protector of that city, whose body with the bodies of St Antilla and of other saints is laid at rest under the same altar.

And as the altar is free-standing, around it and on the side are little scenes in low relief from the life of St Donatus, and as a finishing touch to the work are some tabernacles full of small marble figures, in the round, very finely executed. On the breast of the Madonna is a bezel-shaped gold setting in which, it is said, were very valuable jewels which soldiers, who often lack respect even for the Most Blessed Sacrament, are thought to have carried off, in times of war, together with some little figures in the round that were at the top and around that work, on which altogether, according to certain existing records, the Aretines spent 30,000 gold florins. Nor does this seem excessive, since for

that time it was something as rare and precious as it could possibly be. For this reason, when he was returning from his coronation in Rome and passing through Arezzo, Frederick Barbarossa, many years after it had been made, praised, indeed expressed boundless admiration for it; and truly with good reason, since on top of all the rest, the mosaic parts of the work, which were countless in number, are fixed and bonded together so well that anyone who does not have great experience in the craft can easily conclude that it is all of a piece.

In the same church, Giovanni made the chapel of the Ubertini (a most noble family and still today, as they were so strongly in the past, castle-lords) with many marble ornaments; and these today have been covered over with many other splendid ornaments of grey-stone, which were set up in that place in the year 1535 to the design of Giorgio Vasari, to support an organ above of extraordinary beauty and excellence.

Giovanni Pisano similarly designed the church of Santa Maria de' Servi, which has now been destroyed, together with many palaces of the most noble families of the city, for reasons given above. I shall not fail to mention that when executing that marble altar, Giovanni made use of some Germans, who had apprenticed themselves to him to learn rather than to earn, and they developed so well under his instruction that when they later went to Rome, they served Pope Boniface VIII in many works of sculpture for St Peter's and also in architecture, when he made Civita Castellana. Moreover, the same Pope sent them to Santa Maria in Orvieto, for whose façade they made many marble figures which were reasonably good for those times. But among the others who helped Giovanni with what was needed for the archbishop's palace at Arezzo, Agostino and Agnolo, sculptors and architects of Siena, in time by far surpassed all the rest, as will be told in the right place.

But to return to Giovanni: after he had left Orvieto, he

came to Florence to see the fabric of Santa Maria del Fiore which Arnolfo was making, and likewise to see Giotto, of whom he had heard great things said abroad in Italy. But no sooner had he arrived in Florence, than, by the wardens of the fabric of Santa Maria del Fiore, he was commissioned to make the Madonna which stands between two little angels over the door of the church leading to the canon's house, and this work earned great praise. Afterwards he made the little baptismal font of San Giovanni, with some scenes in half relief from the saint's life.

Then he went to Bologna, where he supervised the building of the principal chapel of the church of San Domenico, for which he was given to do the marble altar by Teodorico Borgognoni of Lucca, a bishop and brother of that Order; and in the same place in the year 1298, he then made the marble panel containing Our Lady and eight other figures, all reasonably good. And in the year 1300, when Nicola da Prato, the Pope's Cardinal Legate, was in Florence to deal with the dissensions of the Florentines, he had him make a convent for nuns at Prato, called, after his name, Santa Nicola, and restore in the same town the convent of San Domenico, and also that of Pistoia, in both of which can still be seen that cardinal's coat of arms.

And because the people of Pistoia venerated the name of Nicola, Giovanni's father, seeing what his talent had accomplished in that city, they had Giovanni make a marble pulpit for the church of Sant' Andrea, similar to the one he had made in the Duomo at Siena; and this he did in rivalry with one which had been made a little while before by a German in the church of San Giovanni Evangelista, which was highly praised. Giovanni then finished his pulpit in four years, having divided the work into five scenes from the life of Jesus Christ, and as well as that he fashioned a Last Judgement with all the diligence he could command, in order to equal or perhaps surpass the one at Orvieto, which was then so highly esteemed. And round the pulpit, over some supporting columns, since it seemed to him that he had

accomplished a great and beautiful work, which was the case given the knowledge of that age, he carved these verses in the architrave:

> Hoc opus sculpsit Johannes, qui res non egit inanes,
> Nicoli natus . . . meliora beatus,
> Quem genuit Pisa, doctum super omnia visa.*

At the same time Giovanni made the marble holy water font of the church of San Giovanni Evangelista in the same city, with three supporting figures of Temperance, Prudence, and Justice; and being regarded as very beautiful, this was put in the middle of the church as an outstanding work. Then before he left Pistoia, though the work had not yet started, he made the model for the campanile of San Jacopo, the city's principal church, on which campanile, standing on the piazza of San Jacopo and by the corner of the church, is this date: AD 1301.

Then when Pope Benedict IX died in Perugia, they sent for Giovanni; and on his arrival there in the old church of San Domenico, belonging to the Friars Preachers, he made a marble tomb for that Pontiff, whose statue, portrayed from life and in pontifical robes, he put full length on the bier with two angels, one on either side, holding up a curtain; and above he made Our Lady between two saints in relief, with many other ornaments round the tomb. Similarly, in the new church of the Friars Preachers, he made the tomb of Messer Niccolò Guidalotti of Perugia, bishop of Recanati, who was the founder of the Sapienza Nuova of Perugia.† So then, in this new church, which had been founded earlier by others, he completed the nave, which was founded by him with far better method than the rest of the church had been, since this

* This work Giovanni carved – no fruitless worker he, Son of Nicola . . . talented to even greater work. From Pisa sprung, and skilled beyond all yet seen.

† The Pope was Benedict XI and the bishop of Recanati and founder of the University was Benedetto, not Niccolò, Guidalotti.

leans to one side and being so badly based threatens to collapse.

And to be sure anyone who sets his hand to building and making things of importance should always take counsel not from those who know little, but from the best. Then there will be no need, when the task is finished, to one's loss and shame, to regret having been badly counselled when good counsel was needed most.

After he had finished his work in Perugia, Giovanni wished to go to Rome to learn from the few ancient things to be seen there, as his father had done; but he was delayed for various good reasons, and decided not to fulfil this desire of his, especially as he heard that the papal court had just gone to Avignon.

So then he returned to Pisa, where the warden, Nello di Giovanni Falconi, commissioned him to do the great pulpit of the Duomo, which is on the right going towards the high altar, attached to the choir. And having made a start on this, and on many figures in the round, six feet high, which were meant for it, little by little he brought it to the form in which it is seen today, resting it partly on those figures and partly on some columns sustained by lions; and at the sides he did some scenes from the life of Christ. But it is truly a shame that so much expense, so much diligence, and so much effort should not have been accompanied by good design, and should lack the perfection, in the absence of invention, grace or style of any worth, such as is possessed by any work of our time made even with less expense and effort. None the less it must have caused no small wonder to the men of those times, accustomed to seeing only very crude and clumsy things.

This work was finished in the year 1320, as appears from certain lines of verse round the pulpit, which run as follows:

> *Laudo Deum verum, per quem sunt optima rerum,*
> *Qui dedit has puras hominem formare figuras;*
> *Hoc opus, his annis Domini sculpsere Johannis*

Arte manus sole quondam natique Nicole,
*Cursis undenis tercentum milleque plenis.**

There are another thirteen verses which are not written here in order not to annoy the reader, and because these are enough to bear witness not only that the pulpit is by the hand of Giovanni, but also that the men of those times were in all things like this.

Also a marble figure of Our Lady between St John the Baptist and another saint, over the main door of the Duomo, is by the hand of Giovanni; and the figure at the feet of the Madonna, kneeling down, is said to be the warden, Piero Gambacorti. Whatever the truth of this, on the base of the statue of Our Lady are carved these words:

Sub Petri cura haec pia fuit sculpta figura:
Nicoli nato sculptore Joanne vocato.†

Likewise, over the side door which is opposite the campanile, there is from the hand of Giovanni a marble figure of Our Lady, with on the one hand a woman on her knees with two children, representing Pisa, and on the other the Emperor Henry. On the base beneath Our Lady are these words: *Ave gratia plena, Dominus tecum;‡* and next to them:

Nobilis arte manus sculpsit Joannes Pisanus
Sculpsit sub Burgundio Tadi benigno . . .§

and around the base of Pisa:

Virginis ancilla sum Pisa quieta sub illa;‖

and around the base of Henry:

* I praise the true God, by whom comes all that is best. Who gave the world the man to shape these forms so fine. This work was carved unaided by the hands of Nicola's son Giovanni, when a thousand and three hundred and eleven of the Lord's full years were run.

† This statue of homage was carved under the patronage of Peter, the sculptor commissioned being Giovanni, son of Nicola.

‡ Hail, full of grace, the Lord is with thee.

§ By the skill of his famed hand Giovanni of Pisa carved this, under the helpful eye of Burgundio Tadi . . .

‖ I am Pisa, handmaiden of the Virgin, at peace beneath her gaze.

*Imperat Henricus qui Christo fertur amicus.**

Now for many years there had been kept in the parish church of the city of Prato, under the altar of the principal chapel, the girdle of Our Lady which Michele da Prato had brought back to his native place on returning from the Holy Land in the year 1141, and had consigned to Uberto, the rector of the church, who placed it under the said altar, and where it had always been held in great veneration. And then in the year 1312, an attempt to steal it was made by a man of Prato, a person of evil life (almost like another Ser Ciappelletto) who, however, was discovered and put to death by the hand of the executioner for the crime of sacrilege.† Moved by this, the people of Prato determined to make strong and proper accommodation for the girdle's better safe-keeping, and so they sent for Giovanni, who was already old, and following his counsel they built in the main church the chapel where the girdle of Our Lady now reposes. And then, following Giovanni's design, they made the church far bigger than it was before, and encrusted it on the outside with white and black marble, and also built the campanile, as can be seen today.

At length, being now very old, Giovanni died in the year 1320, after having made many other works of sculpture and architecture, besides what was said. And indeed a great deal is owed to him and to Nicola, his father: for in times deprived of all goodness of design, they shed amidst such dark shadows not a little light on the matters of arts in which, for their age, they were truly excellent. Giovanni was buried in the Campo Santo, with honour, in the same grave where his father Nicola had been laid to rest.

Many disciples of Giovanni flourished after him, but in particular Lino, a sculptor and architect of Siena, who made in the Duomo at Pisa the chapel all adorned with marble

* The Emperor Henry, counted a friend to Christ.

† In the first *novella* of Boccaccio's *Decameron*, the wicked Ser Ciappelletto even succeeds in deceiving his confessor and being canonized as a saint.

which contains the body of St Ranieri, and likewise the baptismal font which is in the Duomo and bears his name.

No one should marvel that Nicola and Giovanni made so many works for, as well as living a long time, they were the first masters of their time in Europe and so nothing of importance was made without their intervention, as can be seen from many inscriptions, besides those mentioned. And since the affairs of Pisa have been discussed in connection with these two sculptors and architects, I will in addition report that on the top of the steps in front of the New Hospital, around the base that supports a lion and the basin on the porphyry column, are these words:

This is the measure which the Emperor Caesar gave to Pisa, with which was measured the tribute that was paid to him: which has been erected over this column and lion in the time of Giovanni Rosso warden of works of Santa Maria Maggiore in Pisa AD MCCCXIII. The second indiction in March.

LIFE OF
DUCCIO DI BUONINSEGNA

——— · ———

Sienese painter, c. 1255/60–1315/19

THOSE who invent anything notable are unhesitatingly given great prominence in the writings of historians, and this is because the first discoveries are more carefully observed and arouse more wonder and delight for their novelty than all the improvements which follow, no matter by whom, when things are brought to final perfection. For after all, if there were no beginning to anything, there would then be nothing to improve on, and the final outcome would not be so excellent and so wonderfully beautiful.

Therefore Duccio, the highly esteemed Sienese painter, deserved to carry off the palm from those who came many years after him, having in the pavement of the Duomo at Siena made a beginning of the marble inlays of figures in black and white in which modern craftsmen have today created the marvels that we see. Duccio applied himself to the imitation of the old style, and with very sound judgement formed his figures properly and fashioned them excellently, overcoming the problems of the art of painting. With his own hand, imitating the paintings in chiaroscuro, he arranged and designed the beginnings of the pavement in the Duomo, where he also made a panel that was then placed on the high altar, before being taken away to be replaced by the tabernacle for the body of Christ, which is there now. In that panel, according to Lorenzo di Bartolo Ghiberti, there was a Coronation of Our Lady, carried out as in the Byzantine style, but with many elements of the modern; and as it was painted both on the back and on the front, since the high altar was free-standing, on the back

Duccio with great diligence caused to be made all the
principal scenes from the New Testament with very beauti-
ful little figures.* I have sought to discover where the panel
may be found today, but for all my diligence I have never
succeeded in finding it, or in learning what the sculptor,
Francesco di Giorgio, did with it when he remade the
tabernacle in bronze, and the marble ornaments that are
there.

He similarly made throughout Siena many panel paint-
ings on grounds of gold, and one for Santa Trinita in
Florence, depicting the Annunciation. He then painted very
many works in Pisa, in Lucca, and in Pistoia for various
churches, which were all very highly praised and won him
considerable profit and fame.

Finally, it is not known where this painter Duccio died,
nor yet what relations, pupils or belongings he left; enough
that he bequeathed to painting the invention of black and
white pictures in marble, and so for this benefit deserves
unending praise and commendation from painters; and also
to be assuredly numbered among the benefactors who add
distinction and adornment to our profession, considering
that those who spend time investigating the challenge of
rare inventions, leave their memory behind them, as well as
marvellous works.

They say in Siena that Duccio, in the year 1348, did the
design for the chapel which is on the piazza against the wall
of the principal palace; and we read that there lived in his
time, and came from the same native place, a fairly good
sculptor and architect called Moccio, who made many
works throughout Tuscany, and particularly, in Arezzo, in
the church of San Domenico, a marble tomb for one of the
Cerchi family. This tomb acts as a support and ornament
for the organ of that church; and if to anyone it seems work
of no great excellence, considering that he made it while

* The great Florentine sculptor, Ghiberti, in his later years wrote the
Commentarii, with his own autobiography, which provide much in-
formation about early Renaissance art in Florence and Siena.

still a youth, in the year 1356, then it is fairly good. He also served on the building of Santa Maria del Fiore as under-architect and sculptor, making various things in marble for that fabric; and in Arezzo he rebuilt the little church of Sant'Agostino, in the style we see today; and the cost of this was met by the heirs of Piero Saccone de' Tarlati, who had arranged for this before he died in Bibbiena, a town of the Casentino. But as Moccio constructed the church without vaulting, and rested the weight of the roof on the arches of the columns, he ran a great risk and was altogether too bold. Moccio also made the church and convent of Sant' Antonio, which before the siege of Florence stood at the gate of Faenza, and today is utterly in ruins; and he worked in sculpture on the door of Sant'Agostino in Ancona, carving many figures and ornaments similar to those on the door of San Francesco in the same city.

In this church of Sant'Agostino, he also did the tomb of Fra Zenone Vigilanti, bishop and general of the Augustinian Order, and lastly the loggia for the city's merchants, which since then has received, now for one reason, now for another, many improvements in the modern style and ornaments of various kinds.* All these works, although in our day they fall far short of being even fairly good, were then highly praised, in accord with the understanding of the men of the time.

But to come back to our Duccio, his works date from about the year of our salvation 1350.

* Bishop Simone (not Zenone) Vigilanti's tomb was the work of Andrea da Firenze.

PART TWO

——— · ———

LIFE OF
LUCA DELLA ROBBIA

——— · ———

Florentine sculptor, 1400–1482

THE Florentine sculptor Luca della Robbia was born in 1388 in his ancient family home, which is in Florence, under the church of San Barnaba; and there he was brought up in the customary way, until, following the custom of the Florentines, he had learned as much as he needed not only of reading and writing, but also of doing figures. Then later, his father placed him to learn the goldsmith's craft with Leonardo di Ser Giovanni, who was then held to be the finest master of that craft in Florence. Luca, therefore, learned how to design and to work in wax under this man, and as he grew in ambition, he resolved to do some works in marble and bronze; and as these succeeded extremely well, he abandoned the goldsmith's trade completely and devoted himself so much to sculpture that he spent all day chiselling and all night drawing. He applied himself in this way with such zeal that very often at night when he felt his feet growing cold, so as not to leave his drawing, he warmed them up in a basket full of wood-shavings, such as carpenters strip off when they use the plane. Nor does that make me marvel in the slightest, seeing that no one ever achieved excellence in any occupation who did not, when still a child, start to put up with heat and cold, and hunger and thirst, and other discomforts. And so those people utterly deceive themselves who come to believe that they can reach an honourable level while enjoying all the world's ease and

comforts; success comes from continuous study and wakefulness, not from falling asleep.

Luca was barely fifteen years old when, along with some other young sculptors, he was taken to Rimini to do some figures and other marble ornaments for Sigismondo di Pandolfo Malatesta, the lord of that city, who at that time in the church of San Francesco had made a chapel, and also a tomb for his wife who had died. In this work Luca gave an honourable proof of his knowledge in some low reliefs which are still to be seen there; and then, by the wardens of Santa Maria del Fiore, he was recalled to Florence, where for the campanile of that church he made five small scenes in marble, which are on the side facing the church, and which according to Giotto's design were wanted to go alongside those showing the arts and sciences, already, as was said, made by Andrea Pisano. In the first scene, Andrea showed Donatus teaching grammar; in the second, Plato and Aristotle, for philosophy; in the third, a figure playing the lute, for music; in the fourth, the figure of Ptolemy, for astrology; and in the fifth, Euclid, for geometry. For polish, grace, and design, these scenes far surpass those done by Giotto in which, as was said, he did respectively Apelles standing for painting and working with the brush, and Pheidias working with a chisel, for sculpture.

So then the wardens, being persuaded not only by Luca's merits but also by Messer Vieri de' Medici, then a great citizen of the people, who loved Luca deeply, in the year 1405 commissioned from him the marble ornament for the enormous organ which the Office of Works was then having made to go over the sacristy door of that church. On the base of this, Luca did some scenes showing singing choirs, chanting in various fashions; and he completed the work with such zeal and perfect success that, although it stands thirty-two feet above the ground, one can discern the swelling of the singers' throats, the leader of the music beating his hands on the shoulders of the smaller ones, and, in short, diverse kinds of sounds, songs, dances, and other

pleasing actions which offer the delight of music. Then on the big cornice of this ornament, Luca did two figures in gilded metal, namely two nude angels, polished to perfection like all the work, which was held to be a very rare thing, although Donatello, who subsequently made the ornament for the other organ which is opposite the first, executed his with far more judgement and skill than Luca had shown, as will be described in the proper place. This was because Donatello completed the work more or less in rough form, and not highly polished, so that it would appear from afar, as indeed it does, much better than that of Luca, whose work, for all the diligence and good design that went into it, is so perfectly finished and polished that from a distance it is lost to the eye, which more easily takes in that of Donatello which is, as it were, only roughed out. And thus every craftsman should take notice of how we realize from experience that all works which are to be viewed from a distance, whether paintings, or sculptures or whatsoever similar things, are more striking and forceful if brilliantly roughed out rather than highly finished; and as well as the way that distance produces this effect, it also seems that very often work in the rough, brought to birth in an instant from the art's inspired frenzy, can express its maker's concept in just a few strokes, whereas, in contrast, excessive diligence and labour often remove the force and understanding of those who never know how to lift their hands from what they are doing. And anyone who knows that all the arts of design, not just painting, are similar to poetry, also knows that just as poems dictated by poetic frenzy are true and excellent, and better than those which are laboured, so the products of men who excel in the arts of design are better when they are created instantaneously on frenzied impulse than when they derive from the mind's imaginings expressing themselves step by step, with great pain and effort. And he who, as he should, from the beginning possesses a clear idea of what he wants to make, ever walks forward happily and resolutely towards perfection. All the same, because

talented people are not all of the same stamp, there are a rare few who work well only when they take their time. And, leaving painters aside, it is said that among the poets the Most Reverend and learned Bembo, if those who claim this can be believed, would linger over a sonnet for many months and even years. And so it is not surprising that this sometimes happens in the case of the masters of our arts of design. But for the most part the rule is to the contrary, as we said; notwithstanding that the common herd thinks more highly of some evident, external sophistication, whose lack of essential qualities is disguised by diligence, than it does of good work carried out with reason and judgement, but not so smooth and highly polished on the surface.

But to return to Luca, after the work described above was finished, and gave great pleasure, he was commissioned to make the same sacristy's bronze doors, and he divided the ten squares, with five on each side, and with the head of a man at every corner of each section, in the border. He varied all the heads, showing young, old and middle-aged men, some clean-shaven and others with beards, and in short all differently fashioned and all very beautiful of their kind; and so the borders of that work were left very richly adorned. Then for the scenes on each square he made, beginning at the top, first Our Lady clasping her Son, with wonderful grace, and next Jesus Christ coming forth from the tomb. Underneath these, in each of the first four squares, is the figure of one of the Evangelists; and below these are the four Doctors of the Church, who are writing in various attitudes. And all this work is so well finished and polished that it is a marvel, and demonstrates how greatly it was to Luca's advantage to have been a goldsmith.

But then Luca, after finishing these works, made a reckoning of how much he had earned, and how much time he had spent on them, and realized that he had gained hardly anything despite his great efforts. So he resolved to abandon marble and bronze and to see if he could gather more fruit in some other way. So then, having considered the fact that

clay could be worked easily and with little effort, and that all that was wanting was a way by which the works made in clay could be preserved a long time, he let his imagination loose so successfully that he found a way to protect it against the ravages of time; for after many different experiments he found that by giving his works a coating of glaze made with tin, litharge, antimony, and other minerals and mixtures fused in the fire of a special furnace, he could produce this effect splendidly and make works in clay that were almost everlasting. And for this method of working, as the inventor of it, he won the highest praise, and all ages to come will be under an obligation to him.

Having then succeeded in this as much as he wished, he wanted his first works to be those that are in the arch over the bronze door he had made for the sacristy, under the organ of Santa Maria del Fiore; and so he made there a Resurrection of Christ which was so beautiful for its time that after being put in place above, it was admired as something truly rare. Much impressed by this, the wardens then wanted the arch over the door of the other sacristy, where Donatello had made the ornament for the other organ, to be filled by Luca in the same manner with similar figures and works in terracotta; and so Luca made for it a very beautiful representation of Jesus Christ ascending into Heaven.

Now as Luca was not satisfied with this beautiful invention of his, which was so charming and useful, especially for places where there is water and where, for dampness or other reasons, paintings are ruled out, he thought he could go further; and so instead of producing in clay only works in white, he went on to the method of adding colour to them, to everyone's pleasure and amazement. Consequently the Magnificent Piero de' Medici, who was the first to commission Luca to make coloured works in clay, had him complete the entire round vaulting of a study built in the palace, as will be told, by his father Cosimo, with various fanciful things; and likewise the pavement, which was

something most singular and very useful for summertime. And it is surely a marvel that although the technique was very difficult, and it was necessary to take strict precautions when firing the clay, yet Luca executed these works so perfectly that both the vaulting and the pavement appear to be fashioned not from many pieces but from only one.

The fame of these works spread not only through Italy but through all Europe, and so many people came to want them that, much to his profit, Luca was kept continually at work by the Florentine merchants, who distributed what he did to the whole world. And because he could not supply everything himself, he had his brothers Ottaviano and Agostino put away their chisels and he set them to producing those works as well; and along with them he earned far more than all three had ever earned with the chisel. For as well as what was made to send to France and Spain, they worked on many things in Tuscany, and especially, for Piero de' Medici, in the church of San Miniato al Monte, the vaulting of the marble chapel, which rests on four columns in the middle of the church, which they divided very beautifully into octagons. But the most beautiful work of this kind that ever came from their hands was, in the same church, the vaulting of the chapel of San Jacopo, where the cardinal of Portugal is buried; and here, though it has no salient angles, they made the four Evangelists in four tondi at the corners, and the Holy Spirit in a tondo in the middle of the vault, filling the rest of the spaces with tiles which follow the curve of the vaulting and gradually diminish towards the centre; and this was carried out so well that there is nothing better to be seen of this kind nor anything built and put together with more diligence.

Then, in the little arch over the door of the church of San Piero Buon Consiglio, beneath the Old Market, he did a portrait of Our Lady surrounded by angels, all very vivacious. And in a half circle over the door of a little church near San Piero Maggiore, he did another Madonna and angels, regarded as very beautiful. And similarly in the chapter-

house of Santa Croce, under the direction of Pippo di Ser Brunelleschi, for the Pazzi family, he did all the glazed figures we can see on the inside and outside. And it is said that Luca sent to the king in Spain some most beautiful figures in full relief, together with some works in marble. For Naples also, helped by his brother Agostino, he made in Florence the marble tomb for the Infante, brother to the Duke of Calabria, with many glazed ornaments.

Following all this, Luca sought to find a way of painting figures and scenes on a level surface of terracotta to bring life to his pictures, and he experimented with a tondo which is over the shrine of the four saints by Orsanmichele, putting in five parts of the level surface the instruments and insignia of the Guild of Builders, with very beautiful ornaments. In the same place he did two more tondi in relief, in one of which, for the Guild of Apothecaries, he portrayed Our Lady and in the other, for the Mercatanzia, a lily on top of a bale surrounded by a festoon of fruits and foliage of various sorts, so well made that they appear real rather than painted terracotta.

For Messer Benozzo Federighi, bishop of Fiesole, he also made in the church of San Brancazio a marble tomb with Federighi himself lying on top of it, portrayed from life, and with three other half-length figures. And in the ornamentation of the pilasters of this work, he painted on the level surface some festoons of clusters of fruits and leaves, so lifelike and natural that it could not be done better with the brush as an oil painting on a panel. And truly this work is most rare and marvellous, since Luca made the lights and shades in it so well that it scarcely seems possible for it to have been done by fire. And if this craftsman had lived longer than he did, still greater things would have been forthcoming from his hands; for a little before he died, he started to make scenes and figures depicted on a level surface, and I once saw some of these pieces in his house, which led me to think that he would easily have succeeded in this if he had not been unnecessarily robbed of his life by death, which

almost always snatches away the best men, just when they are about to bring some benefit to the world.

Luca left behind him his brothers, Ottaviano and Agostino; and Agostino fathered another Luca, who was very learned in his day. This Agostino, pursuing the same craft after Luca, in 1461 made in Perugia the façade of San Bernardino, containing three scenes in low relief and four figures in the round, very well executed and in a delicate style; and he put his name to this work in the words: AUGUSTINI FLORENTINI LAPICIDAE.

Of the same family, Andrea, Luca's nephew, worked extremely well in marble, as can be seen outside Arezzo in the chapel of Santa Maria delle Grazie, where on the great marble frame he made for the community many small figures both in the round and in half relief; the frame, in fact, being made for a painting of the Virgin by Parri di Spinello, of Arezzo.* The same man made in this city the terracotta panel for the chapel of Puccio di Magio in San Francesco, and that showing the Circumcision, for the Bacci family. Likewise in Santa Maria del Grado, there is from his hand a very beautiful panel with many figures; and on the high altar of the Society of the Holy Trinity there is a panel from his hand showing God the Father supporting in his arms the crucified Christ, surrounded by a multitude of angels, with St Donatus and St Bernard kneeling below. Similarly in the church and other parts of the Sasso della Vernia, he made many panels which are kept in good condition in that wilderness, where no painting could have stayed fresh even for a very few years. This same Andrea executed in Florence all the figures in glazed terracotta that are in the loggia of the Hospital of San Paolo, which are excellent, and likewise the *putti* both swathed and nude placed in the tondi between one arch and another in the Hospital of the Innocenti, all of which are truly splendid

* Parri Spinelli (d. 1452), son of the better-known Spinello Aretino, a forerunner of Masaccio.

and demonstrate the great skill and talent of Andrea; not to
mention the many other, indeed countless number of works
which he made during the space of his life, which lasted for
eighty-four years. Andrea died in 1528;* and when I was a
boy and talking with him, I heard him say, or rather boast,
that he had found himself one of those bearing Donatello to
the tomb; and I remember how vainglorious this good old
man was about this.

But to return to Luca, he was buried among his relations
in San Piero Maggiore in the family tomb; and after him in
the same tomb was placed Andrea, who left two sons as
friars in San Marco, they having received the habit from the
Reverend Girolamo Savonarola, to whom the della Robbia
family was always very devoted, portraying him in the
manner that can still be seen today in medals. The same
man, besides the two friars, had three other sons: Giovanni,
who gave himself to the same craft and whose own three
sons, Marco, Lucantonio, and Simone, showed great
promise but died from the plague in the year 1527; and
Luca and Girolamo, who gave themselves to sculpture. Of
these two, Luca applied himself very diligently to glazed
works, and among many other things he made with his own
hand the pavements of the Papal loggias, which Pope Leo X
had built in Rome under the direction of Raphael of
Urbino, and also those in many living rooms, where he
put the insignia of that Pope. Girolamo, who was the
youngest of all, applied himself to working in marble and in
clay and bronze, and he had already, in rivalry with Jacopo
Sansovino, Baccio Bandinelli, and other contemporary
masters, made himself very competent, when he was taken
by certain Florentine merchants to France, where he made
many works for King Francis at Madrid, a spot not far from
Paris; and notably a palace with many figures and other
ornaments, made from stone like our Volterra alabaster,
but of a better quality, because it is soft when worked and

* In fact, he died in 1525, aged ninety.

becomes hard with time.* He also produced many works in clay in Orleans, and worked throughout all the kingdom of France, acquiring fame and much good property.

After all this, learning that of his relations only his brother Luca remained in Florence, and finding himself rich and alone in the service of King Francis, he brought him to those parts as well, in order to leave him in good standing and credit; but it turned out otherwise, for after a short while Luca died there, and Girolamo again found himself on his own with none of his own people. So having resolved to return to enjoy in his own native land the riches he had won through toil and sweat, and also to leave some memorial of himself there, he was preparing to settle down in Florence in the year 1553; but then he was forced to change his mind, since he saw that Duke Cosimo, by whom he hoped he might be honourably employed, was occupied with the war with Siena, and he left Florence to die in France. And so not only did his house stay closed and his family become extinct, but his art was deprived of the true method of making glazed works; for although there have been some after them to practise that sort of sculpture, no one has ever by a long chalk reached the excellence of the elder Luca, of Andrea, and of the other members of that family.

Now if I have extended myself on this subject more than perhaps seemed necessary, let everyone excuse me, since as Luca discovered these new forms of sculpture, which as far as we know the ancient Romans did not have, it was incumbent on me to talk about this at some length, as I have done. And if, following this life of the elder Luca, I have commented succinctly on his descendants up to our own day, I have done this so as not to have to return to this subject another time.

Luca, then, in moving from one kind of work to another,

* Madrid – Madri in the Italian – a castle in the Bois de Boulogne, was so named to recall Francis I's period of captivity in Spain, after the battle of Pavia in 1525.

and from marble to bronze and bronze to clay, did not do so from slothfulness or because he was, as many are, fanciful, unstable, and discontented with his own craft, but because he felt himself drawn by nature to new things, and from his need for an occupation according to his own taste, and less arduous and more gainful. Therefore, the world and the arts of design came to be enriched by a new, useful, and most beautiful craft, and he won immortal and everlasting glory and praise. Luca was a very good and graceful draughtsman, as can be seen from some sheets of drawings in our book with lights heightened with white lead, on one of which is his self-portrait executed, with great diligence, by looking at himself in a mirror.

LIFE OF

MICHELOZZO MICHELOZZI

—— · ——

Florentine architect and sculptor, 1396–1472

IF all those alive in this world believed they would still be
alive after they could no longer work, many of them would
not come to beg in their old age for what they consumed so
unsparingly in their youth, when rich and plentiful rewards
clouded their common sense and made them spend recklessly
beyond their need. For seeing how harshly we regard
someone who has fallen from prosperity to poverty, every-
one should strive, albeit steering a decent middle course, not
to have to beg a living in old age. And whoever acts like
Michelozzo, who did not imitate his master Donatello in
this matter though he did in his virtues, will not have to
scrape for a miserable living during the last years of life.

Michelozzo, then, applied himself in his youth with
Donatello to sculpture, and also to design; and whatever
difficulty he perceived, he none the less persisted in his
efforts with clay, wax, and marble, in such manner that in
the kinds of work he did subsequently he always showed
great talent and skill. But in one kind he surpassed himself,
and others, insofar as after Brunelleschi he was regarded
as the most orderly architect of his time, best disposed to
lay out and accommodate the living quarters of palaces,
convents, and houses, and as someone who used judgement
to order these matters better, as will be told in the right
place.

Donatello made use of Michelozzo for many years, be-
cause he was very experienced in working marble and in
the practice of bronze casting, as bears witness the tomb in

San Giovanni at Florence, made, as was said, by Donatello
for Pope Giovanni Coscia, since the greater part of it was
executed by him; and there can also be seen from his hand a
very beautiful statue, in marble, five feet in height, repre-
senting Faith, accompanied by one of Hope and one of
Charity, made by Donatello, from which it does not suffer
by comparison. Michelozzo also made, over the door of the
sacristry and Office of Works opposite San Giovanni, in full
relief, a young St John executed most diligently and much
praised.

Michelozzo was so intimate with him, that Cosimo de'
Medici, knowing his talent, had him make the model for
the house and palace that is at the corner of the Via Larga,
beside San Giovannino, since it seemed to him that the one
made, as said, by Filippo di Ser Brunelleschi was too
sumptuous and magnificent, and would be more likely to
foster envy among the citizens than bestow grandeur and
adornment on the city, or bring any benefit to him. Being
pleased with what Michelozzo had done, he had it com-
pleted under his direction as you can see it today, with all its
present useful and beautiful arrangements and graceful
adornments, which possess majesty and grandeur in their
very simplicity. And Michelozzo deserves all the more praise
insofar as this was the first palace built in that city on modern
lines, and containing a series of very beautiful and conveni-
ent rooms. The cellars were dug more than half below
ground level, namely eight feet, and three feet above to let
in the light, and there are also butteries and larders. On the
ground floor, there are two courtyards with magnificent
loggias, overlooked by little reception rooms, chambers and
antechambers, studies, closets, bathrooms, kitchens, wells,
and public and private staircases, all very commodious. And
on each floor are family quarters and apartments with all
conveniences to suit not only a private citizen, as Cosimo
then was, but howsoever most splendid and honoured a
king. Thus in our own times, it has comfortably accom-
modated kings, emperors, popes, and as illustrious princes as

there are to be found in Europe, and won endless praise
both for the magnificence of Cosimo and for Michelozzo's
outstanding talent in architecture.

Then, in the year 1433, Cosimo was sent into exile, and
Michelozzo, who loved him deeply and was very faithful to
him, spontaneously decided to go with him to Venice,
where he wished to stay as long as Cosimo lived there. And
there at Venice, as well as doing many designs and models
for private and public dwellings, and decorations for the
friends of Cosimo and for many gentlemen, he made at
Cosimo's instructions and expense the library of the
monastery of San Giorgio, belonging to the Black Friars of
Santa Giustina, which was completed with its walls, shelves,
woodwork, and other adornments, and also stocked with a
large number of books. This was how Cosimo sought
diversion and relaxation during his exile, from which, when
he was recalled to his native land in the year 1434, he re-
turned almost in triumph, and Michelozzo along with him.

Then, when Michelozzo was in Florence, the public
palace of the Signoria threatened to collapse, because some
columns in the courtyard were giving way, either because
there was too much weight pressing on them, or because of
their weak and lopsided foundations, and even perhaps
because they had been poorly built with the pieces badly
put together. But, whatever the reason, it was entrusted to
Michelozzo who gladly undertook the enterprise, since he
had provided against a similar danger in Venice, near San
Barnaba, in the following way. A gentleman, who had a
house in danger of collapsing, entrusted it to Michelozzo;
and then Michelozzo, according to what Michelangelo
Buonarroti once told me, having had a column made in
secret, assembled a large number of props, and piled
everything on to a boat, went on board himself along with
some builders, and in the course of a single night propped
up the house and replaced the column. So emboldened by
this experience, Michelozzo averted the threat to the palace,
bringing honour to himself and to those who had favoured

him by having given him such a task; and he refounded and rebuilt the columns as they are standing today. First, for the centring of the arches, he made a solid framework of thick beams and props standing upright, made of walnut, to uphold the vaulting, so that this came equally to sustain the overall weight that was previously borne by the columns. And then, little by little, removing those that were made of pieces badly joined together, he put in the pieces of other columns, very diligently wrought, in such a manner that the building did not give way at all and has never moved a hair's breadth since. And so that his columns might be distinguished from the others, he made some of them at the corners with eight sides, with capitals that have the foliage carved in the modern fashion, and some round; and all are easily distinguished from the old ones made there previously by Arnolfo.

Later, on the advice of Michelozzo, by those who then governed the city it was ordained that the arches of these columns should also be unburdened and relieved of the weight of the walls above them, and that the entire courtyard from the arches upwards should be rebuilt, with a row of modern windows, similar to those which he had done for Cosimo de' Medici in the courtyard of the Medici palace, and that the walls should be rusticated and scored with outlines to take the golden lilies that are still to be seen there today. All of this Michelozzo did expeditiously; and on the second tier, directly above the windows of the courtyard, he made some round windows, to differentiate them from those already mentioned, giving light to the rooms above those on the first floor, where the Sala dei Dugento is today. Then he made the third floor, where the Signori and the gonfalonier lived, more ornate, providing on the side towards San Piero Scheraggio some living rooms for the Signori, who had previously slept all together in the same room; and of these living rooms, eight were for the Signori and a larger one for the gonfalonier, all opening on to a corridor with windows overlooking the courtyard. And

above these, for the palace household, he made another set of commodious rooms, in one of which, where the depository is today, is a portrait by the hand of Giotto of Charles, Duke of Calabria, the son of King Robert, kneeling before a Madonna.

Similarly, Michelozzo made there the living room of the ushers, beadles, trumpeters, musicians, pipers, mace-bearers, court officials, and heralds, and all the other rooms required in such a palace. He also at the top of the circular gallery made a stone cornice that went round the courtyard, and beside it a cistern that was filled by rain-water to make some artificial fountains play at certain times. Michelozzo also had restored the chapel where Mass is heard, and beside it many rooms, and very richly decorated ceilings painted with golden lilies on a background of blue; and for both the upper and lower floors of the palace he had fresh ceilings put in to cover all the old ones which were there, made in the ancient manner. So, in short, he brought everything to the perfection that was fitting for such a building. And he even had the water from the wells flowing up to the top floor, to which by means of a wheel it was drawn more easily than usual.

One thing alone could Michelozzo's skill not remedy, and that was the public staircase; for from the beginning it was badly conceived, badly situated, clumsily built, steep, and without lights, and with wooden steps from the first floor up. He none the less laboured to such good purpose that at the entrance to the courtyard he made a flight of round steps as well as a door with pilasters of hard stone* and with very beautiful capitals carved by his own hand, and a well-designed cornice with a double architrave, on whose frieze he arranged all the arms of the Commune. Moreover he made the entire staircase of hard stone up to the floor housing the Signoria, and he fortified it with a portcullis at the top and another half-way in case of tumults;

* *pietra forte*, used for many of the finest buildings of Florence and quarried in Tuscany from early times.

and at the head of the stairs he made what was called the *chain-door* where there was always an usher standing by to open or close it as commanded by those in charge. Michelozzo also used huge iron bands to reinforce the campanile, which had cracked because of the weight of the unsupported part that is on the brackets towards the piazza.

And finally, he improved and restored that palace in such a manner that he was commended for it by the entire city, and in addition to receiving other rewards was made a member of the College, a very honourable magistracy to hold in Florence.* And now if it seems to anyone that I have dwelt on this building perhaps longer than was needed, I deserve to be excused: for having shown in the life of Arnolfo as regards its first construction (in the year 1298) that it was built out of the true and lacking all reasonable measure, with unequal columns in the courtyard, arches some large, some small, incommodious stairways and rooms all askew and ill-proportioned, I then was bound also to point out the condition to which it was brought by the talent and judgement of Michelozzo, though even he did not render it an agreeable dwelling-place, nor other than still extremely inconvenient and uncomfortable. Finally, after the Lord Duke Cosimo had gone to live there in the year 1538, his Excellency began to have it put into better form, but there was never any ability to understand or carry out the Duke's concepts among the architects serving him for so many years on that project, and so he determined to see if it were possible, without spoiling the old part with its good features, to set it to rights and to give order, convenience, and proportion to the inconvenient and uncomfortable rooms and stairways.

So he had Giorgio Vasari, Aretine painter and architect, then serving Pope Julius III, brought from Rome, and commissioned him not only to put right the rooms he had

* The *Collegi* were part of the government of Florence with a membership of guilds' representatives and eminent citizens, sharing authority with the Signoria.

begun in the separate apartment above, over against the Piazza del Grano, which were askew in relation to the ground-plan, but also to give his mind to whether the palace interior could, without spoiling what had been done, be brought to such a form that it might be possible to walk throughout from one part to another, and from one spot to another, by means of private and public stairways and by ways as level as possible. Therefore, while these rooms, already begun, were being adorned with gilded ceilings and with scenes painted in oil, and the walls with frescoes, while some others were being decorated in stucco, Giorgio drew the ground-plan for the whole circumference of the palace, both the old and the new; and then having drawn up instructions with no small labour and study for all he wanted to do, he began little by little to bring it to a good form, and, without spoiling in the least what had already been done, to connect the unconnected rooms which were previously of varying heights, some high, some low, on the same floors. And so that the Lord Duke might see the whole design, in the space of six months he had completed a well-proportioned wooden model of all that great structure, which has the form and grandeur of a castle rather than a palace. The model pleased the Duke, and so on the same lines many commodious rooms and convenient stairways, both public and private, have been made opening on to all levels, and the whole connected together; and this arrangement freed the halls which had previously been used like public streets, with no one able to go to the upper floors without passing through them. And the whole has been magnificently adorned with varied and diverse pictures. And finally, the roof of the great hall has been raised twenty-four feet higher than it was. As a result, if Arnolfo, Michelozzo, and the others who worked on it since its first plan were to come back to life, they would not recognize it; rather they would believe that it was not theirs at all, but a new set of walls and another edifice.

But returning now to Michelozzo, let me say that after

the church of San Giorgio had been given to the friars of
San Domenico in Fiesole, they stayed there only from the
middle of July till the end of January, because Cosimo de'
Medici and his brother Lorenzo obtained from Pope
Eugenius the church and convent of San Marco, the former
seat of the Silvestrine monks, giving the latter San Giorgio
in exchange; and being much inclined to the practice of
religion and divine service and worship, they ordered that,
following Michelozzo's design and model, the convent of
San Marco should be rebuilt on the most spacious and
magnificent lines and with all the conveniences that the
friars could best desire.

A beginning was made on this in the year 1437, and the
first to be done was the part looking out on to the old
refectory, opposite the stables of the Duke, those which
Duke Lorenzo de' Medici came to build. In this place,
twenty cells were installed, the roof was put on, wooden
furniture was made for the refectory, and all was finished in
the manner in which it still is today. Then, for the time
being, no more was done, since they had to wait to see the
outcome of a lawsuit which a certain Maestro Stefano, the
general of the Silvestrines, had brought against the friars of
San Marco; then, when this ended in favour of the friars
of San Marco, he once more began to continue building.
But since the main chapel, which had been put up by Ser
Pino Bonaccorsi, had later come into the hands of a lady of
the Caponsacchi family, and from her to Mariotto Banchi,
after I don't know what lawsuit was settled over this,
Mariotto gave the chapel to Cosimo de' Medici after he
had defended his claim and taken it from Agnolo della
Casa, to whom the Silvestrines had given or sold it; and
Cosimo, for his part, gave Mariotto 500 crowns for it.

Afterwards, when Cosimo had likewise bought from the
Society of the Holy Spirit the site where the choir is today,
the chapel, the tribune, and the choir were built under the
directions of Michelozzo, and furnished in all respects in the
year 1439. There the library was made, 180 feet long and 36

feet wide, and vaulted both above and below with 64 shelves of cypress wood filled with splendid books. Next, he brought to completion the dormitory, which he made square in form, and finally the cloister, and all the very commodious rooms of that convent, thought to be the best considered, the most beautiful, and the most commodious in all Italy, thanks to the talent and industry of Michelozzo, who handed it over completely finished in the year 1452.

It is said that on this fabric Cosimo spent 36,000 ducats, and that while it was being built he gave the friars 336 ducats every year for their upkeep; and concerning the construction and consecration of this church on a marble epitaph, over the door leading into the sacristy, we read these words:

*Cum hoc templum Marco Evangelistae dicatum magnificis sumptibus CI.V. Cosmi Medicis tandem absolutum esset, Eugenius Quartus Romanus Pontifex maxima Cardinalium, Archiepiscoporum, aliorumque sacerdotum frequentia comitatus, id celeberrimo Epiphaniae die, solemni more servato, consecravit. Tum etiam quotannis omnibus, qui eodem die festo annuas statasque consecrationis ceremonias caste pieque celebraverint, viserintve, temporis luendis peccatis suis debiti, septem annos, totidemque quadragesimas, apostolica remisit auctoritate. A. M. CCCC.XLII.**

Similarly Cosimo had made to Michelozzo's design the noviciate of Santa Croce in Florence, including the chapel and the entrance way that goes to the sacristy, to the noviciate itself, and to the stairs of the dormitory; and the beauty, convenience, and adornment of all these are not inferior to any whatsoever of the buildings which the truly Magnificent Cosimo de' Medici had built or which Michelozzo executed.

* When this church, dedicated to Mark the Evangelist, was at last finished by the splendid generosity of the Lord Cosimo Medici, Pope Eugenius IV, escorted by a great assembly of cardinals, archbishops and other priests, consecrated it in solemn ceremony on the great day of the Epiphany. By his apostolic power he then enacted that each year whosoever on the same feast day reverently and duly celebrated the appointed yearly rites of dedication or made a visit to the church should have remitted seven years of debt of atonement for sin; and likewise in time of Lent. AD 1442

Many other things apart, the grey-stone door which he made, leading from the church to the other places, was much praised in those times for its novelty and its finely made pediment, it being very little the custom then to imitate the good style of antique work as this does.

Cosimo also made, following Michelozzo's advice and design, the palace of Cafaggiolo in the Mugello, giving it the form of a fortress with ditches around it, and he laid out farms, roads, gardens, and fountains amidst copses, fowling-places, and other highly esteemed adjuncts for villas; and two miles distant from the palace at a spot called the Bosco a'Frati, again taking Michelozzo's opinion, he had brought to completion the fabric of a convent for the Observant Friars of St Francis, which is very beautiful. Likewise at the villa at Trebbio he carried out restoration work, as can still be seen. And likewise, two miles distant from Florence, he restored the palace of Careggi, richly and magnificently; and to this villa Michelozzo brought the water for the fountain which can still be seen. Then for Cosimo de' Medici's son, Giovanni, Michelozzo made at Fiesole another esteemed and magnificent palace, sinking the foundation for the lower part into the hillside, at great expense but not without considerable benefit since down below he constructed vaults, cellars, stables, vat-stores, and many other fine and commodious living-spaces; and above, as well as chambers, halls, and other ordinary rooms, he made some for books and others for music. In short, Michelozzo demonstrated in this building how able he was in architecture for, besides what we have said, it was built in such a way that even though it stands on that mountain, it has never moved a hair's breadth. After the palace was finished, Michelozzo built above it, almost on the summit of the mountain, the church and convent of the friars of San Girolamo, again at the expense of Cosimo de' Medici. He also made the design and model which Cosimo sent to Jerusalem for the hospice he arranged to be built there for the pilgrims going to the sepulchre of Christ.

Then again, for the façade of St Peter's in Rome, he sent the design for six windows which were subsequently completed, with the arms of Cosimo de' Medici; of these, three were taken away in our own time and replaced by Pope Paul III with others bearing the arms of the Farnese family. Later on, after Cosimo had learned that at Santa Maria degli Angeli, in Assisi, there were problems with water, to the great inconvenience of the people going there on the first of August every year to gain the Indulgence, he sent Michelozzo there; and Michelozzo brought a supply of water from a spring half-way up the slope of the mountain to the fountain in Assisi, which he covered over with a charming and richly decorated loggia resting on some columns made of separate pieces and bearing the arms of Cosimo; and inside the convent, on Cosimo's orders too, he carried out for the friars many useful restorations; and these subsequently the Magnificent Lorenzo de' Medici improved still further with more ornamentation and at greater expense, also putting there for her church the wax image of the Madonna, which is still to be seen. As well as this Cosimo had the road leading from the Madonna degli Angeli to the city paved with bricks; and moreover, before he left those parts, Michelozzo did the design for the old citadel of Perugia.

Having finally returned to Florence, Michelozzo built a house on the Canto dei Tornaquinci for Giovanni Tornabuoni, almost entirely similar to the palace he had made for Cosimo, except that the façade is not rusticated and has no cornices above, but is plain. On the death of Cosimo, who had loved Michelozzo as much as any dear friend could, his son Piero commissioned him to build the marble chapel with the Crucifix in San Miniato al Monte, and in the half circle of the arch behind the chapel, Michelozzo carved a falcon in low relief, with the diamond, the emblem of his father, Cosimo, which was a truly most beautiful work.

As Piero de' Medici intended after these things to build

the chapel of the Nunziata in the church of the Servites, he wished Michelozzo, now an old man, to give his opinion on the matter, both because he loved his talent and also because he knew how faithful a friend and servant he had been to his father. After Michelozzo had responded, the work was entrusted to Pagno di Lapo Partigiani, a sculptor from Fiesole, who, as one who wished to include a great deal in a small space, displayed much ingenuity in this work. Supporting his chapel are four marble columns about eighteen feet high, of the Corinthian order with double flutings, and with the bases and capitals cut in different ways and with duplicated members. The columns support architrave, frieze, and a big cornice, also with double members, and carvings full of various fantasies, and especially emblems and arms of the Medici, and foliage. Between these and other cornices, made for another row of windows, there is a large marble slab with an inscription, carved in marble and very beautiful. Below, between the four columns and forming the ceiling of the chapel, is a marble partition all carved, full of enamels fired in a furnace and of wonderfully designed mosaic work of golden colour and precious stones. The surface of the pavement is full of porphyry, serpentine, variegated marble, and other most rare stones fitted together and arranged in a beautiful pattern.

This chapel is enclosed by a grille of bronze ropes, with candelabra above attached to a marble ornament, which makes a very beautiful finish to the bronze and the candelabra. And at the front, the door which closes the chapel is similarly of bronze and very well arranged. Piero left it that there should be lighting from thirty silver lamps placed round the chapel, and this was done. But because these were ruined during the siege, the Lord Duke gave orders many years ago for them to be remade, and the greater part of this has already been done, and the work still goes on; and yet, however, there has never been a time when all the lights were not burning, as Piero left them to be, though from when they were destroyed they have not been of silver.

Pagno added to these adornments a very large lily made of copper, issuing from a vase resting on the corner of the gilt and painted wooden cornice which holds the lamps. But the cornice does not take all the weight itself, for the whole is held up by two branches of the lily which are made of iron and painted green, and plugged with lead into the corner of the marble cornice, holding those of copper suspended in the air. And truly this work was made with judgement and invention, so that it deserves all the praise it attracts as something beautiful and fanciful.

To the side of this he made another chapel facing the cloister which serves as a choir for the friars, with windows that take their light from the courtyard and give it both to the chapel just mentioned and also the room containing the little organ, by the side of the marble chapel, since they stand opposite two similar windows. On the front of the choir there is a large cupboard for storing all the silverware of the Nunziata; and on all these ornaments and everywhere else are the arms and emblem of the Medici. Outside and opposite the chapel of the Nunziata the same man made a large bronze chandelier, ten feet high; and at the entrance of the church the holy water font in marble, and in the middle a St John, which is very beautiful. Moreover, above the counter where the friars sell candles, he made a half-length Madonna in marble in half relief, holding her Son in her arms, life-size and very devotional; and he did another similar to this in the Office of the Wardens of Santa Maria del Fiore.

Pagno also made some figures for San Miniato al Tedesco, in company with his master Donatello, while still a youth; and he made a marble tomb in the church of San Martino in Lucca, opposite the chapel of the Blessed Sacrament, for Messer Piero Nocera, shown there portrayed from life. Filarete writes in the twenty-fifth book of his treatise that Francesco Sforza, the fourth Duke of Milan, gave the magnificent Cosimo de' Medici a very fine palace in Milan, and that the latter, in order to show the Duke how pleasing

this gift was to him not only richly adorned it with marble and wood carvings but also enlarged it, to the designs of Michelozzo, making it 175 feet whereas before it had been only 168 feet.* As well as this he had many paintings done there, and in particular for a loggia, scenes from the life of the Emperor Trajan. In these, among some decorations, he caused to be included the portrait of Francesco Sforza himself, with the Signora Bianca, his consort the Duchess, and also their children, as well as many other lords and notables, and likewise the portraits of eight emperors. And to these portraits, Michelozzo added that of Cosimo, made by his own hand. Moreover, throughout all the rooms he disposed the arms of Cosimo in different ways, with his emblem of the Falcon and Diamond. And these pictures were all from the hand of Vincenzio di Foppa, a contemporary painter from that region of no small reputation.

It is recorded that the money Cosimo spent on the restoration of this palace was paid by Pigello Portinari, a Florentine citizen, who at that time in Milan looked after Cosimo's banking and business affairs, and lived in the palace. In Genoa, from the hand of Michelozzo, there are some works in marble and in bronze, and many others elsewhere, known by Michelozzo's style.

But we have now said enough about him. He died at the age of sixty-eight, and was entombed in San Marco in Florence. His portrait by Fra Angelico is in the sacristy of Santa Trinita in the figure of Nicodemus, shown as an old man with a cap on his head, who is taking Christ down from the cross.

* Filarete (c. 1400–69) was the assumed name of Antonio Averlino, a Florentine goldsmith and architect whose fanciful, illustrated work on architecture was well circulated and read.

LIFE OF

ANDREA DEL CASTAGNO AND DOMENICO VENEZIANO

——— · ———

Painters, 1419/21–1457 and d. 1461

I CANNOT at all think it is possible to express in words how shameful it is for a person of excellence to possess the vice of envy, and how wicked and horrible it is, under the guise of pretended friendship, to destroy not only the fame and glory of someone else, but his very life as well. For this kind of wickedness defeats all the skill and resources of language, no matter how eloquent. Therefore, without lingering over the matter, I shall simply say here and now that in people of that kind there must reside a spirit not only inhuman and fierce but utterly cruel and devilish, and so alien to all virtue that they cannot be thought of as animals, let alone as men, and they are not worthy to live. It is rightly held to be estimable and praiseworthy, as necessary and useful to the world, when, in pursuit of honour and glory, through emulation and competition men apply their talents to vanquish and surpass those who are ahead of them; and on the other hand, given this is so, to the same or even greater extent, envy with all its wickedness deserves to be condemned and vituperated. This is so when, unable to bear the honour and esteem won by others, it sets out to deprive of life someone whom it cannot despoil of glory. And this was the wickedness of Andrea del Castagno, who certainly possessed great excellence in painting and design, but still greater rancour and envy towards other painters. Because of this, his dark crime overshadowed and buried his splendid talent. Since this man was born in a small village called

Castagno, in the Mugello, in the territory of Florence, he took this name for his surname when he came to stay in Florence, which happened in this manner.

Castagno was left fatherless when still in his early childhood and was taken in by one of his uncles who, for many years, kept him guarding his herds, since he saw him to be so very ready and alert and formidable, that he could keep good care not only of his cattle but of the pasture and everything else that touched his own interest. While Castagno was still following this occupation, it happened that one day, when he was trying to escape the rain, he came by chance to a place where one of those local painters, who work for little money, was painting a shrine for a peasant. And Andrea, who had never seen such a thing, was suddenly struck with wonder, and very attentively started to study and consider the style of this kind of work; and there of a sudden came to him so tremendous a desire and passionate longing for this art that, losing no time at all, on walls and stones, with charcoal or the point of his knife, he began to scratch drawings of animals and figures, such that everyone seeing them was filled with wonder.

Thus the fame of this new study of Andrea's began to spread among local peasants and when, as his luck would have it, this came to the ears of a Florentine gentleman, called Bernardetto de' Medici, whose estates were thereabouts, he wished to know the boy. Finally, having seen him and heard him discourse with his usual readiness, he asked him if he would be willing to take up the painter's art. Andrea replied that nothing could happen to him more welcome than this or that could please him more, and so, in order to perfect his skills, Bernardetto took him with him to Florence where he arranged for him to work with one of the masters who were then most highly regarded. As a result, pursuing the art of painting, and giving himself over completely to its study, Andrea showed the most perfect understanding of its problems, and especially in drawing. Yet he was then not so successful in colouring his works,

which he made somewhat crude and harsh, greatly diminishing their grace and excellence, and, above all, the kind of loveliness which his colouring lacks. He displayed great boldness in the movement of his figures, and awesomeness in the heads of both men and women, depicting them grave of aspect and with good design.

There are works from his hand in fresco executed when he was in early youth, in the cloister of San Miniato al Monte, on the way up from the church to the convent, where he painted a scene showing St Minias and St Crescentius, when they were parting from their father and mother. There used to be many pictures by his hand in a cloister and in the church of San Benedetto, a very beautiful monastery outside the Pinti gate, which need not be mentioned since they were destroyed during the siege of Florence. Within the city, in the first cloister opposite the principal door in the monastery of Santa Maria degli Angeli, he painted the Crucifixion (which is still there today), with the Madonna, St John, St Benedict, and St Romuald. And at the head of the cloister, over the garden, he did another like this, varying only the heads and a few other things. In Santa Trinita, beside the chapel of Maestro Luca, he painted a St Andrew. In a hall at Legnaia, for Pandolfo Pandolfini, he did portraits of many illustrious men; and for the Guild of the Evangelist, a standard to be carried in procession, held to be very beautiful.

In some chapels for the Servites in the same city, he painted in fresco three flat niches, of which St Julian's has scenes from the life of that saint, with a fair number of figures and a dog in foreshortening, which was much praised. Above this, in a chapel dedicated to St Jerome, employing good design and great diligence, he painted that saint, all shaven and wasted away. And above this he did a Trinity, with a Crucifix foreshortened so well that Andrea deserves high praise for it, since he accomplished the foreshortenings far better and in a more modern manner than others before him had done. However, this picture can

no longer be seen, as the family of the Montaguti placed a panel over it. In the third, which is beside the one below the organ, and was erected by Messer Orlando de' Medici, he painted Lazarus, Martha and the Magdalen. For the nuns of San Giuliano, he painted in fresco a Crucifixion, with Our Lady, St Julian, and St John; and this picture, which is among the best that Andrea did, is universally praised by all craftsmen.

In Santa Croce, in the Cavalcanti chapel he painted a St John the Baptist and a St Francis, which are held to be excellent figures. But what amazed the craftsmen was the fresco he did at the top, opposite the door in the new cloister of that convent, showing Christ being scourged at the column, a most beautiful scene, to which he added a loggia with columns in perspective and cross vaults with diminishing strips and with the walls decorated with lozenges in coloured stone mosaic with such zeal and skill that he showed that he understood no less the problems of perspective than he did those of design in painting. In this same scene, we see beautiful and most violent attitudes on the part of those who are scourging Christ, showing hatred and rage in their faces as clear as the patience and humility in Jesus Christ; in whose body, tightly bound with ropes to the column, we see how Andrea tried to show the suffering of the flesh, while the divinity hidden in the body maintains a certain noble splendour; and moved by this, Pilate, seated among his councillors, appears to seek some way of freeing him. And in short, if, for the little care that was taken of it, this picture had not been scratched and spoiled by children and simpletons, who have scratched all the heads and the arms and almost the entire figures of the Jews, as if taking revenge on them for the wrongs of Our Lord, it would certainly be the most beautiful of all Andrea's works. And if nature had given him gracefulness in colouring, even as she gave him invention and design, he would have been held truly marvellous.

In Santa Maria del Fiore, he painted the image of Niccolò

da Tolentino on horseback, and while he was working on this, because a boy who was passing by jostled his ladder, he flew into such a temper that, like the brutal man he was, he jumped down and chased him as far as Canto de' Pazzi. He also made, in the cemetery of Santa Maria Nuova infra l'Ossa, a St Andrew which was so pleasing that he was then commissioned to paint in the refectory, where the orderlies and other attendants eat, Christ's Last Supper with the Apostles. This won him favour with the Portinari family and with the governor of the hospital, and he was commissioned to paint a part of the main chapel, of which another part had been allotted to Alesso Baldovinetti and the third part to the then very celebrated painter Domenico Veneziano, who had been brought to Florence because of the new method he had of colouring in oil.

Then, while each one of them was attending to his own work, Andrea conceived a great envy for Domenico, because although he knew that he himself had more excellence in drawing, he none the less resented a foreigner such as Domenico being warmly treated and looked after by the citizens; and on account of this, the anger and contempt he felt grew so strong that he began to think how, in one way or another, he would get rid of him. Now Andrea was no less cunning a dissembler than clever a painter, showing happiness in his face when he wished, ready of speech and fiery in spirit, and resolute in all the actions of his body, as of his mind. And so he had taken against others as against Domenico; and he would secretly mark the works of other craftsmen, scratching them with his nail, if he detected a mistake. And in his youth, if ever his works were blamed for some fault or other, he would let the fault-finders know by blows and insults that, in whatever way, he could get his revenge for their insults.

But to say something first about Domenico, as we come to the work for the chapel: in the sacristy of Santa Maria di Loreto, in company with Piero della Francesca, he had executed some paintings with such grace that, beyond what

he did elsewhere (such as Perugia, where he painted an apartment in the house of the Baglioni family, which is now in ruins), they won him fame and recognition in Florence before he arrived there.

Then, after his call to Florence, first of all he did a fresco painting of Our Lady in the midst of some saints, for a shrine on the Canto de' Carnesecchi, where the two streets meet, one going to the new and the other to the old Piazza di Santa Maria Novella. Because this pleased and won high praise from the citizens and the craftsmen of those times, it caused still greater envy and contempt to burn in the accursed soul of Andrea towards poor Domenico.

And so determined to accomplish through deception and treachery what he could not do openly without obvious risk, he pretended to be very friendly towards Domenico, a good and loving person who delighted in playing the lute and sang to music and who therefore gladly accepted Andrea's friendship, in the belief that he was a very talented and amusing person. So this friendship, on the one side true, on the other feigned, continued its course, and every night the two men would come together to entertain and serenade their mistresses, much to the delight of Domenico, who, being honestly fond of Andrea, taught him the method of colouring in oil, which was not yet known in Tuscany.

Then, to take events in order, Andrea painted an Annunciation on his wall in the chapel of Santa Maria Nuova, which was held to be very beautiful, for in that work he depicted the Angel up in the air, which had not been done previously. In a still more beautiful work, however, he showed Our Lady climbing the steps of the Temple, on which he portrayed many beggars, and one banging another on the head with a pitcher. Not only this figure but all the others are wonderfully beautiful, as he made them with great care and love, out of rivalry with Domenico. Also to be seen there, in the middle of a piazza, is a temple with eight sides drawn in perspective, free-standing and full of pilasters and niches; and with the façade finely adorned with

figures made to look like marble. Then round the piazza are various very beautiful buildings, on one side of which falls the shadow of the temple caused by the light of the sun, a very beautifully contrived and difficult idea.

On the other part, Domenico did an oil painting of Joachim visiting his consort, St Anne, and below, the birth of Our Lady, where he depicted a very ornate room with a *putto* in an extremely graceful way knocking on the door. Beneath this he painted the wedding of the Virgin, with a fair number of portraits from life, among which are those of Messer Bernardetto de' Medici, Constable of the Florentines, wearing a big red cap; Bernardo Guadagni, who was Gonfalonier; Folco Portinari, and others of that family. He also put there a dwarf who is breaking a staff, a very lively figure, and some women wearing clothes in the fashion of the times, which are charming and graceful beyond belief. But this work remained unfinished, for reasons that will be given below.

Meanwhile, on his façade, Andrea had shown the death of Our Lady in an oil painting in which, from rivalry with Domenico and also to make himself known as the master he truly was, he depicted in foreshortening with incredible diligence a bier holding the dead Virgin, which appears to be six feet in length though it is only three. Around it are the Apostles, presented in such a way that although one recognizes in their faces their joy at seeing their Madonna being borne up to Heaven by Jesus Christ, one also recognizes their sense of bitterness over remaining on earth without her. Among the Apostles are some angels holding burning lights, with beautiful expressions on their faces and so well executed that it can be seen that Andrea knew how to manage oil colours as well as his rival, Domenico. In these pictures, Andrea portrayed from life Messer Rinaldo degli Albizzi, Puccio Pucci, and Falganaccio, who brought about the liberation of Cosimo de' Medici, as well as Federigo Malevolti, who held the keys of the *Alberghetto*.*

* *Alberghetto* or little inn, the nickname for a small room in the Palazzo Vecchio once used as a prison.

Similarly, he portrayed in that painting Messer Bernardo di Domenico della Volta, governor of the hospital, who was kneeling and looks as if alive; and in a medallion at the beginning of the work he painted himself as the Judas Iscariot he was, both in appearance and in deed.

So then, after he had very successfully brought this work to a finish, blinded by his envy of the praises that he heard of Domenico's talent, he determined to get rid of him; and having thought of many different methods of doing this, he adopted one of them as follows. One summer evening, in his usual manner, Domenico took his lute and made his way out of Santa Maria Nuova, where he left Andrea drawing in his room after Andrea had declined the invitation to go for a walk with him, on the pretext that he had to do some important drawings. So after Domenico had gone off by himself to seek his pleasure, Andrea went to wait for him unseen round a street corner, and when Domenico came across him on his way home, he ruptured both his lute and his stomach at the same time with some lead weights; but as he thought he had not achieved what he wanted, he then beat him wickedly about the head with the same weapon. And then, leaving him lying on the ground, Andrea returned to his room in Santa Maria Nuova, where he left the door ajar and sat down to draw just as he had been left doing by Domenico. Meanwhile after great commotion, all the servants, on realizing what had happened, ran to summon Andrea and to give the bad news to the murderer and traitor himself. And Andrea running to where the others were clustered round Domenico, kept crying out in-consolably: 'Oh alas, my brother, alas, my brother!' Finally Domenico died in his arms, and, despite all the diligent inquiries that were made, it was never discovered who had done him to death. And if Andrea had not revealed it in confession when he himself was nearing death, it would still not be known.

In San Miniato fra le Torri at Florence, Andrea painted a panel picture showing the Assumption of Our Lady with two figures; and in a shrine for the nave at Anchetta, outside

the Porta alla Croce, he painted a Madonna. Also, in the house of the Carducci family, today belonging to the Pandolfini, Andrea depicted several famous men, some as he imagined them and some drawn from life. Among the others, he portrayed Filippo Spano degli Scolari, Dante, Petrarch, Boccaccio, and others. At Scarperia in the Mugello, over the door of the Vicar's palace, he painted a very beautiful nude Charity, which has since been ruined. Then in the year 1478, when by the Pazzi family along with other conspirators and adherents of theirs Giuliano de' Medici was done to death and his brother Lorenzo was wounded in Santa Maria del Fiore, the Signoria ordained that all those who had conspired together should be painted as traitors on the wall of the palace of the Podestà. Whereupon, when this work was offered to Andrea, as a servant and dependant of the Medici family he very readily accepted; and setting to work he did the painting so beautifully that it was a marvel; and it would be impossible to express how much skill and judgement could be seen in those figures, which were for the most part from life and shown hanging by their feet in strange attitudes, all most varied and beautiful. As this work pleased the whole city, and especially those who understood and appreciated the painting of pictures, Andrea from then on was no longer called Andrea del Castagno but Andrea degli Impiccati.*

Andrea lived in honourable style; and because he spent money freely and especially on his clothes and on maintaining a magnificent household, he left very little property, when he passed to the next life at the age of seventy-one. But soon after his death his impious treatment of Domenico who loved him so much became known, and so he was buried with odious obsequies in Santa Maria Nuova, where the unhappy Domenico, at the age of fifty-six, had also been interred. And the work which Domenico had started in Santa Maria remained imperfect and was never

* i.e. of the Hanged Men. The conspiracy was perhaps that of the Albizzi in 1440, not the Pazzi attempt on the life of Lorenzo de' Medici in 1478.

completely finished, unlike the panel he did for the high altar of Santa Lucia de' Bardi, where he very diligently executed Our Lady holding her Son in her arms, St John the Baptist, St Nicholas, St Francis, and St Lucy. Shortly before he died, he had brought this panel to perfect completion. Disciples of Andrea were Jacopo del Corso, who was a reasonably good master, Pisanello, Il Marchino, Piero Pollaiuolo, and Giovanni da Rovezzano.

LIFE OF
JACOPO, GIOVANNI, AND GENTILE BELLINI

——— · ———

Venetian painters, c. 1400–70/71,
c. 1430–1516, and c. 1429/30–1507

ENTERPRISES endowed with virtue and talent, even if very often at the start they seem mean and common, always gradually climb higher; and they never pause or rest till they have reached the height of glory. This was clearly illustrated by the slight and common origins of the Bellini family, and by the rank it then achieved by means of painting. Thus Jacopo Bellini, a painter of Venice, and once a disciple of Gentile da Fabriano, worked in competition with the same Domenico who taught Andrea del Castagno how to colour in oil, but although he laboured hard to achieve excellence in that art, he did not acquire fame for it till Domenico had himself left Venice. But then, when he found himself without any rival to equal him in the city of Venice, adding all the time to his fame and reputation, Jacopo reached such a pitch of excellence that he became the greatest and most renowned man in his profession. And so that the name he had won for himself in painting should not only be preserved but grow greater still in his family and successors, he had two sons who were very much inclined to the art of painting, and of shining intelligence: one was called Giovanni and the other Gentile, whose name he gave him as a loving father in fond memory of Gentile da Fabriano, his former master.

When, therefore, they were old enough, Jacopo himself with the utmost diligence taught them the elements of

design; but it was not long before both the one and the other surpassed the father by a great measure; and this was a cause of much rejoicing for Jacopo who never failed to encourage them, showing that he wanted them to do as the Tuscans did, who gloried among themselves in striving hard to surpass each other as each one came in turn to practise the art: thus Giovanni should surpass himself, and then Gentile both of them, and so on in succession.

The first things to bring Jacopo fame were the portraits of Giorgio Cornaro and of Caterina, Queen of Cyprus; a panel picture that he sent to Verona, showing the Passion of Christ, with many figures, among which he included himself drawn from life; and a story of the Cross, which is said to be in the Scuola of St John the Evangelist. All those and many others were painted by Jacopo with the aid of his sons; and the last scene was done on canvas, as has nearly always been the custom in Venice, where they very rarely make use, as they do elsewhere, of panels of wood made from the tree known to many people as poplar and to some as silver poplar.* This wood grows for the most part alongside rivers and other kinds of water, and is extremely soft and splendid for painting on, since it holds very firm when joined together with gum mastic. But in Venice they do not make panels, and when they occasionally do so they use only wood from the fir, of which that city has an abundance, because of the river Adige which brings a great quantity of it from German soil; and this as well as the large amount coming from Sclavonia. So then, it is much the custom in Venice to paint on canvas, either because it does not split or become worm-eaten, or because they can make pictures whatever size they wish, or again for the convenience, as said elsewhere, of being able to send paintings wherever they want, with little bother or expense.

But whatever the reason, Jacopo and Gentile, as said above, made their first works on canvas; and then Gentile

* *oppio* and *gattice*.

alone added to the above-mentioned story of the Cross a further seven or eight pictures in which he painted the miracle of the Cross of Christ, which the Scuola keeps as a relic; and this miracle story was as follows. For some reason or other, this Cross was thrown down from the Paglia bridge into the canal and, for the reverence many felt for the piece of wood it contained from the Cross of Christ, they threw themselves into the water to retrieve it; but, as God willed, none was worthy of being able to retrieve it except the head of the Scuola. So, then, when he represented this story, Gentile drew in perspective along the Grand Canal many houses, the Ponte della Paglia, the Piazza di San Marco and a long procession of both men and women following behind the clergy. Similarly he showed many people who had thrown themselves into the water, others in the act of doing so, many half immersed, and others again in other very beautiful styles and attitudes; and finally, he included the head of the Scuola himself as he was retrieving the Cross. The diligence and effort which Gentile put into this work were truly very impressive considering the countless figures it contained, many drawn from life, the way those in the distance are diminished, and the portraits in particular of almost all the men who were then members of the Scuola or society. And finally we see the scene, with many very beautiful and well-considered details, when the Cross is put back in place. All these scenes, painted on canvases as we mentioned, won very great fame for Gentile.

Then after Jacopo had completely withdrawn to work alone, so did the two sons, each of them studying the art of painting on his own. But I shall make no more mention of Jacopo, because as in comparison with those of his sons his own works were not extraordinary, and as he died not long after his sons left him, I think it better worth while to talk at length just about Giovanni and Gentile. I shall not refrain from mentioning, indeed, that although each of the two brothers went off to live alone, they nevertheless each had such reverence for the other, and both for the father, that

each always sang the other's praises, holding himself to have fewer merits, and in this modest way sought to surpass one another no less in goodness and courtesy than in excellence as painters.

The first works of Giovanni were some portraits from life which were found very pleasing, and notably one of the Doge Loredano; although some say that it was, in fact, Giovanni Mocenigo, brother of that Piero who was Doge long before Loredano himself. Afterwards, for the altar of St Catherine of Siena in the church of San Giovanni, he did a very large panel picture in which he painted Our Lady seated with the Child in her arms, St Dominic, St Jerome, St Catherine, St Ursula, and two other Virgins; and standing at the feet of our Lady he depicted three *putti* singing from a book, in a very beautiful way. Above this, Giovanni showed the space of a vaulting in perspective in a building, which is also very beautiful; and this work was one of the best done up to that time in Venice. For the altar of Job, in the church of that saint, Giovanni also painted a richly designed and beautifully coloured panel, on which, seated in the middle on a slightly raised throne, he depicted Our Lady with the Child in her arms, and St Job and St Sebastian in the nude, and beside them St Dominic, St Francis, St John, and St Augustine; and below are three *putti* playing instruments very gracefully. And this picture was not only praised for its great beauty then, when newly seen, but has also been praised constantly since.

Being very affected by these highly praised works, some gentlemen began to discuss whether it would not be a good idea, taking advantage of such rare masters, to decorate the hall of the Great Council with scenes in which there should be depicted the glorious triumphs of their marvellous city, its great deeds, its exploits in war, its enterprises, and similar things worthy to be recalled by painting to the memory of those who should come after, so that to the profit and pleasure derived from written histories might be added the entertainment, equally for the eye as for the intellect, of

seeing from the most skilful hands images of so many illus-
trious lords, and the distinguished deeds of so many gentle-
men, utterly worthy of eternal memory and fame. So those
governing the city ordained that Giovanni and Gentile, who
every day made greater progress, should be commissioned
to do this work, and they were ordered to make a beginning
as soon as possible. But it should be realized that Antonio
Veneziano (as is described in his *Life*) had been given the
same hall to paint a long time before, and had finished a
large scene there when, through the enmity of some
malignant men, he was forced to go away and abandon that
most honourable enterprise. Now Gentile, either because he
had more skill and better method in painting on canvas than
in fresco, or for whatever other reason, managed matters in
such a way that he easily won agreement to his doing the
work, not in fresco but on canvas.

And so having put his hand to it, he showed the Pope
presenting the Doge with a wax candle, so that he might
carry it in the solemn processions that were to take place. In
this work, Gentile painted all the exterior of St Mark's, and
he showed the Pope standing in his pontifical robes with
prelates behind him, and the Doge also standing, and
accompanied by many senators. In another part he depicted
the Emperor Barbarossa benignly receiving the Venetian
legates, and then, in great anger, preparing for war; and in
this scene there are some very beautiful perspectives and
countless portraits from life executed with excellent grace,
and a vast number of figures. In the following scene he
painted the Pope exhorting the Doge and the lords of Venice
to equip thirty galleys at their common expense to go out
to do battle with Frederick Barbarossa. Here the Pope is
wearing a surplice and seated on a pontifical throne, with
the Doge by his side and many senators at his feet. In this
part Gentile also drew, but in a different style, the piazza
and façade of St Mark's, and the sea, with such a great
multitude of men that it is a marvel. Then in another part
the same Pope is seen standing in his pontifical robes giving

his blessing to the Doge who, bearing arms and followed by a crowd of soldiers, is shown setting off on the enterprise. Behind the Doge there are countless gentlemen in a long procession. And in the same part, drawn in perspective, are the palace and St Mark's. And this is one of the very best works from the hand of Gentile, although there seems to be more invention in the other part, where a naval battle is depicted, because it contains a countless number of galleys engaged in combat and incredible numbers of men; and in sum, because here he demonstrated no less an understanding of warfare at sea than of the skills of painting. In this work, indeed, all that Gentile depicted, the number of galleys entangled in battles; the soldiers fighting each other; the boats properly diminishing in perspective; the beautifully arranged combat; the fury, the force, the defence, and the thrusts of the soldiers; the different sorts of death; the cleaving of the water by the galleys; the confusion of waves and the different kinds of naval armament, all of this great diversity, I say, cannot but attest to the great spirit of Gentile, to his craftsmanship, invention, and judgement, since each single item was perfectly executed, just as was the composition of the whole.

In another scene Gentile showed the Pope in the act of receiving the Doge, embracing him when he returns with the desired victory, and giving him a gold ring with which to marry the sea, as his successors have done and still do every year to symbolize the true and perpetual dominion which they deservedly exercise over it. Seen in this part of the story is Otto, the son of Frederick Barbarossa, drawn from life and kneeling in front of the Pope; and just as there are many armed soldiers behind the Doge, so behind the Pope there are many cardinals and gentlemen. In this scene there appear only the poops of the galleys, and on the Admiral's ship is Victory, represented in gold, seated, with a crown on her head and a sceptre in her hand.

The scenes that were to be done in the other parts of the hall were allocated to Giovanni, the brother of Gentile; but

since the order of the scenes he did there was related to those executed in great part by Vivarino, but not finished, we need to say something about the latter.

So the part of the hall which Gentile did not do was partly allocated to Giovanni and partly to this Vivarino, so that competition should encourage them all to perform better. Vivarino, then, putting his hand to the part which fell to him to paint, executed beside the last scene from Gentile the figure of the above-mentioned Otto, who is offering to the Pope and to the Venetians to go to make peace between them and his father, Frederick; and who, after he has obtained this, goes on his way, dismissed on his oath. In this first part, as well as the other things he did, which are all worthy of consideration, Vivarino painted in beautiful perspective an open temple with stairs and many figures. And in front of the Pope, who is seated in the midst of many senators, Otto appears again, kneeling to bind himself on his oath. Behind this he showed Otto arriving in front of his father, who receives him happily; a most beautiful perspective of buildings; and Barbarossa seated and his son kneeling down, and holding his hand, accompanied by many Venetian noblemen drawn from life so well that it is clear how very well he imitated Nature. Poor Vivarino would have finished the remainder of his part with much honour to himself; but, as pleased God, he died from exhaustion and his sickly constitution, and so he carried the work no further, and indeed since even what he had done was incomplete, Giovanni Bellini in some places had to retouch it.

Giovanni had meanwhile made a start on four scenes which follow in due order what was described above. In the first, he showed in the church of St Mark's, which he painted exactly as it was, the Pope extending his foot for Frederick Barbarossa to kiss; however, for whatever reason, this first scene of Giovanni's was done again incomparably better and livelier by the truly excellent Titian. Continuing with his scenes, Giovanni made in the next the Pope saying Mass

in St Mark's and then, standing between the Emperor and the Doge, granting a plenary and perpetual indulgence to those visiting the church of St Mark at certain times, especially on the Ascension of Our Lord. He depicted there the interior of the church with the Pope in his pontifical robes at the head of the steps coming down from the choir, surrounded by many cardinals and noblemen: an assembly which makes this a dense, rich and beautiful scene.

In the next one, below this, the Pope is seen wearing his surplice and giving the Doge a canopy, having given another to the Emperor and kept two for himself. In the last scene that Giovanni painted there, Pope Alexander, the Emperor, and the Doge are seen arriving at Rome, where outside the gates by the Roman people and clergy the Pope is presented with eight standards of different colours and eight silver trumpets, which he gives to the Doge so that he and his successors may have them for their insignia. Here Giovanni portrayed Rome, a little way off, in perspective, a large number of horses, countless foot soldiers, with many banners, and other signs of rejoicing, over Castel Sant'Angelo.

And because these truly very beautiful works of Giovanni were infinitely pleasing, arrangements were just being made to commission from him all the rest of the hall when, being now an old man, he died.

So far we have discussed only the hall, in order not to interrupt the sequence of the scenes; and now, going back a little, we must say that from the hand of the same man are to be seen many other works. They include a panel painting which is today on the high altar of San Domenico in Pesaro; and in the chapel of San Girolamo in the church of San Zaccaria in Venice, there is a very diligently composed panel of Our Lady with many Saints, and a building finished very judiciously. And in the same city, in the sacristy of the Friars Minor, known as the Ca' Grande, there is another panel, also from his hand, executed in a good style and well drawn; there is yet another in San Michele di Murano, a monastery of the monks of Camaldoli. Moreover, in the

old church of the San Francesco della Vigna, the seat of the Observant Friars, he did such a beautiful picture of the dead Christ that when its praises came to be sung before Louis XI, the king of France, he asked for it so insistently that its possessors were forced, albeit most unwillingly, to gratify his wish. In its place was put another painting signed by Giovanni, but it was neither as beautiful nor as well executed as the first; and some believe that this picture was chiefly the work of Girolamo Mocetto, a pupil of Giovanni. Then again, in the possession of the Confraternity of St Jerome, there is another work by Bellini, with little figures, which is highly praised. And in the house of Messer Giorgio Cornaro there is a picture which is likewise most beautiful, showing Christ, Cleophas, and Luke.

In the hall referred to, he also painted, though not at the same time, a scene of the Venetians bringing forth from the Monastery of the Carità a pope (I do not know which) who had fled to Venice, and when in hiding there served for a long time as cook to the monks of the monastery; and this scene contains many portraits from life, and many other very beautiful figures.

Not long afterwards, when an ambassador brought some portraits to Turkey for the Grand Turk, they caused that emperor so much wonder and amazement that, although by the Muhammadan law pictures are forbidden, he none the less very eagerly accepted them and endlessly praised the man who made them and the mastery he displayed; and what is more, he requested that the master of those works should be sent to him. Whereupon, after the Senate had reflected that Giovanni was of an age when he could ill endure hardship (and anyhow they did not want to deprive their city of a man like him, especially as he was then busy with the hall of the Great Council), they resolved to send his brother Gentile instead, thinking that he would do as well as Giovanni. Having had Gentile make his preparations, therefore, they brought him safe and sound in their own galleys to Constantinople, where, after he had been pres-

ented by the plenipotentiary of the Senate to Muhammad, he was gladly received and treated affectionately as something new, above all after he had presented that prince with a most delightful picture which filled him with admiration, as if he could not believe that a mortal man had within him, as it were, some divinity, enabling him to express the things of Nature so vividly. Gentile had not lived long in that part of the world before he portrayed the emperor Muhammad from life so well that it was held to be a miracle. And after he had seen many examples of his art, this emperor asked Gentile if he were bold enough to do a self-portrait; and Gentile, after answering yes, did not let many days pass before drawing his own portrait with a looking-glass, and so realistically that it seemed alive. Indeed, when he carried it to the ruler, the latter marvelled so much at what he saw, that he could only think that Gentile was divinely inspired. And if, as said earlier, the Turks were not forbidden by law to exercise the art of painting, that emperor would never have let Gentile depart. But then either from fear of murmurings, or some other reason, one day he had Gentile brought before him, and first having thanked him for the courtesies he had shown, he went on to praise him fulsomely as a man of incomparable excellence, and then added that he should ask any favour he wished, and it would be granted to him without fail. Gentile, like the modest and upright person he was, requested only a letter of favour, recommending him to the most serene Senate and most illustrious Signoria of Venice, his native place. And after this was done with all possible warmth, Gentile was given his leave with honourable gifts and the award of a knighthood.

And among other things which that lord gave him on his departure, in addition to many privileges, there was hung round his neck a chain of Turkish workmanship, weighing 250 gold crowns, which is still in the possession of his heirs in Venice.

After leaving Constantinople, Gentile journeyed very happily back to Venice where he was received with great

joy by his brother Giovanni, and there was general rejoicing over the honours with which Muhammad had rewarded his talent. Then he wanted to pay his respects to the Doge and the Signoria, by whom he was gladly received and commended for having, as they had desired, given satisfaction to that emperor. And so that he should see the account they took of the letters in which that prince had recommended him, they arranged for him an allowance of 200 crowns a year, which was paid for the rest of his life. After his return, Gentile executed few more works. Finally, being already nearly eighty, he passed to the next life, and by his brother Giovanni was given an honourable burial in SS. Giovanni e Paolo, in the year 1501.

Bereft of Gentile, whom he had always loved most tenderly, Giovanni, old as he was, carried on working a little, to while away the time; and having devoted himself to doing portraits from life, he started in Venice the custom by which anyone of a certain rank should have a portrait done either by him or by some other painter. So there are many portraits in all the houses of Venice, and in many gentlemen's homes one may see their fathers and grandfathers back to the fourth generation, and in some of the more noble houses back further still. And this custom has certainly always been deserving of praise, and goes back to the time of the ancients. Who is there who does not feel endless joy and pleasure, in addition to the honour and adornment which they confer, on seeing the likenesses of his ancestors, and especially if they have been famous and renowned for their role in governing their republics, for outstanding deeds in times of war or peace, for their learning, or any other noteworthy and shining talent? And for what other purpose, as has been said elsewhere, did they in the ancient world put the images of great men with honourable inscriptions in public places than to fire the minds of their successors with the love of achievement and glory? Giovanni then drew for Messer Pietro Bembo, before he went to stay with Pope Leo X, a portrait of his mistress that was so

lifelike that, just as Simone Martini was deservedly cele-
brated the first time by the Florentine Petrarch, so was he
secondly by the Venetian, as in this sonnet:

> O image pure, celestial

where at the beginning of the second quatrain Bembo says:

> I think that my Bellini with the face

and so forth. And what better rewards could our craftsmen
want for their exertions than to be celebrated by the pens of
illustrious poets, as the most excellent Titian has also been
by the most learned Messer Giovanni della Casa in the sonnet
which begins:

> In new forms, Titian, do I now discern;

and in the other:

> These are Love's lovely tresses fair?

And was not the same Bellini numbered among the best
painters of his time by the most famous Ariosto at the
beginning of canto XXXIII of the *Orlando Furioso*?

But to return to the works of Giovanni, or rather to the
principal works (since it would take too long if I wished to
mention the pictures and portraits in gentlemen's houses in
Venice and in other places in the state), I should add that in
Rimini, for Signor Sigismondo Malatesta, he did a large
picture containing a Pietà, supported by two *putti*, which is
now in San Francesco in that city. Among other things, he
also did the portrait of Bartolomeo d'Alviano, captain of
the Venetians.

Giovanni taught everyone with loving-kindness and so
he had many disciples, among whom, now sixty years old,
was Jacopo da Montagnana, who closely imitated his style,
as is demonstrated by the works of his to be seen in Padua
and Venice. But the one who imitated him most closely,
and did him the greatest honour, was Rondinelli da
Ravenna, of whom Giovanni made considerable use in all

his works. This Rondinelli did a panel in San Domenico at Ravenna, and another in the Duomo, which is held to be a beautiful example of that style. But surpassing all his other works was what he did in the same city in the church of San Giovanni Battista, of the Carmelites, in which as well as Our Lady he did a very beautiful head in the figure of St Albert, one of their friars; and indeed the whole figure is highly praised.

Also with him, although he did not produce much fruit, was Benedetto Coda from Ferrara, who lived in Rimini, where he did many pictures, leaving behind him a son called Bartolomeo, who did the same. It is said that even Giorgione da Castelfranco studied painting with Giovanni, as a beginner, as did many others besides, both from the territories of Treviso and Lombardy, whom we do not need to record.

Finally Giovanni, having reached the age of ninety, passed from this life, succumbing to old age, and leaving an everlasting memorial of his name in the works he did in Venice, his native land, and abroad: and he was honourably buried in the same church and tomb where he had placed his brother Gentile. Nor were there lacking in Venice those who, with sonnets and epigrams, sought to honour him when dead, just as he had, when living, honoured both himself and his native land.

At the same time as the Bellinis were alive, or a little before, Giacomo Morazone painted many pictures in Venice, and, among other things, for the chapel of the Assumption in Santa Lena did the Virgin with a palm, St Benedict, St Helen herself, and St John, but in the old style and with the figures on tip-toe, as was the custom of those painters living in the time of Bartolomeo da Bergamo.

ANTONIO AND
PIERO POLLAIUOLO

——— · ———

Florentine painters and sculptors, c. 1432–92 and
c. 1441–96

MANY men in a humble spirit begin with poor work and
then, heartened by their growing talent, they also grow in
forcefulness and proficiency till, tackling ever greater pro-
jects, they almost reach up to Heaven with their beautiful
ideas; and then, raised up by Fortune, they very often en-
counter a good prince who, in return for being well served,
is bound to remunerate them for their labours so generously
that they bequeath their descendants lavish benefits and
advantages. Thus men of their sort make their way to such a
glorious end that they leave the world with marvellous
memorials of themselves, as was the case with Antonio and
Piero Pollaiuolo, who were so very highly regarded in their
time, for the talents that they had acquired through their
skill and effort.

The two of them were born a few years apart in the city
of Florence, of a father in poor and lowly circumstances
who, recognizing from many signs his sons' sound and sharp
intelligence, and lacking the means of giving them an
education in letters placed Antonio in the goldsmith's art
with Bartoluccio Ghiberti, a contemporary master who
excelled in that craft, and set Piero to painting with Andrea
del Castagno, who was then the best in Florence. Then
Antonio, brought on by Bartoluccio, as well as learning how
to set jewels and fire enamels on silver, came to be regarded as
the ablest in handling the tools of that art. And so Lorenzo

Ghiberti, who was then working on the doors of San
Giovanni, having given an eye to Antonio's style, brought
him into the work he was executing in company with many
other young men; and put him to doing one of the festoons
which he then had in hand, and on which Antonio made a
quail, which is still there, so perfect and beautiful that it
does everything but fly. Antonio, therefore, had not spent
many weeks on this work, before he was recognized as the
best of all those employed on the project as regards his
draughtsmanship and patience, and indeed as the most
talented and diligent of all. So, as his fame and talent in-
creased, he left Bartoluccio and Lorenzo, and in the New
Market of Florence, he opened his very own splendid and
highly respected goldsmith's shop, where for many years he
pursued that craft, all the time designing and executing in
relief wax models and other fanciful things which very soon
caused him to be held, as he truly was, the leader in that
kind of work.

At the time there lived another goldsmith called Maso
Finiguerra,* who was very renowned, and rightly so; in
engraving and niello there had never been seen anyone who
could make as many figures as he could, whether in a large
or a small space, as demonstrated by some paxes he did in
the church of San Giovanni in Florence, with minutely
wrought scenes of the Passion of Christ. He did very many
excellent drawings, and in our book of designs there are
many sheets of figures both draped and nude, and scenes in
water-colour. In competition with him, Antonio did some
scenes which matched his in the diligence of their execution
and surpassed them in design.

Because of this, the Consuls of the Guild of Merchants,
seeing the excellence of Antonio, decided among themselves
that since they had to commission some scenes in silver for
the altar of San Giovanni, as it had always been the custom

* Maso Finiguerra, engraver and goldsmith, to whom Vasari attributed
the development of engraving on copper, is also mentioned in Benvenuto
Cellini's *Autobiography*.

to invite various masters to make these at different times, so Antonio, too, should work on them; and so it happened. The works he did succeeded so splendidly that they are held to be the best of them all. They comprised the feast of Herod and the dance of Herodias; but the most beautiful of all was the figure of St John in the middle of the altar, executed entirely by the chasing-tool, and much praised. For this reason the Consuls allocated him the candelabra, each six feet high, and the cross in proportion; where he did such a wealth of carving and brought it to such perfection, that both by foreigners and by his own countrymen, it has always been regarded as something marvellous.

Antonio laboured long and hard in this business, both on the works he made in gold and those in enamel and silver. Among these are some very beautiful paxes in San Giovanni, which were so coloured in the fire, that they could scarcely be done better with the brush. And some of his miraculous enamels are also to be seen in other churches of Florence and Rome, and other parts of Italy. He taught the same craft to the Florentine Mazzingo and to Giuliano del Facchino, both of whom were competent masters, and to Giovanni Turini of Siena, who far surpassed those companions of his in this business, in which, from Antonio di Salvi (who executed many good works, such as a big silver cross for the abbey of Florence and other things) to our own time, nothing of great account has been produced. But many of his works and those of Pollaiuolo, because of the city's needs in times of war, have been destroyed and melted in the fire.

Then, realizing that the craft he was following did not produce long-lasting results from the labours of those who practised it, because of his desire to be remembered for a longer time, he decided to abandon it. And as his brother Piero was a painter, he approached him in order to learn the various ways of handling and applying colours. His sudden resolve to give up his former craft was the reason why he turned to painting, which otherwise he would never have dreamed of doing, as it seemed too different to him.

However, to avoid being shamed rather than in pursuit of gain, he learned the skills of colouring in only a few months, and he became an excellent painter. He joined Piero full time, and they worked together on many pictures, among which, since they took great delight in colour, for the cardinal of Portugal they made a panel in oils in San Miniato al Monte, outside Florence, which was placed on the altar of his chapel; and on this they painted St James the Apostle, St Eustace, and St Vincent, which have been much praised. Piero, in particular, painted some prophets there on the wall, in oil (the way he had learned from Andrea del Castagno) in the corners of the angles below the architrave by the lunettes of the arches; and in one of the lunettes he painted an Annunciation with three figures; and for the Captains of the Party he painted a Madonna with her Son in her arms, in a half circle, with a frieze of seraphim all around, also executed in oils.

They also painted in oil on canvas on a pilaster of San Michele in Orto, an Angel Raphael with Tobias, and in the Mercatanzia of Florence they made some Virtues, in the place where its magistrates hold their sittings. Antonio portrayed from life Messer Poggio, secretary of the Signoria of Florence, who continued the history of Florence after Messer Leonardo of Arezzo; and of Messer Giannozzo Manetti, a learned and highly regarded person, he also did a portrait in the same place where, some while before, other masters had depicted Zanobi da Strada, a Florentine poet, Donato Acciaiuolo, and other proconsuls. And in the Pucci Chapel, in San Sebastiano de' Servi, he did the altar panel, which is a rare and excellent work, displaying wonderful horses, male nudes, and very beautiful figures in foreshortening, with St Sebastian himself portrayed from a living figure, namely Gino di Lodovico Capponi; and this work was the most praised of any that Antonio ever did. This was because, to succeed in imitating Nature as closely as possible, he showed in one of the archers, who is resting his crossbow against his chest and kneeling down in order to load it, all

the force that a man of strong arm can exert in loading that weapon, for we can perceive in him the swelling in his veins and muscles, and how he holds his breath to exert more force. And not only did he finish this figure with great attention, but all the others in their various attitudes display very clearly all the consideration and skill he applied to that work, which were certainly recognized by Antonio Pucci, who gave him for it 300 crowns, which he commented would hardly cover the cost of the paint. And it was finished in the year 1475.

Taking courage, therefore, from this, at San Miniato fra le Torri he then painted a St Christopher, twenty feet high, which was very beautiful and executed in the modern manner, and it was the best-proportioned figure of its size that had been done up to then. Next, on canvas he did a Crucifixion with St Antoninus, and this was placed in the saint's chapel in San Marco.

In the palace of the Signoria of Florence, for the Porta della Catena he executed a St John the Baptist; and in the house of the Medici, he painted for the elder Lorenzo three figures of Hercules in three pictures each ten feet high. The first shows him slaying Antaeus, and is a very beautiful figure, in which the strength of Hercules as he crushes the other is seen realistically, for the muscles and the nerves of the hero are all strained in the effort to burst Antaeus asunder, and the painting of his head reveals him gnashing his teeth in such accord with the other parts of his body that the very toes of his feet are raised in the effort. Nor was he in the slightest less alert when doing the figure of Antaeus who, crushed in the arms of Hercules, is shown as fainting and losing all his strength, as with his mouth open he renders up his spirit. The next shows Hercules killing the lion, with his left knee hard against its chest and, grasping the lion's jaws with both hands, clenching his teeth and stretching his arms, as he opens and tears them apart by main force, though the wild beast is tearing his arms grievously with its claws. The third, of Hercules killing the Hydra, is truly something

marvellous, especially the serpent whose colouring he made so lively and realistic that it could not be more lifelike. In it we see venom, fire, ferocity, and rage depicted so directly that Antonio deserves to be celebrated and closely imitated in this by all good craftsmen.

For the Confraternity of Sant'Angelo in Arezzo, he did an oil painting on cloth with a crucifix on one side, and on the other a St Michael fighting the dragon, as beautiful as anything to be seen from his hand; for the figure of St Michael, with clenched teeth and knotted brow defiantly confronting the dragon, seems truly to have come down from Heaven to wreak God's vengeance on the pride of Lucifer; and it is indeed a marvellous work.

He understood about painting nudes in a way more modern than that of previous masters, and he dissected many bodies to view their anatomy, and he was the first to show how to seek out the muscles and so give them their proper position and form in his figures; and he engraved on copper a battle scene of nudes all girt round with a chain; and then he did other engravings, far better incised than those of previous masters.

For these reasons, he grew famous among all the craftsmen, and, on the death of Sixtus IV, by the Pope's successor, Innocent, he was brought to Rome, where for the latter he made a tomb of metal on which he portrayed him from life, seated in the attitude he adopted when giving his blessings, which was placed in St Peter's; and he also made the tomb of Pope Sixtus, which was completed at great expense and then put in place in the chapel named after that pontiff. And on this free-standing and richly adorned tomb lies the figure of the Pope, extremely well done; and the tomb of Innocent is in St Peter's, by the chapel containing the Lance of Christ. It is said that the same man also designed the fabric of the Belvedere Palace for Pope Innocent, although, as he did not have much experience in building, the work was carried out by others. Finally, after they had grown rich, both of the brothers

died,* one a little after the other, in 1498, and their relations buried them in San Piero in Vincula; and as a memorial, by the middle door on the left as one goes into the church, they were both portrayed in two marble tondi with this epitaph:

Antonius Pullarius patria Florentinus, pictor insignis, qui duor. pont. Xisti et Innocentii aerea moniment. miro opific. expressit, re famil. composita ex test. hic se cum Petro fratre condi voluit. Vixit an. LXXII. Obiit an. Sal. M.IID.†

He also made a low relief in metal of a very beautiful battle of nude figures, which was sent to Spain, and of which every craftsman in Florence has a plaster cast. And after his death, there was found the design and model that he made at the request of Lodovico Sforza for the equestrian statue of Francesco Sforza, Duke of Milan; and we have this design in our book in two forms: in one the Duke has Verona beneath him, in the other he is all in armour, over a pedestal full of battle scenes, and making his horse jump on an armed man. And the reason why he did not put these designs into execution I have not yet been able to discover. He also made some very beautiful medals, including one showing the Pazzi conspiracy, with the heads of Lorenzo and Giuliano de' Medici, and on the reverse the choir of Santa Maria del Fiore and the whole event just as it happened. Similarly he made the medals of several pontiffs, and many other things which are known to craftsmen.

Antonio was seventy-two years old when he died, and Piero seventy-five years. He left many disciples, and among them was Andrea Sansovino. He had a very happy life in his time, finding rich pontiffs, and his own city at its height, and delighting in the presence of talent; so he was greatly esteemed. Whereas if he had lived in adverse times, he would

* Piero died in 1496, and Antonio in 1498.

† Antonio Pollaiuolo, Florentine by homeland, renowned painter, whose marvellous skill shaped the bronze monuments of two Popes, Sixtus and Innocent, asked that when his personal affairs had been settled according to his will, he should be interred here with his brother Piero. He lived seventy-two years, and died in the year of our Saviour 1498.

not have produced the fruits he did, since troubled times are great enemies of the branches of knowledge which men practise and pursue and in which they take delight.

From the design of this craftsman, there were made for San Giovanni of Florence two albs and a cope and pluvial of double brocade, woven all in one seamless piece; and for their borders and ornamentation were embroidered scenes from the life of St John with exquisite workmanship and skill by Paolo da Verona, an inspired master of that craft, of rare intelligence beyond all others. And by him the figures were executed with the needle as well as they had been painted by Antonio's brush; so we are under no small obligation to the one for his talent in design, and to the other for his patience in embroidery. It took twenty-six years to complete this work; and of these embroideries made with a close stitch, which as well as being longer-lasting seem to be really painted with the brush, the good method is now almost lost, for nowadays the more open stitch is used, which is less lasting and less charming to the eye.

LIFE OF
BERNARDINO PINTORICCHIO

—— · ——

Painter of Perugia, c. 1454–1513

JUST as there are many who are helped by Fortune and are not endowed with much talent, so on the contrary there are countless talented men who are persecuted by hostile and contrary Fortune. Thus it is an open secret that her children are those who are not helped by talent but depend on her; for she likes to raise by her favour some who would never win recognition through their own merits. And this is seen in the case of Pintoricchio of Perugia, who, even though he executed many works and was helped by various people, none the less won a far greater reputation than his works deserved; all the same he was someone who had great skill in large works, and who kept many occupied continuously on his projects.

Pintoricchio, then, having in his early youth worked on many things with his master Pietro of Perugia, taking a third of all the profit, was called to Siena by Cardinal Francesco Piccolomini to paint the library that had been built in the Duomo of that city for Pope Pius II. But it is true that the sketches and cartoons for all the scenes he made there were from the hand of Raphael of Urbino, then a very young man, who had been his companion and fellow disciple in the household of Pietro, whose style Raphael had learned very well. And one of these cartoons can still be seen today in Siena, while some of the sketches from the hand of Raphael are in our book.

So then the scenes shown in this work, in which Pintoricchio was helped by many of his own apprentices and

labourers, all from the school of Pietro, were divided into ten panels. The first painting shows when Pope Pius II was born to Silvio Piccolomini and Vittoria, to be given the name Aeneas, in the year 1405, in the Valdorcia in the castle-town of Corsignano, which is today known, after him, as Pienza, since subsequently he rebuilt it as a city.* And in this panel Silvio and Vittoria are portrayed from life. In the same painting is when with Domenico, cardinal of Capranica, he crosses the Alps, covered with snow and ice, to go to the council in Basle. In the second is when the Council sends Aeneas himself on many legations, namely three times to Strasbourg, to Trent, to Constance, to Frankfurt, and to Savoy. In the third is when Aeneas again is sent by the anti-Pope Felix† as orator to the Emperor Frederick III, in whose presence Aeneas's quickness of mind, eloquence, and grace were so deserving that he was crowned by Frederick poet laureate, made his proto-notary, received among his friends, and appointed first secretary. In the fourth is when he was sent by the same Frederick to Eugenius IV, by whom he was created bishop of Trent and then archbishop of his own native place, Siena. In the fifth scene is when the same emperor, wishing to come to Italy to take the Imperial crown, sends Aeneas to Telamone, the Sienese port, to meet his wife, Leonora, coming from Portugal. In the sixth, Aeneas, sent by the Emperor, is on his way to Calixtus III to induce him to make war on the Turks; and in that part is seen where the same pontiff (as Siena was being harassed by the Count of Pitigliano and others at the instigation of Alfonso, King of Naples) sends Aeneas to treat for peace; and this being achieved, he prepares for war against the Orientals, while Aeneas, having returned to Rome, is made a cardinal by the Pontiff. In the seventh, after the death of Calixtus, Aeneas is seen being made Supreme Pontiff, taking the name Pius II. In the eighth, the

* The first instance of Renaissance town-planning, Pius's birthplace was rebuilt and embellished from 1459 after designs by Bernardo Rossellino.

† Felix V, the last anti-Pope in history, elected by dissident bishops at the council of Basle in 1439.

Pope goes to the council at Mantua for the expedition against the Turks, and there Marquis Lodovico receives him with the most splendid display and incredible magnificence. In the ninth, Aeneas, again, enters in the catalogue of saints or, as is said, canonizes Catherine of Siena, a nun and holy woman of the Order of Friars Preachers. In the tenth and last scene, while Pope Pius is preparing a huge armada against the Turks with the blessing and help of all the Christian rulers, he dies in Ancona; and a hermit of Camaldoli, a holy man, sees the soul of the Pope at the instant of death, as we can also read, borne by angels into Heaven. Then in the same scene, his body is being transported from Ancona to Rome by an honourable escort of innumerable lords and prelates, who are lamenting the death of so great a man and so rare and holy a pontiff. And this work is all full of portraits from life, all of whose names it would be a long story to recount; and it is all painted with the most fine and lively colours, and executed with various gold ornaments, and splendidly devised compartments in the heavens; and under each scene is a Latin epitaph describing what it contains.

Cardinal Francesco Piccolomini and his nephew brought to this library and placed where they are now in the middle of the room the three Graces, made of marble, very beautiful and ancient, which were the first antiques to be highly esteemed in those times.

The library, which contains all the books left by Pius II, was only just finished when Cardinal Francesco, Pius II's nephew, was made Pope and chose to be called Pius III in memory of his uncle. And in a very large picture over the door of the library, looking on to the Duomo, in a scene so large that it covers the whole façade, Pintoricchio painted the coronation of Pius III with many portraits from life, and with these words written below:

*Pius III Senensis, Pii II nepos, MDIII Septembris XXI apertis electus suffragiis, octavo Octobris coronatus est.**

* Pius III of Siena, nephew of Pius II, after being duly elected on 21 September 1503, was crowned on 8 October.

Pintoricchio was working in Rome in the time of Pope Sixtus, and assisting Pietro Perugino, and at that time he had entered the service of Domenico della Rovere, cardinal of San Clemente, who, after building a very beautiful palace in the Borgo Vecchio, wanted Pintoricchio to do all the painting, and to put on the façade the coat of arms of Pope Sixtus, upheld by two *putti*. Pintoricchio also did some things for Sciarra Colonna in the palace of Santi Apostoli.* And not long after, in the year 1484, the Genoese Pope, Innocent VIII, had him paint some halls and loggias in the Belvedere Palace, where, as the Pope wished, among other things he painted a loggia entirely with landscapes, depicting Rome, Milan, Genoa, Florence, Venice, and Naples in the style of the Flemings, which, being rarely used till then, gave great pleasure; and in the same spot he painted a fresco of Our Lady, at the entrance of the main door.

In the chapel in St Peter's containing the lance that pierced the side of Christ, he did a panel painting in tempera for Innocent VIII showing Our Lady, larger than life-size. And in the church of Santa Maria del Popolo he painted two chapels, one for Domenico della Rovere, cardinal of San Clemente, who was later buried there, and the other for Cardinal Innocenzio Cibo, who was also interred there; and in each of the chapels he portrayed the cardinal who commissioned it from him.

In the palace of the Pope he painted some rooms, overlooking the courtyard of St Peter's, where the ceilings and pictures were renewed a few years ago by Pope Pius IV. In the same palace, Alexander VI commissioned him to paint all the rooms where he lived, and the whole of the Borgia tower, where he painted scenes showing the liberal arts in one room, and decorated all the vaults with stucco and

* The Borgo Vecchio was one of the old streets destroyed in the 1930s to build the grandiose Via della Conciliazione leading to St Peter's; Domenico della Rovere's Palazzo dei Penitenzieri still stands, as a hotel, and lodges the priests who hear confessions in St Peter's.

gold. But since they did not have the method of doing stuccoes in the manner they are done today, this ornamentation is for the most part spoiled. In the palace he also portrayed over the door of one of the living rooms Signora Giulia Farnese in the features of Our Lady, and in the same picture the face of Pope Alexander, who is adoring the Madonna. In his pictures, Bernardino used to make great use of relief ornaments set in gold, to satisfy those who understood little about the art, and give them more show and lustre, which is a barbarous thing to do in painting. Then he did in those rooms a scene from the life of St Catherine, and the way he represented the arches of Rome and the figures he painted, with the figures in the foreground and the buildings behind, brought the objects to be seen as receding further forward than those that should be larger to the eye: a tremendous blunder in our art of painting.

In Castel Sant'Angelo he painted countless rooms with grotesques, and in the great tower in the garden below he executed scenes from the life of Pope Alexander, with portraits of the Catholic queen, Isabella, Niccolò Orsini, Count of Pitigliano, Gian Giacomo Trivulzio, and other relations and friends of that Pope, and in particular Cesare Borgia, his brother, and his sisters, with many talented men of that time.

At Monte Oliveto in Naples in the chapel of Paolo Tolosa, there is a panel picture of the Assumption from Pintoricchio's hand. He also painted countless other works throughout Italy which, since they are not very good, but routine works, I shall pass over in silence.

Pintoricchio used to say that to give his work the highest relief a painter should himself stand out on his own and owe nothing to princes or any other people. He also did some work in Perugia, but only a few things. In Araceli he painted the chapel of St Bernardino, and in Santa Maria del Popolo, where as we have said he painted the two chapels, on the vault of the main chapel he did the four Doctors of

the Church. Then when he reached the age of fifty-nine years, he was commissioned to do a panel of the Birth of Our Lady for San Francesco in Siena; and when he set his hand to this, the friars consigned him his own room to live in and left it for him, as he wished, clear and empty of everything, save for a high antique chest, as this seemed to them too cumbersome to move. But Pintoricchio, being such a strange and fanciful man, kept on making such a fuss about it that they finally, in desperation, resolved to take it away, and, as their luck would have it, as it was being taken out one of its drawers burst open to reveal 500 gold ducats of the Camera; and this so displeased Pintoricchio and he took so badly the good fortune of those poor fathers that it was unimaginable; indeed he was so heart-broken that he could never think of anything else, and it was the death of him.

His pictures were done about the year 1513. His friend and companion, although older than him, was Benedetto Buonfiglio, a painter from Perugia, who, along with other masters, executed many things in the palace of the Pope in Rome. And in his native land of Perugia, in the chapel of the Signoria, he did scenes from the life of St Ercolano, bishop and protector of that city, as well as some miracles performed by St Lodovico. In San Domenico, he painted on a panel in tempera the story of the Magi, and on another panel a crowd of saints. In the church of San Bernardino, he painted a Christ in the sky with St Bernardino himself, and a crowd of people below. In brief, this painter was very greatly esteemed in his own native land, before Pietro Perugino won recognition.

Another friend of Pintoricchio who collaborated with him on many works was Gerino of Pistoia, who was regarded as a very diligent colourist and sound imitator of the style of Pietro Perugino, with whom he worked almost till his death. He did a few things in his native town of Pistoia. At Borgo San Sepolcro, for the Society of the Holy Child Jesus, he did a panel in oils of the Circumcision,

which is reasonably good. For the parish church in the same place, he painted a chapel in fresco, and by the road on the Tiber which leads to Anghiari, for the local community, he also frescoed a chapel; and in the same place, for San Lorenzo, an abbey of the monks of Camaldoli, he did another chapel; and through this work he stayed so long at Borgo that he almost adopted it as his native home. Gerino lived wretchedly as a painter; he toiled wearily over his work, and he would struggle so hard to finish one of his paintings that it was a torture to him.

In those times, Niccolò Alunno was regarded as an outstanding painter in the city of Foligno, for up to the time of Pietro Perugino oil painting was not very usual, and so many men were thought to be competent, who subsequently came to nothing. And Niccolò gave great satisfaction with the pictures he produced, as even though he worked only in tempera, since he gave his figures faces drawn from life and looking very realistic, his personal style was very pleasing. In Sant'Agostino at Foligno, there is a panel from his hand of the Nativity of Christ, and a predella with little figures. In Assisi, he did a banner for carrying in processions, the panel picture for the high altar of the Duomo, and another for San Francesco. But the best painting which Niccolò ever did was a chapel in the Duomo, where there is a Pietà with two angels bearing torches and weeping so realistically that I believe any other painter whatsoever, no matter how excellent, would have been able to do little better. In the same place he painted the façade of Santa Maria degli Angeli, and many other works, which there is no call to mention, as it was enough to have touched on the best.

And this ends the *Life* of Pintoricchio, who, among other things, gave much satisfaction to many princes and lords, since he quickly finished and handed over his works as they wanted, though such works are perhaps less good than those done slowly and carefully.

LIFE OF

PIETRO PERUGINO

—— · ——

Painter, c. 1445/50–1523

How beneficial poverty may sometimes be to talented
people, and great its power to make them perfect or out-
standing in one capacity or another, can be seen quite clearly
in the actions of Pietro Perugino. For, desirous of using his
talents to achieve a good position, he fled from calamitous
misfortunes at Perugia and went to Florence, where he
stayed some months in poverty, sleeping in a chest for want
of a proper bed; he turned night into day and with tremen-
dous fervour spent all his time on the study of his profession.
Having made a habit of this, his only pleasure was always to
work hard on his craft and always to be painting. This was
because he always had the fear of poverty before his eyes
and so he did things to make money, which probably he
would not have troubled to do if he had possessed the
wherewithal to keep himself. And it may be that riches
would have closed to him and his talents the path to excel-
lence as decisively as poverty opened it to him; but sheer
need spurred him on in his desire to rise from a poor and
inferior condition, if possibly not to the supreme heights,
then at least to a rank where he had the means to support
himself. On account of this, he never worried about cold,
hunger, discomfort, inconvenience, or fatigue, if he could
live one day in ease and repose, and he would always say, as
if it were a proverb, that after bad weather there has to be
good, and that when the weather is good is the time one
needs to build houses for shelter.

But to give a better understanding of this craftsman's

progress, starting from his origins, let me say that, according to popular report, there was born in the city of Perugia to a poor person from Castello della Pieve, known as Cristofano, a son who at his baptism was called Pietro; and, being brought up amidst poverty and hardship, he was given by his father as an errand-boy to a painter in Perugia, who was not very able in that calling but who greatly venerated both the craft of painting and the men who excelled in it. Nor did he ever talk to Pietro of anything other save how much profit and honour painting brought to those who did it well; telling him of the rewards that had been won from painting by the ancients and the moderns, to encourage Pietro to study it. He inspired him in such a manner that Pietro formed the ambition of becoming one of these paint- ers himself, if Fortune were on his side.

So Pietro often used to ask, of those he knew to have travelled the world, whereabouts were the best masters of that calling; and particularly he asked this of his master, who always replied to the same effect, namely that in Flor- ence more than anywhere else appeared men who were perfect in all the arts, and especially in painting, because in that city people are spurred on by three things. First is the sharp criticism so often expressed by so many people, as the air of Florence breeds naturally free spirits not generally content with mediocre works, but always considering them more in respect of the good and the beautiful than with regard to those who made them. Next, if anyone wishes to live there, he needs to be industrious, which simply means to say, to employ constant intelligence and judgement, and to be quick and clever in everything; and finally, to know how to earn money, as Florence does not have a large and fertile countryside such as would allow all those who stay there to make easy livings as happens in places where there is abundant wealth. And the third spur, surely no less effective than the others, is a lust for glory and honour which the very air of Florence generates in those of every profession, and which if they are persons of spirit will not

let them simply be the equals of those they see to be men like themselves, let alone lag behind, though they acknowledge them as masters. On the contrary, they are very often constrained to seek their own greatness so avidly that, if they are not kind and wise by nature, they end up being slanderous, ungrateful, and blind to all the benefits they have received.

It is very true that when a man has learned all that he needs to, and he wants to do more than live from day to day like an animal but desires to make himself rich, then he needs to leave the city and cash in abroad on the excellence of his works, and the reputation of Florence, as do the learned men with the fame won from their university. For Florence deals with its craftsmen as Time does with its own works, which, once they are done, it then undoes and consumes bit by bit.

Moved by this advice, therefore, and by the persuasions of many others, Pietro came to Florence with the ambition to achieve excellence; and he succeeded very well, for the reason that at that time works done in his kind of style were highly prized. He studied as a pupil under Andrea Verocchio, and his first figures were painted outside the Porta a Prato in the convent of San Martino, now ruined because of the wars. And in Camaldoli, he did a wall painting of St Jerome, which was then highly esteemed by the Florentines and especially praised for the way he portrayed the old saint as thin and wizened, staring at the crucifix, and so emaciated that he looks like an anatomical model, as can be seen in a copy of it belonging to Bartolommeo Gondi.

Within a few years, therefore, Perugino acquired such renown that his works filled not only Florence and Italy but France, Spain, and many other countries to which they were sent. And so, as his paintings were very highly valued and regarded, the merchants started to buy them up and to send them abroad to various countries, to their own considerable profit and gain. For the nuns of Santa Chiara, he did a panel of the dead Christ with such lovely and novel

colouring that he convinced all the craftsmen that he was bound to become marvellous and outstanding. This work displays some very fine heads of old men, along with figures of the Marys, who, having ceased to weep, are contemplating the dead body with extraordinary wonder and love; as well as these, he painted a landscape which was then held to be extremely fine, since at that time the true way to do landscapes as shown since had not yet been seen. It is said that Francesco del Pugliese offered to pay the nuns three times as much as they had given Pietro, and to have a similar one made for them by the same man's hand; but they would not consent, because Pietro said that he did not believe he could make its like again.

There were also many things by the hand of Pietro in the convent of the Jesuate friars* outside the Pinti gate; and because the church and convent are today in ruins, I will not regard it as irksome, before I proceed further with this *Life*, to take this opportunity of saying something about them. So, then, this church, whose architect was Antonio di Giorgio from Settignano, was eighty feet long and forty feet wide. At the head of the church, a few steps or stairs led up to a dais twelve feet in extent on which stood the high altar ornamented with many stone carvings, on which was a richly framed panel picture, as was said, from the hand of Domenico Ghirlandaio. In the middle of the church was an interior wall with a door in open-work from the middle up, and with an altar on each side. Over each altar, as will be told, stood a panel picture by the hand of Pietro Perugino; and over the door was a very beautiful Crucifixion by the hand of Benedetto da Maiano, with figures of Our Lady and St John in relief on either side; and before the dais of the high altar, standing against the wall, was a very beautifully made choir of walnut in the Doric order. Then above the main door of the church was another choir supported by

* *Ingesuati*, a religious Order taking its name from the mystical theological concept of being 'lost in Christ'. The Gesuati were approved as an Order in 1367 by Pope Urban V, not Boniface, as Vasari says below.

well-constructed woodwork which formed a balcony with a very beautiful partition, and a row of balusters acting as a parapet for the front of the choir, which faced the high altar. This choir was convenient for the friars of that convent to say their Office during the night and for their private prayers, and also for weekdays. From the main door of the church, which was beautifully adorned with stone carvings, there was a colonnade extending all the way to the door of the convent; and over the door in a half circle was a beautiful figure of St Justus as bishop between two angels from the hand of the illuminator Gherardo; for the church was dedicated to St Justus, and it contained a relic preserved by the friars, namely an arm of the saint himself.

At the entrance to the convent was a little cloister of exactly the same size as the church, namely eighty by forty feet long; and the arches and vaulting encircling it rested on stone columns, providing a very convenient and spacious loggia all the way round. In the middle of the courtyard of the cloister, which was all neatly paved with flagstones, was a very attractive well under a loggia, similarly supported by stone columns, and providing a rich and beautiful ornament. Inside the cloister was the friars' chapter-house, whose side-door led to the church and the stairway going up to the dormitory, and to other of the friars' own rooms. Beyond the cloister, in line with the main door of the convent, was a gallery as long as the chapter-house and the bursar's office together, leading to another cloister, finer and bigger than the first. And all this line of buildings, namely the eighty-foot long loggia of the first cloister, with the gallery, and that of the second cloister, made a very extended enfilade, more beautiful than words can say, especially since from the further cloister, in the same line, there stretched a garden walk 400 feet long. And all this, for someone coming from the main door of the convent, presented a marvellous view. In the second cloister was a refectory 120 feet long and 36 feet wide, with all those properly appointed rooms and offices, as the friars call them, which are required in such a

convent. Above was a dormitory in the shape of a T, one part of which, the main part of the upright, was double, with cells on each side; and at the upper end, in a space of thirty feet, was an oratory, with a panel by the hand of Pietro Perugino, and over the door of the oratory from the hand of the same painter was another work in fresco, mentioned below; and then on the same floor, over the chapter-house, was a large room where the fathers busied themselves making glass windows, with all the little furnaces and other useful items needed for this kind of work. And since, while Pietro lived, he made the cartoons for many of their works, all they did in his time was excellent.

Then again, the garden of this convent was so beautiful and so well maintained, and the vines around the cloister and everywhere else so well arranged, that nothing finer could be seen anywhere around Florence. Similarly the rooms where, as was their custom, they distilled scented waters and medicines have all the best possible conveniences imaginable. In sum, this convent was one of the finest and best ordered in the State of Florence; so I wish to leave this record of it, especially as the majority of the pictures it contained were by the hand of our Pietro Perugino.

And now to come back to Pietro; let me say that of the works he made in the convent mentioned above only the panel pictures have been preserved, since the fresco paintings, along with the whole of the building, were ruined because of the siege of Florence, when the panels were carried to the gate of San Pier Gattolini, where the friars were given accommodation in the church and convent of San Giovannino. Then the two panels which were on the rood-screen mentioned earlier were by the hand of Pietro, and on one of them was Christ in the garden with the sleeping Apostles, in whom Pietro showed the power of sleep over grief and distress, as he had depicted them asleep in attitudes of total relaxation. And on the other he did a Pietà, of Christ in the lap of Our Lady surrounded by four figures no less excellent than the others in his own style.

And among other things he made the dead Christ all stiffened, as showing to what he had been reduced by the length of time and the cold after hanging on the Cross so long; so because of this he showed him supported by St John and the Magdalen, all weeping and distraught. On another panel, with infinite diligence, he executed a Crucifixion with the Magdalen and, at the foot of the Cross, St Jerome, St John the Baptist, and Blessed Giovanni Colombini, founder of that Order. These three panels have deteriorated a great deal, and in the dark parts and where there are shadows, they are full of cracks; and this happens when the first coat of colour which is applied to the ground (for three bands of colour are used one on top of the other) is worked on before it is properly dry; and so afterwards, with time, they contract through their layers and come to have the force to cause those cracks. But Pietro could not know this, because in his time they were only just beginning to paint well in oil.

Then, as the works of Pietro were being highly commended by the Florentines, a prior of the same convent of the Jesuates, who took delight in the art of painting, commissioned from him the wall of the first cloister, in the manner of a miniature, a Nativity with the Magi, which he finished perfectly with marvellous detail and charm. For it contained a countless number of varied heads, and not a few portraits from life, among which was the face of Andrea del Verrocchio, his master. In the same courtyard over the arches of the columns, he made a frieze with life-size heads, very well executed. And among them was one of the prior himself so lifelike and produced in so good a style that it was judged by the most experienced craftsmen to be the best thing that Pietro ever made; and he was commissioned to make in the same cloister over the door leading to the refectory a scene showing when Pope Boniface confirmed the habit of his new Order for the Blessed Giovanni Colombino, in which he portrayed eight of the friars, and did a very beautiful view receding in perspective, which

was deservedly much praised, because Pietro specialized in
this. In another scene below this, he began a Nativity of
Christ with some angels and shepherds, executed with the
freshest colouring. And in an arch over the door of the
oratory he did three half-length figures of Our Lady, St
Jerome, and the Blessed Giovanni in such a beautiful style
that it was held to be one of the best wall-paintings that
Pietro ever did.

The prior, according to what I once heard tell, was very
excellent at making ultramarine blues, and therefore, since
he had an abundance, he wanted Pietro to make a gener-
ous use of them in all the works mentioned above; none
the less, he was also so mean and suspicious that, not
trusting Pietro, he wanted to be present himself whenever
Pietro was using blue in his work. So then Pietro, who
was naturally honest and upright and wanted nothing
from others unless he earned it through his labours, took
the prior's lack of trust very ill, and determined to put
him to shame. Having found a basin of water, therefore,
and having done his priming for the draperies, and for
anything else he wished to do in blue and white, he time
and time again kept getting the prior (who grudgingly
produced his little bag) to put the ultramarine into the
little earthen pot containing the distemper; and having
started the work, at every second brushstroke Pietro
would again always moisten his brush in the basin, so that
more ultramarine stayed in the water than was being
applied to the picture; and the prior, who saw his little
bag of ultramarine growing empty and not much of the
picture appearing, kept saying over and over again:

'Oh, what a lot of ultramarine this plaster is eating up!'

'Just as you see,' Pietro would reply.

After the prior had left, Pietro recovered the ultramarine
from the bottom of the basin, and then, when the time
seemed right, he gave it back to the prior and remarked:

'Father, this is yours: learn to trust upright men who
never deceive those who trust them, but who all the same

know, if they so wish, how to deceive the mistrustful, such as you.'

Because of these works and many others besides, Pietro won such fame that he was almost forced to go to Siena where, in San Francesco, he painted a large panel picture that was held to be very beautiful, and, in Sant'Agostino, another of a Crucifixion with some saints. A short while after this, in the church of San Gallo at Florence, he did a panel picture of St Jerome in Penitence, which is now in San Jacopo tra'Fossi, where live the above-mentioned friars, near the Canto degli Alberti. He was commissioned to paint a Dead Christ with St John and the Madonna over the steps of the side-door of San Pietro Maggiore, and he executed this in such a manner that, though exposed to wind and rain, it has been preserved as fresh-looking as if it had just now come from Pietro's hand. Certainly Pietro's intelligence understood colours well, both in fresco and in oil; and because of this, a debt is owed to him by all those experienced craftsmen who through him have come to an understanding of the lights that pervade his works.

In Santa Croce, in the same city, he did a Pietà with the dead Christ in Our Lady's arms and two figures which are marvellous to see, not so much for their excellence as for its remaining so fresh and vivid in the colours painted in fresco. By Bernardino de' Rossi, a Florentine citizen, he was commissioned to paint a St Sebastian to send to France, for an agreed price of 100 gold crowns. This was then sold by · Bernardino to the king of France for 400 gold ducats. At Vallombrosa, he painted a panel for the high altar, and similarly, in the Carthusian house at Pavia, he executed a panel picture for the friars. At the behest of Cardinal Caraffa of Naples for the high altar in the bishop's palace, he painted the Assumption of Our Lady with the Apostles standing in amazement around her tomb; and at Borgo San Sepolcro, for the abbot Simone dei Graziani, he painted a large panel picture, which he made in Florence, and which, at considerable expense, was carried on the shoulders of porters to San Gilio in the Borgo.

To San Giovanni in Monte at Bologna, he sent a panel with some figures standing upright, and a Madonna in Heaven. As a result, the fame of Pietro spread so much throughout Italy and beyond, that to his great glory he was brought to Rome by the Pontiff Sixtus IV to work in his chapel in company with other excellent craftsmen; and there, in company with Don Bartolomeo della Gatta, abbot of San Clemente of Arezzo, he executed the scene showing Christ giving the keys to St Peter; and similarly, the birth and the baptism of Christ; and also the birth of Moses, with Pharaoh's daughter taking him safely from the little ark. And on same wall, where the altar is, he painted a mural picture of the Assumption of Our Lady, with a portrait of Pope Sixtus on his knees. But these works were destroyed in making the wall ready for the Last Judgement of the divine Michelangelo in the time of Pope Paul III. On a vault in the Borgia tower of the Papal palace, he executed several scenes of the life of Christ, with some foliage in chiaroscuro, which in his time won an extraordinary reputation for excellence. In San Marco, likewise in Rome, he painted a scene of two martyrs next to the tabernacle, one of the best works he did in Rome. For Sciarra Colonna, in the palace of Sant'Apostolo, he also painted a loggia and other rooms; and these works put a great deal of money in his hands.

So having then resolved not to stay any longer in Rome, with the good favour of all the court he left to return to his native place of Perugia; and in many parts of the city, he executed panel paintings and frescoes, and in particular for the chapel of the palace of the Signori a panel in oils showing Our Lady and other saints. At San Francesco del Monte, he painted two chapels in fresco, in one depicting a scene of the Magi going with their offerings to Christ, and in the other, the martyrdom of some Franciscan friars, who were killed when they went to the sultan of Babylon. In the convent of San Francesco, he similarly painted two panels in oils, one containing the Resurrection of Christ and the other

St John the Baptist and other saints. Likewise, he painted two panels for the Church of the Servites: one containing the Transfiguration of Our Lord, and the other, by the sacristy, the story of the Magi. But as these are not of the same excellence as Pietro's other works, it is held as certain that they are among the first that he did. In the same city, in the chapel of the Crucifix of the Duomo of San Lorenzo, from the hand of Pietro are the pictures of Our Lady, St John and the other Marys, St Laurence, St John, and other saints. Also for the Altar of the Blessed Sacrament, where the ring with which the Virgin Mary is married is preserved, he painted the Marriage of the Virgin. Afterwards, he painted in fresco all the Audience Chamber of the Bankers' Guild, depicting in the compartments of the vaulting the seven planets drawn along on chariots by diverse animals, following the old custom; and on the wall opposite the entrance door, he did the Birth and the Resurrection of Christ, with a panel showing St John the Baptist among various other saints. Then on the side walls, in his own style, he painted first Fabius Maximus, Socrates, Numa Pompilius, Fulvius Camillus, Pythagoras, Trajan, L. Sicinius, the Spartan Leonidas, Horatius Cocles, Fabius, Sempronius, the Athenian Pericles, and Cincinnatus.* On the other wall, he did the prophets, showing Isaiah, Moses, Daniel, David, Jeremiah, and Solomon, as well as the sibyls, namely the Erythrean, the Libyan, the Tiburtine, the Delphic, and so on. And below each of these figures, he put in writing some words which they had uttered, appropriate to that place. And on the ornamentation, he did his own most lifelike portrait, writing some lines under his name as follows:

PETRUS PERUSINUS EGREGIUS PICTOR
Perdita si fuerat pingendi, Hic rettulit artem
Si nusquam inventa est, Hactenus ipse dedit.
Anno Salut. M.D.†

* The names should be Furius (not Fulvius) Camillus, Pithacus (not Pythagoras) and Scipio (not Fabius and Sempronius).

This work, which was very beautiful and more praised than any other executed by Pietro in Perugia, is today highly valued by the men of that city as a memorial of so renowned a craftsman and fellow citizen. Later, in the principal chapel of the church of Sant'Agostino, the same painter did a large free-standing panel surrounded by a rich frame, with St John baptizing Christ on the front part, and on the back, that is the side facing the choir, the Birth of Christ with some saints in the upper parts, and in the predella many scenes with little figures, very diligently executed. In the same church in the chapel of St Nicholas he made a panel picture for Messer Benedetto Calera.

After returning to Florence, for the monks of Cestello he painted a panel picture of St Bernard, and in the chapter-house a Crucifixion, with the Madonna, St Benedict, St Bernard, and St John. And in the second chapel on the right in San Domenico of Fiesole, he did a panel containing Our Lady and three figures, including a highly praised St Sebastian.

Pietro had done so much work and always had so much on hand that very often he used the same subjects; and he had reduced the theory of his craft to such a set style that he gave all his figures the same expression. For this reason, as Michelangelo had already come to the fore at this time, Pietro wanted very much to see his figures, because of the fame bestowed on him by the craftsmen. And seeing that the greatness of his own name, which he had established everywhere through his magnificent beginning, was being obscured, he was always trying to insult his fellow workers with biting words. And because of this, as well as the crude attacks of the craftsmen, he deserved it when Michelangelo said in public that he was a clumsy fool of a painter. But as Pietro could not bear such ignominy, both of them appeared

† Even were the art of painting to have become lost, here by the distinguished Pietro of Perugia was it restored; had it nowhere yet been devised, at this level he gave it to us. In the year of our Saviour 1500.

before the Tribunal of Eight, where Pietro came off with very little honour.

Meanwhile, the Servite friars at Florence had formed the wish to have the panel for their main altar executed by a famous person and had, on account of the departure of Leonardo da Vinci, who had gone to France, handed it over to Filippino, when the latter passed from this life to the next, having done half of one of the two panels that were required. Thereupon, because of their faith in him, the friars commissioned Pietro to do all the work himself. In the panel where he had been painting the Deposition of Christ from the Cross, Filippino had finished the figures of Nicodemus, seen taking Him down; and Pietro continued below with the swooning of Our Lady and with some other figures. And as the entire work was to consist of two panels, one facing the choir of the friars and the other the body of the church, the Deposition from the Cross was to be placed behind, facing the choir, and the Assumption of Our Lady in front; but Pietro made the Assumption so commonplace that the Deposition of Christ was put in front and the Assumption on the side facing the choir. Meanwhile, in order to make room for the tabernacle of the Blessed Sacrament, today both of these have been taken away and placed on certain other altars about the church; and of the whole work there remain only six pictures, containing some saints painted by Pietro in certain niches. It is said that when this work was revealed, it was severely censured by all the new craftsmen, and particularly because Pietro had employed the same figures he used for his works at other times; whereupon, trying him on, his friends said that he had made no effort, and that he had put aside the good way of working either from avarice or to save himself time. And Pietro answered them: 'I have used in this work figures which you've other times praised, and which have pleased you beyond words. If they now displease you and earn no praise, what can I do?' But those people went on lambasting him with open insults and in sonnets.

So then, though now an old man, Pietro left Florence and returned to Perugia where he carried out some works in fresco in the church of San Severo, a monastery of the Order of Camaldoli, in which place, as I shall tell in his *Life*, Raphael of Urbino did some figures when he was a young man and Perugino's disciple. He worked likewise at Montone, at La Fratta, and in many other places in the district of Perugia, and particularly in Assisi at Santa Maria degli Angeli where, on the back wall of the Lady Chapel which faces the monks' choir, he did a fresco painting of Christ on the Cross, with many figures. And for the high altar of the church of San Pietro, an abbey of the Black Friars in Perugia, he painted a large panel of the Ascension, with the Apostles below looking up to the sky; in the predella of this panel there are three scenes executed with great diligence, namely the story of the Magi, the Baptism of Christ, and the Resurrection. The entire work shows much fine effort and achievement, and so ranks as the best of the oil paintings in Perugia from the hand of Pietro. He also started a work in fresco of no little importance at Castello della Pieve, but he did not finish it. As a man who trusted no one he was accustomed, when going and coming between the Castello and Perugia, to carry all the money he possessed on his person. And so certain men, after lying in wait for him at a pass, robbed him of his money, but, as he desperately implored them to, they spared his life for the love of God. Then by various means and through his friends, of whom he had not a few, he also recovered a large part of the money taken from him; but none the less his grief nearly killed him.

Pietro was a person of very little religion, and he could never be brought to believe in the immortality of the soul; instead, using words in keeping with his pigheadedness, he obstinately rejected every good argument. He placed all his hope in the gifts of Fortune, and he would have done anything for money. He did win great riches, and he built and bought houses in Florence; and in Perugia and Castello della

Pieve he acquired a great deal of property. He took for wife a very beautiful young woman and he had children by her; and he took so much pleasure in her wearing charming head-dresses, in and out of doors, that it is said he very often attired her with his own hands. Finally having reached old age, at the age of seventy-eight he ended the course of his life at Castello della Pieve, where he was buried honourably in the year 1524.*

Pietro made many masters in his own kind of style, including one truly outstanding, who having devoted himself totally to the honourable studies of painting, greatly surpassed his master; and this was the miraculous Raphael Sanzio of Urbino, who for many years worked with Pietro in company with his father, Giovanni de' Santi. Another disciple of Perugino was Pintorrichio, a painter of Perugia, who as was said in his life, always held to Pietro's style. Similarly a disciple of his was Rocco Zoppo, a Florentine painter, from whose hand is the tondo of a very beautiful Madonna which is in the possession of Filippo Salviati, though admittedly it was brought to completion by Pietro himself. This Rocco also painted many pictures of Madonnas, and he did many portraits, which there is no need to discuss. Let me add that in the Sistine Chapel in Rome he portrayed Girolamo Riario and Fra Pietro, cardinal of San Sisto.

Also Pietro's disciple was Montevarchi, who painted many pictures in San Giovanni di Valdarna, and particularly, in the Church of the Madonna, the stories of the Miracle of the Milk. He also left many works in his native town of Montevarchi. Likewise instructed by Pietro and working with him for a fair amount of time was Gerino da Pistoia, who is discussed in the *Life* of Pintoricchio, and also Baccio Ubertino of Florence, who was very diligent both in colouring and drawing, because of which Pietro made great use of him. In our book from his hand is a drawing done with the pen of Christ being scourged at the column, which is very lovely.

* Perugino died at Fontignano, from the plague, in 1523.

Baccio had a brother Francesco similarly a disciple of Pietro, whose surname was Bacchiacca and who was a most diligent master of small figures, as can be seen from many works that have been executed by him in Florence, and especially in the house of Giovan Maria Benintendi and that of Pier Francesco Borgherini. Bacchiacca took delight in making grotesques; and so for the Lord Duke Cosimo he covered a cabinet with animals and rare plants drawn from Nature, which are regarded as very beautiful. Moreover, he completed the cartoons for many tapestries which were then woven in silk by the Flemish master, Giovanni Rosto, for the rooms of his Excellency's palace.

Another disciple of Pietro was the Spaniard Giovanni, with the surname of Lo Spagna, who was a better colourist than any of the others whom Pietro left behind after his death; and Giovanni would have then stayed in Perugia had he not been so persecuted by the envy of the local painters, who are inordinately hostile to strangers, that he was forced to withdraw to Spoleto, where because of his goodness and talent he was given a wife of good family and made a citizen of that land. He executed many works in that place, as he did in all the other cities of Umbria; and at Assisi he painted the altarpiece for the chapel of Santa Caterina in the lower church of St Francis, for the Spanish Cardinal Egidio, and likewise a panel in San Damiano.

In Santa Maria degli Angeli, in the little chapel where St Francis died, he painted some half-length figures which were life-size, namely some companions of St Francis and other saints, all very vivacious and on either side of a St Francis in relief.

But among these disciples of Pietro the best master of all was Andrea Luigi of Assisi, called L'Ingegno, who in his early youth competed with Raphael of Urbino under the instruction of Pietro, who always used him to help with his most important pictures, as can be seen in the Audience Chamber of the bankers of Perugia, where there are very beautiful figures from his hand; in the paintings he did in

Assisi; and finally in the chapel of Pope Sixtus at Rome. In all of these works Andrea gave such an account of himself that it was expected that he must come to surpass his master by a long way. And this would certainly be the case, save that Fortune, who nearly always puts herself gladly in opposition to lofty beginnings, did not allow L'Ingegno to reach perfection; for a cataract assailed his eyes and then, to the infinite grief of those who knew him, made the wretched man totally blind. When Pope Sixtus heard of this occurrence, which was altogether deserving of compassion, as one who always loved talented men he ordered that, during the lifetime of Andrea, every year he should be paid a pension in Assisi by those in charge of the revenue. And so it was done till he died at the age of eighty-six.

Also disciples of Pietro, and Perugians as well, were Eusebio San Giorgio, who painted the panel of the Magi in Sant'Agostino, Domenico di Paris, who did many works in Perugia and neighbouring townships, being followed by his brother Orazio; and likewise Giannicola, who painted a panel picture of Christ in the Garden in San Francesco, and the All Saints altarpiece in the chapel of the Baglioni in San Domenico, and scenes from the life of St John the Baptist in fresco in the chapel of the Guild. Bendetto Caporali, known as Bitti, was also a disciple of Pietro, and there are many pictures from his hand in his native city of Perugia; moreover, he was so immersed in architecture that as well as carrying out many works he wrote a commentary on Vitruvius, as we can all see for ourselves, since it was printed. His son Giulio, the Perugian painter, followed him in these studies.*

But among so many disciples none ever equalled Pietro in diligence or in the grace he showed in colouring in his own personal style, which proved so pleasing in his time

* Eusebio di Jacopo di Cristoforo; Domenico di Paride Alfani; Orazio di Domenico; Giovanni Nicola di Paolo Manni; Giovanni Battista di Bartolomeo. Orazio was the son of the Perugian painter, Domenico, not his brother.

that in order to learn it many people came from France, from Spain, from Germany, and from other countries. And, as we said, many people came to deal in his works, which were sent to various parts of the world, before there appeared the style of Michelangelo, which, having shown the true and good path to the arts, has led them to the perfection which will be seen in the next and third part of these lives. In this, we shall treat of the excellence and perfection of art, and show to craftsmen that whoever works hard and studies continually, and does not indulge in fantasy or caprice, not only leaves behind him his works but also acquires fame, wealth, and friends.

PART THREE

——— · ———

LIFE OF

PIERO DI COSIMO

——— · ———

Florentine painter, c. 1462–1521?

WHILE Giorgione and Correggio were to their great credit and glory honouring the regions of Lombardy, Tuscany herself also did not lack men of splendid talents, among whom not the least was Piero, the son of a certain Lorenzo, a goldsmith, and the pupil of Cosimo Rosselli, after whom he was known as and never called other than Piero di Cosimo. And truly when someone teaches us excellence and gives us a good way of life, he puts us no less in his debt and must be no less regarded as a true father than the one who begets us and simply gives us life.

Seeing his son's lively talents and his inclination to the art of design, Piero's father handed him over to the care of Cosimo, who was more than willing to accept him; and as he saw him grow both in years and in talent, among the many disciples he had, he loved him as a son and always held him as such. This young man had from Nature a very lofty spirit, and he was very set apart and very different in his thoughts and fancies from the other young men who were staying with Cosimo to learn the same art. He was sometimes so intent on what he was doing that when some topic was being discussed, as often happens, at the end of the discussion it was necessary to go back to the beginning and recount everything again, since his mind had wandered off on some other track. And he was likewise so fond of solitude that he was never happy except when, wrapped up in his

own thoughts, he could pursue his own ideas and fancies, and build his castles in the air; and so his master Cosimo had good reason to think well of him, since he made use of him in his own works so much that time and time again he had him carry through projects of considerable importance, knowing that Piero had a more beautiful style and better judgement than he did himself.

For this reason he took Piero with him to Rome, when he was called there by Pope Sixtus to do the scenes for the chapel, in one of which Piero depicted a most beautiful landscape, as said in the life of Cosimo. And because Piero drew most excellently from life, while in Rome he did many portraits of distinguished people, particularly of Virginio Orsino and Roberto Sanseverino, whom he introduced into these scenes.

Then he also did a portrait painting of Duke Valentino, the son of Pope Alexander VI, which, as far as I know, is not to be found today, though the cartoon by his hand still exists and is in the possession of the Reverend and discriminating Cosimo Bartoli, provost of San Giovanni.

Piero did many pictures for a great number of citizens in Florence, dispersed among their houses, and I myself have seen many good examples, as well as various things with many other people. In the noviciate of San Marco is a picture by his hand of Our Lady standing with the Child in her arms, coloured in oils; and for the chapel of Gino Capponi in the church of Santo Spirito at Florence he painted a panel showing the Visitation of Our Lady, with St Nicholas and St Anthony, who is reading with a pair of spectacles on his nose, a very lively figure. Here he counterfeited a book bound in vellum, looking quite old, and as if it were real, and also some spheres for St Nicholas gleaming with highlights, and casting reflections of light one to another, from which men of even his own time realized the strangeness of Piero's mind, and how he pursued difficult problems.

Piero showed this still more after the death of Cosimo, when he stayed all the time shut up indoors and never let himself be seen at work, and followed a way of life more like that of a brute beast than a human being. He would not allow his rooms to be swept; he would eat only when he felt hungry; and he would never let his garden be dug or the fruit trees pruned, but rather he let the vines grow and the shoots trail along the ground; nor were his fig trees or any others ever trimmed, but he was content to see everything run wild, like his own nature, asserting that nature's own things should be left to her to look after, and that was enough. He frequently took himself off to see animals or plants or other things that nature often creates accidentally or from caprice, and he derived from these a pleasure and satisfaction that completely robbed him of his senses; and he mentioned them in his conversation so many times that sometimes, although he himself derived pleasure from this, others found it tedious. He would sometimes stop to contemplate a wall at which sick people had for ages been aiming their spittle, and there he described battles between horsemen, and the most fantastic cities, and the most extensive landscapes ever seen: and he experienced the same with the clouds in the sky.

He executed some oil paintings, having seen works by Leonardo with gradations of colour and finished with that extreme diligence which Leonardo used to employ, when he wished to display his skill; and as this method pleased Piero, he sought to imitate it although he was afterwards very distant from Leonardo, and far, far removed from other styles, because it could truly be said that he changed his style almost from one work to the next. And if Piero had not been so abstracted and had paid more heed to himself in his life than he did, he would have won recognition for the great talent he possessed, in such manner that he would have been adored, whereas through his brutish ways he was rather held to be a madman, even though at the end he did harm to no one except himself and his works

were beneficial and useful to the art he practised. For this reason every person of sound talent, and every excellent craftsman, should learn from these examples and then keep his eyes on the purpose of life.

I shall not leave out that when he was very young, since he was wildly inventive and fanciful, Piero was much in demand for the masquerades held during the carnival; and he won the attention of the young noblemen of Florence, because he greatly enhanced that kind of pastime of theirs in regard to invention, adornment, grandeur and pomp.

And it is said that he was one of the first to stage the masquerades in the form of triumphs; or at least he greatly improved them by accompanying the scene that was created not only with words and music appropriate to the subject, but also with an accompaniment of incredible pomp composed of men on foot and on horseback, with attire and apparel also appropriate to the story: and this produced a very rich and beautiful effect and was at the same time both grandiose and ingenious. It was certainly very splendid to see, by night, twenty-five or thirty pairs of horses, very richly caparisoned, with their riders in costume according to the theme that had been devised, and six or eight grooms for each one, clothed in the same livery, with torches in their hands, sometimes numbering more than 400; and then the triumphal chariot covered with ornaments, spoils or most bizarre and fanciful objects: altogether something that sharpens men's minds and gives great pleasure and satisfaction to the people.

Among these spectacles, both numerous and ingenious, I wish to touch briefly on one which was principally invented by Piero when he was already mature in years, which was not, like many of them, pleasing on account of its charm but, on the contrary, gave no little pleasure to the people on account of its strange, horrible, and unexpected novelty; for just as sometimes, with food, bitter things give exquisite pleasure to the human palate, so do horrible things in these pastimes, so long as they are done with skill and judgement,

as is the case, for example, when tragedies are staged. The invention was the chariot of Death which was constructed by Piero with the greatest secrecy in the Hall of the Pope, so that nothing of it could ever be spied till it was seen and its meaning understood instantaneously. The triumph was a huge chariot drawn by buffaloes, black all over and painted with human bones and white crosses, and over the chariot was a huge figure of Death, with scythe in hand, and all around the chariot were a large number of covered tombs; and at all the places where the triumph halted for the chanting, these tombs opened, and from them issued figures draped in black cloth, on which were painted all the bones of a skeleton on their arms, breasts, backs, and legs: and all this, with the white standing out from the black, and with the appearance in the distance of those torch-bearers with masks that represented skulls, both back and front, and on the neck, besides seeming utterly real, struck the eye as fearsome and horrible. And the dead, at the sound of certain muffled trumpets with harsh and mournful tones, came forth from the tombs and seating themselves upon them sang to music full of melancholy the song so celebrated today:

Grief, woe and penitence . . .

Riding in front of and behind the chariot were a great number of the dead mounted on horses chosen very carefully from the leanest and most broken-down that could be found, in black trappings covered with white crosses, each with four grooms in the costumes of Death, with black torches and a large black standard with crosses and bones and skulls. Ten black standards were trailed after the triumphal chariot, and while they were walking along with trembling voices and all in unison, the entire company sang the psalm of David, the *Miserere*.

This dreadful spectacle, because as I have said of its novelty and awesomeness, filled the whole city both with terror and with wonder; and although at first sight it did

not seem suitable for carnival time, none the less, for its elements of novelty, and its wholly excellent presentation, it satisfied people's minds and it earned Piero, its creator and inventor, fulsome praise and commendation; and it was the reason why thereafter increasingly witty and ingenious inventions came to be devised so that truly the city of Florence has never had an equal for such subjects or for putting on such festivals. Moreover, among the old men who saw it, there still remains a vivid memory of it, and they can never talk enough about Piero's odd and original invention.

I have heard it said by Andrea di Cosimo, who helped him in this work, and by Andrea del Sarto, who was his disciple and also with him at the time, that it was then believed that this invention was made to foreshadow the return of the House of Medici to Florence in 1512; for when the triumph was put on, they were exiles, and, so to speak dead, but destined to come to life again after a short while; and it was in this sense that they used to interpret the words in the song:

> We are dead, as now you see,
> And we'll see you dead too:
> Once alive like you were we,
> Just like us will be you . . .

And this was meant to refer to the Medici's return home, as if it were a resurrection from death to life, and the expulsion and downfall of their opponents; or perhaps many gave it this interpretation as a result of the ensuing return of that most illustrious family to Florence, so seductive to the human mind is the application of all earlier words and deeds to subsequent events. But certainly this was what many people believed, and it was much talked about.

But to return to Piero's pictures and actions, he was commissioned to do a panel picture for the church of the Servite friars in the chapel of the Tedaldi, where they preserve the vesture and cushion of St Philip, a friar of their Order, in which he imagined Our Lady standing,

raised from the ground on a pedestal, and with a book in her hand, but without her Son, lifting up her head towards Heaven, while the Holy Spirit illumines her from above.

Nor did Piero wish that any light other than that shed by the dove should illuminate her and the figures around her, including a St Margaret and a St Catherine, who are adoring her on their knees, while St Peter and St John the Evangelist are standing and observing her together with St Philip, the Servite friar, and St Antonino, archbishop of Florence. And besides this he painted a landscape looking very bizarre, considering its strange trees and grottoes. Then there are truly several very beautiful features in this work, such as some heads which are well designed and graceful, and in addition the colouring which is very evenly used, for certainly Piero enjoyed great facility in oil painting. In the predella he painted some beautifully executed little screens, among which there is one showing St Margaret * issuing from the belly of the dragon; he made the beast so foul and deformed that I do not think there is anything better of that kind to be seen, for its eyes reveal venom, and fire and death, in a truly terrifying aspect. Certainly I do not believe that anyone did such things better than him, or came anywhere near to him in imagining them, as can bear witness a sea-monster which he made and gave to the Magnificent Giuliano de' Medici and which is so freakish, bizarre, and fantastic in its deformity that it seems impossible that Nature should produce such strange and deformed creatures. This monster is now in the wardrobe of Duke Cosimo de' Medici, as is also a book again from Piero's hand, of similar animals, very beautiful and bizarre, drawn very diligently with the pen, and completed with inestimable patience. And this book was given to him by Messer Cosimo Bartoli, provost of San Giovanni, a close friend of mine and of all

* This St Margaret (d. 304) was one of the popular virgin saints of Catholic Europe, often represented leading on a chain a dragon which had swallowed her before her miraculous return to life.

our craftsmen, being someone who has always delighted and still delights in our profession.

Likewise, around an apartment in the house of Francesco del Pugliese he did a variety of scenes with little figures; and it is impossible to convey all the diversity of the fantastic things that he took delight in painting in every one of them, including the buildings, the animals, the costumes, the various instruments, and other fanciful things which came into his mind, being stories drawn from fables. After the death of Francesco del Pugliese and his sons, these scenes were taken away, and I do not know where they are now. It is the same with a picture of Mars and Venus with her Cupids and with Vulcan, which he executed with great skill and incredible patience.

For the elder Filippo Strozzi, Piero painted a picture with little figures of Perseus freeing Andromeda from the monster, containing some very beautiful things, which is now in the house of Signor Sforza Almeni, first chamberlain to Duke Cosimo, who had it given to him by Messer Giovanni Battista, son of Lorenzo Strozzi, as he knew that this lord delighted in painting and sculpture; and he puts great store by it, since Piero never did a lovelier or more highly finished picture, seeing that it would be impossible to find a more bizarre sea-monster or one more fantastic than that which Piero imagined and painted, or a fiercer attitude than that of Perseus, as he raises his sword in the air to smite the beast. Here we see the bound figure of Andromeda torn between hope and fear, with a most beautiful countenance, and there in the foreground are many people wearing all kinds of strange costumes, playing music and singing, including some inspired heads of those who are smiling and rejoicing to see the freeing of Andromeda. The landscape is most beautiful, and the colouring soft and graceful, and he executed the whole work with tremendous diligence to achieve the utmost harmony and gradation of colours.

He also painted a picture of a nude Venus and likewise a

Mars, who sleeps stripped naked in a meadow full of flowers, and around are various *amori* or Cupids, who, some here and some there, are carting off the helmet, the armlets, and other pieces of armour belonging to Mars. There, too, is a grove of myrtle and a Cupid fearful of a rabbit, and there are also the doves of Venus and other symbols of love. This picture is in Florence in the house of Giorgio Vasari, kept by him in memory of Piero, as this master's caprices have always pleased him.

One of Piero's great friends was the director of the hospital of the Innocenti, and wishing to have a panel picture done for the Pugliese chapel, at the entrance into the church on the left, he commissioned it from Piero, who completed it at his leisure; but before this he brought the director to despair, for he would never once allow him to see it before it was finished. And how strangely this struck the director, in view of their friendship and also his supplying him daily with money, yet not seeing what he did, he made plain to Piero when, on the occasion of the final payment, he would not hand it over till he saw the work. But when Piero threatened to destroy all he had done, he was forced to give him the rest and to wait patiently for him to install it, more angry than ever.

For a chapel, in the church of San Piero Gattolini, Piero undertook to paint a panel, and in it he showed Our Lady seated, with four figures around her, and in the sky two angels, who are crowning her; and it was so diligently executed that Piero won praise and honour for this work, which is to be seen today in San Friano, the other church having been destroyed. For the rood-screen of the church of San Francesco at Fiesole he painted a picture of the Immaculate Conception, which is quite a good little work, with figures that are not very large. For Giovanni Vespucci, who lived in a house now belonging to Piero Salviati, opposite San Michele in the Via de' Servi, he did some bacchanalian scenes around one of the apartments, in which he painted such strange fauns, satyrs, and wood-nymphs, and *putti*, and

Bacchantes that it is a marvel to see all the diverse pelts and costumes and the many various goatish features, all done gracefully and most accurately imitated. Thus in one of the scenes we see Silenus mounted on an ass, with many children, some supporting him and some giving him drink; and this displays all the joy of life expressed by Piero with great talent. Indeed, in everything that is seen of his can be discerned a spirit set apart and very different from other painters, and with a penetrating subtlety in the investigation of certain subtle secrets hidden deep in Nature, without regard to time or effort, but only for his own delight and for pleasure in the art. And it could not be otherwise, for having fallen in love with painting, he cared nothing for his creature comforts and reduced himself to eating only boiled eggs which, to economize on fire, he used to cook whenever he was boiling glue, not six or eight, but fifty at a time, keeping them in a basket and eating them one by one.

And living this sort of life he discovered such out-of-the-way pleasures that he thought that any other was, in comparison, like slavery. He could not stand babies crying, men coughing, bells ringing, or friars chanting; and when the rain was pouring down from the sky, he loved to watch it as it ricocheted off the roof-tops and hurtled on to the ground. He went in terror of lightning, and when the thunder roared he would wrap himself up in his cloak, shut fast the doors and windows, and crouch in a corner of the room till the storm abated. In his conversation he was original and entertaining, sometimes saying such witty things that his hearers burst out laughing. But in old age, by the time he had reached the age of eighty, he had grown so odd and whimsical, that nothing could be done with him. He would not let his assistants stay by him, and so all help came to fail him, because of his fiercely unsocial behaviour. When he wanted to work, but was unable to because of his paralysis, he fell into a rage and struggled to make his hands obey his will; but while he mumbled to himself, it was pitiful that he would let fall his maulstick and even his

brushes. He would rage over the flies, and even shadows came to exasperate him. And so it was when, ill through old age, he happened to be visited by some friends who begged him to reconcile himself with God; but he refused to believe he was dying, and put them off from day to day: not that he was not a good man or did not have faith; in fact he was most zealous, never mind that he lived unsocially like an animal. He sometimes talked of the torments which ravage men's bodies through different ills, and of the wretched suffering of those who die in slow stages, as their vital spirits ebb away; this, he said, was a terrible affliction. He spoke ill of doctors, and of apothecaries, and of those who nurse the sick and cause them to die of hunger; besides the torments of syrups, medicines, clysters, and other martyrdoms, such as not being allowed to sleep when you are drowsy, drawing up your will, seeing your relations weeping around you and being kept in your room in the dark. He praised death by public execution, saying it was splendid to go to one's end in that manner, seeing so much of the open sky and so many people, and being comforted with sweets and kind words; having the priest and the people praying for you, and going with the angels to Paradise; and he said that he was a very lucky man who quit this life at one blow. And so Piero would talk away, twisting things into the strangest meanings that could ever be heard. And in this way living so strangely, with all his strange fantasies, Piero brought himself to such a state that one morning, in the year 1521, he was found lying dead at the foot of a staircase.

Piero had many disciples, and one among them was Andrea del Sarto, who counted for many. His portrait I had from Francesco da San Gallo, who did it when Piero was old, being his close friend and intimate; and Francesco still possesses from the hand of Piero (a work I must not pass by) a most beautiful head of Cleopatra, with an asp wound round her neck, and two portraits, one of his father Giuliano, the other of his grandfather, Francesco Giamberti, which seem to be alive.

LIFE OF

FRA BARTOLOMMEO
OF SAN MARCO

———— · ————

Florentine painter, c. 1474–c. 1517

NEAR the town of Prato, which is ten miles from Florence,
in a village called Savignano was born Bartolommeo,
known, according to Tuscan custom, as Baccio, for short.
And as he showed in his boyhood not only an inclination
but also an aptitude for drawing, through the influence of
Benedetto da Maiano, he was placed with Cosimo Rosselli
and lodged with some of his own relations who were living
at Porta San Piero Gattolini, where he stayed many years;
so he was never called or known by any other name other
than that of Baccio della Porta.* After he had left Cosimo
Rosselli, he started to study with great liking the works of
Leonardo da Vinci, and in a short time he made such fruitful
progress in colouring that he acquired credit and reputation
as one of the best young men of the art of painting, both in
colouring and drawing.

He had a companion called Mariotto Albertinelli, who in
a short time adopted his style quite well and executed with
him many pictures of Our Lady which are scattered through-
out Florence; but to mention them all would take too long.
So touching only on some excellent paintings which were
done by Baccio, there is one in the house of Filippo di
Averardo Salviati which is very beautiful and which he
greatly prizes and cherishes. Another one, not very long
ago, was bought (along with some old furniture) by Pier
Maria della Pozze, someone very fond of painting, who
realized its beauty and so would never let it go for money;

* Baccio of the Gate.

and it contains a picture of Our Lady done with extraordin-
ary diligence. Piero del Pugliese had a little Madonna in
marble, in very low relief, by the hand of Donatello, for
which, to do it special honour, he had a wooden tabernacle
made with two little doors to enclose it. This he gave to
Baccio della Porta who on the inner side of the doors painted
two little scenes, one of the Birth of Christ and the other of
his Circumcision, which Baccio executed with small figures
in the fashion of miniatures, in such a way that it could not
be done better in oils. And for when the tabernacle is closed,
on the outer side of the doors, he also did an oil painting, in
chiaroscuro, of Our Lady receiving the Annunciation from
the Angel. This work is today in the study of Duke Cosimo,
where he keeps all his little antique figures of bronze, his
medals and other rare pictures in miniature, and it is treas-
ured by his Most Illustrious Excellency as the rare thing it
truly is.

Baccio was loved in Florence for his virtues, for he was
assiduous in his work, quiet, good by nature, and very God-
fearing; he was pleased to live a peaceful life, shunning evil
company, and he took great pleasure in hearing sermons
and always sought to be with learned and prudent people.
And in truth rarely does Nature cause to be born a gentle
craftsman of fine talent without also in time providing him
with peace and favour, as she did for Baccio, who, as will be
told below, came to obtain all he desired. After reports had
spread that he was as able as he was good, his fame increased
so much that he was commissioned by Gerozzo di Monna
Venna Dini to paint a chapel in the cemetery where are kept
the bones of the dead from the hospital of Santa Maria
Nuova, and there he began to paint a Last Judgement in
fresco, which he executed with so much diligence and in so
beautiful a style, in the part he finished, that he acquired
because of it even greater fame than was his already, and
won much credit for having in such a finely considered way
expressed the glory of Paradise and Christ with the twelve
Apostles, judging the twelve tribes, in which the figures are
so beautifully draped and softly coloured. Moreover, in the

figures which are being dragged down to Hell, drawn, but left still to be finished, we see the despair, the grief, and the shame of everlasting death, just as we recognize contentment and happiness in those who are being saved, though this work remained incomplete, since he preferred to attend to religion rather than to painting.

This was because Fra Girolamo Savonarola from Ferrara, of the Order of Friars Preachers, the very famous theologian, was to be found at San Marco at that time, and Baccio continued hearing his sermons, because of the devotion they inspired in him; and so he became very familiar with Savonarola and lived almost constantly in the convent, having also struck up a friendship with the other friars. Then it happened that Fra Girolamo, going on with his sermons and declaiming from his pulpit every day that lascivious pictures and making music and amorous books often induced people's minds to wrongdoing, persuaded himself that in houses where there were young girls it was not right to keep painted figures of naked men and women; and therefore the following carnival time, when the people of the city would usually make bonfires of old twigs and other bits of wood, and on the Tuesday evening, by ancient custom, would burn them, with amorous dances, in which men and women hand in hand whirled round and round singing certain dance songs, he had stirred them up so effectively by what he said that, on that day, they brought along to the fire great numbers of paintings and sculptures of nude figures, many by the hand of excellent masters, and likewise books, lutes, and song sheets, and this meant a tremendous loss, but particularly for painting.

And Baccio himself carried to that place all the collection of drawings he had made of nudes, and also Lorenzo di Credi and many others, who were named *piagnoni,* copied his example.* It was not long afterwards that, because of

* *Piagnoni* — snivellers or weepers — were the followers of Savonarola (1452–98) who after a period of powerful political influence in Florence was hanged and burned as a heretic. The Tuesday when the bonfire of vanities took place was Shrove Tuesday, at the beginning of Lent.

the affection he bore towards Fra Savonarola, Baccio did a
portrait of him, on a panel, which was very beautiful, and
which was then taken to Ferrara, from where not long since
it came back to Florence to the house of Filippo di Alam-
anno Salviati, who, since it is by the hand of Baccio, holds
it very dear. Then it happened that one day the party factions
opposed to Fra Girolamo moved to seize him and to deliver
him to the powers of justice because of the seditions he had
stirred up in that city. And when the friar's friends saw this,
they also banded together to the number of more than 500,
and shut themselves up in San Marco, and Baccio along
with them, for the great affection he felt for their party. It is
true that as he had little courage, rather, he was excessively
timid and cowardly, when soon after he heard an attack
being made on the convent and some being killed, he began
to fear for himself tremendously; and he therefore made a
vow that, if he escaped from all that fury, he would immedi-
ately put on the habit of that Order; and he kept his vow
faithfully. Consequently, when the uproar had died down
and the friar had been taken and condemned to death, as the
historians describe very clearly, Baccio went off to Prato
where he became a monk in San Domenico on 26 July
1500, to the acute displeasure of all his friends whose grief
over losing him was boundless, especially having heard that
he had made up his mind to give no more attention to
painting.

Thereupon, Mariotto Albertinelli, his friend and com-
panion, at the entreaty of Gerozzo Dini, took over the
materials of Fra Bartolommeo (as he was named by the
prior, when he clothed him in the habit) and completed the
work of the Ossuary in Santa Maria Nuova. Here he por-
trayed from life the then director of the hospital and some
friars skilled in surgery, with Gerozzo, who had given him
the work, and his wife, full-length figures kneeling on the
side walls; and in a nude figure, sitting down, he portrayed
Giuliano Bugiardini, his pupil, as a young man with long
locks, as was the fashion at that time, in which hairs could
be counted separately, they were painted so diligently. He

also painted there his own self-portrait, in the long-haired head of someone coming out from one of the tombs. Also in this work, where the blessed in Heaven are shown, is to be seen the portrait of the painter Fra Giovanni da Fiesole. This painting was executed all in fresco by Fra Bartolommeo and Mariotto, so that it has remained, and still remains, in splendid condition, and is highly prized by the crafts-men, since in that kind of work it is hardly possible to do better.

But after he had been many months in Prato, Fra Bar-tolommeo was then sent by his superiors to live as a con-ventual in San Marco at Florence, where because of his talents he was warmly welcomed by the friars. In those days, Ber-nardo del Bianco had had erected in the abbey of Florence a stone* chapel carved very richly and beautifully after the design of Benedetto da Rovezzano, which was, and today still is, greatly esteemed for some varied, ornamental work, in which, as a finishing touch, Benedetto Buglioni placed in several niches angels and other figures made of glazed ter-racotta, in the round, and friezes covered with cherubs and the emblems of Bianco himself. And as he wished to include a panel picture worthy of that adornment, and had the idea that Bartolommeo would be the right person to do it, he strove his best through friends and in other ways to win him over. Fra Bartolommeo was staying at the convent, attending only to the divine offices and the obligations of the Rule, though still often implored by the prior and his own dearest friends to do some painting; and for more than four years now he had refused to do any work. But on this occasion, being pressed by Bernardo del Bianco, he finally began the panel picture of St Bernard, in which the saint is writing, and is so rapt in contemplation at the sight of Our Lady, with the Child in her arms, being borne by many angels and *putti* all delicately coloured, that we perceive in him I know not what kind of celestial quality,

* *una cappella di macigno*, a green-grey sandstone.

which when anyone studies it attentively shines out from that work, into which Fra Bartolommeo put so much loving care; not to forget an arch painted in fresco above it.

He also did some pictures for Cardinal Giovanni de' Medici, and painted for Agnolo Doni a picture of Our Lady, of extraordinary beauty, to serve as the altarpiece for a chapel in his house.

At that time the painter Raphael of Urbino came to study his art in Florence, and he taught the best principles of perspective to Fra Bartolommeo; and wanting to colour in the same style as the friar, and being pleased by his handling of colours and way of harmonizing them, he was always in his company. It was at that time that Fra Bartolommeo painted in San Marco in Florence a panel picture with an infinite number of figures, which is now in the possession of the King of France, to whom it was given after being on show for many months in San Marco.

He then painted another picture in the same place, also containing an infinite number of figures, to replace the one which was sent to France, in which there are some children flying through the air, and holding open a canopy, depicted with skill and with good drawing and such strong relief that they seem to spring forth from the picture, and coloured with flesh tints, they display the beauty and excellence which every able craftsman seeks to give his works. This picture is still today regarded as most excellent. It contains many figures surrounding a Madonna, all most praiseworthy and lively, executed with grace, feeling, and rapid boldness, and then coloured in so strong a style that they seem to be in relief. For Fra Bartolommeo wished to show that, as well as drawing well, he knew how to give force to his figures and to make them stand out by means of the darkness of his shadows; as may be seen in some *putti* around a canopy which they are holding up and who, as they fly through the air, spring out of the panel. Moreover, there is an infant Christ who is marrying St Catherine as a nun, so painted with the dark colouring he used that nothing more lifelike

could be imagined; and on one side there is a circle of saints diminishing in perspective, around the opening of a huge recess, who are arranged in such well-designed order that they seem real, as do those on the other side. And he was truly very successful in imitating the paintings of Leonardo in his colouring, especially in the shadows, for which he made use of lampblack and the black of burnt ivory. This panel has now become much darker than when he painted it, because of these blacks, which have grown murkier and deeper. In the foreground, among the principal figures, he did a St George in armour, with a standard in his hand, a bold, spirited, and lively figure, in a beautiful attitude. And then there is a St Bartholomew, which merits the highest praises, standing together with two children who are playing, one the lute and the other the lyre; one of those he showed with a leg crossed over to support his instrument, his hands strumming on the strings, an ear intent on the harmony, and his head raised up with his mouth slightly open, in such a manner that anyone looking at him cannot but believe he should also hear his voice. No less natural is the other, who, ready to one side, and bending an ear to his lyre, seems to be listening to hear how far it is in tune with the sound of the lute and the other's voice, while as he provides the melody he continues with his eyes downcast listening steadfastly to his companion's playing and singing. These inspired ideas are truly ingenious; and the children, who are seated and clothed in light draperies, are marvellous to look at and executed with great assiduity by the practised hand of Fra Bartolommeo; and the entire work is thrown into sharp relief by the gradation of dark shadows.

A short while afterwards he made a second panel picture to face the other which is well regarded, and shows Our Lady surrounded by saints. He earned extraordinary praise for having introduced a method of blending the colour tones of his figures, so that he imparted a marvellous harmony to his painting and made them appear alive and in relief, brought to perfection through his excellent style.

Hearing word of the noble works being made in Rome by Michelangelo, and also of those of the gracious Raphael, and compelled by the fame which continually reached his ears of the marvels wrought by those inspired craftsmen, with the prior's permission he moved to Rome; and there he was looked after by Fra Mariano Fetti, friar of the Piombo,* for whom at his own convent of San Silvestro at Montecavallo, he painted two pictures of St Peter and St Paul. But he did not succeed in working as well in the climate of Rome as he had in that of Florence, and more-over, between the ancient and the modern works that he saw, in such great abundance, he grew so bewildered that he lost much of the ability and excellence he thought he possessed; and so he resolved to quit, and he left Raphael of Urbino to finish one of his unfinished pictures, namely St Peter. This was retouched all over by the hand of the splendid Raphael and given to Fra Mariano. And Fra Bartolommeo thus returned to Florence where it had often in the past been alleged that he did not know how to paint nudes.

For this reason, he wanted to prove himself and to show through his efforts that he was as utterly competent as anyone else in all excellent work of painting. So for proof of this, he did a picture of St Sebastian, naked, very realistic in the colouring of his flesh, who has an air of great charm, and whose body was likewise executed with corresponding beauty. This won him endless praise among the craftsmen. It is said that when this painting was put on show in the church, after the friars had found women in confession who on looking at it had sinned through the captivating and sensuous resemblance of a living figure given to it by Fra Bartolommeo's talent, they removed it from the church and sent it to the chapter-house, where it did not remain long before it was bought by Giovan Battista della Palla and sent to the King of France. Fra Bartolommeo,

* *Piombo* – an office of the Curia in charge of the seal (*piombo*) for papal documents.

meanwhile, had been angered by the woodcarvers who made the frames to adorn his panels and pictures, because of their custom, which they still follow today, of always covering an eighth part of the figures with the inner edge of the frame; because of this he was determined to find some advice for doing without frames for his pictures, and for this painting of St Sebastian he had the panel made in the form of a semicircle in which he drew a niche in perspective, apparently carved in relief on the panel. And thus, using a border of painted ornamentation, he provided a frame for the figure in the middle; and he did the same thing for our St Vincent,*and for the St Mark, to be discussed after the St Vincent.

For the arch of a door leading into the sacristy, Fra Bartolommeo did an oil painting, on wood, of St Vincent, a member of their Order, representing him as preaching on the subject of the Last Judgement, and consequently showing in his attitude, and particularly in his face, the dread and fury generally seen in the expression of preachers, when they strive their utmost, threatening the justice of God, to lead obstinate sinners to a perfect life, in such a manner that to whoever studies it attentively this figure appears not painted but real and alive, it is executed with such strong relief. But it is a shame that it is all cracked and spoiled, having been painted with fresh coats of colour on fresh sizing, as I said of the works of Pietro Perugino, in the convent of the Ingesuati.

To show that he well knew how to paint large figures, it having been alleged that he had a miniaturist's style, Fra Bartolommeo on a sudden whim painted for the wall with the door to the choir a panel picture of St Mark the Evangelist ten feet high, executed with very good design and great excellence.

Then Salvador Billi, a Florentine merchant, on his return from Naples, having heard of Fra Bartolommeo's fame and

* 'our' St Vincent suggests that Vasari was nodding as he copied the reference to this painting from a Dominican friar's manuscript.

seen his works, commissioned from him a panel picture of Christ the Saviour, in allusion to his own name of Salvador, with the Four Evangelists round Him. At the foot there are also two *putti* holding the globe of the world, whose flesh looks soft and fresh and who are very well executed, as is the rest of the work. There are also two highly praised figures of prophets. This picture has been put in the Annunziata at Florence, under the great organ, as Salvador wished, and it is very beautiful, being finished by the friar very finely and lovingly, and surrounded by marble ornamentation, all carved by the hand of Pietro Rosselli.

Afterwards, as Fra Bartolommeo needed a change of air, the prior of that time, who was a friend of his, sent him to one of their monasteries where, during his stay, he combined the labour of his hands with the contemplation of death, for the good of his soul and of the friars' house. And for San Martino in Lucca he made a panel picture in which, at the feet of Our Lady, is a little angel playing a lute together with St Stephen and St John, all done with excellent design and colouring, and showing his talent. Likewise in San Romano he painted a picture on canvas of Our Lady of Mercy on a stone pedestal with some angels holding her mantle; along with her, he depicted a throng of people on some stairs, some standing, some seated, and others kneeling, and looking at a figure of Christ on high, who is sending down on them shafts of lightning and thunderbolts. And in this work, to be sure, Fra Bartolommeo demonstrated his great ability in handling the gradation of shadows and darkness in painting, executing very strong reliefs, and showing how he could manage the problems of painting with rare and consummate mastery and invention, colouring and design: a work as perfect as any he ever made. In the same church he painted another panel, also on canvas, with a Christ and St Catherine the Martyr, together with St Catherine of Siena, raised aloft in ecstasy, a figure as fine as any of that sort could be.

After he had returned to Florence, he occupied himself with music, and as he took great pleasure in this he used sometimes to pass the time singing. At Prato opposite the prison, he painted a panel picture of the Assumption, and he painted some Madonnas for the house belonging to the Medici, and other pictures as well for various people, such as one of Our Lady which Lodovico di Lodovico Capponi has in his room, and similarly another of the Virgin holding her Son in her arms, with two heads of saints, belonging to the most excellent Messer Lelio Torelli, chief secretary to the most illustrious Duke Cosimo, who cherishes it greatly, both on account of the talents of Fra Bartolommeo and also because he takes delight in, and loves and favours, not only those men who paint but all talented and intelligent spirits. In the house of Pier del Pugliese, now belonging to Matteo Botti, a Florentine citizen and merchant, he made for an antechamber at the top of a staircase a painting of St George in armour, on horseback, who is tilting his lance to slay the dragon, a very spirited figure, which he executed in chiar-oscuro in oils. And this method he delighted in using thus in all his works, sketching them like cartoons, before colouring them, either in ink or shaded in asphaltum, as may still be seen both from many panels and pictures begun but left unfinished because of his death, and from many of his drawings in chiaroscuro, which are now mostly in the monastery of Santa Caterina da Siena on the piazza of San Marco, in the possession of a nun who paints and who will be recorded in the proper place. And he made many similar works besides, which adorn our book of drawings in memory of him, and of which some are with Messer Francesco del Garbo, a very excellent physician.

Fra Bartolommeo always had a mind, when he was working, to keep living things in front of him, and so as to be able to draw draperies, armour and suchlike objects, he caused a life-size wooden model to be made with joints that could be moved, and he clothed it with real draperies, from which he painted very beautiful things, as he could

keep them in place just as it pleased him till he had finished perfectly whatever he was working on. This selfsame model, worm-eaten and ruined as it is, is kept in our possession in memory of him.

In the abbey of the Black Friars at Arezzo, he painted the head of Christ in dark tones, a very beautiful work, and the panel of the Society of Contemplatives, which was preserved in the house of the Magnificent Messer Ottaviano de' Medici, and has now been put in a chapel of that house, with many ornaments, by his son Messer Alessandro, who cherishes it in memory of Fra Bartolommeo and because he takes infinite delight in painting. In the chapel of the noviciate of San Marco, there is a panel picture of the Purification which is very charming and which he designed and finished perfectly. And at Santa Maria Maddalena, a convent of the friars of his Order, outside Florence, when he was staying there for his own pleasure, he painted a Christ and a Magdalen; and he also did some works in fresco for that place. Likewise he painted in fresco an arch over the guest-house of San Marco, depicting Christ with Cleophas and Luke and portraying Fra Niccolò della Magna, when he was a young man, who later became archbishop of Capua, and finally a cardinal. In San Gallo he began a panel picture which was later finished by Giuliano Bugiardini, and is today on the high altar of San Jacopo tra'Fossi, on the Canto degli Alberti; and likewise a picture of the rape of Dinah, now belonging to Messer Cristofano Rinieri, which was later coloured by the same Giuliano, and in which there are some highly praised buildings and imaginative compositions. Piero Soderini commissioned from him the panel for the Council Chamber, which he drew in chiaroscuro and began to paint in such a manner that it would have brought him very great honour; indeed, imperfect as it is, it is today kept in a place of honour in the chapel of the Magnificent Ottaviano de' Medici, in San Lorenzo. It shows all the patrons of the city of Florence, and those saints on whose days the city has won its victories, and contains the portrait

of Fra Bartolommeo himself, done with a mirror. What happened was, that having begun the picture and finished all the drawing, as he was working continually under a window, with the light from it beating on his back, he became completely paralysed on that one side, and could not move at all. He was therefore advised, on the orders of his doctors, to visit the baths at San Filippo, and there he stayed a long time, but improved very little as a result.

Fra Bartolommeo was very fond of fruit, which pleased his palate greatly, but was very damaging to his health. And so one morning, after he had eaten a large number of figs, on top of his existing illness, he developed a very nasty fever which in the space of four days ended the course of his life, at the age of forty-eight, when with a clear mind he rendered up his soul to heaven.

The death of this man grieved his friends, and particularly the friars, who gave him an honourable interment in their burial-place in San Marco in the year 1517 on 8 October.* He had been dispensed from attending any of the offices in the choir with the friars, and the profit from his works went to the convent, leaving him enough money in hand to pay for his colours and other materials needed for painting.

Fra Bartolommeo left disciples in Cecchino del Frate, Benedetto Cianfanini, Gabriello Rustici, and Fra Paolo of Pistoia, to whom his belongings were bequeathed. After his death, Fra Paolo painted from his drawings many panels and pictures, of which three are in San Domenico in Pistoia, and one in Santa Maria del Sasso in the Casentino.

So much grace was imparted to his figures through his colouring by Fra Bartolommeo, and in modern ways he enhanced their originality so much, that for this he deserves to be numbered by us among the benefactors of the art of painting.

* He died on 31 October 1517; by Vasari's reckoning he would have been born in 1469.

LIFE OF
ANDREA DEL SARTO

—— · ——

Most excellent Florentine painter, 1486–1530

WE have now come, after the lives of so many craftsmen who have been outstanding, some for colouring, some for drawing, and others for invention, to the most excellent Andrea del Sarto, in whose single person Nature and art showed all that painting can achieve by means of drawing, colouring and invention: and indeed if Andrea had possessed a little more boldness and daring of spirit, to match his very profound judgement and talent as a painter, he would, there is no doubt at all, have been without equal. But a certain timidity of spirit, along with a sort of abjectness and simplicity of character, never let there be seen in him the kind of lively ardour or the boldness which, added to his other attributes, would have made him truly inspired * in his work; and so for this reason he lacked those adornments, that grandeur and copiousness of styles, which are seen in many other painters. None the less his figures, despite their simplicity and purity, were well conceived, without errors, and in all respects utterly perfect. The expressions of the faces he painted, whether boys or women, are natural and graceful, and those of his men, both young and old, are done with vivacity and splendid animation while his draperies are a beauty to behold, and his nudes are very well conceived. And although he drew with simplicity, his colours are none the less rare and truly inspired.

* Vasari uses the word '*divino*', sparingly employed in the *Lives*, and most often for Michelangelo.

Andrea was born in the year 1478 in Florence, of a father who had always been a tailor★ by trade, and so everyone called him that; and when he reached the age of seven he was taken away from his reading and writing school and apprenticed to the goldsmith's craft; and in this he was always far more willing to practise designing (to which he was drawn by natural inclination) than to handle the tools for working with silver or gold. So then it came about that a Florentine painter, Gian Barile, albeit gross and common, having seen the boy's good method of drawing took him in, and having made him give up goldsmith's work, introduced him to the art of painting; and having embarked on it with great enjoyment, Andrea realized that Nature had made him for that profession. And so very soon he began to work in colour so well that Gian Barile and all the other craftsmen of the city were filled with wonder.

After three years the boy had achieved a very good standard of proficiency through continuous study and work, and Gian Barile realized that if he persisted in his studies he would attain extraordinary success; so having discussed the matter with Piero di Cosimo, who was then held to be among the best painters in Florence, he placed Andrea with him; and as Andrea was desirous of learning, he never ceased studying and applying himself to his work. And Nature, having created him a painter, wrought in him so effectively that, when he handled colours, it was as if he had been doing so for fifty years; whereupon Piero came to love him very deeply, and he was incredibly pleased to hear that whenever he had any time to spare, especially on feast days, he would spend all day long with other young men drawing in the Hall of the Pope, which housed the cartoon of Michelangelo and that of Leonardo da Vinci, and that, though still a lad, he surpassed all the other draughtsmen both native and foreign, who competed there endlessly. Among these, the personality and conversation of the painter

★ *Sarto.*

Franciabigio pleased Andrea more than those of all the others, just as his did Franciabigio. So they became friends, and then Andrea told Francia that he could no longer tolerate the oddities of Piero, who was now old, and that he therefore wanted to take a room for himself; and on hearing this, Francia, who was in the same straits, since his master Mariotto Albertinelli had abandoned the art of painting, told his companion Andrea that he needed a room too, and that it would be convenient for them both to find a place together.

So then having found a room on the Piazza del Grano, they completed many works in collaboration, including the curtains covering the panel pictures on the high altar of the Servites, which were commissioned from them by one of the sacristans, a very close relation of Francia. For these cloths, on the side facing the choir they painted an Annunciation, and on the other, in front, a Deposition of Christ from the Cross, which is similar to that on the panel which was there, from the hands of Filippo and Pietro Perugino.

At the head of the Via Larga in Florence, above the house of the Magnificent Ottaviano de' Medici and opposite the garden of San Marco, there used to assemble men belonging to the Confraternity known as the Scalzo,* in a building of theirs, dedicated to St John the Baptist, which had been constructed at that time by a large number of Florentine craftsmen, who had made there, among other things, a walled entrance court with columns of no great size. Then, when some of them saw that Andrea was entering the ranks of the very best painters, they determined, their resolve being grander than their resources, that around this cloister he should paint twelve pictures in chiaroscuro, that is to say in fresco with terracotta, containing twelve scenes from the life of St John the Baptist. So Andrea put his hand to this, and did the first scene, of St John baptizing Christ, with great diligence and in such good style that it therefore won him

* Barefooted, or discalced: like the religious, such as the Carmelites, who go barefooted or in sandals.

credit, honour, and fame, so that many people turned to him with commissions for work, as to one whom they reckoned must in time reach the honourable goal of which the extraordinary beginning of his working career held out such promise.

Among the other things he created in that early style was a picture that is now in the house of Filippo Spini, where it is held in great veneration in memory of so skilled a craftsman. Not long afterwards, in San Gallo, for the church of the Eremite Observantines of the Order of St Augustine, outside the San Gallo gate, he was commissioned to paint in one of the chapels a panel of Christ appearing to Mary Magdalen in the garden, in the guise of a gardener. And this work, because of its colouring and a certain softness and harmony, is sweetness itself, and was so well executed that it led not long afterwards to his painting two other pictures for the same church, as will be told below. This panel is now in San Jacopo tra' Fossi, on the Canto degli Alberti, as are the other two.

After these works, Andrea and Francia left the Piazza del Grano and took new rooms in the Sapienze, near the convent of the Nunziata. Thus it happened that Andrea and Jacopo Sansovino, who was then a young man and was working on some sculpture in the same place under his master Andrea Contucci, formed such a strong and close friendship one with the other that they were never apart, day or night; and as their discussions were mostly about the problems of the art of painting, it is therefore no wonder that both of them achieved great excellence, as I am now recounting of Andrea and shall do in the right place of Jacopo.

At that time, in the convent of the Servites, selling the candles at the counter, there was a friar called Mariano del Canto alla Macine, who was also the sacristan; he heard everyone singing Andrea's praises and saying that he was continuing to make marvellous progress in his painting, and so he thought of how he might fulfil a desire of his own

without much expense. So trying out Andrea (who was a sweet and good man) in a matter of honour, he tried to persuade him, as if he were asking a friendly favour, to help in an enterprise which would bring him honour and profit, and would make Andrea so well known that he would never more be poor.

Now many years before, for the first cloister of the convent of the Servites, Alesso Baldovinetti had, as mentioned above, painted a Birth of Christ, on the wall that has the Annunciation behind it; and on the other side of the same courtyard, Cosimo Rosselli had begun a scene showing St Philip (founder of that Servite Order) taking the habit. But Cosimo had not completed this scene, since he was overtaken by death the very moment he began working on it. Therefore the friar, who wished very anxiously to pursue the rest of the work, thought for his own gain to persuade Andrea and Francia, who from being friends had become rivals in painting, to compete with one another, each doing a part. This would both suit his purpose very well, and also make the expense less and their efforts greater. So having confided in Andrea, he persuaded him to undertake the task, claiming that as the place was public and much frequented, he would win recognition for this work no less among foreigners than Florentines, and that on account of this he should not settle any price, nor even wait to be asked, but rather himself ask if he might do it. And he added that if Andrea did not wish to do it, there was Franciabigio, who to win recognition had offered to undertake it, and leave the price to him.

These inducements were strong enough to make Andrea resolve to undertake the task, especially as he was weak-willed; and the last point, made about Franciabigio, induced him to resolve the matter completely and to come to a written agreement for the whole of the work, excluding anyone else. So then, having engaged Andrea and paid him some money, the friar wanted him first of all to continue the life of St Philip; and for each scene he was paid by him

no more than ten ducats, which the friar said came from his own pocket and was also being done more for Andrea's own good and convenience than for any gain or advantage to the convent.

Andrea then pursued the work with the utmost diligence, like a man thinking more of the honour than the gain he got from it, and in a short time of the whole task he finished the first three scenes and unveiled them. They showed in one when St Philip, already a friar, clothed the naked; in another when, as he was rebuking some gamblers who were blaspheming against God and scoffing at the saint, making a joke of his warnings to them, all of a sudden lightning falling from the sky strikes a tree under which people are sheltering and kills two of them, to the incredible fright of the others. And among these, some, with their hands to their heads, stagger forward in bewilderment, and others run away screaming with fright. One woman beside herself with fear from the thunder and lightning looks so natural as she takes to flight that she seems truly a living person; and a horse, running wild with fright at all the noise and commotion, by rearing up and leaping fearsomely reveals what fear and terror are caused by such sudden and unexpected happenings. And in all of this one can recognize how much thought Andrea gave to variety of incidents in the events that took place, with the alert attention that is certainly something beautiful and necessary for one who practises painting.

In the third, Andrea painted the scene when St Philip casts out spirits from a woman, with all the considerations that could be imagined in such an act; and so in their entirety these scenes won him very great honour and fame. Heartened by this, therefore, he continued with another two scenes for the same courtyard. On one side, St Philip lies dead, surrounded by his friars who are full of lamentation; and as well as this we see a dead child, who returns to life on touching the bier on which the saint lies, and so is seen first dead, and then revived and brought back to life, and all

with a beautiful, appropriate and natural effect. In the last scene on that side, he represented the friars laying the garments of St Philip on the heads of certain children; and in this he portrayed Andrea della Robbia, the sculptor, in an old man clothed in red, who comes forward stooped, with a staff in his hand. He also portrayed in this his son, Luca, just as in the scene already mentioned, of St Philip lying dead, he portrayed Girolamo, another son of Andrea, who was a sculptor and very much his friend, and who died not long ago in France.

And so, having brought to completion that side of the cloister, and thinking that though the honour was more than great the price was small, Andrea resolved to abandon the rest of the work, however much the friar complained. But because of the legal engagement he was unwilling to disengage him, unless Andrea first promised to do two other scenes, albeit at his own convenience and leisure, and with a bigger payment from the friar; and so they reached agreement.

As these works won greater recognition for Andrea, he received commissions to do many pictures and other works of importance, including, from the general of the Monks of Vallombrosa, one for the arch of the vaulting, with a Last Supper on the façade, for the monastery of San Salvi outside the Porta alla Croce. On this vault in four medallions, he painted the four figures of St Benedict, St John Gualberti, St Salvi the bishop, and St Bernard degli Uberti, a friar of their Order and a cardinal; and in the middle he did a medallion, with three faces which are one and the same, to represent the Trinity. As a painting in fresco this work was very well executed, and because of it Andrea became recognized for his true worth as a painter. Thereupon he was commissioned by order of Baccio d'Agnolo to paint in fresco in an enclosure on the slope of Orsanmichele, which leads to the New Market, the Annunciation, which is still to be seen there, in a minutely detailed style, which did not win him much praise; and this could have been because

Andrea, who worked well without exerting himself or forcing his talent, was, it is believed, anxious in this work to force himself and to paint with excessive application.

As to the many pictures which he then painted throughout Florence, which it would take too long to want to discuss one by one, I note that among the most distinguished can be counted the painting now in the apartment of Baccio Barbadori, containing a full-length Madonna with the Child in her arms and with St Anne and St Joseph, executed in a beautiful style and held very dear by Baccio. Another similarly much praised painting which he did is today in the possession of Lorenzo di Domenico Borghini, and another, for Leonardo del Giocondo of Our Lady, is at present owned by the latter's son Piero. For Carlo Ginori he painted two pictures, not very big, which were later bought by the Magnificent Ottaviano de' Medici; and today one of these is in his very fine villa of Campi, while the other, along with many other modern pictures done by outstanding masters, is in the apartment of Signor Bernardetto, the worthy son of his great father, who honours and esteems the works of famous craftsmen and likewise is in all his deeds a truly magnificent and generous lord.

In the meanwhile, the Servite friar had commissioned from Franciabigio one of the scenes for the courtyard mentioned above, but he had not yet finished making the platform and screen when Andrea, becoming apprehensive, because he thought that Franciabigio was a more practised and able master than him in handling colours in fresco, made, as if to compete with him, the cartoons for his two scenes which he intended to paint on the angle between the side-door of San Bastiano and the smaller door leading from the cloister into the Annunziata. Having made the cartoons, he set to work in fresco, and in the first he painted the Birth of Our Lady with a composition of figures which were beautifully proportioned and gracefully arranged in a room where some women, as friends and relations, have come to visit her and are standing about the newly delivered mother,

all clothed in the garments that were customary at that time; and some other, less illustrious, women, gathered by the fire, are washing the little new-born girl, while others still prepare the swaddling-clothes and are performing other such services. Among them is a very lively-looking little boy, warming himself at the fire, and an old man, resting on a couch, very true to life. Similarly there are some women carrying something to eat to the woman in the bed, in a very natural way. And all these figures, together with some *putti* hovering in the air and scattering flowers, in their expressions, their clothes, and in every other detail are most carefully depicted, and coloured so softly, that they all seem to be truly made of flesh, and everything else real rather than painted.

In the other scene, Andrea painted the three Magi from the East who, guided by the star, were going to adore the infant Jesus Christ, and he showed them dismounted, as if they were close to their destination; this was because there was only the space containing two doors between them and the Birth of Christ by the hand of Alesso Baldovinetti. In this scene, Andrea depicted the court of the three kings following behind with all their baggage and belongings and servants accompanying them, including, in a corner, three people drawn from life and wearing Florentine clothes: one of these is Jacopo Sansovino, portrayed full-length and staring straight towards you, as you look at the picture; the other with an arm foreshortened, who is leaning against Jacopo and making a sign, is Andrea, the master of the work; and the third, seen in profile behind Jacopo, is the musician, Aiolle. There are as well some little boys who are climbing on to the walls so as to see from there the magnificent procession and the strange animals the three kings have brought with them. This is equally as good as the one mentioned above; indeed in both the one and the other Andrea surpassed himself, let alone Franciabigio, who also finished his scene.

At this time, Andrea did for the abbey of San Godenzo, a

benefice belonging to the same friars, a panel picture which was regarded as very well executed. And for the friars of San Gallo, he painted a panel picture of the Annunciation, with Our Lady and the angel, in which there is a very pleasing harmony of colouring, and in which the heads of angels accompanying Gabriel show a sweet gradation of tints and beautifully expressive faces, executed perfectly. And the predella below this was painted by Jacopo Pontormo, then a disciple of Andrea, who gave proof when still so young of the beautiful works he would later on complete in Florence with his own hand, before becoming, one can say, a different painter, as will be described in his *Life*.

Afterwards, for Zanobi Girolami, Andrea made a picture with some figures, of moderate size, and containing a scene from the life of Joseph, the son of Jacob, which he completed with such very unremitting diligence that it was held to be very fine. Then not very long after this, for the men of the Confraternity of Santa Maria della Neve, behind the nunnery of Sant'Ambrogio, he undertook to paint on a little panel picture three figures, of Our Lady, St John the Baptist, and St Ambrose; and in due course, when finished, this work was placed on the altar of the Confraternity.

In the meantime, because of his talent, Andrea had struck up a close friendship with Giovanni Gaddi, who was later Clerk of the Camera; and Giovanni, because he always delighted in the arts of design, at that time kept Jacopo Sansovino constantly employed. He also found Andrea's style pleasing, and so he commissioned from him a picture of a very beautiful Madonna, which, as Andrea painted various patterns and other ingenious devices all around it, was prized as the most beautiful work he had painted up to then. After this, he did another picture of Our Lady for Giovanni di Paolo, the mercer, which pleased infinitely all those who saw it, as being truly most beautiful. And for Andrea Santini, he executed another picture, showing Our Lady, Christ, St John, and St Joseph, all done with such great diligence that in Florence the painting has always been

held to be very praiseworthy. These works won such a name for Andrea in his city that among the many men, both young and old, who were painting at that time, he was regarded as one of the most excellent of those who were handling brushes and colours. Therefore, he found himself not only being honoured but also, even though he charged little or nothing for his labours, in a state of life that made it possible for him partly to help and support his own family, and protect them from the usual trials and vexations of the poor.

But Andrea fell in love with a young woman, and a short while after, when she had been left a widow, he took her for his wife; and then he had more than enough to do for the rest of his life, and much more trouble than he had ever experienced in the past: for as well as the trials and tribulations that such entanglements usually bring with them, he suffered still more into the bargain, being someone afflicted now by jealousy, now by heaven knows what else. But to return to the works he made, which were as rare as they were numerous: after those discussed above, for a friar of Santa Croce, of the Order of Minorites,* who was then governor of the nunnery of San Francesco in Via Pentolini, and who delighted in paintings, on the panel for the church belonging to those nuns, Andrea depicted Our Lady standing on high on an octagonal pedestal, at the corners of which are seated some harpies, who appear to be adoring the Virgin; and with one hand Our Lady is holding up her Son, who in a most beautiful attitude clasps her most tenderly with His arms, and with the other she is holding a closed book, while gazing at two naked *putti* who, as they help to support her, serve as ornaments to her figure.

The Madonna has on her right hand a beautifully executed figure of St Francis in whose face can be recognized the goodness and simplicity truly present in that holy man. As well as this, the feet are marvellously beautiful, as are the

* Friars Minor or Franciscans.

draperies, for Andrea always did the outlines of his figures with a very rich flow of folds and with certain delicate hollows shaded so as to reveal the naked form. On her left hand the Madonna has a St John the Evangelist, made to appear as a young man, and in the act of writing the gospel, in a very beautiful manner. Moreover, in this work we see above the building and the figures a haze of transparent clouds, which appear to be moving. This picture, then, among Andrea's works is now held to be of singular and truly rare beauty. For the carpenter Nizza, he made a picture of Our Lady which was considered no less beautiful than his other works.

Then the Guild of Merchants determined that they should have some triumphal chariots made of wood like those of the ancient Romans, to be part of the procession on the morning of the feast day of St John, in place of certain altar-cloths and wax candles which the cities and townships carry in token of tribute, passing in front of the duke and the chief magistrates; and of the ten that were made at the time, Andrea painted some in oil and chiaroscuro, with scenes which were highly praised. And although it was to have followed on from this that some chariots were to be made every year, till each city and town had one of its own (which would have provided a display of great magnificence), this custom was none the less abandoned in the year 1527.

Now while Andrea was adorning his city with these and other works, and his fame was increasing day by day, the men of the Confraternity of the Scalzo determined that he should finish the work in their cloister, which he had already begun when he did the scene of the Baptism of Christ. So making a start on the work very readily, he painted two scenes, and also two most beautiful figures of Charity and of Justice to adorn the door leading into the Confraternity's building. In one of the scenes he depicted St John preaching to the crowds in a very lively attitude, looking thin and shrivelled, as he would from the life he led, and with an

expression on his face of rapt attention. The variety and the
vivacity of those who listen to him are likewise marvellous,
with some standing there in wonder and all of them aston-
ished at hearing a new message and such rare and never
previously heard teaching. But still more did Andrea exer-
cise his talent in painting John as he baptizes with water an
endless number of people, of whom some are stripping off
their clothes, while others are receiving the baptism, and
others, stripped naked, are waiting for him to finish bap-
tizing those before them. Andrea showed a very strong
emotion in all of them and a most ardent desire in the
attitudes of those who are hastening to be cleansed from sin;
not to mention that the figures are so well executed in
chiaroscuro that they look like true marble scenes and very
real.

I shall not leave out that while Andrea was engaged on
these and other pictures, there were published some copper
engravings by Albrecht Dürer and Andrea made use of
them, taking some of their figures and reproducing them in
his own style. This has persuaded some people not that it is
wrong to make skilful use of the good work of others, but
that Andrea was not very inventive.

At that time there came to Baccio Bandinelli, then a very
highly regarded draughtsman, the desire to learn how to
colour in oils; and so realizing that no one in Florence knew
better how to do that than Andrea himself, he commissioned
from him his own portrait, which was very like him as he
was at that age, as can still be seen; and thus through seeing
Andrea paint this and other works, he saw his method of
colouring, although subsequently, whether because of the
difficulties or through not caring, he did not pursue
colouring, finding sculpture more to his purpose.

Andrea did a picture, for Alessandro Corsini, of Our
Lady seated on the ground with the boy Child in her arms,
surrounded by swarms of *putti*, which was carried out with
fine artistry and with very pleasing colouring; and for a
mercer who had a shop in Rome and was a close friend of

his, he painted a very beautiful head. So also Giovan Battista Puccini of Florence, taking extraordinary pleasure in Andrea's style of work, commissioned from him a picture of Our Lady to send to France; but it proved to be so very beautiful that he kept it for himself and utterly refused to send it. None the less, while he was trading and doing his business deals in France, and arising from this, receiving commissions to arrange for the dispatch of outstanding pictures, he ordered from Andrea a picture of a Dead Christ surrounded by some angels, who with sad and sorrowful gestures stand contemplating their Maker, reduced to such wretchedness through the sins of mankind. When it was finished, this work gave such universal pleasure that Andrea, at the urging of many people, had it engraved in Rome by Agostino Veneziano; but as it did not succeed very well, he would never again have anything engraved.

Coming back to the painting, let me say that it gave no less pleasure in France, to which country it was sent, than it had done in Florence; and so much so that the king, burning with still greater desire to have some works by Andrea, gave orders for him to execute some more. And this was the reason why, persuaded by his friends, Andrea resolved shortly after to go to France.

Meanwhile the Florentines, hearing in the year 1515 that Pope Leo X wished to grace his native land with his presence, for his reception in the city ordered superb festivals and a magnificent and sumptuous spectacle, with so many arches, façades, temples, colossal figures, and other statues and ornaments that never before had there been seen anything more sumptuous or richer or more beautiful; for in Florence at that time there flourished a greater abundance of fine and exalted talent than had ever been seen in earlier periods. At the entrance of the gate of San Piero Gattolini, Jacopo di Sandro, in company with Baccio da Montelupo, made an arch covered with historical scenes. At San Felice in Piazza, Giuliano del Tasso made another arch, as well as some statues at Santa Trinita, with the obelisk of Romulus; and Trajan's

column in the New Market. In the Piazza de' Signori, Antonio, the brother of Giuliano da San Gallo, made a temple with eight sides; and Baccio Bandinelli made a giant on the loggia. Granaccio and Aristotile da San Gallo made an arch between the abbey and the palace of the Podestà, and on the corner of the Bischeri, Rosso made another, with a very beautifully ordered arrangement and a variety of figures. But most esteemed of all was the façade of Santa Maria del Fiore, made of wood, and so well decorated with various scenes by our Andrea that it would be impossible to wish for anything better. The architecture of this work was by Jacopo Sansovino, as were some scenes in low relief and many figures sculpted in the round, and so the Pope judged that this edifice could not have been more beautiful, even if made of marble. (And it was devised by Lorenzo de' Medici, father of the pontiff, when he was alive.) The same Jacopo also made a horse, similar to the one in Rome, for the piazza of Santa Maria Novella, which was held to be marvellously beautiful.* Moreover, innumerable ornaments were made for the Hall of the Pope on the Via della Scala, and that street was half-way filled with very beautiful scenes made by a large number of craftsmen, but for the most part designed by Baccio Bandinelli. So then when Leo entered Florence that year, on 3 September, this spectacle was judged to be the most grandiose ever devised, and the most beautiful.

But to return now to Andrea: being again requested to paint another picture for the king of France, in a short while he finished one containing a most beautiful Madonna, which was sent off immediately, and for which the dealers received four times as much as they had paid. At that very time, Pier Francesco Borgherini had arranged to be made by Baccio d'Agnolo very fine panelling, chests, chairs, and a bed, all carved in walnut wood, for furnishing an apartment; and to

* The horse in Rome was the equestrian statue of Marcus Aurelius later set up on the Piazza del Campidoglio on a base designed by Michelangelo in 1538.

ensure that the paintings corresponded in excellence to the rest of the work, he had part of the scenes executed by Andrea with figures of no great size, representing the deeds of Joseph, the son of Jacob, in rivalry with some painted by Jacopo da Pontormo, which are very beautiful. Andrea forced himself to devote an extraordinary amount of time and diligence to this work, so that his scenes should be more perfect than those of the others mentioned above; and he succeeded extremely well, for through the variety of incidents which he depicted in his stories he showed his great worth as a painter. These scenes were so excellent that, on account of the siege of Florence, Giovan Battista della Palla wished to remove them from where they were to send them to the king of France; but since they were fixed in such a way that all the work would be spoiled if that were done, they stayed where they were, along with a picture of Our Lady, which is regarded as most rare.

After this Andrea did a painting of the head of Christ, which is now kept by the Servite friars on the altar of the Annunziata, and is so beautiful that for myself I do not know whether any human mind could imagine a more beautiful Head of Christ.

For the chapels in the church of San Gallo, outside the gate, as well as Andrea's panel pictures many others had been painted, which were not the equal of his; and so when another painting was to be commissioned, the friars contrived to persuade the patron of the chapel to give it to Andrea; and having begun it immediately, he depicted four figures standing upright, in a disputation about the Trinity; namely, St Augustine, robed as a bishop and looking truly African, and moving impetuously towards St Peter Martyr, who is holding up an open book in a truly fierce and awesome attitude. Beside the latter, whose head and figure are highly praised, is a St Francis, who holds a book in one hand while he presses the other against his breast, and who seems to be expressing with his lips an ardent fervour which almost consumes him in the heat of the argument. And

there, too, is a St Lawrence, who, as a young man, listens
and seems to be yielding to the authority of the others.
Kneeling below are two figures, one a Magdalen, most
beautifully clothed, whose face is a portrait of Andrea's
wife, since he never depicted the features of a woman in any
place without copying them from her. And if Andrea did
happen to make use of the features of other women, because
he was so used to seeing her continually, and had drawn her
so often, and moreover had her appearance so much im-
pressed on his mind, it came about that almost all the heads
he painted of women resemble her. The other one of the
four figures was a St Sebastian, who, being naked, shows his
back, which seems to all who look at it to be not painted but
indeed living flesh. And to be sure this picture, among so
many works in oils, was held by craftsmen to be the best;
this was for the reason that in it may be seen the most careful
consideration of the proportions of the figures, a very
ordered method, and very fitting expressions in the looks of
the subjects: sweetness of manner in the faces of the young
men, hardness in the old, and in the looks of the middle-
aged a mixture of both one and the other. In sum, this panel
is beautiful in every detail; and it is now to be found in San
Jacopo tra'Fossi on the Canto degli Alberti, together with
others from the hand of the same master.

While Andrea stayed put in Florence engaged on these
works, living very poorly and not improving his lot one
scrap, the two pictures sent to France had been considered
by King Francis I, along with many others that had been
sent from Rome, from Venice, and from Lombardy, and
they had been judged by far the best. After the king had
praised them extravagantly, he was told that Andrea could
easily be induced to come to France to enter his Majesty's
service; this was very welcome to the king, and so after
orders had been given by him for all that was necessary, and
that the money needed for the journey should be paid to
him in Florence, Andrea set off happily on the road to
France, taking with him his assistant, Andrea Sguazzella.

When they finally arrived at the court, they were very lovingly and joyfully received by the king; and before the day was over, Andrea experienced the great generosity and courtesy of that magnanimous king, when he received gifts of money and rich and noble garments. Starting to work soon after, he made himself pleasing to the king and all the court in such a manner that he was fondly treated by everyone, and so it appeared to him that his departure from Florence had led him from extreme unhappiness to the greatest happiness.

Among the first things he did was a portrait from life of the dauphin, the son of the king, born only a few months previously and so still in swaddling-clothes; and when he took it to the king, he received a gift of 300 gold crowns. Afterwards, continuing to work, he painted for the king a figure of Charity which was considered a very rare work and held by that king in the estimation it deserved. Thereupon, the king provided him with a very substantial allowance, and did all he could to ensure that Andrea would be happy to stay with him, promising that he would want for nothing; and this was because he admired the promptness and resolution displayed in the conduct of his work by Andrea, who was contented with everything. Moreover, giving great satisfaction to the entire court, he completed many pictures and other works; and if he had borne in mind what he had left behind and where chance had led him, he would undoubtedly, not to mention riches, have climbed to a very honourable station in life.

But one day, when Andrea was working on a St Jerome in Penitence for the mother of the king, some letters written by his wife arrived from Florence, and he started, for whatever reason, to think of leaving. He therefore requested leave of the king, saying that he wished to go to Florence, and that when various affairs of his were settled, he would return to his Majesty, no matter what; that to rest more content he would bring his wife back with him; and that on his return he would bring valuable pictures and sculptures.

Trusting Andrea, the king gave him money for his purpose; and Andrea swore on the Bible to return to him in a few months. And so arriving happily in Florence, he enjoyed for several months his beautiful wife, and his friends and the city.

Finally the time when he should have returned to the king having passed by, in the end, what with building, and taking his pleasures, and not working, he found he had used up all his own money and likewise the king's. He wished to return, none the less, but the prayers and pleas of his wife prevailed with him more than his own need and his pledge to the king; and so (to please his wife) he did not go back; and the king was so enraged by this that for a long time he would never again look with a favourable eye on Florentine painters, and he swore that if ever Andrea fell into his hands again, he would do him more harm than good, without the slightest regard for his talent. So Andrea stayed in Florence, and from a very high station in life he sank to a lowly one, and he lived, whiling away the time, as best he could.

When Andrea left for France, the men of the Scalzo, thinking that he was certain never to come back, commissioned all the remaining work of their cloister from Franciabigio, who had already executed two scenes there; and then, seeing Andrea back in Florence, they ensured that he took the work up again; and, carrying on with it, he painted four scenes, one beside another. In the first is St John led before Herod. In the second are the feast and dance of Herodias, with figures that are very well arranged and appropriate. In the third is the beheading of St John, in which the executioner, a semi-naked figure, is extremely well drawn, as are all the others. In the fourth scene, Herodias is presenting the head; and here there are some figures expressing their astonishment, executed with splendid care and attentiveness. These scenes have for some time been the study and school of many young men who are now outstanding in their craft.

In a tabernacle outside the Pinti gate, on a corner where

the road leads to the Ingesuati, Andrea painted in fresco a Madonna seated with the Child in her arms and the infant St John, who is laughing, a figure made with great skill and executed so perfectly, that it is highly esteemed for its beauty and vivacity; and the head of Our Lady is a portrait of Andrea's wife. Because of the incredible beauty of this picture, which is truly marvellous, this tabernacle was left standing in 1530 when, on account of the siege of Florence, the convent of the Ingesuati, along with many other very beautiful buildings, was pulled down.

In those days the elder Bartolommeo Panciatichi was carrying on a considerable trading business in France, and as he was desirous of leaving a memorial of himself in Lyons, he ordered Baccio d'Agnolo to have a panel picture painted for him by Andrea, and to send it to him there, saying that he wanted an Assumption of Our Lady with the Apostles around the tomb. So Andrea brought this work to near completion but then, because several times the wood of the panel split, he would sometimes work, sometimes put it aside, so that on his death it was left partly unfinished. Afterwards it was placed by the younger Bartolommeo Panciatichi in his house, as a work truly deserving praise for the beautifully executed figures of the Apostles, not to mention the Madonna, who has a choir of *putti* standing all around her, while others support and raise her aloft with extraordinary grace. And in the foreground of the panel, among the Apostles, there is a portrait of Andrea himself, so natural that he seems to be alive. This painting is today at the villa of the Baroncelli, a little way out of Florence, in a small church built by Piero Salviati, near his villa, to house and honour that picture.

At the head of the garden of the Servi, in two angles, Andrea painted two scenes of Christ and the Parable of the Vineyard, one showing the vines being planted, bound and staked; the other the head of the household calling to work those who are standing idle, among whom is one man who, while he is being asked if he wants to have work to do, stays

sitting down and rubs his hands together and ponders whether he really wants to join those at work, looking exactly like those layabouts who are shy of work. Still more beautiful is the other scene, in which the head of the household is having him paid, while the others are murmuring complaints; and among them is one who, as he counts his money over by himself, absorbed in checking how much, seems really alive, as does the steward who is making him the payments. And these scenes are in chiaroscuro and executed in fresco, with masterly skill.

After he finished them, in the noviciate of the same convent, in a niche at the head of a stairway, he painted a Pietà coloured in fresco, which is most beautiful. He painted another small Pietà in oils, and also a Nativity, in the room of that convent where the General, Angelo Aretino, used to stay. For Zanobi Bracci, who very much desired to have work from his hand, Andrea executed for one of his living rooms a painting of Our Lady, in which she is kneeling and leaning against a boulder as she contemplates Christ, who lies on a bundle of drapery and smiles up at her, while St John, who stands nearby, makes a sign to Our Lady as if indicating that Christ is truly the son of God. Behind these figures is a St Joseph with his head reposing in his hands, which are resting on a rock, and who appears to be rejoicing at heart on seeing that the human race had become divine through the birth of Christ.

After Cardinal Giulio de' Medici had been instructed by Pope Leo to adorn with stucco and paintings the ceiling of the great hall of Poggio a Caiano, a palace and villa of the house of Medici, situated between Pistoia and Florence, the supervision of the work and arrangements for the payments were given to the Magnificent Ottaviano de' Medici, as a person who, not falling short of the standards of his ancestors, understood that business, and was a loving friend of all the practitioners of our arts, delighting more than others in having his dwelling-places adorned with the works of the most excellent among them. So then, though the burden of

the entire work had been entrusted to Franciabigio, he ordered that he should have just a third, Andrea a third, and Jacopo da Pontormo the rest. However, it proved impossible, despite all the Magnificent Ottaviano's solicitations, and all the money he offered and even paid them, to have the work brought to completion. Andrea alone finished with great diligence a scene on one wall, representing Caesar being presented with tribute of all kinds of animals. The drawing for this work is in our book of drawings, together with many others by his hand; it is in chiaroscuro and the most finished that Andrea ever made. In this work, in order to surpass Franciabigio and Jacopo, Andrea exerted himself as never before, drawing a magnificent perspective-view and a very difficult flight of steps, which provided the ascent to the throne of Caesar. And he adorned these with very cleverly devised statues, since it was not enough for him to have shown his splendid talent in all the various figures that are carrying on their backs so many diverse animals, such as the figure of an Indian who is wearing a yellow coat and bears on his shoulders a cage in perspective, with some parrots both inside and on the outside, a truly rare composition. And so, in addition, are some other figures who are leading Indian goats, lions, giraffes, panthers, lynxes, and apes, with Moors and other fine and fanciful things, arranged in a beautiful manner and executed in fresco in a most inspired way. On these steps, also, he depicted a dwarf sitting down and holding a box containing a chameleon, so well done that one cannot imagine more beautiful proportions than those he gave to this creature in all the deformity of its fantastic shape. However, as was said, this work remained unfinished because of the death of Pope Leo. And although Duke Alessandro de' Medici was desirous that Jacopo da Pontormo should finish it, he was unable to prevail on him to do so. And in truth it suffered a very grievous wrong in remaining unfinished, seeing that, for one in a villa, the hall is the most beautiful in the world.

Having returned to Florence, Andrea painted a panel

picture of a nude half-length figure of St John the Baptist, which is very beautiful; this was commissioned from him by Giovan Maria Benintendi, who afterwards gave it to the Lord Duke Cosimo.

While matters progressed in this manner, Andrea, remembering sometimes about his time in France, would sigh from the heart; and if he had thought to find pardon for the wrong he had committed, he would doubtless have returned there. Indeed, to test his luck, he decided to see whether his talent could prove useful to him in this matter. So Andrea did a picture of St John the Baptist, half-naked, intending to send it to the Grand Master of France, so that he should exercise himself in having him restored to the king's favour. But, for whatever reason, he did not in fact send it to him, but sold it instead to the Magnificent Alessandro de' Medici, who as long as he lived always valued it very highly, just as he also did two pictures of Our Lady, which Andrea painted for him in the same style, and which are now at his home. Not long after, Zanobi Bracci commissioned him to paint a picture for Monsignor de Beaune, and he executed this with great diligence, hoping that it would be the cause of his being restored to favour with King Francis, to whose service he wished to return.

He also did a painting for Lorenzo Jacopi of far greater size than usual, showing Our Lady seated with the Child in her arms and accompanied by two other figures sitting on some steps, and the whole is similar in design and colouring to his other works. He likewise executed for Giovanni d'Agostino Dini a most beautiful painting of Our Lady which is now highly esteemed for its beauty; and he did a portrait of Cosimo Lapi from life so well that it seems absolutely alive.

Then, in the year 1523, the plague came to Florence and also affected some of the nearby country districts; and to escape it, and to do some work or other, through the agency of Antonio Brancacci, Andrea went to the Mugello to paint a panel picture for the nuns of San Piero a Luco, of the

Order of Camaldoli, taking with him his wife and step-daughter, and similarly his wife's sister and an assistant. Living there quietly, therefore, he began to do the work. And since those venerable ladies from one day to another showed his wife, himself, and all his household more and more kindness and courtesies, he applied himself very lovingly to working on that picture, in which he painted a Dead Christ mourned by Our Lady, by St John the Evangelist, and by the Magdalen, such lifelike figures that they appear truly to have the breath of life. In St John may be seen the devoted tenderness of that Apostle, with love in the tears of the Magdalen, and utter grief in the attitude and countenance of the Madonna, whose appearance, as she beholds Christ, whose dead body looks real and natural, arouses such compassion that St Peter and St Paul stand there completely dazed and bewildered, as they contemplate the dead Saviour of the world in the lap of His mother. And these marvellously considered ideas make one recognize how much Andrea delighted in the aims and achievements of the art of painting; and to tell the truth, that picture has brought more fame to the convent than all the buildings and all the other costly works ever carried out there, no matter how extraordinary and magnificent.

After he had finished the picture, as the danger from the plague had not yet disappeared, he stayed living for some weeks more in the same place, where he was so well regarded and kindly treated. During this time, so as not to stay idle, he painted not only a Visitation of Our Lady to St Elizabeth, which is in the church, on the right hand over the crib, as a finishing touch to a little antique panel, but also on a not very large canvas a most beautiful head of Christ, somewhat similar to the one over the altar of the Annunziata, but not so finished. This head, which can truly be numbered among Andrea's very best works, is now in the monastery of the monks of the Angeli in Florence, in the possession of the Very Reverend Father Don Antonio of Pisa, who loves not only the men who excel in our arts, but generally all men of

talent. Several copies have been made of this picture; for Don Silvano Razzi entrusted it to the painter Zanobi Poggini, so that he might make a copy for Bartolommeo Gondi, who had asked him for one, and then there were made several other copies, which are held in tremendous veneration in Florence.

In this way, therefore, Andrea passed the time of the plague without danger; and those ladies received from this highly talented man a work that can stand comparison with the most excellent pictures in our time: thus it is no wonder that Ramazzotto, local leader at Scaricalasino, several times during the siege of Florence, sought to have it sent to his chapel in San Michele in Bosco at Bologna.

After Andrea had returned to Florence, he painted for Beccuccio Bicchieraio of Gambassi, a close friend of his, a panel picture of Our Lady in the sky with her Son in her arms and four figures below, St John the Baptist, St Mary Magdalen, St Sebastian, and St Rocco; and on the predella he did portraits from life of Beccuccio himself, and his wife, which are very strong; and today this picture is at Gambassi, a castle-town in Valdelsa, between Volterra and Florence. For a chapel at the villa of Zanobi Bracci in Rovezzano, he did a very beautiful picture of Our Lady suckling her Child, with St Joseph, figures executed with such diligence that they stand out from the panel, so bold is the relief; and this picture is now in the house of Messer Antonio Bracci, Zanobi's son.

About the same time, and in the earlier-mentioned cloister of the Scalzo, Andrea painted two other scenes, in one of which he depicted Zacharias, who as he offers sacrifice is struck dumb by the apparition of the Angel, while in the other is the Visitation of Our Lady, marvellously beautiful.

Federigo II, Duke of Mantua, was then passing through Florence on his way to do reverence to Clement VII, when over a door in the house of the Medici he saw the portrait of Pope Leo between Cardinal Giulio de' Medici and Cardinal de' Rossi, which the most excellent Raphael of Urbino

had executed previously. And as it pleased him immensely, he thought, as someone who delighted in excellent pictures made in this fashion, to secure it for himself; and therefore in Rome, when the time seemed right, he requested it as a gift from Pope Clement, who courteously granted him that favour. So then orders were sent to Florence, to Ottaviano de' Medici, under whose care and governance were Ippolito and Alessandro, that it should be packed up and taken to Mantua. This greatly displeased the Magnificent Ottaviano, who was unwilling to deprive Florence of so fine a picture, and he marvelled that the Pope should have given it up so suddenly. However, he replied that he would not fail to oblige the Duke, although as the frame was poor, he was having a new one made, and when this had been gilt he would send the picture with every safeguard to Mantua. And after that, to keep both the goat and the cabbages, as the saying goes, he sent secretly for Andrea and told him how the matter stood, and that there was no other remedy for it but to counterfeit it most carefully; and then, after sending a likeness of it to the Duke, to retain (covertly) the one from the hand of Raphael.

After he promised to do as best he knew and could, Andrea had a panel prepared similar in size and all its details, and then he worked on it secretly in the house of Messer Ottaviano; and he applied himself to this in such a manner that Messer Ottaviano himself, though deeply knowledgeable about everything to do with the arts, when it was finished could not tell the one picture from the other, nor distinguish the true and real picture from the likeness made of it, especially as Andrea had counterfeited even the spots of dirt, just as they were in the true one itself. So having hidden Raphael's picture, they sent the one from the hand of Andrea in a similar frame to Mantua; and the Duke rested very content with this, after it had been praised very highly by the painter Giulio Romano, a disciple of Raphael, who had not tumbled to what had been done. And Giulio would have kept to his opinion and thought the picture was indeed

from the hand of Raphael; but then Giorgio Vasari chanced to come to Mantua, and he, having been as a boy taken under the wing of Messer Ottaviano, and seen Andrea working on that picture, revealed how things stood. For after Giulio had welcomed Vasari very affectionately and shown him many antiquities and paintings, and then that picture of Raphael's, as the best work there, Vasari said:

'It's a very beautiful work, but not possibly from the hand of Raphael.'

'How not so?' said Giulio. 'Shouldn't I know it myself, when I recognized some of my own brush strokes in it?'

'You have forgotten them,' Giorgio went on, 'for it is from the hand of Andrea del Sarto, and as a mark of this, look at the mark' (and he pointed to it) 'that was made in Florence, so that when the two pictures were together, they could not be confused.' Having heard this, Giulio turned the picture round, and having seen the distinctive mark, he shrugged his shoulders and spoke these words:

'I value it no less than if it were from the hand of Raphael, indeed much more, because it is something out of the natural order that one man of excellence should imitate the work of another so well, and make something so similar.' Enough then for it to be recognized that Andrea's talent was so sound, both in comparison and alone. And so through the judicious advice of Messer Ottaviano the Duke was given satisfaction, while Florence was not deprived of a most splendid work, which, having been given to Ottaviano later by Duke Alessandro, was kept by him for many years, till he made a gift of it to Duke Cosimo, who has it in his wardrobe with many other famous pictures.

While Andrea was making this copy, he also did a picture for Messer Ottaviano of just the head of Cardinal Giulio de' Medici, who later became Pope Clement, similar to that by Raphael; a very beautiful portrait, it was later given by Messer Ottaviano to the old Bishop de' Marzi.

Not long afterwards, Messer Baldo Magini of Prato desired to have a most beautiful panel picture painted for

Santa Maria delle Carceri in his native town, for which he had already commissioned a very noble frame, and, among other painters, Andrea was proposed to him. Thereupon Messer Baldo, although he did not understand much about it, inclined to think it should be him rather than any of the others, and had almost expressed the intention that he wished him and no one else to do it, when a certain Niccolò Soggi of Sansovino, who had friendly connections in Prato, was suggested to Messer Baldo for the task, and so effectively helped on his way with the claim that a better master than him could not be obtained, that he was given the work. Meanwhile after his supporters had sent for him, Andrea, thinking for sure that the work would be his, went to Prato with Domenico Puligo and other painters who were his friends. But when he arrived Andrea found that Niccolò had not only changed the mind of that Messer Baldo but was bold and brazen enough to say to him, in the presence of Messer Baldo, that he would wager any sum of money with Andrea in painting something and let the winner take all.

Andrea, who knew just how good Niccolò was, although he normally showed little spirit, retorted: 'I have here with me this assistant of mine who has not been painting very long, and if you wish to bet with him, I shall put the money down for him, but not for the world will I let you do so with me; for if I were to vanquish you, it would do me no honour, and if I were to lose, it would be utterly shaming.' Then, having told Messer Baldo that he should give the work to Niccolò, because he would do it in a manner to please anyone hunting for a street bargain, he went back to Florence; and from Pisa he was commissioned to paint a panel divided into five pictures, subsequently placed round the Madonna of Sant'Agnese, beside the walls of the city, between the old citadel and the Duomo. Placing a figure in each picture, he depicted in two of them, St John the Baptist and St Peter, on either side of the miraculous Madonna. In the others are St Catherine the Martyr, St Agnes, and St

Margaret, separate figures whose individual beauty fills with
wonder anyone who looks at them, and which are regarded
as the most charming and lovely women that he ever
painted.

Messer Jacopo, a Servite friar, in releasing and absolving a
woman from a vow, had laid down that she should provide
for the painting of a figure of Our Lady over the outside of
the door of the Annunziata leading into the cloister; and so,
finding Andrea, he told him that he had the money to
spend, and that although it was not much, it seemed to be
right and proper that, since Andrea had won such fame
from the other works he had executed in that place, he and
no one else should do this as well. Andrea, who was nothing
if not soft-hearted, moved by the persuasions of this father,
and his own wish for profit and glory, answered that he
would do the picture very willingly; and having put his
hand to it shortly afterwards, he executed in fresco a very
beautiful Madonna, seated, holding her Son in her arms,
and St Joseph leaning on a sack, with his eyes fixed on an
open book. So well was this work done, that for
draughtsmanship, grace, and excellence of colouring, and
for vivacity and relief, it demonstrated that he outstripped
and surpassed in great measure all the painters who had
worked till that time. In truth this painting is such that with
no need of any other praise it speaks for itself as most rare
and wonderful.

There was wanting only one scene in the cloister of the
Scalzo for it to be completely finished; so Andrea, who
added grandeur to his style through seeing the figures which
Michelangelo had begun and partly finished for the sacristy
of San Lorenzo, set his hand to doing this last scene; and
giving the final proof of his improvement, he painted the
birth of St John the Baptist, with most beautiful figures
which were far better and stronger in relief than those he
had done previously in the same place. Among the ex-
tremely beautiful figures in this work is a woman bearing
the naked child to the bed, where lies St Elizabeth, who,

too, is very beautifully depicted; and also Zacharias, who writes on a sheet of paper that he has placed on one knee, holding it in one hand while with the other he is writing the name of his son, with such vivacity that he only lacks breath to be alive. Likewise very beautiful is an old woman seated on a stool, who is smiling happily because the other old woman has given birth, and whose attitude and expression are as natural as they would be in real life.

After he had finished that work, which certainly deserves the highest praise, he did a panel painting for the General of the Vallombrosan Order of four very beautiful figures, St John the Baptist, St John Gualbertus, founder of the Order, St Michael the Archangel, and St Bernard, a cardinal and monk of the Order, with some *putti* in the middle that could not be more vivacious or more lovely. This painting is at Vallombrosa, at the top of a rock, where, separated from the others, some of the monks live in rooms called the Cells, almost leading the lives of hermits.

After this Giuliano Scala commissioned from him a panel picture, to send to Sarzana, of Our Lady with her Son in her arms, and two half-length figures, from the knees upwards, of St Celsus and St Julia, with St Onofrio, St Catherine, St Benedict, St Anthony of Padua, St Peter, and St Mark; and this panel was held to be the equal of Andrea's other works. And in the hands of Giuliano Scala, against the balance of the money due to him from those on whose behalf he had paid out, there remained a lunette containing an Annunciation, which was to go above the panel, to complete it; and this is now in his chapel in the great tribune encircling the choir, in the church of the Servites.

The monks of San Salvi had let many years pass by without worrying whether Andrea should start work on their painting of the Last Supper, which they had commissioned from him at the time he did the arch with the four figures, when finally an abbot of theirs, a judicious and gentlemanly person, determined that he should finish the picture. Andrea, who had already committed himself to it on a previous

occasion, put up no resistance; rather, having set his mind to it, doing a section at a time at his own pleasure, he finished it not many months later. And he painted it in so good a style that this work was held to be, as it certainly is, the most smooth, the most vivacious in colouring and drawing that he ever did, or rather that anyone could do. For apart from all the rest, he gave such infinite grace, grandeur, and majesty to all the figures that I do not know how to praise his Last Supper without saying too little, it being so fine that whoever sees it is stupefied. It is no wonder that, because of its excellence, during the devastations of the siege of Florence in the year 1529, it was allowed to be left standing, while the soldiers and wrecking squads, by command of those in charge, destroyed all the suburbs around the city, and the monasteries, hospitals and all the other buildings. These men, let me say, having destroyed the church and the campanile of San Salvi, and started to tear down part of the convent, had reached the refectory containing the Last Supper when the man who led them, seeing and perhaps having heard speak of this marvellous painting, abandoned what they had embarked on and would not let any more of the place be destroyed, putting this off till they could not do otherwise.

Afterwards, on a processional banner for the Society of St James, called *il Nicchio*,* Andrea painted a St James, who is fondling a little boy dressed as a flagellant, by chucking him under the chin, and another little boy with a book in his hand, done with beautiful grace and very lifelike.

He did a portrait from life of a steward of the monks of Vallombrosa, who always stayed in the country to look after the needs of his monastery, and this picture was put under a vine-arbour, where he had made trellises and contrivances of his own with various fanciful devices, and there it was buffeted by the wind and the rain, as was wanted by

* The Shell or Niche. (St James the Apostle's emblems included a cockleshell as one of the signs of pilgrimage; he is the patron saint of pilgrims and furriers, and of Spain.)

the steward, who was a friend of Andrea. And because, when the work was finished, some colours and lime were left over, Andrea, having taken hold of a tile, called his wife, saying: 'Come here, for we have these colours left over and I want to do a portrait of you, so that everyone may see how well preserved you are, even at your present age, though they will none the less realize how much your appearance has changed, and that you look different from the early portraits.' But his wife, who perhaps entertained other ideas, would not come; and Andrea, as if guessing that he was near his end, took hold of a mirror and then did such a good self-portrait on the tile that it is the living image of him. And this portrait is in the possession of his wife, Madonna Lucrezia, who is still alive.

He likewise portrayed a canon of Pisa, a close friend of his; and this portrait, which is very lifelike and most attractive, is still in Pisa. Then for the Signoria, he began the cartoons meant for the paintings to be executed on the hangings of the balcony overlooking the piazza, with many splendid and fanciful ideas, over the city's coat of arms, with banners of the heads of the associations of guilds, supported by some *putti* with ornaments as well, in the form of images of all the virtues, and likewise the most famous rivers and mountains of the dominion of Florence. But this work, so begun, remained unfinished through the death of Andrea, as also remained not quite finished a panel which he painted for the monks of Vallombrosa, for their abbey of Poppi in the Casentino. On this panel he painted an Assumption of Our Lady in the midst of a large number of *putti*, with St John Gualbertus, St Bernard the Cardinal, a monk of their Order as we said, St Catherine, and St Fidelis; and this panel, unfinished as it is, is now, as stated, in the abbey of Poppi. The same happened to a panel of no great size, which, when finished, was to have gone to Pisa. However, he left completely finished a very fine picture, which is today in the home of Filippo Salviati, and a few others.

About that time, Giovan Battista della Palla, having

bought as many notable pictures and sculptures as he could, and having made copies of those he could not buy, had despoiled Florence of a countless number of works, chosen regardless in order to furnish a suite of rooms for the king of France, which was to be richer in such adornment than any other. This man, therefore, desirous that Andrea should return to the service and favour of the king, commissioned two pictures from him. In one of them, Andrea painted Abraham in the act of preparing to sacrifice his son, and this was executed with such diligence that it was judged that up to then he had done nothing better. The inspired figure of the old man expressed that living and steadfast faith, which made him unflinchingly most ready and willing to kill his own son. The same Abraham can likewise be seen turning his head towards a very beautiful little angel, who seems to be telling him to stay his hand. I shall not describe the gestures, the garments, the footwear and other details to do with that old man, because not enough could ever be said about them; but I must mention that the young boy Isaac, tender and most beautiful, was to be seen all naked and trembling with the fear of death, and seemingly already almost lifeless before being struck. The same boy had nothing else except his neck sunburned, and the parts of his body that in his three days' journey had been sheltered from the sun by his clothes were white as white. In like manner, the ram caught among the thorns seemed to be alive, and the clothes of Isaac on the ground looked more real and natural than painted. Moreover, there were some naked servants looking after an ass that was grazing, and a landscape so well executed that the actual scene, where the event took place, could not have been more lovely or in any way different. This picture was bought by Filippo Strozzi after the death of Andrea and the capture of Battista,* and he made a gift of it to Signor Alfonso d'Avalos, Marquis del

* Giovan Battista della Palla was an anti-Medicean supporter of the Republican government of Florence, who died in captivity after the return of the Medici in 1529. See also the *Life* of Pontormo.

Vasto, who had it taken to the island of Ischia, near Naples, and placed in some rooms of his along with other very noble paintings.

In the other picture, he made a most beautiful figure of Charity with three *putti*, and this was later bought from Andrea's wife, after he died, by the painter Domenico Conti, who then sold it to Niccolò Antinori, who cherishes it as the rare work it undoubtedly is.

In the meanwhile, the Magnificent Ottaviano, seeing from this last work how greatly Andrea had improved his style, desired to have a painting from his hand. So then Andrea, who wanted to serve him since he was very much under an obligation to that lord, who had always favoured men of high talent, and especially painters, painted for him a picture of Our Lady seated on the ground with a little boy riding astride her knees, who is turning to face a little St John held up by an old St Elizabeth, so well depicted and natural that she seems to be alive, even as everything else is wrought with incredible diligence, skill, and draughtsmanship. When he had finished this picture, Andrea brought it to Messer Ottaviano; but because, in view of the siege of Florence, that lord had other things on his mind, he told him he should give it to whoever would like it, though he excused himself and thanked him effusively. All Andrea said in reply was:

'The labour was endured for you, and yours it will always be.'

'Sell it,' replied Messer Ottaviano, 'and use the money for yourself; because I know what I am talking about.'

Thereupon, Andrea left and went home; nor for all the requests made to him would he ever let anyone have the picture. Rather, when the siege was over and the Medici returned to Florence, he brought it back to Messer Ottaviano; and he accepted it very willingly, thanked Andrea, and paid him double for it. This work is in the chamber of his wife Madonna Francesca, the sister of the Most Reverend Salviati; and she holds the beautiful pictures left to her by

the problems of the art of painting, than to aim to force one's nature and talent in one bound. Nor is there any doubt that if Andrea had stayed in Rome, when he went there to see the works of Raphael and Michelangelo, along with the city's statues and ruins, he would have greatly enriched his style in the composition of scenes, and would one day have come to give more refinement and greater force to his figures, which has never been achieved except by those who have spent some time in Rome, in order to grow familiar with those works and study them in detail.

As he had from nature a sweet and graceful manner of drawing, and smoothness and liveliness of colouring, both in fresco and in oils, it is believed without doubt that had he stayed in Rome he would have surpassed all the craftsmen of his time. But some believe that he was deterred from this by the abundance of works in sculpture and painting to be seen in that city, both ancient and modern, and by seeing many young disciples of Raphael and of others, bold in draughtsmanship and confident and effortless in painting, whom, so timid was he, Andrea did not have the heart to emulate. And so, riddled with doubt, he decided it would be best to return to Florence; and there, reflecting little by little on what he had seen, he benefited so much that his works since have been highly prized and admired, and, moreover, imitated more after his death than during his lifetime. Those who own them cherish them, and anyone wanting to sell one of his works has received three times more than was paid to Andrea, given that he was always paid poorly for his works, either because he was, as said, by nature timid, or because certain interior decorators, who were then doing the best work in citizens' houses, in order to favour their friends never let any work be commissioned from Andrea, unless they knew he was in acute need; and then he would accept any price. But this does not prevent his works from being most rare, or his being held in very great account because of them, and deservedly, for he was

one of the best and greatest masters ever to exist even till now.

In our book of drawings there are many from his hand, and all good; but in particular one utterly beautiful drawing is of the scene that he painted at Poggio, showing Caesar being presented with the tribute of all the animals from the East. This drawing, in chiaroscuro, is a rare work and one of the most finished that Andrea ever did; for when he drew objects from life to put them in his works, he merely did sketches in rough outline, as it was enough for him to grasp the essential characteristics; then when he put them in his paintings he brought them to perfection. So his drawings served him more as reminders of what he had seen than models from which to copy his pictures exactly. Andrea had countless disciples, but they did not all pursue the same studies under his guidance, for some stayed with him a long time and some only a little while; and this was the fault not of Andrea but of his wife, who, with respect for no one, ordered all of them about imperiously, making their lives a torment.

His disciples, then, included Jacopo da Pontormo; Andrea Sguazzella, who followed Andrea's style and decorated a palace in France, outside Paris, with work that is much praised; Solosmeo; Pier Francesco di Jacopo di Sandro, who has painted three panel pictures in Santo Spirito; Francesco Salviati, and Giorgio Vasari of Arezzo, who was Salviati's companion, though he did not stay long with Andrea; Jacopo del Conte, of Florence, and Nannoccio, who is in very good standing in France with Cardinal de Tournon. Likewise Jacopo, called Jacone, was a disciple of Andrea, and a close friend and imitator of his style. While Andrea was alive, this Jacone was helped by him a great deal, as can be seen in all his works, and especially in the façade painting of the knight Buondelmonti on the piazza of Santa Trinita. Left after Andrea's death as the heir to his drawings, and other belongings to do with painting, was Domenico Conti, who made little progress in painting; and one night

by, as it is believed, fellow painters, he was robbed of all the
drawings, cartoons and other things he had from Andrea,
nor could it ever be found out who these men were. Well
then, Domenico Conti, being not ungrateful for the benefits
received from his master, and desiring to give him after his
death all the honours he deserved, ensured that Raphael of
Montelupo of his courtesy made for him a richly orna-
mented marble tablet, which was built into a pilaster in the
church of the Servites with the following epitaph, composed
by the very learned Messer Pier Vettori, then a young man:

ANDREAE. SARTIO
ADMIRABILIS. INGEÑII. PICTORI
AC. VETERIBUS. ILLIS
OMNIVM. IVDICIO. COMPARANDO.
DOMINICVS. CONTES. DISCIPVLVS
PRO. LABORIBVS. IN. SE. INSTITVENDO. SVSCEPTIS
GRATO. ANIMO. POSVIT
VIXIT. AN. XLII. OB. ANN. MDXXX*

After a long time, some citizens, who were wardens of
that church, through ignorance rather than from enmity
towards noble remembrances, angry because the tablet had
been put up without their leave, made arrangements for its
removal; and it has not yet been installed anywhere else. By
this, Fortune wished perhaps to show that the influence of
the Fates can be felt not only during one's life but also on
one's memorials after death. But despite them, the works
and fame of Andrea are sure to last a very long time, and
these my writings, I hope, will preserve their memory for
many centuries.

We may conclude, therefore, that although Andrea dis-
played poor spirit in the actions of his life, and contented
himself with very little, this does not mean that in the art of

* To Andrea del Sarto, painter of splendid skill, and in the judgement of
all a match for the great ones of old. His pupil Domenico Conti set this
memorial in gratitude for the work of his own instruction. He lived forty-
two years, and died in the year 1530.

painting he was not of exalted talent, and very prompt and practised in all his exertions; and with his works, besides the adornment they conferred on the places where they are, he did great service to his fellow craftsmen through their qualities of style, their draughtsmanship, and their colouring; and all with fewer errors than any other Florentine painter, since, as was said earlier, he understood very well the handling of light and shade, and how to make objects recede in the dark parts, and his pictures were painted with sweetness and vivacity; not to mention that he showed the way to work in fresco with perfect harmony of lights and colours, without much retouching *a secco*, which makes every work of his appear to have been executed in a single day. And because of this he can serve everywhere as an example to the craftsmen of Tuscany, and claim among their most celebrated and brilliant masters the highest praise and the palm of honour.

LIFE OF

GIOVANNI BATTISTA ROSSO

—— . ——

Florentine painter, 1494–1540

HIGHLY esteemed men, who devote themselves to the arts
and espouse them with all their strength, sometimes have
been excessively honoured and exalted before the whole
world, when it is least expected, as can clearly be seen from
the efforts that Rosso, a Florentine painter, put into the art
of painting. Although in Rome and in Florence his labours
were not pleasing enough to those who could reward them,
he did, however, find someone to give him recognition for
them in France, and with such results that the glory he won
could have quenched the thirst of every degree of ambition
that could fill the breast of any craftsman whatsoever. Nor
could he, in this existence, have obtained greater dignity,
honour or rank; since he was well regarded and much
esteemed above everyone else in his profession by a king
as great as that of France. And to be sure, the merits of
Rosso were such that if Fortune had procured less for him,
she would have done him great wrong. This was for the
reason that Rosso, apart from his painting, was endowed
with a very handsome presence; his way of speaking was
very gracious and grave, he was a very good musician, and
had a splendid grasp of philosophy; and what mattered
more than all his other excellent qualities was that he was
continually very poetic in his composition of figures, bold
and well-grounded in design, with charming style and
awesome flights of the imagination; and he was a splendid
composer of figures themselves. In architecture he was most
excellent and out of the ordinary, and, poor though he

might be, he was always rich in the grandeur of his mind. Therefore those who follow the course set by Rosso in the endeavours of painting will be continually celebrated, as are the works he himself produced, which are unequalled for their *bravura*, and executed without laboured effort, since he kept from them that listless overelaboration indulged in by innumerable artists to make their worthless works appear to be something.

In his youth, Rosso drew from the cartoon* of Michelangelo, and he was willing to practise painting with only a few masters, since he had certain opinions of his own which ran contrary to their style; and this may be seen from a tabernacle executed in fresco for Piero Bartoli at Marignolle, outside the San Piero Gattolini gate at Florence, containing a Dead Christ. For in this he began to show how much he desired to develop a style to marvel at, full of charm, and stronger and grander than that of the others.

While still a beardless youth, when Lorenzo Pucci was made a cardinal by Pope Leo, Rosso executed over the door of San Sebastian de' Servi the coat of arms of the Pucci family, with two figures, which astonished the craftsmen at that time, since they had not expected the result he achieved. And this heightened his ambition so much that, having made a picture of Our Lady, half-length, with the head of St John the Evangelist, for Maestro Jacopo, a Servite friar, who applied himself to poetry, at his persuasion, for the cloister of the Servites, alongside the scene of the Visitation, which was executed by Jacopo da Pontormo, he did a painting of the Assumption of Our Lady. In this he showed a Heaven full of angels, all in the form of little naked children dancing in a circle around Our Lady, foreshortened with beautifully flowing outlines as they wheel through the air in a most graceful way; and he painted this in such a manner that if his colouring had been done with the same mature

* The famous cartoon of the Battle of Cascina.

skill that he acquired with time, he would instead of equalling the other scenes with his grandeur and good design, by a long way have even surpassed them. He painted the Apostles much burdened with draperies, altogether in too much abundance, but their attitudes and some of their faces are more than beautiful.

The director of the hospital of Santa Maria Nuova commissioned from him a panel picture in which, when he saw it sketched out, as someone who little understood the art of painting, all the saints appeared to him like devils. For Rosso's custom in these oil sketches was to give certain faces an air of cruelty and despair, and then subsequently to soften their expressions and render them as they should be. So because of this, the director fled the house, refusing the panel picture, and complaining that he had been tricked.

In the same manner, over another door leading into the cloister of the convent of the Servites, Rosso painted the coat of arms of Pope Leo with two children, now destroyed. And in various citizens' homes may be seen several of his pictures and many portraits. For the visit of Pope Leo to Florence, he executed a most beautiful arch on the Canto de' Bischeri. Then, for the Lord of Piombino, he painted a panel with a Dead Christ, which was most beautiful, and also decorated a little chapel; and then again at Volterra he painted a very beautiful Deposition from the Cross.

Thereupon, having grown in fame and esteem, for Santo Spirito in Florence he executed the panel picture of the Dei family, which they had formerly commissioned from Raphael of Urbino, who abandoned it to look after the work he had undertaken in Rome. And he painted it with superb grace and design, and vivacity of colouring. And let no one imagine that any work could possess more force and look more beautiful from a distance than this picture, which on account of the *bravura* of the figures he painted, and the abstracted gaze of the figures, not then usual among painters, was held to be something astonishing and strange. Although it did not win him much praise at the time, subsequently,

little by little, people have come to recognize its excellence and given it splendid praise; for its blending of colours could not be bettered, seeing that the highlights, where the picture is brightest, along with the less bright areas, come to merge little by little so softly and harmoniously with the dark parts of the painting, with skilful handling of the shadows, that the figures stand over and against each other, one throwing the next into relief by means of chiaroscuro. And this work possesses so much vigour that it may be said to have been conceived and executed with more judgement and mastery than any other ever painted by any master, even one more judicious.

In San Lorenzo he painted for Carlo Ginori the panel picture of the marriage of Our Lady, which is held to be most beautiful. And indeed for facility in painting there has never been anyone who has been able to surpass him in skill or dexterity, or even come anywhere near him, since he was so soft in his colouring, and varied his draperies with such grace and took such delight in this craftsmanship, that he was held most praiseworthy and marvellous. Whoever studies this work of his carefully will know that all I have written is utterly true, when he considers the nudes which are very well conceived and executed with full attention to anatomy. The women are most graceful, and the arrangement of the draperies is truly capricious and bizarre. Likewise Rosso gave all due consideration both to the heads of the old men, with their bizarre looks, and to the women and little children, with their soft and pleasing airs. He was also so richly inventive that in his pictures he never left any space over, and he carried out everything with so much grace and facility that it was a marvel.

For Giovanni Bandini he also did a picture of some very beautiful nudes, in a scene of Moses slaying the Egyptian, which contained some praiseworthy things; and I believe that this was sent to France. He did another likewise for Giovanni Cavalcanti, which was sent to England, showing Jacob taking water to drink from the women at the spring,

which was regarded as inspired, as it contained male nudes and women executed with consummate grace, showing how, for women, he always loved to paint fine wisps of drapery, head-dresses with plaited hair, and finery for their clothing.

When he did this work, Rosso lived in the Borgo de' Tintori, whose rooms open on to the gardens of the friars of Santa Croce, and he took pleasure in a large Barbary ape, which had all the sense of a man rather than an animal; and on account of this, he cherished him and loved him like his own self; and since the ape possessed a marvellous intelligence he used him to perform many different services. Then it happened that the animal fell in love with one of Rosso's assistants, called Battistino, who was very handsome-looking, and he could guess everything that his dear Battistino wanted to tell him from the signs he made. Because of this, there being against the wall at the back of the rooms overlooking the friars' garden a vine that belonged to the guardian, laden with very plump Colombano grapes, the young man used to let the ape down from the window to the vine, which was at some distance, and then pull him back with his hands full of grapes. The guardian finding his vine stripped but not knowing by whom, suspecting it might be rats, lay there in wait; and having seen Rosso's ape climbing down, burning with anger he seized a pole and rushed at him with both hands raised to thrash him. The ape seeing that, if he climbed up, the guardian would nab him, and if he stayed put, the same, started to leap about and destroy the vine. And then, as if determined to throw himself bodily on to the friar, with both hands he grabbed hold of the outside bar round the trellis. Meanwhile, the friar thrust with his pole, and so the ape shook the vine in a panic so much and so forcefully that he wrenched the stakes and the canes from their holes in the ground, and the whole of the vine as well as the ape came crashing down on the friar; and so he howled for mercy, Battistino and the others pulled on the rope, and the

ape was brought safe and sound back into the room. Then the guardian ran off to find refuge on his own terrace, muttering imprecations you don't hear at Mass, and with evil intent stomped off to the Office of the Eight, the greatly feared magistrates in Florence.

After he had lodged his complaint, and Rosso had been summoned, for a joke the ape was condemned to have a weight strapped round his bottom, to stop him leaping on to vines, as he did before. So then Rosso fashioned a weight and shackles and secured the ape so that he could go about the house but not leap off elsewhere, as he did before. The ape, seeing himself condemned to be punished in this way, seemed to guess that the friar was the cause of this; and so every day he exercised himself in jumping step by step with his legs, holding the weight in his hands; and thus taking frequent rests, he achieved his purpose.

What happened was that one day, being let loose about the house, the ape, at a time when the guardian was singing vespers, gradually leaped from roof to roof till he came to the roof over his room; and there, letting fall the weight, for half an hour he enjoyed such a merry dance that not a single tile or gutter was left unbroken; and then he went home again. And three days later, when it rained, all the world could hear the guardian's lamentations.

Having finished all the works he was doing, with Battistino and the Barbary ape Rosso made his way to Rome where his works were in wild demand, since he had aroused great expectations through the sight of some of his drawings which were held to be marvellous, as he drew in a way that was truly inspired and very polished.

Here, above the paintings of Raphael in Santa Maria della Pace, he executed a work which was the worst he ever did in all his days; and I cannot imagine how that came about, unless it was because of something seen not only in him but in many others, which seems amazing and one of Nature's hidden secrets. This is that whenever someone changes his country or even his home, he seems also to change his very nature,

talents, behaviour, and personal habits, so that sometimes he seems not the same man but someone else altogether, and absolutely dazed and stupefied. And this is what could have happened to Rosso in the air of Rome, on account of both the stupendous things he saw there, in architecture and sculpture, and also the pictures and statues of Michelangelo which perhaps unbalanced him, and which also made Fra Bartolommeo of San Marco and Andrea del Sarto take to flight from Rome, before they did any work there.

So then, whatever the reason for it, Rosso never did anything worse; and, moreover, this work had to stand comparison with the works of Raphael of Urbino.

At this time, Rosso painted for his friend, Bishop Tornabuoni, a picture of a Dead Christ, held up by two angels, which now belongs to the heirs of Monsignor della Casa, and which proved a very beautiful enterprise. For Baviera he made drawings of all the Gods, for copper plates, which were then engraved by Jacopo Caraglio: one of Saturn changing himself into a horse, and notably one of Pluto raping Proserpine. He executed a sketch of the Beheading of John the Baptist, which is today in a little church on the Piazza de' Salviati in Rome.

Meanwhile, when the sack of Rome took place, poor Rosso was taken prisoner by the Germans and was treated very badly; for, as well as stripping off his clothes, they made him, in bare feet and with nothing to cover his head, carry heavy loads on his back and empty a cheesemonger's shop of almost its whole stock. Ill-treated by them in this way, he dragged himself to Perugia, where after being fondly welcomed and given new clothing by the painter, Domenico di Paris,* he drew for him a cartoon for a panel picture of the Magi, which is to be seen at his home, and is a very beautiful work. But he did not remain in that part of the world very long, for hearing that the Bishop Tornabuoni, who had also fled from the sack of Rome, had gone

* Domenico di Paride Alfano (c. 1480–1555), Perugian painter also mentioned in the *Life* of Perugino.

to Borgo San Sepolcro, he moved there too, as he was a close friend of his.

In Borgo San Sepolcro at that time was someone who had been a pupil of Giulio Romano, the painter Raffaello da Colle, who had undertaken to paint in his native city for a small price a panel picture for Santa Croce, seat of the Society of Flagellants, for which he lovingly gave up the commission in favour of Rosso, so that that city might retain some memorial of him; and though the Society resented this, the bishop gave Rosso many facilities. So when the picture, which brought him much credit, was finished, it was put in Santa Croce, because the Deposition from the Cross which it shows is something very rare and beautiful as Rosso had observed in his colouring a certain effect of darkness from the eclipse that took place on the death of Christ, and as it had been executed with tremendous diligence.

He was afterwards commissioned in Città di Castello to paint a panel picture on which he was about to begin working when, while he was priming it with gesso, a roof crashed down and completely shattered it; and as then Rosso developed such a raging fever that he was likely to die of it, he had himself carried from Castello to Borgo San Sepolcro. This illness was followed by the quartan fever, and so he then went for a change of air to Pieve Santo Stefano and finally to Arezzo, where he was taken into his home by Benedetto Spadari, who, using Giovann'Antonio Lappoli, of Arezzo, and all the friends and relations they had, managed things in such a manner that Rosso was commissioned to paint in fresco a vault, previously allocated to the painter Soggi, in the Madonna delle Lagrime; and to ensure that he should leave a memorial of himself in that city, they allotted him a payment of 300 crowns in gold. So Rosso began the cartoons in a room they had consigned to him in a place called Murello, and there he finished four of them.

In one of these, Rosso painted our first parents bound to the tree of original sin, with Our Lady removing from their

mouths their sin as represented by the apple, and treading
the serpent underfoot; and in the air (wanting to signify that
she was clothed with the sun and the moon) he painted
Phoebus and Diana in the nude. In the other, he painted
Moses bearing the Ark of the Covenant as represented by
Our Lady surrounded by five Virtues. And in another, he
showed the throne of Solomon, also represented by the
Madonna, to whom votive offerings are being offered, to
signify those who have recourse to her for favour, with
other bizarre ideas, which were devised by the fine mind of
Messer Giovanni Pollastra, a canon of Arezzo and friend of
Rosso, to gratify whom Rosso made a very beautiful *modello*
of the entire work, which is today in our home in Arezzo.

Rosso also drew a study of nude figures for that work,
which is a very rare thing, and it was a shame that it was
never finished, for if he had put it into execution and done
it in oils rather than in fresco as he had to, it would truly
have been a miracle. But he always hated to work in fresco,
and so he kept dragging out work on the cartoons, mean-
ing to have them finished by Raffaello dal Borgo and others,
so much so that they were never finished.

At that time also, being a courteous person he did many
drawings in Arezzo and neighbouring places for pictures
and buildings, including, for the rectors of the Fraternity,
one of the chapel which is at the foot of the piazza, where
the Holy Face of Christ is today; ★ and also for them he did
the design for a panel, which he was to paint himself to be
set in the same place, showing an image of Our Lady with a
multitude of people under her cloak. And this drawing,
which Rosso did not put into execution, is in our book
along with many other beautiful drawings from his hand.

But to return to the work which he was to do for the
Madonna delle Lagrime: there stood as surety for this work
his very faithful friend from Arezzo, Giovann'Antonio
Lappoli, whose loving kindness towards Rosso proved itself
in all kinds of willing services. But in the year 1530, as

★ Santo Volto is the customary name for ancient crucifixes at Lucca and
San Sepolcro.

Florence was being besieged, and as through Papo Altoviti's lack of prudence the Aretines had regained their liberty, they launched an attack on the citadel and razed it to the ground. And since the people of Arezzo bore ill-will towards the Florentines, Rosso would not trust himself to them but went off to Borgo San Sepolcro, leaving his cartoons and drawings for the work locked away in the citadel. Those at Città di Castello who had commissioned the panel picture from him wanted Rosso to finish it; but because of the ill-health he had experienced at Castello he would not return there, and so he finished their panel for them at Borgo San Sepolcro, nor would he ever give them the pleasure of seeing it. In this painting he represented a multitude of people and Christ in the air, being adored by four figures, and he also depicted Moors, gypsies, and the strangest things in the world; and, apart from the figures, which are good and perfect, the composition attends to everything other than what those who requested the picture from him had in mind. At the same time as he was engaged on this painting, he disinterred dead bodies in the Vescovado where he lived, and he did a very splendid anatomical model. And truly, Rosso was extremely studious with regard to the art of painting, and few days passed without his drawing a nude figure from life.

Now he had always fancied the idea of finishing his life in France and so of getting away, as he said, from a certain wretchedness and poverty which afflicts men who live in Tuscany or where they happen to be born; and he made up his mind to leave. And he had just learned the Latin language, in order to appear better versed in everything with all-round competence, when something occurred to make him greatly hasten his departure. For on a Maundy Thursday, when matins are said in the evening, a lad from Arezzo, Rosso's apprentice, being in church, during the proceedings of the so-called *tenebrae,** suddenly produced a

* The darkness created during the service at Easter-time by the gradual extinguishing of the candles, in commemoration of the death of Christ.

blaze of fire and flames with a lighted candle-end and a little
resin, upon which the boy was scolded and treated rather
roughly by some of the priests. Seeing this, Rosso, at whose
side the youngster was sitting, sprang to his feet and squared
up to one of the priests; and so there was a great uproar,
with no one knowing the reason why, and swords were
abruptly drawn against poor Rosso, who was hard at it
with the priests. Then he took to flight, regaining his rooms
very expeditiously without having been hurt or overtaken
by anyone.

But as he held himself to have been affronted by all this,
after he had finished the panel for Castello, without
worrying about the work at Arezzo, the damage he was
causing Gian Antonio, or his surety (for over 150 crowns),
he left by night and, taking the road by Pesaro, went off to
Venice. Here, being entertained by Messer Pietro Aretino,
on a sheet of paper he did a drawing for him, which was
subsequently engraved, of Mars asleep with Venus and of
the Cupids and the Graces despoiling him and playing tricks
with his cuirass.

After leaving Venice, Rosso went to France, where he
was welcomed very warmly by the Florentine community.
He painted some pictures which were later on placed in the
gallery at Fontainebleau; and these he gave to King Francis,
who took enormous pleasure in them, though much more
in the presence, the speech and the manner of Rosso, who
was of imposing build, with red hair, in conformity with
his name, and in all his actions grave, considerate, and very
judicious.

So then the king straight away ordered that he should
have an allowance of 400 crowns, and gave him a house in
Paris, where Rosso stayed very infrequently, so as to spend
most of the time at Fontainebleau where he had rooms and
lived like a lord; and then the king made him superintendent
of all the buildings, pictures, and other ornaments of that
place. There, first of all, Rosso began to construct a gallery
over the lower court, creating overhead not a vault but

rather a soffit or false ceiling of woodwork, very hand-
somely partitioned. The side-walls he decorated all over
with stuccoes with bizarre and fanciful partitions, and he
used several kinds of cornice with life-size figures carved on
the piers; everything below the cornices, between one pier
and the next, he adorned with very richly executed festoons
either of stucco or painted, with very lovely fruits and
foliage of all varieties. After this, in a large space, he caused
to be painted from his own design (if what I have heard is
true) about twenty-four scenes in fresco, representing, I
believe, the deeds of Alexander the Great; and for these, as I
said, he did all the designs, painting them with water-colours
in chiaroscuro.

At the two ends of this gallery are two oil paintings,
designed and painted by Rosso's hand, of such perfection
that little better can be seen in painting. One of them con-
tains a Bacchus and a Venus, executed with marvellous skill
and judgement. The Bacchus is a naked youth, so tender,
soft and delicate, that he truly seems to be made of flesh,
palpable and living rather than painted. And about him are
some vases painted in imitation of gold, silver, crystal, and
various precious stones, and surrounded by so many bizarre
and fanciful objects that whoever beholds this work, with
all its many inventions, stands stupefied before it. Among
other items, there also is a satyr raising the side of a tent,
whose head, with its strange goatish looks, is marvellously
curious, especially as it seems to be smiling and filled with
joy by the sight of so handsome a youth. There is also a boy
riding on a bear, very beautiful, with many other fine and
graceful ornaments round about. In the other painting are
Cupid and Venus with many other lovely figures. But the
figure on which Rosso worked most intently was the Cupid,
for he simulated a boy of twelve years, but well grown and
more mature in all his charms than expected at that age, and
very attractive in every part.

On seeing these works, which pleased him greatly, the
king came to regard Rosso with incredible affection, and so

no long time passed before he gave him a canonry in the Sainte Chapelle of Our Lady in Paris and so many other revenues and benefits that Rosso, with a good number of servants and horses, lived like a lord and laid on extraordinary receptions and banquets for all his friends and acquaintances, and especially for the Italians who arrived as strangers in those parts.

Rosso then did another hall, called the pavilion, because it is above the rooms on the first floor and so on top of all the others, and in the form of a pavilion. This room he decorated from the floor level up to the roof beams with a rich variety of stucco ornaments and figures in relief, distributed at regular intervals, with *putti*, festoons, and all kinds of animals (as well as a seated figure in fresco in each of the compartments on the walls). And their number is so great that among them are to be seen all the Gods and Goddesses of the ancient pagan world. Then at the end, over the windows, is a frieze all adorned with stuccoes, and very rich but with no pictures. Next, for all the many living rooms, bathrooms and other apartments, he completed innumerable other works, again in stucco and painting. Some copies exist that were published as engravings and are very beautiful and graceful, as are also the innumerable designs that Rosso made for salt-cellars, vases, shell-shaped bowls, and other fanciful things, all of which the king then had made in silver and which were so many in number that it would take too long to mention them all. Enough, therefore, to say that he produced designs for all the vessels of a sideboard for the king, and for all other items needed for the trappings of horses, for masquerades and triumphs, and everything imaginable, and with such strange and bizarre concepts that it is impossible to do better.

In the year 1540, when the Emperor Charles V went to France under the safe-conduct of King Francis, with no more than twelve men, Rosso executed at Fontainebleau half of all the adornments that the king commissioned to

honour this great emperor, while Francesco Primaticcio of Bologna executed the other half. But what Rosso did by way of arches, colossal figures, and similar things, were, so it was said at the time, the most stupendous that had ever been made by anyone till then. However, a large area of the rooms done by Rosso for the site at Fontainebleau have been destroyed, following his death, by this Francesco Primaticcio, who erected there a new and bigger building.

Those who worked with Rosso on these adornments in stucco and relief, and who were loved by him above all the others, were Lorenzo Naldino of Florence, Master Francesco of Orleans, Simone of Paris and Master Claudio, also a Parisian, Master Lorenzo Piccardo, and many others. But the best of all was Domenico del Barbiere, who is an outstanding painter and master of stucco, and an exceptional draughtsman, as is shown by his engraved works, which can be numbered among the best in general circulation.

Likewise the painters whom he made use of for these works of his at Fontainebleau were Luca Penni, brother of Giovanni Francesco Penni, called Il Fattore, who was a disciple of Raphael; Leonardo Fiammingo, a very able painter who executed the designs of Rosso in colours to perfection; the Florentine Bartolommeo Miniati; Francesco Caccianimici; and Giovan Battista of Bagnacavallo. And these last entered his service when, on the orders of the king, Francesco Primaticcio went to Rome to make moulds of the Laocoön, the Apollo and many other rare antiquities, for doing casts in bronze.

I shall stay silent about the woodcarvers, the master-joiners and no end of others, of whom Rosso made use in his works, because there is no need to discuss everyone, even though many of them produced very praiseworthy work.

With his own hand, in addition to the above, Rosso executed a St Michael, a rare work; and for the Constable he painted a panel of a Dead Christ, also something rare, which

is at one of the Constable's places, called Ecouen; and he also made some very choice miniatures for the king.

Rosso then drew a book of anatomical studies, which was to be printed in France, and there are some sheets of these from his hand in our book of drawings. There were also found among his belongings after his death two very beautiful cartoons, in one of which is a Leda, of singular beauty, and in the other the Tiburtine Sibyl, who is showing to the Emperor Augustus the glorious Virgin with Christ in her arms. And in this he drew King Francis and the queen, the guards and the people, with such a number of figures and so well executed that this can truly be said to be one of the loveliest things he ever did. Because of these works and many others we know nothing about, Rosso won such favour from the king that, a short while before his death, he found himself with an income of over a thousand crowns, without counting the allowances for his work, which were very substantial.

Living in the style no longer of a painter but of a prince, he kept very many servants and teams of horses, and he had his house furnished with tapestries and silver and other valuable furniture and fittings; and then Fortune, who very rarely if ever leaves anyone who trusts in her too much to continue riding high, brought him down in the strangest way in the world. For while Francesco di Pellegrino, of Florence, who delighted in painting and was very friendly with Rosso, was associating with him in very familiar terms, Rosso was robbed of some hundreds of ducats. Thereupon, suspecting no one else save this Francesco, Rosso had him apprehended, taken to court, and rigorously examined under severe torture. But Francesco, knowing he was innocent, and confessing nothing but the truth, was finally released; and then, moved by just anger, he was forced to show his resentment towards Rosso over the shameful charge which had been falsely levelled against him; so therefore, having issued him with a writ for libel, he pressed him so closely that Rosso, unable to defend or help himself, realized he was in dire

straits, perceiving that he had not only falsely shamed his friend but also stained his own honour, and to retract what he had said or embark on any other shameful course, would likewise proclaim him as a disloyal and evil man; so, having decided to kill himself, rather than be punished by others, he took that course.

One day, when the king found himself at Fontainebleau, Rosso sent a peasant to Paris for a certain most poisonous liquid, pretending it was to be used for making colours or varnishes, but with the intention of poisoning himself, as he did. The peasant duly returned with it to Rosso and then (such was the malignity of that poison) merely by holding his thumb over the mouth of the phial, though it was carefully stopped with wax, he came near to losing that digit, which was consumed and almost eaten away by the deadly potency of the poison. And a little later it did kill Rosso, who was in the best of health, who had drunk it so that it might rob him of his life, which within a few hours it did. The news was brought to the king and grieved him beyond measure, as it seemed to him that through the death of Rosso he had lost the most outstanding craftsman of the day.

But so that the work should not suffer, he had it continued by Francesco of Bologna, who, as said, had already produced many works for him, giving him a fine abbey, as he had conferred a canonry on Rosso.

Rosso died in the year 1541, leaving great regret among his friends and fellow craftsmen, who, through him, have learned how much may be acquired from a prince by one who has all-round competence and is well-mannered and gentle in all his actions, as he was; and for many reasons he has deserved and still deserves to be admired as indeed outstandingly excellent.

LIFE OF

FRANCESCO MAZZUOLI
(PARMIGIANINO)

——— · ———

Painter of Parma, 1503–1540

AMONG many people of Lombardy who have been
endowed with the graceful talent of design and with a cer-
tain liveliness of mind in invention and a particular style in
painting very beautiful landscapes, we would not rank lower
than anyone else, rather we would rank higher than all the
others, Francesco Mazzuoli of Parma, who was generously
endowed by Heaven with all the attributes required by a
painter of excellence. For he gave to his figures, in addition
to what has been said of many others, a certain loveliness,
sweetness, and charm in their attitudes which were par-
ticularly his own. Equally in the heads which he painted, it
can be seen that he possessed all the awareness that is needed;
and so much so that his style has been well observed and
imitated by innumerable painters, since he illuminated their
art with such grace that his works will always be highly
praised, and he himself held in honour, by all students of
design. And would to God that he had always pursued his
studies in painting, and not indulged in fantasies of soli-
difying quicksilver to make himself richer than he had been
created by Nature and Heaven! For then he would have
been without equal in painting, and truly unique. Whereas
by seeking for what he could never find, he wasted time,
scorned his art, and did harm to his own life and fame.

Francesco was born in Parma in the year 1504, and since
he lost his father when he was still a young child, he was put
in the care of his two uncles, his father's brothers, who were

both painters. And they brought him up very lovingly, teaching him all those praiseworthy ways that befit a law-abiding Christian man. After he had grown a little, no sooner had he a pen in his hand in order to learn to write than, at the prompting of Nature, who had created him for design, he started to produce some marvellous things, and when the master who was teaching him to write noticed these, and perceived what the boy's abilities could in time achieve, he persuaded his uncles to make him study design and painting. Thereupon, although they were old men and not well known as painters, possessing sound judgement in matters of their craft, and having recognized that God and Nature had been the youth's first masters, they did not fail most conscientiously to make him learn to draw under the instruction of outstanding masters, so that he should acquire a good style. And when, as matters progressed, they became convinced that he had, as it were, been born with paint brushes in his hand, so on the one hand they encouraged him, and on the other, for fear too much studying would damage his health, they sometimes restrained him.

But finally, having reached the age of sixteen, and after having wrought miracles in design, he painted a panel picture showing after his own fancy a St John baptizing Christ, which he executed in such a manner that anyone seeing it is amazed that so good a work could succeed so well coming from a young boy. This panel was placed in the Annunziata at Parma, the seat of Observant friars. Yet not content with this, Francesco wished also to prove himself in fresco and so he painted a chapel in San Giovanni Evangelista, a house of the Black Friars of St Benedict; and as he proved successful in this sort of work, he did as many as seven. At that time, however, Pope Leo X sent Signor Prospero Colonna with an army to Parma, and Francesco's uncles, fearing that he might lose time or be led astray, sent him, in company with his cousin, Girolamo Mazzuoli, also a boy painter, to Viadana, a place belonging to the Duke of Mantua; and there during their stay all the time that the war

lasted, Francesco painted two panels in tempera, one of which, showing St Francis receiving the stigmata, and St Clare, was placed in the church of the Observant friars, and the other, showing the Marriage of St Catherine and containing many figures, was placed in the church of San Piero. Nor does anyone believe that these are the works of a young beginner, but rather of an old master.

After the end of the war and Francesco's return, along with his cousin, to Parma, he first of all completed some paintings which he had left behind unfinished, which are in the hands of various people; and afterwards he did an oil painting of Our Lady with her Son in her arms, with St Jerome on one side and the Blessed Bernardino da Feltro on the other; and in the face of one of these figures he portrayed the patron of the picture so well that only breath was lacking. And all these works he executed before he was nineteen years old. After this, having formed the desire to visit Rome, since he was someone set on the path of progress who had heard the works of the great masters highly praised and especially those of Raphael and Michelangelo, Francesco expressed his desire and intention to his old uncles who, believing that his desire was nothing if not praiseworthy, said that they were quite agreeable but that it would be a good idea if he took along with him something by his own hand to serve to introduce him to the local gentry and to the craftsmen of his profession. This counsel was not displeasing to Francesco, and so he painted three pictures, two small and one quite large, depicting in the last Our Lady holding in her arms her Son who is taking some fruits from the lap of an angel, and an old man with his arms covered with hair, executed with skill and judgement, and charmingly coloured.

Moreover, in order to explore the finer points of painting, Francesco one day set himself to do his own portrait, looking at himself in one of those convex barbers' mirrors. And in doing this when he saw those bizarre effects made by the roundness of the mirror on the curve of the beams of

ceilings, causing them to twist, and on the doors and other parts of buildings, which recede in a strange way, he formed the wish to copy all of this just as he fancied. And so he had a ball of wood made by a turner and then divided it in half to make it the same shape and size as the mirror; and with tremendous skill he set himself to counterfeit on it all that he saw in the mirror, and particularly himself, with results so lifelike it could not be imagined or believed. And as all the things near to such a mirror are magnified, and all those away from it diminished in size, he showed a hand that is busy drawing, quite big, as the mirror reflected it, and so beautifully done it seemed absolutely real. And because Francesco had a very fine air about him, and a very gracious face and aspect, more like those of an angel than a man, his likeness on that ball was something divine rather than human. Indeed he succeeded so felicitously in all this work that what was real was no different from what was painted, with the latter showing the lustre of the glass, every reflection in detail, the shadows, and the lights so true and right that one could hope for nothing better from human ingenuity.

Having finished these works which were regarded not only by his old uncles as extraordinary but by many who well understood the art of painting as marvellous and stupendous, and having packed up the pictures and the portrait, accompanied by one of his uncles, Francesco made his way to Rome. And there, when the Datary had seen the pictures and assessed them at their true worth, the young man and his uncle were immediately introduced to Pope Clement, who, when he saw the works and the youthfulness of Francesco, was struck with astonishment, as was all the court along with him. And afterwards his Holiness, after doing him many favours, said that he wished to commission Francesco to paint the Hall of the Popes, where Giovanni da Udine had already done the stuccoes and the pictures for all the ceilings.

Having given his pictures to the Pope, and having

received various favours and gifts, as well as promises, stimu-
lated by the praise and glory he heard bestowed upon him,
and by the profit he could hope to earn from so great a
pope, he painted a very fine picture of the Circumcision.
And this was regarded as a work of rare invention on ac-
count of the three instances of his fantastically imaginative
use of lights in the picture; for the first figures were illuminated
by the blaze from the countenance of Christ, the second
were receiving light from some men bearing gifts to the
sacrifice, ascending some steps with burning torches in their
hands, while the last were revealed and illuminated by the
dawn, which showed a most entrancing landscape with
innumerable buildings. Then, having finished this picture,
Francesco gave it to the Pope, who did not, however, do
with it as he had done with the others.

For after having given the picture of Our Lady to Car-
dinal Ippolito de' Medici, his nephew, and the mirror-
portrait to Messer Pietro Aretino, the poet, who was in his
service, the picture of the Circumcision he kept for himself,
and it is surmised that in time it fell into the hands of the
Emperor. But the mirror-portrait I remember having seen,
being still a youth, in Arezzo at the home of Messer Pietro
Aretino, where strangers passing through the city would
come to see it for its rare quality. I do not know how, but
afterwards it fell into the hands of Valerio Vicentino, the
crystal-engraver, and it now belongs to Alessandro Vit-
toria, the sculptor in Venice, who is a pupil of Jacopo
Sansovino.

But to return to Francesco: while studying in Rome he
wanted to see all the ancient and modern works to be found
in that city, both in sculpture and in painting; but he held in
supreme veneration especially those of Michelangelo
Buonarroti and Raphael of Urbino; and indeed it was said
later that the spirit of Raphael had entered into the body of
Francesco, when that young man was seen to be as rare a
painter and as gentle and gracious in his ways as was Raph-
ael; and above all, when it was learned how greatly he

strove to imitate Raphael in everything, but most of all in painting. Nor was this study in vain, for the many little pictures which he executed in Rome, the greater part of which subsequently came into the hands of Cardinal Ippolito de' Medici, were truly marvellous; such, for example, is a most beautiful circular picture of the Annunciation which he did for Agnolo Cesis, and which is now kept in that family's house and honoured as a rare work. Likewise he did a picture of the Madonna with Christ, some little angels and a St Joseph, which are beautiful in the extreme for the air he gave to their faces, for the colouring, and for the evident grace and diligence with which they were painted. This work was formerly in the possession of Luigi Gaddi, and must now be with his heirs.

Lorenzo Cibo, commander of the Papal guard, and a very handsome man, coming to hear of his fame, had his portrait done by Francesco, who could be said not to have portrayed him but to have made him in the living flesh. Then for Madonna Maria Bufalini of Città di Castello, Francesco was commissioned to paint a panel picture intended to be placed in San Salvatore del Lauro, in a chapel near to the door; and in this he painted in the air the figure of Our Lady who is reading and has the Christ Child between her knees, while on the ground below he showed, kneeling on one knee, the figure of St John, who turns his body and points to Christ, in an extraordinarily beautiful attitude, and also here on earth the foreshortened figure of St Jerome in Penitence, lying asleep.

But he was prevented from bringing this work to full completion by the sack of Rome in 1527, which not only for a time caused the banishment of the arts but also the taking of the lives of many craftsmen; and Francesco himself came very near to losing his own life, because when the sack of Rome began he was so wrapped up in his work that even after the soldiers had started to penetrate the houses and there were already several Germans in his, despite all the uproar he remained intent on what he was doing. But when they

reached him and saw him at his work, they were thunder-
struck at the painting which they saw, and, like the gentle-
men they must have been, let him continue. And so while
the poor city of Rome was being devastated by the impious
cruelties of those barbarian troops, profane and sacred things
alike, with no respect to God or men, Francesco was
provided for and greatly honoured by those Germans, and
protected from all harm. The most disagreeable thing that
happened to him at that time was that as one of them was a
lover of things to do with paintings, he was forced to pro-
duce innumerable drawings in water-colours and with the
pen, which constituted the payment for ransom. But then,
when the soldiers changed quarters, he very nearly came off
badly; for when he was going in search of some friends of
his, he was taken prisoner by some other soldiers and he had
to pay over as ransom some few crowns that he possessed.
Thereupon his uncle, grieving over this and the way the
disaster had cut short Francesco's hopes of accumulating
knowledge, honour, and property, determined, seeing that
Rome was almost totally in ruins and the Pope a prisoner of
the Spaniards, to take him back to Parma. So he set Fran-
cesco on the way towards his native place, but himself
remained on for a few days in Rome, where he deposited
the panel picture made for Madonna Maria Bufalini with
the friars of the Pace; and it stayed in their refectory for
many years, till it was taken by Messer Guido Bufalini to
their family church in Città di Castello.

After he had arrived in Bologna, Francesco was enter-
tained by many of his friends and in particular in the home of
his very close friend, a saddler from Parma, and he stayed
living several months in Bologna, because he liked the ac-
commodation. During this time he had some works
engraved and printed in chiaroscuro, including one of the
Beheading of St Peter and St Paul, and a large figure of
Diogenes. He also prepared many others, to have them
engraved on copper and printed, having along with him for
this purpose a certain Master Antonio da Trento; but he did

not carry out this intention for the time being, because he had to set his hand to executing many pictures and other works for various gentlemen of Bologna. And the first picture of his to be seen in Bologna, in the chapel of the Monsignori in San Petronio, was a very large St Rocco, whom he painted with a most attractive air, and with all the parts of his body depicted as very beautiful, imagining him somewhat relieved from the pain caused him by the plague spot on his thigh, which he shows, and looking towards Heaven with upraised head in the act of thanking God, as good people do despite the adversities that come upon them. This work he did for a Fabrizio da Milano, of whom he painted a lifelike figure from the waist up and with hands clasped on the left hand of the picture; and equally natural is the dog in the painting, as are some beautiful landscapes, at which Francesco was particularly excellent. Then for Albio, a doctor of Parma, he painted a Conversion of St Paul, with many figures and an exceptionally fine landscape; and for his friend the saddler he did another picture of extraordinary loveliness, showing Our Lady, who is turning to one side in a beautiful attitude, and several other figures. He painted another picture for Count Giorgio Manzuoli, and two canvases in gouache, with some little figures which are all well done and graceful, for Luca dai Leuti.

At this time Antonio da Trento, mentioned earlier, who was with Francesco as an engraver, one morning when the latter was still in bed, broke open a strong-box and robbed him of all the copper engravings, woodcuts and other drawings that he had, decamped with the devil, and was never heard of again. However, Francesco did recover the prints, as the engraver had left them with a friend of his in Bologna, with a mind perhaps to returning for them when it was opportune; but he was never able to recover the drawings. So half in despair he turned to painting, making a portrait, for the sake of money, of some count or other of Bologna, and afterwards he did a picture of Our Lady with the Infant Christ holding a globe of the world. The

Madonna has a most beautiful expression and the Child is also very natural, for Francesco always used to impart to the faces of his little boys a truly childish liveliness which reveals the subtle and mischievous spirit which children very often have. He also attired Our Lady in extraordinary fashion, clothing her in a mantle with sleeves of yellowish gauze and seemingly striped with gold, which gave a truly most graceful effect, revealing the flesh in a realistic and most delicate manner.

Nor can one see anywhere hair painted in a more convincing way than it is done in this picture. It was produced for Messer Pietro Aretino, but as Pope Clement came to Bologna at this time, Francesco gave it to him. Then, in some way or another, it fell into the hands of Messer Dionigi Gianni, and today it is with Messer Bartolommeo his son, who has been so accommodating with it that (it is so highly prized) fifty copies have been made of it.

Francesco also, for the nuns of Santa Margherita in Bologna, painted a panel picture of Our Lady, St Margaret, St Petronius, St Jerome, and St Michael, held in utmost veneration, as it deserves, since in the expressions of the faces and all the other details it is on the same high level as all the other works of this painter. He also did many drawings, and particularly some for Girolamo del Lino, and for Girolamo Fagiuoli, a goldsmith and engraver, who sought them for engraving on copper; and these drawings are held to be very graceful indeed. He did his portrait from life for Bonifazio Gozzadino, and that of Bonifazio's wife, which remained unfinished. He also roughed out a picture of a Madonna which was then sold in Bologna to Giorgio Vasari of Arezzo, who keeps it in his newly built house in Arezzo, with many other noble pictures, sculptures and antique marbles.

When the Emperor Charles V was in Bologna to be crowned by Clement VII, Francesco, who would sometimes go along to see him at table, without drawing his living image, did a large oil painting of him, in which he depicted

Fame crowning him with laurel, and a boy in the form of a little Hercules offering him a globe of the world, as if to give him dominion over it. And when it was finished, he had this work shown to the Pope, who liked it so much that he sent it, along with Francesco, and accompanied by the bishop of Vaison, then the Datary, to the Emperor; and as it pleased the Emperor very much, he made it understood that it should be left with him; but Francesco, being badly advised by one of his untrustworthy or ignorant friends, saying that it was still unfinished, did not want to leave it; and so his Majesty did not keep it, and Francesco was not rewarded as he doubtless would have been. Having later come into the hands of Cardinal Ippolito de' Medici, this picture was given by him to the cardinal of Mantua; and it is now in the wardrobe of the duke of that city, with many other most noble and beautiful pictures.

After Francesco had been away from his own native place, as we have told, so many years, and had made himself greatly experienced in the art of painting, yet without having acquired any wealth, but just friends, he finally, to satisfy his many friends, and relations, went back to Parma. After his arrival, he was immediately commissioned to execute in fresco, in the church of Santa Maria della Steccata, a vault of some considerable size. But since in front of the main vault there was a flat arch which followed the same curve and acted as a sort of façade, he set to work first on the arch, as being easier to do, and painted on it six very beautiful figures, two coloured and four in chiaroscuro;★ and between one figure and the next he did some very fine ornaments, surrounding rosettes in relief, which on a whim he took it into his head to execute himself in copper, expending enormous labour on them. In the meantime, for the knight Baiardo, a gentleman of Parma and an intimate friend of his, he painted a Cupid who is making a bow with his own hand, and at his feet he depicted two *putti*, both

★ There were in fact five figures on each side, four of which may have been excluded by Vasari as painted by Parmigianino's assistants.

seated, one of whom is catching the other by his arm and laughingly urging him to touch Cupid with his finger, and the *putto* who does not want to do this is weeping, expressing his fear of burning himself at the fire of Love. This picture, which is charming in its colouring, ingenious in its invention, and graceful in its style, and has been and still is imitated and much studied both by the craftsmen and by those who delight in the art of painting, is today in the study of Marc' Antonio Cavalca, heir of the knight Baiardo, along with many drawings of every kind, which he has collected, from the hand of the same painter, and which are all very beautiful and well finished; as too are those by Francesco's hand on many sheets in our little book, particularly that of the Beheading of St Peter and St Paul of which, as was said, he published copper engravings and woodcuts while he was staying in Bologna. For the church of Santa Maria de' Servi, he painted a panel of Our Lady holding the Child asleep in her arms, with some angels at the side, one of whom has in his arms a crystal urn in which glitters the image of a cross, which Our Lady is contemplating. He left this work unfinished, since he was not very happy with it; none the less it is much praised, being in that style of his, full of grace and beauty.

Meanwhile, Francesco started to abandon the work for the Steccata, or at least to do it so slowly that it was realized that he went there dragging his feet; and this happened because he had started to study things to do with alchemy and altogether pushed aside those of painting, thinking he must soon make himself rich through solidifying mercury.

So racking his brains, but not to devise beautiful ideas for his paint brushes or the colours on his palette, he wasted all the day long rummaging about with charcoal, wood, glass bottles, and suchlike bagatelles, which made him spend more in one day than he earned from a week's work on the chapel of the Steccata. Having no other income, and yet still needing to live, he was consuming his substance little by little with these furnaces; and, what was worse, the men of

the Society of the Steccata, seeing that he had altogether abandoned the work, and having, as happens, perhaps paid him too much, brought a suit against him. So then, thinking it better to withdraw, he fled by night with some of his friends to Casal Maggiore; and there, putting alchemy out of his mind, for the church of Santo Stefano he did a panel picture of Our Lady in the air, with St John the Baptist and St Stephen below. And afterwards (this was his last painting ever) he did a picture of Lucrezia Borgia, which was truly inspired and among the best works from his hand, but however it may be, it has been purloined, and no one knows where it is.

Also from his hand is a picture of some nymphs, which is now in the house of Messer Niccolò Bufalini at Città di Castello and a child's cradle, which was made for Signora Angiola de' Rossi da Parma, wife of Signor Alessandro Vitelli, which is similarly at Città di Castello. Finally, still always obsessed by that alchemy of his, like all the others who have once lost their wits over it, and changing from a gentle and fastidious person into an almost savage man quite different from what he was, with a beard and long straggling locks, he was assailed, in this sorry state of melancholy and oddness, by a grave fever and cruel dysentery which in a few days made him pass to another life; and in this way he found an end to the travails of this world, which was never known to him save as a place full of trials and tribulations. He wished to be buried in the church of the Servite friars, called La Fontana, distant a mile from Casal Maggiore; and, as he had directed, he was buried naked with a cross of cypress upright on his breast. He ended the course of his life on 24 August 1540, to the great loss of the art of painting, because of the exceptional grace that his hands bestowed on the pictures he did.

Francesco took delight in playing the lute, and his hand and mind were so well accommodated to this, that he was no less excellent at it than he was at painting. But it is certainly true that if he had not worked capriciously and

had put aside the foolishness of the alchemists, he would truly have been one of the rarest and most outstanding painters of our age. I do not deny that to work when fired with enthusiasm, and when one wishes to, may be the best course; but I certainly blame anyone who is happy to work very little or not at all, and always wastes time on thinking up schemes, seeing that the wish to use trickery and so attain a goal one cannot achieve otherwise often causes one to lose what one knows in seeking what cannot be known.

Francesco had from nature a beautiful and gracious manner and a very lively mind, and if he had worked consistently every day he would have gradually become so proficient in the art of painting that, just as he gave beautiful and gracious expressions and great charm to the faces he painted, so he would have surpassed himself and the others in the perfection, the principles, and the excellence of his drawing.

He left behind his cousin, Girolamo Mazzuoli,* who to his great credit always imitated his style, as demonstrate the works from his hand in Parma, and also at Viadana where he fled with Francesco because of the war. There in San Francesco, a seat of the Observant friars, young man though he was, he painted a little panel picture of a most beautiful Annunciation, and he painted another for Santa Maria ne' Borghi. For the Conventual friars of St Francis in Parma, he did the panel for the high altar, containing Joachim being driven from the temple, with many figures. And in Sant' Alessandro, a convent of nuns in that city, he painted a panel picture of Our Lady in Heaven with the Christ Child holding out a palm to St Justina, and angels drawing aside a cloth, with St Alexander the Pope and St Benedict. In the church of the Carmelite friars, he did the panel for the high altar, which is very beautiful; and in San Sepolcro, he painted another very large panel picture. In San Giovanni Evangelista, the nuns' church in that city, there are two

* Girolamo Bedoli (c. 1500–69), called Mazzola, who in fact was married to Parmigianino's cousin.

panels from the hand of Girolamo, which are very beautiful, though not as much as the little doors of the organ or the panel of the high altar, with its Transfiguration, a very fine picture most diligently executed. The same Girolamo has painted a perspective view in fresco in the refectory of those nuns, and an oil painting of Christ's Last Supper with the Apostles, and fresco paintings in the chapel of the high altar in the Duomo. For Madama Margherita of Austria, Duchess of Parma, he has portrayed her son, Prince Don Alessandro, in full armour with his sword over a globe of the world, and a figure of Parma, also armed and kneeling before him.

In the chapel of the Steccata at Parma, he has painted in fresco the Apostles receiving the Holy Spirit, and in an arch similar to the one painted by his relation Francesco, he has depicted six Sibyls, two coloured and four in chiaroscuro, and in a niche opposite that arch he painted, but did not completely finish, the Birth of Christ, with the shepherds adoring Him, which is a very lovely picture. For the high altar of the Charterhouse outside Parma, he has painted the panel showing the three Magi, and in San Pietro, the abbey of the monks of St Bernard, a panel picture, and in the Duomo of Mantua another, at the cardinal's behest; and yet another panel for San Giovanni in the same city, showing Christ in glory and around Him the Apostles and St John, of whom he appears to be saying: *Sic eum volo manere . . .*,* and around this panel in six large pictures are the miracles of St John the Evangelist. In the church of the Observant friars, on the left, there is a large panel picture of the Conversion of St Paul, a very beautiful work, from the same hand; and in San Benedetto in Pollirone, a place twelve miles distant from Mantua, he has painted for the high altar a panel picture of Christ in the manger adored by shepherds, with the angels singing.

He has also painted, I do not know, however, exactly where, a most beautiful picture of five Cupids, one of whom

* So I wish him to remain . . . (John 21 : 22).

is sleeping while the others are despoiling him, one taking his bow, another the arrows, and the other his torch; and this picture belongs to the Lord Duke Ottaviano who holds it in great account because of the talent of Girolamo, who has not in the slightest degenerated compared with his kinsman Francesco as an excellent painter, courteous and gentle beyond all measure. And because he is still living, there are still to be seen coming from him other beautiful works, which he has constantly in hand. A great friend of this Francesco was Messer Vincenzio Caccianimici, a Bolognese gentleman, who painted and who strove to imitate, as best he could, the style of Francesco Mazzuoli himself. He was a very good colourist and so those things which he did for his own pleasure and to present to various lords and to his own friends, are truly very praiseworthy; but particularly a panel in oils, which is in his family chapel in San Petronio, showing the Beheading of St John the Baptist. This talented gentleman died in the year 1542, and there are some very fine drawings by his hand in our book.

LIFE OF

JACOPO PALMA AND
LORENZO LOTTO

—— · ——

Venetian painters, c.1480–1528 and c.1480–1556

So effective are technical skill and particular excellence, when seen even in merely one or two works perfected in the particular art a man practises, however small these may be, that craftsmen and connoisseurs are bound to praise them, and writers to celebrate and commend the craftsmen who made them, in the manner we are now doing for the Venetian, Palma. Although he was not outstanding or rare in the perfection of his painting, he was none the less so polished and diligent in the art, and so submissive in its service, that at least a proportion of his works, if not all, achieve a particular excellence, because they are close imitations of life, and of man's natural appearance. Palma stood out much more for his patience in harmonizing and graduating colours than for boldness of design, and he employed them with exquisite polish and grace, as is to be seen in Venice in many pictures and portraits which he made for various gentlemen. But I shall not say anything else about these, since I will let it be enough to mention some altarpieces and a head, which we hold to be truly inspired and wonderful. One of the altarpieces he painted in Sant'Antonio, at Venice, near to Castello, and the other for Sant'Elena, near the Lido, where the monks of Monte Oliveto have their monastery. In this panel, which is on the high altar of the church, he painted the Magi presenting their offerings to Christ, with a fair number of figures some of whose heads are truly praiseworthy, as are the

draperies, executed with beautifully flowing folds, which clothe them.

In the church of Santa Maria Formosa, for the altar of the Bombardieri, Palma also painted a life-size figure of St Barbara, with two smaller figures at the sides, namely St Sebastian and St Anthony; and the St Barbara is one of the best figures that this painter ever did. Again, for the church of San Moisè, near the piazza of San Marco, he executed another panel, showing Our Lady in the air, and St John below.

As well as this, for the room on the piazza of SS. Giovanni e Paolo where the men of the Scuola of San Marco have their meeting place, to rival those already produced by Giovanni Bellini, Giovanni Mansueti, and other painters, Palma executed a most beautiful scene, depicting a ship carrying the body of St Mark to Venice. And in this picture we see how Palma simulated a most horrifying tempest at sea and some boats battered by the fury of the winds, executed with great judgement and fine attention to detail; as indeed is also a group of figures painted in the air, and demons of diverse forms, who are blowing like winds upon the boats, which, driven by oars and striving in various ways to clear their way through the high and hostile waves, are on the verge of sinking. In short, to tell the truth, such is this work and so fine in invention and other qualities that it seems almost impossible for colours or brushes, even in the hands of the outstanding masters, to be able to express anything more realistic or natural. For it shows us the fury of the winds, the strength and dexterity of the men, the surge of the waves, the flashes of lightning in the sky, the water broken by oars, and the oars bent by the waves, and by the force exerted by the rowers. Need more be said? As for myself, I do not recall ever having seen a more horrendous scene than the one in the picture which is so well executed, and with such attention paid to design, invention, and colouring that the panel seems to shake, as if everything painted on it were real. For this work Jacopo Palma deserves to be given the

highest praise, and to be numbered among those who domi-
nate the art of painting and possess the ability to express all
their challenging concepts in paintings. This is because in
challenging subjects of this kind, many painters, as if guided
by a certain fury of inspiration, in the first rough sketching
of their work achieve some particular excellence and
boldness, which then disappears in the finishing, along with
all the excellence derived from the fire of inspiration. And
this happens because very often someone finishing a picture
concentrates on the details and not the whole of what he is
doing, and (as his ardour cools) then loses his streak of
boldness; whereas Jacopo always held steadfast to his first
purpose and fully expressed the concept he first had in mind,
which won him infinite praise at the time, and always will.

But without doubt, however many and however highly
esteemed the works of Palma may be, the best of all, and
surely most stunning, is the self-portrait he did by looking
in a mirror, of himself draped in camel skins, with tufts of
fur, giving such a vivid impression that nothing better can
be imagined. For Palma was so powerfully inspired to do
this particular painting, that he made it a miracle of extra-
ordinary beauty, as everyone affirms, since it is seen almost
every year at the festival of the Ascension. And it truly
deserves to be celebrated for its design, craftsmanship, and
colouring, and in sum for being altogether perfect, beyond
any other work that had been executed by a Venetian painter
up to that time; for apart from everything else, there is seen
in the picture a look in the eyes so expressed that Leonardo
da Vinci or Michelangelo would not have effected it other-
wise. But it is better to stay silent about the grace, the
gravity, and the other qualities to be seen in that portrait,
because one cannot say enough about its perfection to ex-
haust its merits. And if Fate had wished that Palma should
die after executing this work, he himself would have
carried off the glory of having surpassed all those whom we
celebrate as rare and inspired intellects, whereas the long
duration of his life, which kept him working all the while,

brought it about that, not maintaining the good beginning he had made, he came to deteriorate just as much as people without number had thought he must improve.

Finally, content enough that one or two perfect works should to some extent have freed him from the censure he risked because of the others, he died at the age of forty-eight, in Venice.

A friend and companion of Palma was Lorenzo Lotto, a Venetian painter, who having for a while imitated the style of Bellini, then began to follow that of Giorgione, as is demonstrated by certain pictures and portraits in various gentlemen's houses in Venice. In the house of Andrea Odoni is the latter's portrait, which is very handsome, by the hand of Lorenzo, and in the house of Tommaso da Empoli, a Florentine, there is a picture of the Birth of Christ, painted to give the effect of night, which is very beautiful, especially because in a very lovely way it shows Christ's radiance illuminating the picture, in which Our Lady is kneeling, and where a full-length figure, adoring Christ, is a portrait of Messer Marco Loredano. The same painter executed for the Carmelite friars a panel picture of St Nicholas in epi-scopal robes, suspended in the air, with three angels; St Lucy and St John are shown below, some clouds on high, and beneath these a very beautiful landscape with many little figures and animals in various places. And on one side is St George on horseback, slaying the dragon, and at a little distance the damsel, with a city nearby and an arm of the sea. In S S. Giovanni e Paolo, in the chapel of St Antoninus, archbishop of Florence, Lorenzo did a panel picture of that first saint seated, with two priests serving him, and many people below.

While this painter was still young, and imitating partly the style of Bellini and partly that of Giorgione, in the church of San Domenico at Recanati he painted the panel for the high altar, which contained six pictures. In the middle is Our Lady with her Son in her arms, giving the habit, by the hands of an angel, to St Dominic, who is kneeling in

front of the Virgin; and in this picture there are two *putti*, one playing a lute and the other a little rebeck. Next in another picture are the Popes St Gregory and St Urban. And in the third picture are St Thomas Aquinas and another saint, who was bishop of Recanati.* Above these pictures are the other three: in the middle, over the Madonna, is a Dead Christ supported by an angel, with his Mother, kissing his arm, and a St Magdalen. Above the painting of St Gregory are St Mary Magdalen and St Vincent; and in the next, over St Thomas Aquinas, are St Gismondo and St Catherine of Siena. The predella, a rare work with little figures, has a picture in the middle of the Holy House of Mary being carried by the angels from the region of Slavonia to its present site. Of the two scenes placed either side, one shows St Dominic preaching, and has the most graceful little figures in the world; and the other shows Pope Honorius who is confirming the Rule of St Dominic. From the hand of the same painter, there is in the middle of this church a fresco picture of St Vincent, the friar; and in the church of Santa Maria di Castelnuovo there is a panel picture in oils showing the Transfiguration of Christ, with three scenes containing little figures in the predella: Christ leading the Apostles to Mount Tabor, praying in the Garden, and then ascending to Heaven.

After doing these works, Lorenzo went to Ancona, just when Mariano da Perugia had finished for the high altar in Sant'Agostino a panel picture with a large frame, which did not come up to satisfaction, and he was commissioned to paint a panel picture, which is placed in the middle of the same church, showing Our Lady with her Son in her arms, and two figures of angels in the air, foreshortened, who are crowning the Virgin. Finally, being an old man and having almost lost his voice, after having done some other work of little importance in Ancona, Lorenzo went off to the church of the Madonna at Loreto, where he had already painted a

* St Facianus.

panel in oils, which is in a chapel on the right, after the entrance. And here, being resolved to end his days in the service of the Madonna and to live in that Holy House himself, he set his hand to painting scenes of figures, two feet or less in height, around the choir, over the priests' stalls. He painted in one scene Jesus Christ being born, and in another the Magi adoring him; the presentation to Simeon followed on, and after this Christ being baptized by John in the Jordan with, in addition, the woman caught in adultery being led before Christ, all gracefully executed. He painted there two more such scenes, filled with figures; one showed David having a sacrifice offered, and the other St Michael the Archangel in combat with Lucifer, after having driven him from Heaven. When these were finished, not long passed when, just as he had lived like a good, decent Christian, so too he died, rendering up his soul to the Lord God. And these last years of his life proved very happy for him and full of tranquillity of mind; and moreover, as is believed to be true, they prepared him for the benefits of the life to come, which would perhaps not have happened if at the end of his life he had been unduly wrapped up in the things of this world which, weighing too heavily on those who make them their object in life, prevent them from ever raising their minds to the true benefits of the next life, and its supreme blessedness and happiness.

There also flourished in Romagna at this time Rondinelli, an excellent painter, of whom I made some remembrance in the *Life* of Giovanni Bellini, since he had been his disciple and assisted him greatly in his works. Rondinelli, then, after he left Giovanni Bellini, laboured at the art of painting in such manner that, as he was very diligent, he produced many praiseworthy works, as witness in the Duomo at Forlì the panel picture of the high altar, painted with his own hand, showing Christ giving communion to the Apostles, which is very well executed. In the lunette above this he painted a Dead Christ, and in the predella some scenes with little figures, with the deeds of St Helena, mother

of the Emperor Constantine, when she found the Cross,
executed with great diligence. He also painted there a St
Sebastian, a very beautiful single figure in a picture in the
same church. For the altar of St Mary Magdalen in the
Duomo at Ravenna, he painted a panel in oils containing
the single figure of this saint, and below in the predella
using little figures, he painted three very graceful scenes:
Christ appearing to Mary Magdalen in the form of a gar-
dener, and in another St Peter leaving his boat to walk on
the water towards Christ; and in the middle of these, the
baptism of Jesus Christ, and all very beautiful.

In the same city, for San Giovanni Evangelista he did two
panels; one shows St John consecrating the church, and in
the other are three martyrs, St Cantius, St Cantianus, and St
Cantianilla, most beautiful figures; and in the same city
again, in Sant'Apollinare, are two highly praised pictures
with two figures, one in each of them, namely St John
the Baptist and St Sebastian. In the church of the Spirito
Santo, there is a panel picture which also comes from his
hand showing Our Lady with St Catherine, Virgin and
Martyr, on one side and St Jerome on the other. Similarly
he painted two pictures in San Francesco; in one of them are
St Catherine and St Francis, and in the other he depicted
Our Lady with many figures, and St James the Apostle and
St Francis. He also did two other panels for San Domenico,
one on the left of the high altar, showing Our Lady with
many figures, while the other, which is very beautiful, is on
one of the walls of the church. In the church of San Niccolò,
a convent of the Augustinian friars, he painted another panel
with St Lawrence and St Francis; and these works were so
remarked on, that, as long as he lived, he was held in great
account not only in Ravenna but throughout the Romagna.
Rondinelli lived till the age of sixty, and he was buried in
San Francesco at Ravenna.

This craftsman left behind him Francesco da Cotignola,★
a painter who was also highly esteemed in that city. He

★ Francesco da Cotignola (d. 1532).

painted many works and particularly, in the church of the
abbey of Classe in Ravenna, a very big panel picture for the
high altar showing the raising of Lazarus, with many figures.
Consequently in the year 1548, for Don Romualdo of
Verona, the abbot of that place, Giorgio Vasari executed
opposite this another panel picture showing the Deposition
of Christ from the Cross, with a large number of figures.
Francesco also did a panel in San Niccolò with the birth of
Christ, a very large picture; and likewise two panels with
various figures in San Sebastiano; while in the hospital of
Santa Caterina he painted a panel showing Our Lady and St
Catherine, with many other figures, and in Sant'Agata he
painted a panel with Christ on the Cross, and Our Lady at
His feet, also with many other figures, for which he won
praise. For Sant'Apollinare, in the same city, he painted
three panels, one on the high altar, showing Our Lady, St
John the Baptist, and St Apollinaris, with St Jerome and
other saints; while in the other he showed Our Lady with St
Peter and St Catherine, and in the third and last Jesus Christ
carrying the Cross, which he was unable to finish because
death intervened. He was a very charming colourist, but he
was not as good a draughtsman as Rondinello, though he
was held in great account by the people of Ravenna. This
painter wished to be buried after his death in Sant'Apol-
linare, where he had executed all those figures, being content
that his bones should rest in the place where he had laboured
when living.

LIFE OF

GIULIO ROMANO

Painter, 1492 or 1499–1546

AMONG the many, indeed innumerable disciples of Raphael
of Urbino, of whom the greater part proved themselves
very able, there was no one who imitated him more in
style, invention, design, and colouring than Giulio Romano,
nor anyone among them who was better grounded, bolder,
sounder, more fanciful, varied, prolific, and versatile than
him; not to mention for the present that he was most
charming in conversation, obliging, affable, gracious, and
altogether perfect in manner and conduct. Because of these
attributes, he was so loved by Raphael that if he had been
his son, he could not have loved him more; and therefore he
always made use of his services in his most important works,
and particularly in executing the Papal loggias for Leo X.
For after Raphael himself had done the drawings for the
architecture, the ornaments, and the scenes, he caused Giulio
to execute many of the pictures there, including the creation
of Adam and Eve, and that of the animals, the building of
Noah's ark, the sacrifice, and many other works re-
cognizable by the style, such as the painting in which
Pharaoh's daughter and her maids find Moses in the little
basket thrown into the river by the Hebrews: a work that is
marvellous for its very well-executed landscape. He also
helped Raphael to colour many works in the apartment in
the Borgia Tower which contains the burning of the Borgo,
and particularly the bronze-coloured base, with the
Countess Matilda, King Pepin, Charlemagne, Godfrey of
Bouillon, King of Jerusalem, and other benefactors of the

church, all the figures being very good indeed. And not long ago prints were published of part of this scene, taken from a drawing by the hand of Giulio himself. He also executed the greater part of the scenes in fresco in the loggia of Agostino Chigi; he worked in oils on a very beautiful picture of St Elizabeth, which was painted by Raphael and sent to King Francis of France, together with another picture of St Margaret, executed almost entirely by Giulio following the design of Raphael, who sent to the same king the portrait of the wife of the Viceroy of Naples, of which Raphael did only the drawing of the head, from life, while the remainder was finished by Giulio. These works, which were very pleasing to the king, are still in France, in the chapel of the king at Fontailebleau.

So exerting himself in this manner in the service of his master, Raphael, and learning about the greatest difficulties of the art of painting, which by Raphael himself were taught to him with incredible kindliness, it was not long before he knew extremely well how to draw in perspective, to measure buildings, and to draw up plans; and when sometimes Raphael designed and sketched inventions of his own devising, he would then have measured drawings of them done by Giulio on a larger scale for use in his works of architecture. After this pleasurable start, Giulio applied himself to architecture so well that when he came to practise it, he proved a very outstanding master. When Raphael died, leaving Giulio and Giovanni Francesco, called Il Fattore, as his heirs, with the charge of finishing the works started by Raphael himself, they brought the greater part of them to completion with honour.

Now Cardinal Giulio de' Medici, who was afterwards Clement VII, took a site in Rome under Monte Mario where, as well as a beautiful view, there were springs, with some gently sloping woodlands, and a beautiful plain which, running alongside the Tiber as far as the Ponte Molle, formed on one side and the other an expanse of meadowland which extended as far as the Porta di San Pietro, and on the

top of the slope, on the same level ground, he then planned
to build a palace with all the comforts and conveniences of
apartments, loggias, gardens, fountains, woods, and so
forth, the best and most beautiful that could be desired; and
in charge of everything he appointed Giulio, who having
willingly accepted this task and set his hand to it, brought
that palace, which was then called the Vigna de' Medici,
and now the Villa Madama, to the perfection that will be
described below. Accommodating himself to the nature of the
site and the wishes of the cardinal, he made the façade to the
front of the palace in the form of a semicircle, like a theatre,
with a range of niches and windows of the Ionic order,
which was so highly praised, that many people believe that
Raphael did the first sketch for it, and that subsequently the
work was pursued and carried to completion by Giulio.
And Giulio executed many pictures in the living rooms and
elsewhere; and particularly beyond the first vestibule in a
very fine loggia, adorned all round with niches large and
small, in which is a great quantity of ancient statues, in-
cluding one of Jove, a rare work, which was subsequently
sent by the Farnese family to King Francis of France, with
many other beautiful statues. And as well as these niches,
this loggia is all wrought with stuccoes, and the walls and
ceilings painted all over with grotesques from the hand of
Giovanni da Udine.

At the head of this loggia, Giulio painted in fresco a huge
Polyphemus with innumerable children and little satyrs
playing round him, for which he won great praise, as he did
also for all the works and designs he executed for that place,
which he adorned with fish ponds, pavements, rustic
fountains, little woods, and so forth, all most beautiful and
created with fine order and judgement. It is, of course, true
that, with the occurrence of the death of Leo, for the time
being the work was pursued no further, because Adrian was
created the new pontiff and the Cardinal de' Medici returned
to Florence, and so with this work all the public works
started by the Pope's predecessor were held back.

In the meantime, Giulio and Giovanni Francesco brought to completion many of the works of Raphael which had remained unfinished, and they were preparing to carry into execution some of the cartoons that he had made for the paintings in the great hall of the palace, in which Raphael had begun to paint four scenes from the life of the Emperor Constantine, and had, when he died, already covered one wall with the right mixture of undercoat for working with oils, when they became aware that Adrian, as a man who took pleasure neither in pictures nor sculptures nor any other good thing, did not care for the hall to be finished. In despair, therefore, Giulio and Giovanni Francesco, and along with them Perino del Vaga, Giovanni da Udine, Sebastiano Veneziano and the other excellent craftsmen, came near, while Adrian was alive, to dying of hunger. But, by the will of God, while the court, so used to the grand gestures of Leo, was plunged into gloom, and all the best artists were wondering where to flee, since they saw that talent was no longer esteemed, Adrian died, and as Supreme Pontiff there was elected Giulio de' Medici, who took the name Clement VII, with whom in one day all the arts of design, along with all the other virtuous skills, were restored to life. And then Giulio and Giovanni Francesco, by order of the Pope, at once cheerfully set themselves to finish the above-mentioned Hall of Constantine; and they scraped from one wall the preparation laid on it for painting in oils, leaving as they were, however, two figures they had previously painted in oils, serving as ornaments for the figures of certain popes; and these were Justice and another similar figure.

The arrangement of the hall, because it is low, had been designed with careful judgement by Raphael, who had placed at the corners, over all the doors, some large niches adorned with *putti* holding various devices of Leo, such as lilies, diamonds, plumes, and other devices of the House of Medici, and within the niches were seated several popes in pontifical robes, each under his own panoply inside the niche; and around these popes were several *putti* like little

angels who were holding books and other appropriate
objects in their hands; and each pope was framed by two
Virtues, one on either side of him, related to his chief merits.
Just as the Apostle Peter had Religion on one side, and
Charity or Piety on the other, so all the others had com-
parable Virtues; and the popes in question were Damasus I,
Alexander I, Leo III, Gregory, Sylvester, and some others,
all of whom were so well positioned and brought to com-
pletion by Giulio, who did the best things in this work in
fresco, that he evidently worked on them very hard and
diligently, as can be seen in a St Sylvester on a sheet of
paper, which was very well drawn by him and perhaps
possesses more grace than the painting of that saint. Indeed
it can be affirmed that Giulio always expressed his concepts
better in drawings than in his finished works or paintings,
since in the former we see more vivacity, boldness, and
emotion; and this could perhaps be so because he boldly
dashed off a drawing in an hour in the heat of working,
whereas over a painting he consumed months and even
years. Thus growing weary of them, and losing that intense
and ardent love one has at the start of anything, no wonder
that he did not give them the utter perfection we see in his
drawings.

But to return to his scenes: Giulio painted on one of the
walls Constantine making an address to his soldiers, while in
the air there appears a radiant Sign of the Cross, with some
putti and letters which read: IN HOC SIGNO VINCES.*
And there is a dwarf at the feet of Constantine, putting a
helmet on his head, who is executed with great skill. Then,
on the main wall, there is a battle of horsemen which took
place near Ponte Molle, in which Constantine routed
Maxentius. And this work is most praiseworthy, when one
considers the figures of the wounded and the dead, and the
varied and extraordinary attitudes of the foot soldiers and
horsemen who are fighting in groups, all executed so boldly;
not to mention the many portraits from life. And if this

* In this sign you will conquer.

scene were not too much tinged and scored with blacks, which Giulio always loved to use when colouring, it would be utterly perfect; but this takes away a great deal of its grace and beauty. In the same scene he depicted the whole landscape of Monte Mario, and the river Tiber in which Maxentius on horseback, all proud and terrible, is drowning. In sum, in this work Giulio acquitted himself in such a manner that it has been like a beacon for all those who following him have since then painted scenes of that sort. And he himself learned so much from the ancient columns of Trajan and Antoninus that are in Rome, that he availed himself of this knowledge a great deal in the attire of the soldiers, the armour, ensigns, bastions, palisades, battering rams, and in all the other accoutrements of war depicted throughout that hall. And underneath these scenes, the whole way round, he painted many objects in the colour of bronze, all of them very beautiful and praiseworthy. On the other wall, Giulio did St Sylvester the Pope baptizing Constantine, and he represented the very bath made by Constantine himself, which is today at St John Lateran; he also did a portrait from life of Pope Clement in the figure of Pope Sylvester who is baptizing, with some assistants in vestments and many people. Among many of the Pope's household whom he also painted there from life are portrayed Cavalierino, who was then a close adviser to his Holiness, and Messer Niccolò Vespucci, a knight of Rhodes. And below this, on the base, in figures the colour of bronze, he painted Constantine having the church of St Peter's built in Rome, an allusion to Pope Clement; and also in these figures he did portraits of the architect Bramante and of Giuliano Leno, holding in his hand the drawing of the ground-plan of the church, in a very beautiful scene.

On the fourth wall, above the fireplace of the hall, he represented in perspective the church of St Peter's in Rome, with the Pope's throne in the manner in which it appears when the Pope chants a pontifical Mass; the body of

cardinals and other prelates of the entire Papal court; the chapel's singers and musicians; and the Pope seated, representing St Sylvester with Constantine kneeling at his feet, presenting him with a figure of Rome made of gold like those on the ancient medals, by which Giulio wished to signify the dowry given by Constantine to the Roman Church. In this scene, Giulio also painted many very beautiful women who are kneeling expectantly to see the ceremony; a poor man asking for alms; a boy amusing himself riding on a dog; and the lancers of the Papal guard, who are making the people give way and move back, as is the custom. And among the many portraits that are in this work, there is one from life of the painter Giulio himself; and of Count Baldesar Castiglione, author of *The Courtier* and his dear friend; of Pontano and Marullo; and of many other men of letters and courtiers. All around and between the windows Giulio painted many devices and mythological scenes which were fanciful and charming; and everything greatly pleased the Pope, who rewarded Giulio generously for his labours.

While this hall was being painted, though not able to satisfy their friends even in part, Giulio and Giovanni Francesco painted a panel picture of the Assumption of Our Lady which was very lovely and which was sent to Perugia and placed in the convent of the nuns of Monteluce; and afterwards Giulio, withdrawing to work on his own, did a picture of Our Lady with a cat that was so natural that it seemed really alive, and so it was called the Picture of the Cat. In another large picture he showed Christ being scourged at the column, and this was placed over the high altar of the church of Santa Prassede in Rome. Not long after this, Messer Matteo Giberti, who was then Datary to Pope Clement and later became bishop of Verona, commissioned Giulio, who was his very close friend, to do the design for some brick-built rooms near the gate of the Papal palace looking out over the piazza of St Peter's where the trumpeters stay who play when the cardinals go into con-

sistory, with a most commodious flight of steps which can be ascended on horseback as well as on foot. For the same Messer Giovan Matteo he painted a panel picture of the Stoning of St Stephen, which Giovan Matteo sent to a benefice of his own, in Genoa, called St Stephen. This panel, which is most beautiful in invention, grace, and composition, shows the young Paul sitting nearby on the garments of St Stephen, while the Jews are stoning him. In short, Giulio never produced a more beautiful work than this, so fierce are the attitudes of those doing the stoning and so finely expressed the patience of Stephen, who seems to be truly seeing Jesus Christ seated on the right hand of the Father in a Heaven painted in an inspired manner. This work, together with the benefice, Messer Giovan Matteo presented to the monks of Monte Oliveto, who have turned the place into a monastery.

Giulio also executed for the German Jacopo Fugger, for a chapel which is in Santa Maria dell'Anima in Rome, a very fine panel in oils, in which are Our Lady, St Anne, St Joseph, St James, St John as a little boy, with the kneeling figure of St Mark the Evangelist, who has at his feet a lion, recumbent and with a book, whose coat twists and turns with its posture: a difficult and beautifully considered effect. Moreover, this same lion has on its shoulders a pair of wings whose feathers are so soft and downy that it seems incredible that Nature could be so imitated by the hand of a craftsman. He also included a building curving round like an amphitheatre, with statues so beautiful and well arranged that nothing better could be seen; and among the other figures, there is a woman who, as she is spinning, keeps an eye on her hen and its chicks, and nothing could seem more natural. And then above Our Lady are some *putti*, very well executed and graceful, who are holding up a canopy; and if this picture, too, had not been so heavily tinged with black, making it very dark, it would have been much better. But the blackness has caused the loss or ruin of the greater part of the work put into it; and this is because black, even if

varnished, ruins what is good, as it always has an arid effect whether it is charcoal, ivory-black, smoke-black or burnt paper.

Among Giulio's many disciples when he was engaged on these projects, such as Bartolommeo da Castiglioni, Tommaso Paparello of Cortona, and Benedetto Pagni from Pescia, those of whom he made the closest use were Giovanni dal Lione and Raffaello dal Colle of Borgo San Sepolcro, both of whom had helped to execute many works in the Hall of Constantine, and for the other projects which we have discussed. So I should not fail to mention that these two, who were very dexterous in painting and close followers of Giulio's style in executing what he designed for them, using his design, painted in colours near the old Mint in the Banchi the coat of arms of Pope Clement VII, each doing a half, with two terminal figures, one on each side of the arms. And the same Raffaello not long afterwards, using a cartoon drawn by Giulio, painted in fresco on a lunette inside the door of the palace of Cardinal della Valle a Madonna who is covering a Child, who is sleeping, with a cloth, and has St Andrew the Apostle on one side and St Nicholas on the other, and this was justifiably held to be outstanding.

Giulio, meanwhile, being very intimate with Messer Baldassare Turini of Pescia, having made the design and the model, built for him on the Janiculum hill, where there are some vineyards with beautiful views, a palace so graceful and well provided with all the comforts desirable in such a place, that it is indescribable; and moreover, the rooms were adorned both with stuccoes and with paintings, he himself having painted there some scenes from the life of Numa Pompilius, whose burial-place was there. In the bathrooms of the palace, with the help of his young men, Giulio painted some scenes of Venus and Cupid, and of Apollo and Hyacinth, which have all appeared as engravings. And having completely parted company with Giovanni Francesco, he completed in Rome various architectural projects, such as the design of the house of the Alberini in the Banchi, though

some believe that the order of the plan came from Raphael, and likewise of a palace, to be seen today on the Piazza della Dogana in Rome, which has been reproduced as an engraving, for its well-ordered beauty. For himself, on a corner of the Macel de' Corvi, where stood his own house in which he was born, he made a fine beginning of a series of windows, which, modest as it is, is very graceful.

Because of his excellent qualities, Giulio, after the death of Raphael, was celebrated as the best craftsman in Italy. And so Baldesar Castiglione, who was then in Rome as the ambassador of Federigo Gonzaga, Marquis of Mantua, and, as said, a good friend of Giulio, was commanded by his lord, the Marquis, to make arrangements to send him an architect to serve him in the needs of his palace and the city, and told that he would particularly like to have his beloved Giulio. Thereupon the Count, with prayers and promises, went to work so effectively that Giulio said he would go at any time, provided that it was by leave of Pope Clement. And after leave had been granted, when he set out for Mantua in order to go to the Emperor, on the Pope's mission, he took Giulio with him; and having arrived at Mantua he presented him to the Marquis who, after greeting Giulio warmly, had him given an honourably appointed house, and ordered a salary and board for him, for his pupil Benedetto Pagni, and for another young man in his service; and moreover, the Marquis sent him several lengths of velvet, satin, and other silk stuffs and cloth for his clothing. Then, later, learning that Giulio had no horse to ride, he sent for a favourite horse of his own, called Ruggieri, and gave it to him; and when Giulio had mounted, they went together as far as a crossbow shot from the San Sebastiano gate to where his Excellency had a dwelling-place with some stables called the Te, in the middle of a meadow, where he kept his stud of horses and mares. Having arrived there, the Marquis said that he would like, without demolishing the old walls, to make arrangements for a small place to retire to now and then for dinner or supper, as

recreation. Giulio, when he had heard the Marquis's wishes, and seen all over and taken the ground-plan of the site, set his hand to the work; and making use of the old walls, he made in the main part the first hall, as one sees it today on entering, with the suite of rooms on either side. And because the place has no living rock, and no convenient quarries that could provide stone for hewing and carving, as used in building by those who can obtain them, he made use of bricks and tiles, to which he then added stucco; and with these materials he made columns, bases, capitals, cornices, doors, windows, and other structures with most beautiful proportions, and in a new and fantastic style the decorations of the vaults, with very lovely compartments and with richly adorned alcoves; and this was the reason why the Marquis resolved, after a humble beginning, to go on to make the building like a great palace.

So Giulio, having made a beautiful model with rustication both without and within the courtyard, pleased that lord so much that he allocated a good supply of funds for the work, which, after Giulio had assembled many master craftsmen, was rapidly completed. The form of the palace is as follows.

The edifice is square, and it encloses an open courtyard, like a meadow or indeed a piazza, with four entrances opening into it crosswise; the first of these straightway runs through or rather merges with an enormous loggia which opens by way of another into the garden, and two others lead into various apartments; all these are adorned with stuccoes and paintings. In the hall, to which the first entrance gives access, the vaulting is divided into various compartments and painted in fresco, and on the walls are portrayed from life all the most beautiful and favourite horses from the stud of the Marquis, along with dogs, of the same colour of coat or markings as the horses, with their names. These were all drawn by Giulio and painted on the plaster in fresco by the painters Benedetto Pagni and Rinaldo Mantovano, his pupils; and in truth so well, that they seem alive. From here, one proceeds to a room at one corner of

the palace which is vaulted with very beautiful compart-
ments of stucco-work and with varied cornices, here and
there touched with gold; and this cornicing divides the
vaulting into four octagons, which rise at the highest part to
a picture, in which Cupid is marrying Psyche, in the sight
of Jove (who appears on high in a dazzling celestial light)
and in the presence of all the gods. It is impossible to see
anything executed with more grace and design than this
scene, for Giulio foreshortened the figures so well, with the
view from below upwards, that though some of them are
scarcely two feet long, to anyone on the ground they look
as if they are six feet high.* They are in truth executed with
splendid ingenuity and skill, since Giulio besides making his
figures seem alive (the relief is so convincing) knew how to
make them deceive the human eye with their pleasing appear-
ance. Then in the octagons are all the other ancient stories of
Psyche, showing the adversities that befell her through the
anger of Venus, executed with the same beauty and per-
fection. In the other angles are many Cupids, as there are in
the windows, producing different effects depending on the
spaces they fill. And this vault is all painted in oils by the
hands of Benedetto and Rinaldo, mentioned above.

The remainder of the stories of Psyche are on the walls
below, and these, the largest, show in one fresco painting
when Psyche is bathing and the Cupids wash her and then
wipe her dry with entrancing gestures. In another part is
Mercury preparing the banquet, while Psyche is bathing,
with the Bacchantes sounding their instruments; and there,
too, are the Graces arranging flowers on the table in a most
beautiful manner, and Silenus held up on his ass by satyrs,
with a goat lying underneath which has two *putti* sucking at
its udders. One of that company is Bacchus, shown with
two tigers at his feet and leaning with one arm on the
sideboard, on one side of which is a camel and on the other

* Vasari's phrase is *al disotto in su*, a technique of illusionist perspective
generally known as *sotto in su*, practised and developed by Renaissance
painters, culminating with Tiepolo.

an elephant. This sideboard, which is barrel-shaped, is decor-
ated with festoons of verdure and flowers and all covered
with vines, laden with bunches of grapes and leaves, under
which are three rows of bizarre vases, bowls, flasks, cups,
goblets, and other vessels with diverse and fantastic shapes,
and so lustrous that they seem to be real silver and gold,
being counterfeited with a simple yellow, and other colours,
so well that they proclaim the intelligence and talents of
Giulio, who in this part of the work showed that he was
versatile, rich and copious in invention and craftsmanship.
A little way off may be seen Psyche who, while the many
women she has around her serve and prepare her, sees
Phoebus afar off among the hills rising in his chariot of the
sun, driven by four horses, while Zephyr lies completely
naked upon some clouds, blowing most gentle breezes
through the horn in his mouth which make the air around
Psyche all mild and playful. These scenes, not many years
ago, were engraved from the drawings of Battista Franco of
Venice; and he copied them exactly as they were painted
from Giulio's great cartoons by Benedetto da Pescia and
Rinaldo Mantovano, who executed all the scenes except the
Bacchus, the Silenus and the two *putti* suckled by the goat;
however, it is true that subsequently nearly all the work was
retouched by Giulio, so it is as if it were all done by him.
And his way of painting, which he learned from his in-
structor, Raphael, is most useful for young men practising
it, so that they generally turn out to be outstanding masters.
And although some of them persuade themselves that they
are greater than the one who sets them to work, such people,
if they lose their guide before they reach the end, or come
to lose the working plans and design, realize that through
having lost or abandoned their guide too soon, they find
themselves wandering blindly in an infinite sea of errors.

But to return to the apartments of the Te: from that
room of Psyche one passes to another apartment full of
double friezes with figures in low relief executed in stucco
after the design of Giulio by Francesco Primaticcio of

Bologna, who was then a young man, and by Giovan Battista Mantovano; and on these friezes is all the array of soldiers on Trajan's column at Rome, wrought in a very beautiful manner. Then in the ceiling or soffit of an antechamber is painted in oils the story of when Icarus, having been instructed by his father Daedalus, seeks to rise too high as he flies, and having seen the sign of Cancer and the chariot of the Sun drawn by four houses in foreshortening, close to the sign of Leo, is left wingless, after the wax has been consumed by the Sun's heat; and next, Icarus is seen hurtling down through the air as if about to fall on top of the beholder, his face all darkened with the hue of death. And this invention showed such splendid imagination and consideration on Giulio's part that it seems truly real; for in it, one sees the scorching heat of the sun burning the wretched young man's wings and the flaming fire emitting smoke, and one can almost hear the crackling of the burning plumes, while death can be seen sculpted on the face of Icarus and the bitterest grief and suffering on that of Daedalus. In our book of designs by various painters is the original drawing of that very beautiful scene by the hand of Giulio himself, who executed in the same place the stories of the twelve months of the year, showing all that is done in each of them in the arts which men practise most; and his painting here is no less remarkable for its whimsicality, its splendid invention and its sheer delight, than for the judgement and diligence with which it was executed.

After passing through this great loggia decorated with stucco-work and many arms and various bizarre adornments, one comes to some rooms so full of various fantasies that one's mind is dazzled. For Giulio, who was very whimsical and ingenious, in an angle of the palace which provided space for a corner room similar to that of Psyche mentioned above, in order to prove what he was worth, planned a room whose walls should match in with the painting, so as to deceive as much as possible those who could see it.

So having had double foundations sunk deeply at that corner, which was in a marshy spot, he had constructed over that angle a large, round room, with very thick walls, so that the four external angles of the masonry should be strong enough to be able to support a double vault, round like an oven. This done, at the corners running right round all the walls of the room, he had the doors, windows and fireplace built in rusticated stones looking haphazardly rough-hewn, and, seemingly, all askew and disjointed so that they appeared to be really leaning over to one side, and indeed about to collapse. And having built this room so strangely, he set out to paint in it the most fantastic and imaginative composition he could devise, namely Jove hurling his thunderbolts against the giants. And so having depicted Heaven on the highest part of the vault, he added the throne of Jove, foreshortening it from below upwards and from the front, within a round temple supported by open columns of the Ionic order, with his canopy in the middle over the divine throne, and his eagle: all this was placed above the clouds. And then lower down, he depicted Jove in his anger hurling thunderbolts against the proud giants; and lower still is Juno who is helping him, and around them are the winds, with strange countenances, blowing towards the earth, while the Goddess Ops turns with her lions at the terrible noise of the thunder, as also do the other Gods and Goddesses, and especially Venus who is beside Mars, and Momus who, with outstretched arms, appears to fear that Heaven will crash down, and none the less stands motionless. Similarly the Graces stand there full of dread, along with the Hours in like manner. All the Deities, in brief, are posed to take to flight in their chariots.

The Moon, and Saturn and Janus, are going towards the lightest of the clouds, to distance themselves from that horrible fear and fury, and Neptune is doing the same, with his dolphins seeming to seek to support himself on his trident, while Pallas and the nine Muses are standing wondering what horrible thing this may be; and Pan, embracing

a nymph who is trembling with fear, appears to wish to save her from the burning fires and lightning flashes with which the sky is full. Apollo stands in the chariot of the sun, and some of the Hours seem to want to hold back his horses in their course. Bacchus and Silenus with nymphs and satyrs show their tremendous fear, and Vulcan, with his ponderous hammer on his shoulder, looks towards Hercules who is speaking about what is happening to Mercury, standing beside Pomona, who is all fearful, as is Vertumnus along with all the other Gods dispersed throughout that Heaven, where too are so well expressed all the effects of fear, both in those who stay where they are and those who flee, that it is impossible to imagine, let alone see, a more beautiful fantasy in painting than this. In the parts below, that is on the walls standing upright below the end of the curve of the vaulting, are the giants, some of whom, those below Jove, have mountains on top of them and huge rocks on their backs, which they are carrying on their strong shoulders in order to pile them up to ascend to Heaven, even as their ruin is being prepared. For with Jove fulminating, and all Heaven enraged against them, it appears that not only do the Deities fear the reckless presumption of the giants, and so send the mountains crashing down on them, but that the entire world is overturned and almost at its final end. In this part, Giulio painted Briareus in a dark cavern, almost covered with enormous fragments of mountains, and the other giants all crushed and some dead under the ruins of the mountains. As well as this, through a cleft in the darkness of a cavern, which reveals a distant landscape executed with beautiful judgement, may be seen many giants fleeing, all stricken by the thunderbolts of Jove, and just about to be overwhelmed by the ruins of the mountains, like the others. In another part again, Giulio depicted other giants down on whom are crashing temples, columns and other pieces of buildings, inflicting horrendous havoc and loss of life on those proud beings; and in this spot, among all the crashing buildings, was positioned the fireplace of the room which,

when there is a fire lit, makes it seem as if the giants are burning, for Pluto is painted there, fleeing towards the centre, with his chariot drawn by lean horses and accompanied by the Furies of Hell. And thus Giulio, still pursuing the theme of the story through this device of the fire, made a very beautiful decoration for the fireplace.

In addition, to make this work even more fearsome and terrible, Giulio showed the giants, huge and physically deformed (smitten as they were in various ways by the thunderbolts and lightning), crashing to earth, some in the foreground and others at the back, some dead, some wounded, and some covered by the ruins of buildings and the mountains. So let no one think ever to see any work of the brush more horrible and frightening, or more realistic, than this; and whoever enters that room and sees the windows, doors and so forth all distorted and apparently hurtling down, and the mountains and buildings falling, cannot but fear that everything will crash down upon him, especially when he sees in that Heaven all the Gods rushing here and there in flight. And what is most marvellous to see in this work is that the whole painting has neither beginning nor end, but is all interconnected and smoothly continuous, with no ornamental partitions or boundaries, so that the objects which are near the buildings seem very large, and those which are in the distance, where the landscapes are painted, gradually recede into infinity. Hence that room, which is no more than thirty feet long, seems like open country; and then, too, the floor being composed of pebbles set evenly, and the lower part of the upright walls being painted with similar-looking stones, there is no sharp angle visible, and so the level surface appears to be one vast expanse; and this effect was achieved with great judgement and beautiful skill by Giulio, to whom our craftsmen owe a great deal for such inventions. The Rinaldo Mantovano mentioned above became a perfect colourist in this work, for, working with Giulio's cartoons, he carried the whole of it through to completion, and the other rooms as well. And

if he had not been taken from this world when still young, just as he shed honour on Giulio while he was alive, so he would have won honour for himself after Giulio's death.

In addition to this palace, where Giulio did many other praiseworthy things, which I shall be silent about so as not to go on too long, he rebuilt with masonry many rooms in the castle where the Duke lived in Mantua, and made two huge spiral staircases with very lavish apartments, adorned with stucco throughout; and in one room, he caused to be painted the entire history of the Trojan war; and likewise, in an antechamber, twelve scenes in oils, below the heads of twelve emperors, previously painted there by Titian Vecelli, regarded as most rare.

In the same way, at Marmirolo, a place five miles from Mantua, following Giulio's design and instructions, there was erected a most commodious building, with large paintings, no less beautiful than those of the castle and of the palace of Te. Also, in the chapel of Signora Isabella Buschetti, in Sant'Andrea at Mantua, Giulio did an altarpiece in oils of Our Lady in the act of adoring the Infant Jesus, who is lying on the ground, with St Joseph, the ass and the ox near a manger; and on one St John the Evangelist and on the other St Longinus, life-size figures. Next, on the walls of this chapel, he caused Rinaldo to colour two beautiful scenes after his own designs: one showing the Crucifixion of Jesus with the thieves; some angels in the air; the crucifiers and the two Marys, with many horses, in which he always delighted, and which he made marvellously beautiful, below, and also many soldiers striking various attitudes. In the other scene he showed when, in the time of the Countess Matilda, the blood of Christ was found, and this was a very fine work. After, for Duke Federigo, Giulio painted a picture in his own hand of Our Lady washing the infant Jesus Christ, who is standing with his feet in a basin, while a little St John is pouring water from a vase, both of these figures, which are life-size, being very beautiful; and in the distance are some small figures, painted from the waist up,

of some ladies who are coming to visit Our Lady. This picture was afterwards given by the duke to Signora Isabella Buschetti, of whom Giulio subsequently painted a most beautiful portrait in a little picture of the Birth of Christ, two feet high, which is now in the possession of Signor Vespasiano Gonzaga, with another picture given him by Duke Federigo, also by Giulio's hand, in which a young man and young woman are embracing each other in the act of making love on a bed, while an old woman looks at them, hidden behind the door. The figures in this picture are a little under life-size, and very graceful. Also in the same house is another very excellent picture, again by Giulio, of a beautiful St Jerome. And in the possession of Count Niccolò Maffei is a picture of Alexander the Great, life-size, with a Victory in his hand, and copied from an ancient medal, which is very beautiful.

After these works, for Messer Girolamo, organist of Milan Cathedral, and his close friend, Giulio painted in fresco over a chimney-piece a Vulcan who is working his bellows with one hand and holding with a pair of tongs in the other the iron tip of an arrow which he is forging, while Venus is tempering in a vessel those already made, and putting them in Cupid's quiver; this is one of the loveliest works that Giulio ever painted, and there is little else to be seen from his hand in fresco.

In San Domenico, for Messer Lodovico da Fermo, he did a panel picture of a Dead Christ, whom Joseph and Nicodemus are preparing to place in the tomb, with his Mother and the other Marys and St John the Evangelist. And a little picture, also containing a Dead Christ, is in the house of the Florentine, Tommaso da Empoli, at Venice. At the same time as he was working on these and other pictures, it happened that Signor Giovanni de' Medici, after being wounded by a musket-ball, was carried to Mantua, where he died; whereupon Messer Pietro Aretino, a most affectionate servant to that lord, and a close friend of Giulio's, wished Giulio with his own hand to create a likeness of him

in death; and he, therefore, having made a death-mask, did a portrait from it which Aretino kept by him for many years.*

When the Emperor Charles V came to Mantua, on the order of the Duke, Giulio devised many superb decorative arches, scenery for plays, and many other things in which he had no rival for invention; nor was there ever anyone more fanciful in devising masquerades and designing extravagant costumes for jousts, festivities and tournaments, as was seen with stunned surprise by the Emperor Charles and all those who were present.

Besides this, at different times Giulio presented so many designs for chapels, houses, gardens, and façades throughout that city of Mantua, and was so eager to embellish and adorn it, that whereas previously it had been buried in mud and full of stagnant waters, and at times almost uninhabitable, he transformed it so thoroughly that through his efforts it is now a dry and healthy place, and altogether pleasant and charming.

While Giulio was in the service of the Duke of Mantua, one year the Po broke its banks and flooded the city so badly that in certain low-lying areas the water rose nearly eight feet; and so for a long time, frogs lived in those parts almost all the year round. Thinking how he could remedy this, Giulio contrived ways of bringing the city back for the time being to its former state of being; and then, so that the same might not happen again, he caused the streets, by command of the Duke, to be raised so much on the affected side that they came to be higher than the level of the water, and the houses stayed well above it. And since, in that part, the dwellings were small and rickety, and not of much importance, he gave the order that they should be converted to better use, and pulled down in order to raise the level of the streets, and rebuilt higher up with bigger and better houses

* The famous *condottiere* known as Giovanni delle Bande Nere (and father of Duke Cosimo I of Florence) died in 1526. One of Aretino's most moving letters describes his martial character and heroic death.

for the benefit and convenience of the city. Many people then began to oppose this, saying to the Duke that Giulio would cause too much damage, but he refused to listen to any of them; instead, he made Giulio immediately super-intendent of the streets, and gave orders that no one should do any building in the city without Giulio's permission. As a result, many people complained and some even threatened Giulio; and when this came to the ears of the Duke he spoke so favourably of Giulio as to make it clear that whatever was done to discredit or damage him, he would consider an affront to himself and teach those responsible a lesson.

This Duke loved Giulio in such a manner that he did not know how to live without him, and in return, such was Giulio's reverence for that lord that nothing greater could be imagined. So there was no favour he asked for himself or for others that he did not obtain, and when he died it was found that, from all he had received from the Duke, he had an income of over a thousand ducats.

Giulio built himself a house in Mantua opposite San Barnaba, for which he made on the outer side a fantastic façade all wrought with coloured stucco; and the inside, too, he had all painted and also wrought with stucco, accommodating many antiquities brought from Rome or obtained from the Duke, to whom he also gave many of his own things. Giulio did so many designs both for Mantua and elsewhere that it is hardly believable; for, as was said, no palaces or other important edifices could be built, especially in the city, without designs from him.

He rebuilt on the old walls the church of San Benedetto, a very large and rich seat of the Black Friars, at Mantua near the Po; and the entire church was embellished with pictures and very beautiful altarpieces designed by him. Then, as his works were highly prized throughout Lombardy, Giovan Matteo Giberti, bishop of Verona, wanted the tribune of the Duomo of that city, as said elsewhere, to be painted by Il Moro of Verona* after Giulio's designs. For the Duke of

* Francesco Torbido (1486-1546).

Ferrara, also, Giulio created many designs for tapestries, which were then woven in silk and gold by Maestro Niccolò and Giovan Battista Rosso, both Flemings, and were published after being engraved by Giovan Battista Mantovano, who engraved innumerable drawings by Giulio, and particularly, besides three drawings of battles engraved by others, a doctor applying leeches to a woman's back, and a figure of Our Lady on the flight to Egypt, with St Joseph leading the ass by its halter, and some angels bending down a date-palm so that Christ may gather its fruit. The same master, using Giulio's design, engraved a wolf on the Tiber, suckling Romulus and Remus, and four scenes of Pluto, Jove and Neptune, who are drawing lots to divide between them the Heavens, the earth and the sea; and likewise the goat, Amalthea, who, as she is held by Melissa, is giving suck to Jove; and a large drawing of many men in a prison, tortured in various cruel ways. Other prints based on inventions by Giulio included Scipio and Hannibal holding a parley with their armies on the bank of a river, the Birth of St John the Baptist, which was engraved by Sebastiano da Reggio, and many others engraved and printed in Italy. In Flanders as well, and in France, have been printed countless sheets from the designs of Giulio, of which, though they may be very beautiful, there is no need to make mention, nor indeed of all his drawings, since, so to say, he made loads of them. Enough to add that every aspect of painting, and particularly drawing, came so easily to him that we do not record anyone who has done more than him.

Giulio was very versatile and could discourse on every subject, but above all on medals, on which he spent a good deal of money, as well as considerable time, to acquire knowledge; and although he was engaged for most of the time on great works, this did not stop him from sometimes putting his hand to very trifling things to oblige his lord and his friends. And no sooner did one of them open his mouth to put some concept to him, than he had understood and drawn

it. Among the many rare things that he had in his home, there was on a canvas of fine Rheims linen a portrait from life of Albrecht Dürer, by Albrecht's own hand, which he had sent, as said elsewhere, as a gift for Raphael of Urbino. This portrait was extraordinary, for it had been coloured in gouache very diligently with water-colours, and Albrecht had completed it without employing any lead-white, but using instead the white of the canvas, whose very fine threads he had presented so well for the hairs of the beard that it was hardly possible to imagine, let alone to do; and held up to the light, it was transparent on either side. This painting, which was very dear to Giulio, he himself showed me as a miracle, when, while he was still living, I went on affairs of my own to Mantua.

On the death of Duke Federigo, by whom he had been loved beyond belief, Giulio was so distressed that he would have left Mantua, had not the cardinal, the brother of the Duke on whom the governing of the state had devolved, as Federigo's sons were still very small, kept him in that city, where he had a wife and children, a house, a place in the country, and all the other requisite possessions of a gentleman of means. And the cardinal did this, for the reasons we said, but also to secure Giulio's help and advice in renovating or almost completely rebuilding the entire Duomo of the city, to which Giulio having set his hand, he carried the work well forward in a very beautiful form. At that time Giorgio Vasari, who was a very great friend of Giulio's, although they knew each other only by reputation and letters, on a journey to Venice went by way of Mantua in order to see Giulio and his works. And so after arriving in the city, he went to find his friend, and when they met, though they had never set eyes on each other before, they recognized each other just as surely as if they had been together in person a thousand times already. At this, Giulio was so happy and content that for four days he never left his side, showing him all his works, and particularly all the ground-plans of the ancient buildings of Rome, Naples,

Pozzuoli, and the Campagna, and all the other best anti-
quities of which we have a record, drawn partly by him
and partly by others. Then having opened a very big cup-
board, Giulio showed him the ground-plans of all the
edifices that had been put up following his designs and
instructions, not only in Mantua and Rome, but throughout
all Lombardy; and they were so beautiful that, for myself, I
do not believe that it is possible to find finer or more original
ideas for buildings, or any so well laid out.

The cardinal then asked Giorgio what he thought of
Giulio's works, and he replied, in Giulio's presence, that
they were so excellent that he deserved to have a statue of
himself put up on every corner of the city, and that since
he had brought about the renewal of Mantua, half of the
state itself would not be enough reward for his labours
and talent. And to this the cardinal replied that Giulio was
more the master of the state than he was himself. And
because Giulio was so kind and loving, and especially
towards his friends, there is no mark of warmth and
affection that Giorgio did not receive from him. Then
after Vasari had left Mantua and gone to Venice, and from
there returned to Rome, just at the time when Michel-
angelo revealed his Last Judgement in the Sistine Chapel,
he sent Giulio through Messer Nino Nini of Cortona,
secretary of the cardinal of Mantua, three sheets containing
the seven mortal sins, copied from that Last Judgement
by Michelangelo, which were welcome beyond measure
to Giulio for what they were, and also because at that time
he had to decorate a chapel in the palace for the cardinal,
and the gift stirred him to aim at greater things than he
had previously had in mind.

So applying himself with the utmost diligence to draw a
very beautiful cartoon, he showed in it very fancifully when
Peter and Andrew, being called by Christ, leave their nets
to follow Him, and from being fishers of fish they became
fishers of men. This cartoon, which succeeded in being the
finest Giulio ever made, was then executed by the painter

Fermo Ghisoni, a pupil of Giulio, and now an outstanding master.

Not long afterwards, the superintendents of the fabric of San Petronio at Bologna, being desirous of making a beginning on the façade of that church, went to great trouble to bring Giulio there, in company with a Milanese architect called Tofano Lombardino, who was then highly esteemed in Lombardy, because of the many buildings to be seen there from his hand. These masters, then, made many designs; and those of Baldassare Peruzzi of Siena having been lost, one that Giulio made, among others, was so beautiful and well ordered that he deservedly won great praise from the local people, and was rewarded with very generous gifts when he went back to Mantua.

Meanwhile, Antonio Sangallo having about that time died in Rome, the deputies of the fabric of St Peter's were left more than harassed, as they did not know whom to persuade to accept the charge of bringing that great building to completion, when they thought that no one would be more suitable than Giulio Romano, whose worth and excellence were universally known. So reckoning that he was bound to accept such a charge more than willingly in order to return with honour and a substantial salary to his native place, they had him approached by some of his friends, but in vain. For although he would gladly have returned, two things held him back: the cardinal who in no way wished him to go, and his wife and friends and relations, who discouraged him in every possible manner. But perhaps neither of these two influences would have been able to prevail on him, had he not at that time found himself not very well. For having considered how much honour and profit he and his children would have secured from the acceptance of such a noble engagement, he was absolutely set and determined to resist with all his might being blocked in this matter by the cardinal, even when the malady began to grow worse. But since it was ordained from above that he should return no more to Rome, and that this should be

the final end of his life, what with his displeasure and his illness, he died within a few days in Mantua, a city which could well have allowed him, even as he had embellished her, so also to adorn and honour his own native city of Rome.

Giulio died at the age of fifty-four, leaving a single male child, to whom, to acknowledge the fond memory he had of his master, he had given his name of Raphael; and this young man had scarcely learned the elements of the art of painting and was giving sure hope of becoming a capable craftsman, when he too died not many years later, together with his mother, Giulio's wife. So there remained only one descendant of his, a daughter, called Virginia, who still lives in Mantua, married to Ercole Malatesta.

Giulio, whose death brought the greatest possible grief to all who knew him, was buried in San Barnaba, where it was proposed to raise some honourable memorial; but his wife and children kept putting things off from one day to another, and then they mostly passed away without having done anything. And indeed it has been a great shame that there has been no one who has at all acknowledged this man, who brought such honour to that city, save those who used his services, and who have often remembered him in their needs. But his own true talent, which brought him such honour during his lifetime, has after his death through his works created for him an everlasting monument which neither time nor the years will ever wear away.

In stature, Giulio was neither big nor small, stocky rather than thin in build, with black hair, handsome face, dark, merry eyes, full of loving-kindness, of impeccable manners at all times, frugal in eating, yet fond of dressing and living in style. He had many disciples, but the best were Gian dal Lione, Raffaello dal Colle of Borgo, Benedetto Pagni of Pescia, Figurino da Faenza, Rinaldo and Giovan Battista Mantovano, and Fermo Ghisoni, who still lives in Mantua and is a credit to Giulio, being an excellent painter; and the same holds true for Benedetto, who has produced a great

deal of work in his native Pescia, and for the Duomo of Pisa an altarpiece which is in the Office of Works, and also a picture of Our Lady full of lovely and graceful, poetic invention, having in it a figure of Florence presenting to the Madonna the dignitaries of the House of Medici: and this picture is now in the possession of Signor Mondragone, a Spanish gentleman, highly favoured by that most illustrious lord, the Prince of Florence. Giulio died in the year 1546, on the day of All Saints, and on his tomb was placed this epitaph:

> *Romanus moriens secum tres Julius arteis*
> *Abstulit (haud mirum), quatuor unus erat.*★

★ In his death Giulio Romano took with him three of the arts: no matter of surprise, for he was equal to four.

LIFE OF

JACOPO PONTORMO

—— . ——

Florentine painter, 1494–1556

SOME people affirm that the ancestors or forefathers of
Bartolommeo di Jacopo di Martino, the father of Jacopo da
Pontormo, whose *Life* we are about to write, had their
origin in Ancisa, a castle-town of upper Valdarno, which is
very famous, since the early origins of the ancestors of
Messer Francesco Petrarch can also be traced there.* But
whether his forefathers came from there or elsewhere, this
Bartolommeo, who was a Florentine, and, as I have been
told, of the Carucci family, is said to have been a disciple of
Domenico Ghirlandaio; and after having executed many
works in Valdarno, being a reasonably good painter for his
time, he finally took himself off to do some works in
Empoli, and when dwelling there and thereabouts, he
married, in Pontormo, a very virtuous and worthy girl
called Alessandra, the daughter of Pasquale di Zanobi and
his wife, Mona Brigida. And so then, in the year 1493,
Bartolommeo's son Jacopo was born. But as his father died
in 1499, his mother in 1504, and his grandfather in 1506,
Jacopo remained in the care of his grandmother Mona
Brigida, who looked after him for several years in Pon-
tormo, where she had him taught how to read and write
and the elements of Latin grammar; and then eventually he
was taken by her, when he was thirteen, to Florence and
made a ward of court as was the practice, so that his modest
property might be safeguarded and preserved by the magis-
trates. And then, after putting him to live with a certain
shoemaker called Battista, a distant relation, Mona Brigida

* Now called Incisa in Valdarno.

went back to Pontormo, taking Jacopo's sister with her. Not long afterwards, Mona Brigida herself died, and Jacopo was forced to bring his sister to Florence, where he placed her in the home of a relation of his called Niccolaio, which stood in the Via de' Servi. But then even this girl, following the others of her family, before she could marry, died in the year 1512.

But to return to Jacopo: he had not yet been many months in Florence before he was placed by Bernardo Vettori with Leonardo da Vinci, and shortly after with Mariotto Albertinelli, with Piero di Cosimo, and finally, in the year 1512, with Andrea del Sarto, with whom similarly he did not remain long; for after Jacopo had done the cartoons for the little arch of the Servites, which will be discussed below, it seems that, for whatever reason, Andrea was never well disposed to him again.

Meanwhile, the first work that Jacopo did at this time was a very small Annunciation for a friend of his, who was a tailor. But the tailor died before the work was finished and it remained in the hands of Jacopo, then living with Mariotto, who was very proud of it and showed it off as something rare to whoever entered his workshop. Then one of those days, Raphael of Urbino came to Florence, saw the work and the young man who had made it, and, absolutely amazed, prophesied for Jacopo the success he was subsequently seen to achieve.

Not long after this, Mariotto left Florence and went to work in Viterbo on the altarpiece which Fra Bartolommeo had begun there; and Jacopo, who was still young as well as melancholy and solitary, being left without a master, went of his own accord to stay with Andrea del Sarto, just when he had furnished for the cloister of the Servites the scenes of St Philip, which absolutely delighted Jacopo, as did Andrea's other works, and his style and drawing. So Jacopo exerted every effort to imitate him, and it was not long before he was seen to have made marvellous progress in drawing and colouring, and also seemed to have been a practising painter

for many years. And then about that time, Andrea having
finished a panel picture of the Annunciation for the church of
the friars at San Gallo, now ruined, as told in his *Life*, he
gave the painting of the predella of that altarpiece to be
done in oils by Jacopo, who painted the Dead Christ with
two little angels shedding light on Him with two torches,
and weeping over Him; and at the sides, in two circular
pictures, he painted two prophets who were so skilfully
executed that they appear to have been done by a skilled
master rather than a young man. But it could also be that, as
Bronzino says he remembers having heard from Jacopo
Pontormo himself, Rosso, too, worked on that panel.
However, just as, in doing this predella, Andrea was assisted
by Jacopo, so he was likewise in finishing the many works
and paintings on which he was always engaged.

In the meantime, Cardinal Giovanni de' Medici having
been made Pope with the name of Leo X, throughout
Florence by the friends and devotees of that family there
were made many coats of arms of the Pontiff in stone, in
marble, on canvas and in fresco; and so as the Servite friars
also wanted to furnish some token of their service and
devotion to that family and Pope, they had Leo's coat of
arms made in stone and placed in the centre of the arch of
the first portico of the Annunziata, which is on the piazza.
And soon after they gave orders for the arms to be gilded
and decorated with grotesques by the painter Andrea di
Cosimo, who was an outstanding master of these, and also
with emblems of the House of Medici, as well as flanked by
a figure of Faith and one of Charity. But as Andrea di Cosimo
knew that he could not carry through this much on his
own, he thought he would give the two figures to others to
do; and so having called Jacopo, who was then no more
than nineteen years old, he handed over the work on the
two figures to him, although it was a hard struggle to
persuade him to accept, since being a very young man he
did not at first wish to put himself so greatly at risk, nor to
work in a place of such importance. Still, Jacopo plucked up

his courage, and even though he was not as experienced in working in fresco as in oils, he undertook to do these two figures; and having taken himself off (for he was still staying with Andrea del Sarto) to do the cartoons at Sant'Antonio by the Faenza gate, where he lived, he brought them to completion in a short while, and then one day took his master Andrea del Sarto to see them. And having looked at them with absolute wonder and amazement, Andrea praised them to the skies; but then, as was said, whether through envy or for some other reason, he never looked kindly on Jacopo, rather when Jacopo went sometimes to his workshop, either it was not opened for him, or he was jeered at by the apprentices, to such effect that he took himself off altogether; and he began to make the most strict economies, for he was a poor young man, and to study with the greatest assiduity.

When, therefore, Andrea di Cosimo had finished gilding the coat of arms and the mantling, Jacopo set out to finish the rest by himself alone; and carried along by the desire to acquire fame, by the wish to create, and by his natural endowment of an impressively graceful and fertile mind, with extraordinary speed he brought that work to the same perfection that a competent and skilled old master would have been able to achieve. So then, his courage strengthened by that experience, and thinking he could do much better work, he had decided, without saying a word to anyone, to pull the work down and begin again from scratch, on the lines of another design of his which he had in mind. But in the meantime, the friars having seen the work was finished and that Jacopo was no longer going to attend it, found Andrea and pressed him so hard that he resolved to reveal it. Therefore, having sought for Jacopo to ask if he wished to do anything more there and not finding him, since he was shut up with his new design and responded to no one, Andrea had the screen and scaffolding taken away and the work revealed. And that same evening Jacopo had left home to go to the Servites, and, under cover of night, take down

the work he had done and begin on the new design; but he
found the staging had been taken away and everything
revealed, with no end of people standing around looking at
it. Very angrily, then, he found Andrea and complained
that he had revealed the work without him, and he went on
to say what he had meant to do. To this Andrea said with a
smile: 'You're wrong to complain, because the work you've
done has come out so well that if you were to do it again I
am sure that you could not do better, and you won't lack
work, so keep your new designs for other occasions.' As can
be seen, the painting was so extremely beautiful, both for its
new style and the sweetness of the faces of the two female
figures, and for the loveliness of the *putti*, so lively and
graceful, that it was the finest work in fresco that had ever
been seen up to that time. For, as well as the *putti* with the
figure of Charity, there are two others who are draping a
cloth in the air over the coat of arms of the Pope, so beautiful
that they could not be done better; and moreover, all the
figures are in such strong relief, and so well coloured and
presented in every other way, that they cannot be praised
enough. And when Michelangelo Buonarroti one day saw
this work, and reflected that a young man of nineteen had
done it, he said: 'This young man will be such, from what
one can see, that if he lives and perseveres, he will exalt
painting to the very heavens.' And when the people of
Pontormo heard of his reputation and fame, they sent for
Jacopo and commissioned from him, for a gate on the main
road inside the town, Pope Leo's coat of arms with two
putti, beautifully done, although it has now been almost
wholly ruined by water.

For the carnival that same year,* as all Florence was
joyfully celebrating the creation of Pope Leo X, many
festivities were arranged, including two very splendid
and expensive ones by two Societies of lords and gentlemen
of the city: one called the Diamond, of which the head was
Signor Giuliano de' Medici, the Pope's brother, who had

* The year 1513.

called it that as the diamond had been the emblem of the elder Lorenzo, his father; and the other having for its name (and badge) the Bough, as its head was Signor Lorenzo, son of Piero de' Medici, and he, may I say, had for his emblem a bough or rather a withered laurel stump which is bursting into green leaf, to show that he was reviving or resurrecting the fame of his grandfather. For the Society of the Diamond, then, Messer Andrea Dazzi, who at that time taught Greek and Latin literature at the University of Florence, was charged to devise the theme for a Triumph; and so he arranged one similar to those the Romans invented for their victory celebrations, with three very handsome chariots carved in wood, richly and cunningly painted. In the first was Boyhood with a very attractive array of children, in the second was Manhood, with many people who in their manly prime had achieved great things, and in the third was Venerability,* with many distinguished men who in their old age had also effected great things. All these personages were so very richly decked out, that no one imagined it could be done better. And the architects of the chariots were Raphael alle Viole, the engraver Carota, the painter Andrea di Cosimo, and Andrea del Sarto. And those who created and arranged the clothing for all the figures were Ser Piero da Vinci, Leonardo's father, and Bernardino di Giordano, both highly gifted men.† But to Jacopo Pontormo alone fell the task of painting all the three chariots, and he did this with various scenes in chiaroscuro depicting many instances of the Gods transformed into diverse forms, which are now in the hands of Pietro Paolo Galeotti, an excellent goldsmith. Written in very clear characters on the first chariot was *Erimus*, on the second *Sumus*, and on the third *Fuimus*, meaning 'We shall be, We are, We were.' The song began: 'The years fly on, . . .'

Having seen these Triumphs and desiring to surpass them, Signor Lorenzo, head of the Society of the Bough, put in

* Vasari uses the near-Latin word *Senettù* (*Senectus*).
† Not Piero but Giuliano da Vinci, Leonardo's half-brother.

JACOPO PONTORMO 241

charge of all that was to be done Jacopo Nardi, a noble and highly educated gentleman (to whom, for what he achieved, his native Florence is much in debt), and Jacopo arranged six Triumphs to double those made for the Society of the Diamond. The first, drawn by a pair of oxen bedecked with green foliage, represented the age of Saturn and Janus, called the golden age, and at the top of the chariot stood Saturn with his scythe and Janus with the two heads and holding the keys of the Temple of Peace, with the bound figure of Fury under his feet, and with innumerable objects pertaining to Saturn, all beautifully made and variously coloured by the genius of Pontormo. Accompanying this Triumph were six couples of shepherds, naked but partly covered with the skins of martens and sables, wearing different kinds of old-fashioned boots, and pouches of goatskin, and garlands of variegated foliage on their heads. The horses, on which the shepherds were mounted, did not wear saddles but were draped with the skins of lions, tigers, and lynxes, whose gilded paws were hanging at their sides to give a most graceful effect. The decorations of the horses' cruppers and of the grooms were in gold thread, the stirrups were heads of rams, dogs, and suchlike animals, and the reins and bridles made of different kinds of foliage and silver thread. Each shepherd was accompanied by four grooms dressed like shepherd boys, clad more simply in skins and carrying torches fashioned to look like dried boughs and pine branches, which made a most splendid sight. On the second chariot, drawn by two pairs of oxen draped in the richest cloths, with garlands on their heads and huge paternosters★ hanging from their gilded horns, was Numa Pompilius, the second king of the Romans, with the books of religion and all the ordinances of the priesthood and things pertaining to sacrifices: for he was the founder and first law-giver for religion and sacrifices among the Romans. This chariot was

★ Rosaries, so called because the bigger beads mark the praying of the Our Father or Pater Noster.

accompanied by six priests on most beautiful mules, their
heads covered with linen hoods embroidered with gold and
silver, fashioned with masterly skill as ivy leaves. And they
wore antique priestly vestments, with very rich borders
and trimmings of gold all round, and in their hands one
was holding a thurible, another a vessel of gold, and another
something similar. At their stirrups they had attendants in
the guise of deacons, and the torches these held in their
hands were like ancient candelabra and made with marvel-
lous craftsmanship. The third chariot represented the Con-
sulate of Titus Manlius Torquatus, who was consul after the
end of the first Punic war, and whose manner of government
was such that, in his time, every kind of prosperity and
every virtue flourished in Rome. This chariot, on which
was Titus himself, had many adornments by Pontormo,
and was drawn by eight very handsome horses, and in front
were six couples of senators in togas, riding horses draped
with cloth of gold, accompanied by a great number of
grooms representing lictors, with their fasces, axes, and other
objects appertaining to the administration of Justice. The
fourth chariot, drawn by four buffaloes made up to look
like elephants, represented Julius Caesar in triumph for the
victory gained over Cleopatra, and it was all painted by
Pontormo with Caesar's most famous deeds. This chariot
was accompanied by six couples of men-at-arms richly clad
in brightly shining armour, all bordered with gold, with
lances at their sides; and the torches which the lightly armed
grooms were carrying took the form of trophies presented
in various ways. The fifth chariot, drawn by winged horses
looking like griffins, had above it Caesar Augustus, lord
and ruler of the Universe, accompanied by six couples of
poets on horseback, who were all crowned like Caesar him-
self, with laurel, and dressed in different costumes according
to the countries they came from; and they were present
because Caesar Augustus always held poets in the highest
favour, while they exalted him in their works to the very
heavens. And so as to be recognized, each one had a scroll

worn crosswise like a swath-band, bearing his name. Then on the sixth chariot, drawn by six pairs of richly draped heifers, was Trajan, the most just of the emperors, before whom, as he sat on the chariot, excellently painted by Pontormo, on handsome and finely caparisoned horses rode six couples of doctors of law, with togas reaching to their feet and with gowns of squirrel fur, as learned doctors used to wear in ancient times; and the grooms who were carrying the torches in great number were clerks, copyists, and notaries, holding books and writings in their hands. After these six came the chariot or rather the Triumph of the Age or Era of Gold, executed with the most beautiful and lavish artistry, with many figures in relief by Baccio Bandinelli, and with the most beautiful pictures by Pontormo, among which especially praised were the figures in relief of the four Cardinal Virtues. From the middle of the chariot rose a great sphere in the form of a globe of the world, on which lay prostrate on his face, as if he were dead, a man clad in rusty armour, with the back opened and cleft, and a child all naked and gilded emerging from the fissure, who represented the resurgence of the Golden Age, and the end of the Age of Iron, from which he emerged and was reborn through the creation of the new Pope; and this same significance attached to the dried-up bough putting forth leaves, though some said that it alluded to Lorenzo de' Medici, who was Duke of Urbino. I may add that the gilded boy, who was the son of a baker, because of the distress he suffered to earn a dozen or so crowns, died soon after.

The song which, following custom, was chanted at the masquerade was composed by Jacopo Nardi, whom we mentioned, and the first stanza ran as follows:

> The one whose laws are writ on Nature's page,
> And varied states and centuries provides,
> Is both the cause of what good he decides,
> As of the ill, which he lets last its age:
> So thus, when here this image

Contemplating, you see,
Footsure and steadily,
One age succeeds another here below,
To change ill into good, and good to woe.

For the work which Pontormo did for this carnival, he gained, as well as what he earned, such praise as perhaps few young men of his age have experienced in that city; so therefore, when Pope Leo then came to Florence, he was made great use of in all the preparations. For he had joined company with Baccio da Montelupo, an elderly sculptor, who did a wooden arch at the head of the Via del Pelagio, at the steps of the abbey, and Pontormo painted it all with very beautiful scenes which subsequently, through the carelessness of the person in charge, came to a sad end. Of these scenes, the only one to remain shows Pallas tuning an instrument in accord with the lyre of Apollo, most carefully; and from this scene one can judge how excellent and perfect were the other works and figures.

For the same display, Ridolfo Ghirlandaio had been charged with fitting out and embellishing the Hall of the Pope, which adjoins the convent of Santa Maria Novella and was once a residence of the popes in Florence; but being pressed for time, in some things he was forced to make use of the works of others, and so having decorated all the other rooms, he laid on Jacopo Pontormo the charge of executing in the chapel, where his Holiness was to hear Mass every morning, some paintings in fresco. So having set his hand to this, Jacopo did there a God the Father with many *putti*, and a Veronica with the image of Jesus Christ on the veil; and this work, which Jacopo did under such pressure of time, was much praised.

He painted in fresco, in a chapel of the church of San Raffaello, behind the Archbishop's Palace in Florence, the Madonna with her Son in her arms, between a St Michael the Archangel and St Lucy, and two other saints, kneeling; and in the lunette of the chapel, a God the Father in the midst of some Seraphim. Then, as he had very much

wanted, he was commissioned by Maestro Jacopo, a Servite friar, to paint a part of the courtyard of the Servites, since Andrea had gone off to France and left the work there unfinished; and so he set out very zealously to do the cartoons. But since he was ill-provided with money, and he needed the wherewithal to live, while he studied in order to win honour, he also, over the door of the women's hospital, behind the church of the priests' hospital, between the piazza of San Marco and the Via di San Gallo, just opposite the wall of the Sisters of St Catherine of Siena, painted two most beautiful figures in chiaroscuro, with Christ in the form of a pilgrim who is waiting for some women in order to give them shelter and lodging; and this work was much praised in those times, as it is today by men of discernment.

At this time, too, he painted some pictures and little scenes in oils, for the masters of the Mint, on the chariot* which goes every year in the procession on St John's Day, and the workmanship of which was Marco del Tasso's; and on the hill of Fiesole, over the door of the Society of St Cecilia, he executed a St Cecilia with some roses in her hand, coloured in fresco, so lovely and blending in so well with that place, that, for the kind of picture it is, it is one of the best works to be seen in fresco.

The Servite friar, Master Jacopo, whom we mentioned earlier, having seen these works and finding his desire still more inflamed, resolved that at all costs he would have Jacopo finish the work in the cloister of the Servites, thinking that in rivalry with the other masters who had worked there, he was bound to do in the remaining space something extraordinarily beautiful. Jacopo, therefore, having set his hand to it, no less from his desire for the glory and fame than for gain, painted the scene of the Visitation of Our Lady in a style rather more airy and gay than had been usual with him hitherto; and this immeasurably added

* The *carro della Moneta*.

to the excellence of the work, apart from its other in-
comparable attractions: for the women, the boys, the young
men and the old are executed in fresco so softly with such
harmonious colours, that it is truly marvellous; and the flesh
tints of a little boy seated on some stairs, and indeed of all
the other accompanying figures, are such that they could
not be done better or more softly in fresco. And so this
work, after the others he had done, gave his fellow craftsmen
certain evidence of his future perfection, when they
compared them to those of Andrea del Sarto and Fran-
ciabigio. Jacopo brought this work to a finish in the year
1516, and received as payment for it sixteen crowns, and no
more.

He was then commissioned by Francesco Pucci, if I re-
member rightly, to paint the altarpiece for a chapel that he
had arranged to be built in San Michele Visdomini in the
Via de' Servi, and Jacopo executed this work in so sound a
style and with such lively colouring that one can scarcely
believe it. The panel shows Our Lady seated and holding
out the Christ Child to St Joseph, whose face is smiling with
so much vivacity and alertness that it is stunning. Also most
beautiful is the figure of the child painted as St John the
Baptist, and the other two naked little boys, who are holding
up a canopy. There is also to be seen a St John the Evangelist,
a most handsome old man, and a St Francis, who is kneeling
down and looks as if alive; for as he stands there with the
fingers of his two hands intertwined, rapt in contemplation
with his eyes and mind fixed on the Virgin and Child, he
seems to breathe. No less beautiful is the figure of St James,
who is seen alongside the others. So no wonder that this is
the finest panel picture this most rare painter ever did.

I believe that it was after this work, not before, that the
same Jacopo painted in fresco for Bartolommeo Lanfredini
the two very pretty and graceful *putti* holding up a coat of
arms over a door within a passage on the Lungarno between
the Ponte a Santa Trinita and the Ponte alla Carraia. How-
ever, since Bronzino, who evidently knows the truth about

these matters, affirms that they were among the first paint-
ings that Jacopo ever did, this must be taken as certain, and
Pontormo praised all the more highly, since their beauty is
such that they are unequalled and yet they were among his
very first works.

But to keep to the order of events: after what has been
described above, for the people of Pontormo, Jacopo did a
panel picture that was placed in the Lady Chapel of their
principal church of Sant'Agnolo, containing a St Michael
the Archangel and a St John the Evangelist. And at this
time, one of the two young men staying with him, namely
Giovanni Maria Pichi, of Borgo San Sepolcro, who lived a
very good life and later became a friar of the Servites, and
executed some works in Borgo and in the parish church of
Santo Stefano, he, I say, while still with Jacopo painted a large
picture of a nude St Quentin being martyred, to send to
Borgo; but because Jacopo, being so fond of this disciple of
his, wanted him to win honour and praise for his work, he
set out to retouch it; and not knowing how to stop, re-
touching one day the head, and the next day the arms, and
the day after the back, the retouching was so extensive that
it can more or less be said it was all from his hand. So there
is no call to wonder at the great beauty of this picture,
which is now in the church of the Observant friars of St
Francis, at Borgo San Sepolcro. The other of the two young
men, namely Giovanni Antonio Lappoli, of Arezzo, of
whom there is an account elsewhere, having, as a vain man,
while he was still with Jacopo painted a portrait of himself
in a mirror, Jacopo thought that it did not resemble him
very much, and so the master put his hand to the picture
and portrayed him so well that it seems a living person; and
this portrait is now in the house of the heirs of Giovanni
Antonio in Arezzo. Likewise Pontormo did portraits in
one and the same picture of two of his closest friends; one
was the son-in-law of Beccuccio Bicchieraio, but I do not
know his name or the other's, and it is enough that the
portraits are by the hand of Pontormo.

Afterwards, for Bartolommeo Ginori, in anticipation of his death, following the Florentine custom, he prepared a series of banners; and in the upper part of all these, on the white taffeta, he painted Our Lady with her Son, and on the coloured band of the lower parts he did the family's coat of arms, in the usual way. For the centre of the series, which numbered twenty-four, he made two banners all of taffeta, without the coloured bands, and he did a figure of St Bartholomew, four feet high, on each of them. And the size of these banners, as well as their almost completely novel style, made all the others made up to that time appear dull and shabby, and was the reason why they started to be made the size they are today, with great charm, and less expense for gold.

At the head of the garden and vineyard of the friars of San Gallo, outside the gate named after that saint, in the chapel that is in line with the entrance, he painted in the middle a Dead Christ, Our Lady weeping, and two *putti* in the air, one of whom held the Chalice of the Passion in his hands, while the other supported the drooping head of Christ. At each end were, on one side, a tearful St John the Evangelist, with arms extended, and on the other St Augustine in episcopal robes who, leaning with his left hand on his pastoral staff, stood in an attitude truly sorrowful, as he contemplated the Saviour in death. He also executed, for Messer Spina, an intimate friend of Giovanni Salviati, in a courtyard opposite the main door of his house, the coat of arms of that same Giovanni, who about that time had been created a cardinal by Pope Leo, with the red hat above and two *putti* standing beside it, which for fresco paintings are very beautiful and highly esteemed by Messer Filippo Spina, as from the hand of Pontormo.

Jacopo also worked, in competition with other masters, on the adornment of the furniture in wood which, as related previously, had been executed in a magnificent manner for some rooms of Pier Francesco Borgherini; and in particular, on two chests he painted with his own hand some scenes from the life of Joseph, in little figures, which were truly most

beautiful. But whoever wishes to see the best work he did in
his life, in order to consider Jacopo's brilliant skill in giving
vivacity to faces, in arranging figures, and in varying atti-
tudes, should look in a corner on the left as one enters
through the door of this living room of Borgherini's, who
was a nobleman of Florence, at a scene of some size, also
with little figures, in which Joseph in Egypt, as if he were a
king or prince, receives his father Jacob, with all Jacob's
sons and brothers, with unbelievable love and kindness. And
among the figures at the foot of the scenes, seated on some
steps, he portrayed Bronzino, then a boy and his disciple, in
a figure with a basket, which is a marvel of liveliness and
beauty. And if this scene were on a bigger scale, rather than
being small, on either a large panel or a wall, I venture to
say that it would be impossible to find another picture
executed with as much grace, perfection, and excellence as
this painting by Jacopo. So it is deservedly esteemed by all
the craftsmen as the most beautiful picture that Pontormo
ever did, and it is no wonder that Borgherini prized it so
highly, nor that he should have been begged by wealthy
men to sell it for them to present to mighty lords and
princes.

Because of the siege of Florence, Pier Francesco Borgh-
erini went away to Lucca, and Giovan Battista della Palla,
who desired to add to the other things that he was trans-
porting into France the decorations of Pier Francesco's living
room, for presenting to the king of France in the name of
the Signori, was so favoured, and knew so well what to say
and do, that the Gonfalonier and the Signori* gave him
permission for them to be taken away and payment made
to the wife of Pier Francesco. So along with Giovan Battista,
some men set off to execute the will of the Signori; but
when they arrived at Pier Francesco's house, his wife, who
was at home, poured on Giovan Battista the worst abuse
ever offered to any man.

* Members of the Signoria, the main governing body of Florence. The
city was besieged in 1529 after it had thrown out the Medici and restored
effective Republican government under Niccolò Capponi.

'So you dare, do you Giovan Battista,' [she said,] 'you low-class, second-hand dealer, you cheapskate twopenny trader, you dare to strip the decorations from the living rooms of gentlemen, and to despoil this city of her richest and most revered treasures, as you've always done and still do to embellish the countries of foreigners and enemies? I am not surprised at you, you common little enemy of Florence, but at the magistrates of the city, who put up with these abominable outrages. This bed that you are looking for, to further your own particular interests, and because of your greed for money, though you cover your evil intentions with the pretence of piety, is my nuptial bed, and it was in honour of my marriage that my father-in-law Salvi made all these regal and magnificent furnishings, which I revere in memory of him and for love of my husband, and which I mean to defend with my own life's blood. So get out of my house with your ruffians, Giovan Battista, and tell those who sent you here with orders to filch these things that I am not the woman to allow a single thing to be removed from here. And if those who put trust in you, a good-for-nothing wretch, want to give presents to the king of France, let them go and strip their own houses bare to send him the ornaments and beds from their own rooms. And if you ever again dare to come to this house for that purpose, I'll make you learn in a very painful way how much respect people of your sort should have for the houses of gentlemen.*

These words, spoken by Madonna Margherita, wife of Pier Francesco Borgherini and daughter of the most noble and prudent citizen Roberto Acciaiuolo, who was a truly valorous woman and the worthy daughter of a great father, were the reason, along with her noble daring and intelligence, why those treasures are still preserved in the house where they belong.

About this time, Giovan Maria Benintendi had decorated one of his antechambers with many pictures from the hands of various able masters, and after the work done for Borgherini by Jacopo Pontormo, encouraged by hearing him endlessly praised, he commissioned from Pontormo a painting of the Adoration of the Magi, when they went to

* Throughout this tirade, Borgherini's wife disparagingly uses the second person singular pronoun *tu* in addressing Giovan Battista.

see Christ in Bethlehem; and this work, since Jacopo did it with great zeal and diligence, proved to be varied and beautiful in its depiction of faces and in every other part, and more than worthy of all praise. Then afterwards, for Messer Goro da Pistoia, secretary to the Medici at that time, he did a picture with the portrait, from the knees upwards, of the Magnificent Cosimo de' Medici the elder, which is also truly praiseworthy; and this is today in the house of Messer Ottaviano de' Medici, in the possession of his son Alessandro, a young man, apart from the nobility and distinction of his blood, of edifying behaviour, well educated, and a worthy son of the Magnificent Ottaviano and Madonna Francesca, daughter of Jacopo Salviati and maternal aunt of the Lord Duke Cosimo.

By means of this work, and particularly the head of Cosimo, Pontormo became a friend of Messer Ottaviano; and when the great hall at Poggio a Caiano had to be painted, he was commissioned to paint the two ends, where the *oculi* (that is, the windows) give light, from the vaulting right down to the floor. Therefore Jacopo, more than usually anxious to do himself credit, both from respect for this country seat and out of rivalry with the other painters working there, set out to apply himself with such great diligence that he overdid it: for destroying and doing again every day what he had done the day before, he racked his brains for ideas so hard that it was piteous; yet all the time he kept on making new discoveries which gave honour to him and beauty to the work. Thus, having to execute a Vertumnus with his husbandmen, he painted a peasant seated with a billhook in his hand, which is so beautiful and well done that it is a very rare thing, just as some little boys depicted there are natural and lively beyond all belief. On the other side, he did Pomona and Diana, with other Goddesses, and he enveloped them, perhaps too fully, with draperies; none the less, all the work is beautiful and highly praised. But while he was working on this project, Leo met his death, and so it remained unfinished, as did many other similar kinds of work at Rome, Florence, Loreto, and other

places; and indeed the whole world was left poor, being bereft of the true Maecenas of men of talent.*

Having gone back to Florence, Jacopo painted in a picture a seated figure of St Augustine as a bishop giving his blessing, with two nude and very pretty *putti* flying through the air. And this picture is over an altar in the little church of the sisters of St Clement, in the Via di San Gallo. He likewise brought to completion a Pietà with some nude angels, which was a very fine work and held very dear by some merchants of Ragusa for whom he painted it; but especially beautiful in this was a landscape, for the most part taken from a print by Albrecht Dürer. He also painted a picture of Our Lady with her Son in her arms, surrounded by some *putti*, which is now in the house of Alessandro Neroni; and then for some Spaniards another picture, likewise a Madonna, but different from the above, and in another style; and when this came on sale in a second-hand dealer's shop many years later, Bronzino persuaded Bartolommeo Panciatichi to buy it.

Then in the year 1522, when there was an outbreak of plague in Florence, and so many left the city and fled in search of safety from this contagious disease, Jacopo was also given the opportunity to go some distance away and flee the city, because a certain prior of the Certosa,† a monastery built by the Acciaiuolo family three miles from Florence, had to have some pictures painted in fresco at the corners of a very large and beautiful cloister that surrounds a lawn, and he was told about Jacopo. The friar had him sought for and, having accepted the work very willingly at such a time, Jacopo went to the Certosa, taking with him only Bronzino. And having tasted that way of life, the quiet, the silence, and the solitude (all things in accord with Jacopo's inclinations and nature), he thought he would use the occasion to let his paintings reveal great strength of

* Pope Leo X, Giovanni de' Medici, died in December 1521.

† The Certosa (Charterhouse) del Galluzzo, founded by Niccolò Acciaiuoli in 1342.

effort, and to show the world that they had come to express greater perfection and a different manner of style from the works he had done previously. Now not long before, there had come from Germany to Florence a great number of sheets printed from engravings done with great subtlety with the burin * by Albrecht Dürer, the outstanding German painter and rare engraver of plates on wood and on copper; and these included many large and small scenes of the Passion of Jesus Christ, in which was all the perfection and excellence of engraving with the burin that could ever possibly be achieved, considering their beauty, variety of garments, and quality of invention. And so Jacopo, as he had, at the corners of the cloisters, to paint scenes from the Saviour's Passion, thought he would make use of the inventions of Albrecht Dürer (as mentioned above) in the firm belief that he would give satisfaction not only to himself but also to the majority of the craftsmen of Florence, who were all, with one voice and by general agreement and consent, proclaiming the beauty of those prints and the excellence of Albrecht.

So having set out to imitate that style, and seeking to give to the expressions of the faces of his figures the same alertness and variety that Albrecht had given to his, he captured it so strongly that the charm of his own early style, which had been given to him by Nature, full of sweetness and grace, was greatly changed by that new intensity and effort, and much damaged by his chance encounter with that German style; in all these works, therefore, beautiful though they may be, there is recognizable only a little of the graceful excellence he had up to then given all his figures. So then he painted on one corner, at the entrance to the cloister, a picture of Christ in the garden, simulating the darkness of the night illumined by the light of the moon so well that it seems to be daylight. And while Christ is praying, not far away lie sleeping Peter, James, and John, executed in a style

* The burin, or graver, a square, very sharp tool, capable of fine engraving.

so similar to that of Dürer, that it is a marvel. Near to hand is Judas who is leading the Jews, he, too, with a countenance so strange, as are the looks of all those soldiers executed in the German style with weird expressions, that it moves anyone looking at them to pity the simplicity of that man, who sought with so much effort and patience to learn what others flee and try to lose, in order to abandon the style which surpassed all the others in excellence and pleased everyone beyond all measure. But did not Pontormo know that the Germans and Flemings came to these parts to learn the Italian style, which he made such great efforts to abandon, as if it were bad?

Beside this scene is one in which Christ is taken by the Jews before Pilate, and in the Saviour he depicted all the humility that can possibly be imagined in the very person of innocence betrayed by wicked men, and in the wife of Pilate the pity and dread for themselves on the part of those who fear the divine judgement; and this woman, while she commends Christ's cause to her husband, gazes at his face with pitying wonder. Around Pilate are some soldiers, who are so characteristically German in the expressions on their faces and in their clothes, that anyone not knowing by whose hand it was, would be sure it was painted by Northerners.* It is true, however, that in the background of this scene there is a cupbearer of Pilate's who is descending some stairs carrying a basin and ewer, for washing Pilate's hands; and this figure is very beautiful and vivacious, and possesses a certain something of Pontormo's old style. Having next to paint, in one of the other corners, the Resurrection of Christ, Jacopo, who as someone who with no set mind was for ever dreaming up new things, took a fancy to change his colouring; and so he painted this work with colours in fresco so soft and so good that, had he executed the whole work otherwise than in the

* The word is *oltramontani*, i.e. ultramontanes or those beyond the mountains. The *maniera tedesca* – the German or Gothic style which Vasari so disliked – he thought of as applying to artistic work done generally north of the Alps.

German style he was using, it would assuredly have been
very beautiful, showing as it did in the faces of those soldiers,
looking as if dead in their varied attitudes, full of drowsiness,
so much excellence that to do better seems impossible.

Then continuing the scenes from the Passion in one of the
other corners, Jacopo painted Christ going with the Cross
on his shoulders to Mount Calvary, with the people of
Jerusalem behind, accompanying him, and in front the two
naked thieves, between the executioners, some on foot and
others on horseback, with the ladders, the inscription for the
Cross, the hammers, nails, and suchlike instruments; and at
the top, behind a little mound, is Our Lady with the Marys,
weeping as they wait for Christ, who having fallen to the
ground in the middle of the scene, is being beaten by many
Jews around Him, while Veronica is offering Him the Veil,
accompanied by some women, young and old, who weep
at the torment they see inflicted on the Saviour. And either
because he had been warned by his friends, or because this
one time Jacopo realized, belatedly, the harm to his own
sweet style his study of the German had done, this scene
came out much better than had the others executed in the
same place. This was because some of the naked Jews and
some of the faces of the old men are so well executed in
fresco that they could not be improved, although that
German style is generally followed in the whole work. After
these, Jacopo was to have gone on, in the other corners,
with the Crucifixion and the Deposition from the Cross;
but he left them for the time being, having it in mind to do
them last; and he executed in its place Christ taken down
from the Cross, using the same style, but with very harmoni-
ous colouring; and in this scene, not only is Mary Magdalen,
who is kissing the feet of Christ, very beautiful, but there are
two old men, representing Joseph of Arimathaea and Nico-
demus who, although painted in the German style, have the
most beautiful expressions and faces of old people, with their
downy beards and softness of colouring, anywhere to be seen.

Now not only did Jacopo invariably take a long time

over his paintings, but he also liked the solitude of the Certosa, and so he spent several years on the work he did there; then the plague ended and he went back to Florence, but even so he did not stop frequenting the place, and he was constantly coming and going between Certosa and the city. And continuing this way of life, he did many things to satisfy those fathers. For example, over one of the doors of the chapels in their church, he did a half-length portrait, from the waist up, of a lay brother attached to the monastery, who was still living at the age of 120; and this figure was so finely expressed, so vivacious and animated, that it alone is enough to earn Pontormo forgiveness for the strange and oddly capricious style that the solitude in which he lived, and his estrangement from human companionship, imposed upon him. Then, in addition, for the prior's room he did a picture of the Birth of Christ, representing Joseph as if in the darkness of the night of the nativity he were giving light with a lantern to Jesus Christ, and this he did in pursuit of the capricious and novel ideas inspired in him by the German engravings.

Let no one think that Jacopo is to be blamed because he imitated Albrecht Dürer in these novel ideas (for there is no error in that, and many painters have done so and still do), but because he adopted the uncompromising German style in everything, in the draperies, the expressions of faces, and the attitudes of his figures, which he should have avoided, save for using its inventive ideas, since he possessed the modern style in all its fullness of grace and beauty.

For the guest-quarters of the same fathers, Pontormo executed a large oil painting on canvas in which, without straining at all or doing violence to nature, he depicted Christ at table with Cleophas and Luke, all life-size; and because in this painting he trusted his own genius, it was a marvellous success, especially as among those serving at table he portrayed some of the friars' lay brothers, whom I have known myself, so well that they could not seem more lifelike or animated than they are.

In the meantime, while his master was doing all these

works for the Certosa, Bronzino very spiritedly continued his studies in painting, with the constant encouragement of Pontormo who loved his pupils, and, without ever having seen oil painting done on the wall, he executed on an arch, on the inner side of the door of the cloister leading into the church, a nude St Lawrence on the gridiron, which was so beautiful it conveyed a glimmering of the excellence which he has subsequently attained, as will be said in the appropriate place. And the picture was also immeasurably pleasing to Jacopo, who foresaw where Bronzino's talent would lead.

Not long after, there returned from Rome Lodovico di Gino Capponi, who had bought that chapel in Santa Felicità, on the right of the entrance into the church, which the Barbadori family had formerly arranged to be built by Filippo Brunelleschi, and he resolved to have the entire vault painted, and then to have an altarpiece prepared for it, with an ornate frame. He conferred with Niccolò Vespucci, who was a knight of Rhodes and his very close friend, as being someone who was also a friend of Jacopo and, what is more, knew the true talent and temper of that outstanding man; and he did and said so much that Lodovico commissioned the work from Pontormo. And so, having put up a barrier, which kept the chapel closed for three years, he set his hand to the work. On the vaulted ceiling above he painted a God the Father, who has four very impressive patriarchs around him; and in the four medallions at the angles he depicted the four Evangelists, that is, he did three by his own hand and Bronzino did one all by himself. I must mention, too, that on this occasion Pontormo hardly ever made use of his own young men or allowed them to touch what he intended to execute himself; and when he did want to make use of one of them, especially to encourage him to learn, he would let him do everything himself, as he did with Bronzino. And in the works which Jacopo carried out up to this point in the above-mentioned chapel, it seemed almost as if he had returned to his early style; but he did not do so in painting the altarpiece, for, intending to do original things, he executed it without shadows and with colouring

so bright and harmonious that one can scarcely distinguish the lights from the intermediate tints and the intermediate tints from the darks.

This altarpiece contains a Dead Christ who has been taken down from the Cross and is being carried to the tomb; there, too, is Our Lady, who is fainting away, and the other Marys, executed in a way so different from the first ones he painted that it is clearly evident that Pontormo's brain was for ever investigating new concepts and strange ways of working, and would never rest content with things as they were. In short, the composition of this panel is utterly different from the figures on the vaulting, and likewise the colouring; and the four Evangelists who are in the medallions on the spandrels in the vaulting are in another style, and far better. On the wall with the window are two figures in fresco: on one side the Virgin, and on the other the Angel coming to her with the Annunciation. But they are both so contorted that they demonstrate that, as I said, his bizarre and fantastic brain never rested content with anything; and so as to do this work in his own way, and allow no one to be a nuisance to him, he would never, when he was busy on it, want even the patron himself to see it. And thus, having painted it in his own way, without even any of his friends being able to point anything out, when it was finally uncovered and seen, all Florence marvelled at it.

For the same Lodovico, he did, in the same style, a picture of the Madonna to go in his room; and in the face of a picture of St Mary Magdalen he portrayed a daughter of Lodovico's, a very beautiful young woman.

Near to the monastery of Boldone, on the road that leads from there to Castello, and at the corner of another that climbs the hill and goes to Cercina, at a spot two miles' distance from Florence, Jacopo painted a tabernacle with a fresco of a Crucifixion showing Our Lady weeping, St John the Evangelist, St Augustine, and St Julian; and all these figures, as his earlier whim had not yet been given full rein

and he was still fond of that German style, were not very dissimilar from those he had painted at the Certosa. And he did likewise in a picture for the nuns of Sant'Anna, at the Porta San Frediano, an altarpiece showing Our Lady with the Child in her arms, and St Anne behind her, with St Peter, St Benedict, and other saints; and in the predella is a small scene with little figures, which represent the Signoria of Florence, when it would go in procession with trumpeters, fifers, mace-bearers, official messengers and ushers, and the rest of the palace household.

While Jacopo was executing this work, Pope Clement VII sent to Florence, under the care of the legate Silvio Passerini, cardinal of Cortona, Alessandro and Ippolito de' Medici, who were both very young men; and the Magnificent Ottaviano, to whom the Pope warmly recommended them, had the portraits of both of them done by Pontormo, who served him very well and made good likenesses, though he did not depart greatly from the style he had learned from the Germans. In the portrait of Ippolito, he included a favourite dog of that lord called Rodon, which was so in character and true to nature that it seemed really alive.

He likewise did a portrait of Bishop Ardinghelli, who later became a cardinal; and for his very dear friend Filippo del Migliore, for his house in the Via Larga, in a niche opposite the main door, he painted a woman as Pomona, and from this it seemed he was beginning to seek to shed in part that German style.*

Now Giovan Battista della Palla, seeing the name of Jacopo by many works becoming more celebrated every day, since he had not succeeded in sending the pictures done by Jacopo and others for Borgherini to the king of France, became determined, knowing the king desired it, to send him at all costs something by the hand of Pontormo. So he exerted himself so much that finally he prevailed on him to paint a most beautiful picture, the raising of Lazarus, which

*Pomona is the Goddess of fruit and fruit trees.

proved to be one of the best works Pontormo ever produced or that was ever sent (among countless others) by della Palla to the king of France. Not only were all the faces very fine, but the figure of Lazarus, whose spirit was repossessing his dead flesh as he came back to life, could not have been more marvellous, for about his eyes were still the signs of putre-faction, and the dead flesh was still cold at the extremities of his feet and hands, to which the spirit had not yet returned.

In a three-foot picture, Pontormo painted for the nuns of the Hospital of the Innocenti, with innumerable small figures, the story of the 11,000 martyrs, who were con-demned to death by Diocletian and all crucified in a wood; and in this painting, Jacopo also represented a very fine battle scene of horsemen, with nude figures, and some beauti-ful *putti*, flying through the air and shooting arrows at the executioners. Every part of this picture merits praise, and it is now greatly cherished by Don Vincenzo Borghini, the governor of the hospital, who was once Jacopo's close friend. For Carlo Neroni, Jacopo did another picture similar to the above, but with only the battle scene of the martyrs, and the angel who is baptizing them, and then the portrait of Carlo himself. Likewise, at the time of the siege of Florence, he did a portrait of Francesco Guardi in the garb of a soldier, which was a very fine work; and afterwards on the cover of this picture, Bronzino painted Pygmalion who is pray-ing to Venus for his statue to come to life and (as it indeed did, according to fables of the poets) become flesh and blood. At this time, after much labour, Jacopo attained something that he had for a long time desired; because having always wished to have a house of his own, to be able to stay in it and live his life in his own way, and not to have to lodge with others, he finally bought one in the Via della Colonna opposite the nuns of Santa Maria degli Angeli.

When the siege finished, Pope Clement ordered Messer Ottaviano de' Medici to have the hall of Poggio a Caiano brought to completion. Therefore, as Franciabigio and

Andrea del Sarto were dead, the charge of this was given entirely to Pontormo, who had the screens and scaffolding made, and began work on the cartoons; but because he then went off into fantasies and ruminations he never made any further progress with this work, which would not perhaps have been the case if Bronzino had been in those parts. But Bronzino, who was then working at the Imperiale, a country seat of the Duke of Urbino near Pesaro, though he was sent for every day by Pontormo, was not in a position to leave; for after he had executed a very beautiful naked Cupid on a spandrel of the vault of the Imperiale, and cartoons for the others, Prince Guidobaldo, having perceived the young man's talent, ordered his own portrait to be done by him. And as he wished to be portrayed wearing some armour that he was expecting from Lombardy, Bronzino was forced to remain with that prince longer than he would have wished, and in the meantime to paint for him the frame of a harpsichord, which greatly pleased him. Finally Bronzino did his portrait, which was very handsome and much to the prince's liking.

Jacopo, then, wrote so many times and employed so many means that finally he brought Bronzino back; but, for all that, the man would never be induced to do other than the cartoons for this work, even though he was pressed by the Magnificent Ottaviano and Duke Alessandro. In one of these cartoons, which are today for the most part in the house of Lodovico Capponi, is a Hercules crushing Antaeus, in another, Venus and Adonis, and in a drawing, a scene of nude men playing football. Meanwhile, after Signor Alfonso d'Avalos, Marchese del Vasto, had obtained from Michelangelo Buonarroti, through Fra Niccolò della Magna, a cartoon of Christ appearing to the Magdalen in the garden, he did his utmost to have Pontormo execute it for him in painting, Buonarroti having said to him that no one could serve him better. Jacopo did then execute that work to perfection, and it was judged to be a rare painting, both for the grandeur of Michelangelo's design and for Jacopo's colouring. Whereupon, after it had been seen by Signor

Alessandro Vitelli, who was then in Florence in command
of the garrison of soldiers, he had Jacopo execute another
picture from the same cartoon, which he then sent to Città
di Castello and had put in his own house.

Then, seeing how greatly Michelangelo esteemed Pon-
tormo, and how diligently Pontormo brought to com-
pletion and translated so perfectly and beautifully into
paintings the designs and cartoons of Michelangelo, Bar-
tolommeo Bettini so set about things that Buonarroti, his
close friend, made for him a cartoon of a nude Venus, being
kissed by Cupid, to be executed as a painting by Pontormo
and placed in the centre of one of his living rooms, in the
lunettes of which he had begun to have painted by Bronzino
figures of Dante, Petrarch, and Boccaccio, with the intention
to put there, too, all the other poets who have sung of love
in Tuscan prose and verse. So having received this cartoon,
Jacopo executed it perfectly, at his leisure, as will be told, in
the manner that all the world knows, without my praising
it further. These designs of Michelangelo's were the reason
why, when Pontormo considered the style of that most
noble craftsman, his ambition was stirred and he resolved
that he would strive with might and main, to the best of his
ability, to imitate and follow it. And then Jacopo realized
what a bad mistake he had made in letting the work at
Poggio a Caiano slip through his hands, although for this he
largely blamed the long and disagreeable illness he had
suffered, and finally the death of Pope Clement, which
completely disrupted the project.

After the works mentioned above, Jacopo painted a
portrait from life of Amerigo Antinori, a young man who
was very popular in Florence at that time, and as this was
highly praised by everyone, Duke Alessandro informed him
that he wished to have his portrait done in a large painting.
Jacopo, more for convenience, initially did the portrait in a
little picture the size of a half-folio sheet, and with such
diligence and care that the works of the miniaturists bear no
comparison with it; for besides being a good likeness, there

is in the head all that could be desired in the rarest of paintings; and then, from this little picture, which is now in the wardrobe of Duke Cosimo, Jacopo made a large portrait of the Duke, with a stylus in his hand drawing the head of a woman. And this bigger picture Duke Alessandro subsequently gave to Signora Taddea Malespina, sister of the Marchioness of Massa. Because of these works, the Duke wished at all costs to make a generous acknowledgement of Jacopo's talent, and he told him through his servant, Niccolò da Montaguto, that he should ask for whatever he wanted, and it would be granted. But (I do not know if I should say this) so great was the pusillanimity, or so excessive the modesty and deference of this man, that all he asked for was just enough money to enable him to redeem a cloak he had just pawned. When the Duke heard this, not without laughing at his foibles, he had him given fifty gold crowns and offered a salary; and even then Niccolò was hard put to it to persuade him to accept.

Meanwhile, Jacopo finished painting the Venus from the cartoon belonging to Bettino, and it proved to be a marvellous work; but it was not given to Bettino for the price at which Jacopo had promised it to him, for certain sycophants, in order to spite Bettino, took the picture from Jacopo almost by force and gave it to Duke Alessandro, returning his cartoon to Bettino. When Michelangelo heard about this, he was very displeased out of love of his friend, for whom he had made the cartoon, and felt ill-disposed towards Jacopo, who, though he had fifty crowns from the Duke, could not be said to have defrauded Bettino, having given up the Venus at the command of the man who was his lord. But some say that the cause of all this was largely Bettino himself, for having wanted too much.

Pontormo having thus been given the occasion, by means of this money, to set his hand to putting his house in order, made a start on the building work, but did nothing of much importance. Indeed, though some affirm that Pontormo was of a mind to spend very heavily, according to his

position, and make a commodious dwelling-place, of good design, it is none the less evident that what he did, whether he did not have the wherewithal to spend, or for some other reason, has the aspect of a building put up by an eccentric recluse rather than of a well-appointed residence, seeing that to the room where he used to sleep and sometimes work, he had to climb by a wooden ladder, which he pulled up by means of a pulley after he was indoors, so that no one could clamber up to him without his consent or knowledge. But what most upset people about him was that he would not work except when and for whom it pleased him, and at his own whim; hence, when he was many times sought after by noblemen who wished to have some of his work, and once in particular by the Magnificent Ottaviano de' Medici, he would not serve them; and then he would be prepared to do all and everything for some low common man, and for a ridiculously low price. Thus the mason Rossino, a very clever person in his own trade, playing the simpleton, had from him, as payment for having laid the bricks in some rooms and done other building work, a very fine picture of Our Lady, a painting which demanded from Jacopo as much toil and trouble as what he built did from the mason. And this Rossino was so capable in business, that, besides that picture, he extracted from Jacopo a most beautiful portrait of Cardinal Giulio de' Medici, copied from one by the hand of Raphael, and, on top of that, a very fine little picture of the Crucifixion; and this, although the Magnificent Ottaviano bought it from the mason Rossino as something from the hand of Jacopo, none the less is known for certain to be by the hand of Bronzino, who made it entirely himself while he stayed with Jacopo at the Certosa, though subsequently, I do not know why, it remained in Pontormo's possession. And all these three pictures, extracted from Jacopo by the mason's ingenuity, are now in the house of Alessandro de' Medici, son of Ottaviano. And now, although Pontormo's behaviour and his manner of living as a recluse in his own way earned little praise, this does not

mean that one would not be able to excuse him if one wished to do so. For it is the case that for the works he did, we should be under an obligation to him, and for those it did not please him to do, we should not blame or censure him. No craftsman, surely, is obliged to work, except when and for whom he wishes; and if Pontormo suffered for this, it was his own loss. As for solitude, I have often heard it said that it is a great friend to study; but even if this were not so, I do not believe that one must heap blame on anyone who, without offending God or his neighbour, lives in his own way, making his dwelling and employing his time in accord with what best suits his nature.

But, leaving these matters aside, to return to Jacopo's works: Duke Alessandro had in some part restored the villa of Careggi, formerly built by the elder Cosimo de' Medici, at two miles' distance from Florence, and had completed the ornamentation of the fountain and the labyrinth, which spread itself in the centre of an open courtyard, on to which there opened two loggias; and he then ordered that these loggias should be painted by Jacopo, but that he should take a partner so that he might finish them sooner, and so that the association, keeping him happy, might be a cause of making him work, without his fantasizing all the time and cudgelling his brains. Indeed the Duke himself, having sent for Jacopo, asked him earnestly if he would completely finish all that work as early as he could. So then Jacopo summoned Bronzino, and he caused him to paint single figures at the bases of each of five compartments of the vaulting, namely Fortune, Justice, Victory, Peace, and Fame; and on the other, there being six in all, Jacopo painted a Cupid in his own hand. Having designed some *putti* for the oval space of the vault, holding various animals and foreshortened from below upwards, he then had them all save one coloured by Bronzino, who performed very well. And because, while Jacopo and Bronzino were doing these figures, the surrounding ornaments were being executed by Jacone, Pier Francesco di Jacopo and others, the work came

to be finished in a very short while, to the great satisfaction of the Duke, who wished to have the other loggia painted, but was not in time, for the reason that, this work having been finished on 13 December 1536, on 6 January following, the most illustrious lord was killed by his kinsman Lorenzino; and so this and other works remained unfinished.

The Lord Duke Cosimo having then been chosen, and the business of Montemurlo having passed off happily, a beginning was made on the works of Castello, as told in the *Life* of Tribolo; and his most illustrious Excellency, to please the Signora Donna Maria, his mother, ordered that Jacopo should paint the first loggia, which is found on the left hand after entering the palace of Castello.* So Jacopo set to work, and first he designed all the ornaments that were to go there, which for the most part he then had executed by Bronzino, and the men who had done those at Careggi. After that, he shut himself up alone and carried on the work at leisure pursuing his own ideas, while studying with all diligence, so that it should be far better than what was done at Careggi, which he had not executed entirely with his own hand. This he was now able to do comfortably, since he received eight crowns a month for it from his Excellency, whom he portrayed, young as he was, at the beginning of the work, and likewise Signora Donna Maria, his mother. Finally, after the loggia had been screened off for five years, and it was still impossible to see what Jacopo had done, one day this lady lost her temper with him and commanded that the scaffolding and screen be demolished. But Jacopo had heard what was happening, and obtained a few days' grace before it should be finally uncovered, during which he first did some retouching where this seemed necessary, and then had a curtain made of his own devising to keep the loggia covered when those lords were not there, so that the weather might not, as it had done at Careggi, destroy those pictures

* The Battle of Montemurlo was won on 2 August 1537 by Cosimo against his Republican opponents in the struggle for political control of Florence.

which were in oils on the dry plaster; and then he uncovered it amidst eager expectations from everyone, who thought that Jacopo must have surpassed himself in this work and created something stupendous. But the results did not altogether fulfil this view, for although many parts of the work are good, the overall proportion of the figures seems very ugly, and certain of the contorted attitudes to be seen there seem to lack proper rule and measure and to be very weird. But Jacopo excused himself by saying that he had never worked at all willingly in that place, because, as it was away from the city, it seemed that it would only be exposed to the fury of the soldiers and other suchlike dangers. But there was no call for him to fear that, because the weather and the passing of time (since the work had been executed in the way that was described) are destroying it little by little.

So then, in the middle of the vaulting, Jacopo did a figure of Saturn under the sign of Capricorn, and a hermaphrodite Mars in the sign of Leo and Virgo, and some *putti* flying through the air, like those of Careggi. He also painted several huge female figures representing Philosophy, Astrology, Geometry, Music, Arithmetic, and a Ceres, with some medallions containing little scenes executed in different shades of colour, appropriate to the figures. And although this constrained and laboured work did not give much satisfaction, or if any, much less than expected, his Excellency indicated that it pleased him, and he made use of Jacopo on every possible occasion, since this painter was held in great veneration by the people for the many good and beautiful works he had done in the past.

The Lord Duke then brought to Florence Master Giovanni Rosso and Master Niccolò, Flemings and excellent masters in tapestries as woven in Arras, so that this art might be learned and practised by the Florentines; and he gave orders for tapestries in gold and silk to be made for the Council Hall of the Two Hundred, at a cost of 60,000 crowns, and for Jacopo and Bronzino to do the cartoons,

showing scenes from the life of Joseph. So Jacopo made two of them, one of the death of Joseph being announced to Jacob, when the bloodstained clothes are shown to him, and the other of the flight of Joseph from the wife of Potiphar, leaving his garment behind; but these did not please either the Duke or those masters who had to put them into execution, for they appeared strange to them, and unlikely to be successful when executed in woven tapestries. And so Jacopo did not go on to do any more cartoons.

Returning to his usual kind of project, he painted a picture of Our Lady which the Duke gave to Signor Don — who brought it to Spain. And then since his Excellency, following in the footsteps of his ancestors, has always sought to embellish and adorn his city, when it came to him for consideration, he resolved to have painted all the main chapel of the magnificent church of San Lorenzo, formerly built by Cosimo de' Medici the elder. So he gave charge of this to Jacopo Pontormo, either of his own will or, as we said, influenced by Messer Pier Francesco Ricci, his major-domo, and Jacopo was very glad of that favour; for though he was then well advanced in years, and therefore the great size of the work gave him pause to think, and perhaps dismayed him, on the other hand he reflected that, in a work of such grandeur, he had a very wide field in which to demonstrate his talent and worth. Some people say that Jacopo, when he saw the work was being commissioned from him, notwithstanding that the very famous painter Francesco Salviati was in Florence and had brought to a happy conclusion the hall of the palace which was once the audience chamber of the Signoria, must needs pronounce that he would show the world how to draw and paint, and how to work in fresco, and moreover that the other painters were ten a penny, and other such arrogant and overbearing words. But as I myself always knew Jacopo as a modest person, who spoke of everyone honourably and in the way to be expected of a good-mannered and virtuous craftsman, such as he, I believe that these words were imputed to him wrongly and that he

never uttered such boasts, which are for the most part heard
from the mouths of vain men who presume too much of
themselves, and with whose sort neither virtue nor good
breeding have any connection. And though I might have
kept silent about these things, I have not wished it; because
to proceed as I have done seems to me the duty of a con-
scientious and truthful author. It is enough that, although
these utterances went around, especially among our
craftsmen, I none the less hold firmly to the opinion that
they were the words of malignant men, since Jacopo was
always, as he appeared to all, a person of modesty and
perfect manners.

Having then closed off the chapel with walls, hoardings
and curtains, and given himself over to complete solitude,
he kept it for the space of eleven years so firmly locked up,
that no living soul except himself ever went in there, neither
friends nor anyone else. Admittedly some youngsters who
were drawing in the sacristy of Michelangelo, as young
men will, climbed in by its spiral staircase on to the roof of
the church, and having removed some tiles and the batten
of one of the gilded rosettes that are there, saw everything;
and when Jacopo was informed of this, he took it very
badly, but then he reacted only by barricading it even more
painstakingly. (Yet some say that he resolutely chased after
those youngsters, to do something little to their liking.)
Imagining that he must surpass all the other painters, and, it
was said, even Michelangelo, in this work, Jacopo painted
in the upper part several scenes showing the Creation of
Adam and Eve, their eating of the forbidden fruit, their
expulsion from Paradise, the tilling of the earth, the sacrifice
of Abel, the death of Cain, the blessing of the seed of Noah,
and the occasion when he drew up the plan and meas-
urements of the Ark. Then on one of the lower walls, each
of which is thirty feet in both directions, he painted the
inundation of the Flood, in which there are a mass of dead
and drowned bodies, and Noah talking with God. On the
other wall is depicted the universal Resurrection of the

dead, which is to be on the last and glorious day, with such
variety and confusion that the event itself will perhaps not
be more real or, so to say, true to life than Pontormo has
painted it. Then opposite the altar between the windows,
that is, on the middle wall, there is on either side a row of
nude men who, grasping and clinging to each other with
their hands, legs and trunks, are forming a ladder to ascend
to Paradise, leaving the earth, where there are many dead
bodies in company with them; and, on either side, two dead
bodies mark the end, both clothed, except for their legs and
arms, with which they are holding two lighted torches. At
the top, in the centre of the wall, over the windows, he
painted in the middle Christ in majesty, on high, and sur-
rounded by angels, all nude, who is bringing those dead
people back to life to judge them. But I have never been
able to understand the doctrine of this scene (though I know
that Jacopo had a good mind himself and kept company
with learned and well-educated people), specifically what
he meant to signify in that part of the painting where Christ
on high is bringing the dead back to life, while below His
feet is God the Father, creating Adam and Eve. Besides this,
in one of the corners, where stand the four Evangelists,
naked, with books in their hands, it does not seem to me
that in any place at all did he pay heed to any order of
composition, or measurement, or time, or variety in the
faces, or changes in the flesh colours, or, in brief, to any
rule, proportion or law of perspective; and instead, the work
is full of nude figures with an order, design, invention,
composition, colouring, and painting done in his own
personal way, with so much melancholy and so little pleasure
for the beholder, that I am resolved, since even I do not
understand it though I am a painter myself, to let those who
see it judge for themselves. For I truly believe I would drive
myself mad to become embroiled with this painting, just as,
it seems to me, in the eleven years he spent on it, Jacopo
sought to embroil himself and whoever looks at it with
those extraordinary figures. And although there may be in

this work some part of a torso, with its back turned, or from the front, and some side views, executed with marvellous care and effort by Jacopo, who for almost everything made finished models of clay in the round, none the less as a whole it is alien to his own style and, as it appears to almost everyone, lacks correct measurements; because, for the most part, the torsos were large and the legs and arms small, not to mention the heads, in which one could see just nothing at all of the exceptional excellence and grace he used to impart to them, to the perfect satisfaction of those who admire his other pictures. So it seems that in this picture he paid regard only to certain parts, and of the other, more important parts he took no account whatsoever; and, to sum up, whereas he had thought in this work to surpass all the paintings there are, he did not even match to any extent his own pictures that he had done previously. Thus it can be seen that anyone who wishes to do more than he should, and as it were to do violence to nature, ruins the good qualities with which nature has generously endowed him. But what can or should one do except have compassion for him, seeing that men practising these arts of ours are as much subject to error as others? And the good Homer, as it is said, even he sometimes nods off asleep; nor will it ever be that in every single one of Jacopo's works (however much he wanted to do violence to nature) something good and praiseworthy will not be found. And because he died shortly before he finished this work, some affirm that he died from grief, remaining at the end of his days very greatly dissatisfied with himself. But the truth is that being old and exhausted from doing portraits, clay models, and working so much in fresco, he sank into a dropsy, which finally killed him at the age of seventy-five.

After Pontormo's death there were found in his house many very fine drawings, cartoons, and models in clay; and also a panel picture of Our Lady splendidly executed by him, from what one can see, in a beautiful style, many years before, which was subsequently sold by his heirs to Piero Salviati.

Jacopo was buried in the first cloister of the church of the Servite friars, beneath the scene he himself once painted there of the Visitation, and he was honourably accompanied to his grave by all the painters, sculptors and architects.

Jacopo was a very well-bred and frugal man, and in his dress and way of life more miserly than moderate, and he always lived all by himself, never wanting anyone to serve him or cook for him. In his last years, however, he took in, so as to bring him up, Battista Naldini, a young man of fine spirit, who took that modest bit of care of Jacopo's life which Jacopo allowed him to, and who, through his teaching, achieved no little success in design, such indeed that excellent results are hoped for. Pontormo's friends, in particular during this last phase of his life, were Pier Francesco Vernacci and Don Vincenzo Borghini, with whom he sometimes relaxed, if rarely, over a meal. But, above all, always supremely loved by him was Bronzino, who loved him equally in return, in gratitude and acknowledgement of the benefits received from him. Pontormo had some very odd traits, and was so fearful of death that he would not even hear it mentioned, and he fled from having to encounter dead bodies. He never went to festivals or to any places where people get together, to avoid being caught in a crowd; and he was solitary beyond all belief. Sometimes when he was at work, he began to think so deeply about what he wanted to do, that he would leave without having done anything else all day except stand in deep thought; and that this happened innumerable times in the work of San Lorenzo can easily be believed, because when he was determined, as an able and experienced man, he never found it at all hard to do what he wished and had decided to put into execution.

LIFE OF
FRANCESCO SALVIATI

—— · ——

Florentine painter, 1510–1563

THE father of Francesco Salviati, whose *Life* we are about to write and who was born in the year 1510, was a worthy man called Michelagnolo de' Rossi, a weaver of velvets; as he had not only this one child but many others, male and female, he had need of assistance, and so he had made up his mind that at all costs he would make Francesco apply himself to his own trade of weaving velvets. But the young boy, who had turned his mind to something else and who disliked being occupied in that craft, even though in former times it had been practised by, I do not say noble but quite rich and prosperous people, did what his father wished with very bad grace. Indeed, keeping company in the Via de' Servi, where his father had a house, with the sons of Domenico Naldini, their neighbour and an honourable citizen, he showed himself set on living honourably and decorously, and very interested in design. In this regard, he was given not a little bit of help by a cousin of his, called Diacceto, a young goldsmith, who had a fair understanding of design. For not only did Diacceto teach him all that he knew, little as it was, but he also favoured him with many designs by various able craftsmen, with which, unknown to his father, Francesco practised drawing day and night with incredible zeal.

However, Domenico Naldini became aware of this, and then after he had throughly examined the boy, he prevailed on his father, Michelagnolo, to place him in his uncle's

workshop to learn the goldsmith's craft.* And through this opportunity for design, within a few months Francesco made so much progress that everyone was astonished. Moreover, there being at that time a society of young goldsmiths and painters which met occasionally and used to spend holidays drawing the best-praised works around Florence, no one among them worked harder or more devotedly than Francesco. The young men of that society were Nanni di Prospero delle Corniole, the goldsmith Francesco di Girolamo del Prato, Nannoccio da San Giorgio, and many other youngsters who afterwards became very able in their professions.

At this time, when they were both still children, Francesco and Giorgio Vasari became very close friends, for the following reason. In the year 1523, when Silvio Passerini, cardinal of Cortona, was passing through Florence as the legate of Pope Clement VII, his kinsman Antonio Vasari took Giorgio, his eldest son, along to pay his respects. And when the cardinal saw that this little boy, who was then no more than nine years old,† through the care and attention of Messer Antonio da Saccone and Messer Giovanni Pollastra, an outstanding poet of Arezzo, had been taught his first letters so well that he knew a great part of Virgil's *Aeneid*, which he was glad to hear him recite, and also that he had learned to draw, from the French painter, Guillaume de Marcillat, he gave instructions that Antonio should himself take the boy to Florence. There, Giorgio went to stay in the house of Niccolò Vespucci, a knight of Rhodes, who lived at the side of the Ponte Vecchio, above the church of the Holy Sepulchre, and who placed him with Michelangelo Buonarroti; this came to the notice of Francesco, who was then living in the alley of Messer Bivigliano, where his father rented a big house that looked out on the Vac-

* Possibly the uncle was a Michele di Lorenzo Naldini, active in Rome as a goldsmith 1513–31.

† Cardinal Passerini was in Arezzo in 1524, when Vasari was aged thirteen.

chereccia, employing many workmen. And thus, since like attracts like, he set out to ensure that he became a friend of Giorgio, through the medium of Messer Marco da Lodi, one of the cardinal of Cortona's gentlemen, who showed Giorgio a portrait which pleased him greatly, by the hand of Francesco, who had a short while before been placed to learn painting with Giuliano Bugiardini.

In the meantime Vasari, not neglecting the study of letters, by order of the cardinal spent two hours every day with Ippolito and Alessandro de' Medici, under Piero, their very able tutor.

This friendship contracted, as already said, between Vasari and Francesco was such that it never ceased, even though, because of rivalry and a certain touch of arrogance in Francesco's particular way of speaking, there were some who thought otherwise. Vasari, meanwhile, had been some months with Michelangelo when that great man was called to Rome by Pope Clement to receive instructions for beginning the library of San Lorenzo, and he was then placed by Michelangelo, before he left, with Andrea del Sarto. And while Giorgio was studying design under Andrea, he secretly passed on the drawings of his master to Francesco, whose only wish was to see and study them, which he did, day and night.

Then, after being placed by the Magnificent Ippolito de' Medici with Baccio Bandinelli, who was charmed to have the boy with him, and to teach him, Giorgio contrived to have Francesco join him, to the great advantage of both of them; for they learned more and made more progress in one month by working together than they had in two years when drawing by themselves; and so too did another young man, who was also then working under Bandinelli, called Nannoccio, of the Costa San Giorgio, of whom I spoke a little while ago.

Now when, in the year 1527, the Medici were driven out of Florence, during the fighting for the palace of the Signoria, a bench was thrown from on high to fall on those who were

assailing the entrance gate; but, as luck would have it, it struck an arm of Buonarroti's marble David which is on the palace rostrum by the gate, and broke it into three pieces. And so after these pieces had lain on the ground for three days, without being gathered up by anyone, Francesco sought out Giorgio at the Ponte Vecchio and, after he had told what he had in mind, children though they were, they went together to the Piazza and, without thinking of the danger, amidst all the soldiers on guard, they found the pieces and carried them off to the house of Francesco's father, Michelagnolo, in the alley of Messer Bivigliano. And having later recovered them from that house, in due course Duke Cosimo had them restored to their proper place, with copper pegs.

When, later on, the Medici were in exile, and the cardinal of Cortona along with them, Antonio Vasari took his son back to Arezzo, much to his annoyance and that of Francesco, as they loved each other like brothers; but they did not stay separated from each other for long, because when, through the plague that struck the following August, his father died, as well as the best part of his family, Giorgio was so pressed in the letters that came from Francesco, who himself also nearly died of the plague, that he went back to Florence. And then, driven by need and the desire to learn, they made marvellous progress, going along together with Nannoccio da San Giorgio, all three of them, to the workshop of Raffaello da Brescia, under whom Francesco made many little pictures, being the one among them who had most need of procuring the means to live.

With the arrival of 1529, as Francesco felt that he would not profit very much from staying in Brescia's workshop, he and Nannoccio went to stay with Andrea del Sarto with whom they remained as long as the siege lasted, but in so much discomfort that they regretted not having followed Giorgio, who that year stayed with the goldsmith Manno in Pisa, applying himself to the goldsmith's trade for four months to make a living. Then, after Vasari had gone to Bologna, when Charles V was crowned there as emperor

by Clement VII, Francesco, who had remained in Florence, executed in a little panel a votive picture for a soldier who, during the siege, had been murderously attacked by certain other soldiers. And although it was work of a mean kind, he studied it and executed it to perfection. Not many years ago, this votive offering fell into the hands of Giorgio Vasari, who gave it to the Reverend Vincenzo Borghini, governor of the Innocenti, who holds it dear. For the Black Friars of the abbey, he did three small scenes for a tabernacle of the Blessed Sacrament made by a woodcarver Tasso in the manner of a triumphal arch, in one of which is the sacrifice of Abraham, in the second, the manna from Heaven, and in the third, the Hebrews eating the paschal lamb on their departure from Egypt. And this work was a good token of the success he subsequently attained.

Afterwards, for Francesco Sertini, who sent it to France, he did a picture showing Delilah cutting off Samson's hair, and in the distance Samson embracing the columns of the temple to bring them crashing down on the Philistines: a picture which made Francesco's name as the most outstanding of the young painters then in Florence.

Not long after, Benvenuto dalla Volpaia, a master clock-maker, who found himself in Rome at that time, was asked by the elder Cardinal Salviati to find for him a young painter who might stay with him and paint some pictures for his delight. Benvenuto proposed Francesco, who was his friend and whom he knew to be the most capable of all the young painters of his acquaintance; and he did this all the more willingly, as the cardinal had promised he would give the painter every help and convenience to be able to study. The young man's qualities appealed to the cardinal, and so he told Benvenuto to send for him, and give him the money required. And then after Francesco arrived in Rome, as his way of setting about things, and his general behaviour and manner, were pleasing to him, the cardinal ordered that he should have rooms in the Borgo Vecchio, and four crowns a month, and a place at the table of his own gentlemen. The

first works made for the cardinal by Francesco (who felt he had experienced a great stroke of luck) were a picture of Our Lady, held to be very beautiful, and on canvas a picture of a French nobleman chasing in pursuit of a stag which flees to save itself in the temple of Diana; and I keep the drawing of this work from Francesco's hand, in memory of him, in my book. When this canvas was finished, the cardinal commissioned from him a very fine picture of Our Lady, portraying a niece of his, married to Signor Cagnino Gonzaga, with his portrait too.

Being in Rome, and having no more pressing desire than to see his friend Giorgio Vasari in that city, Francesco found Fortune favourable to his desires, but even more so did Vasari. For Cardinal Ippolito, having parted in anger from Pope Clement for the reasons then given, but returning afterwards to Rome accompanied by Baccio Valori, in passing through Arezzo found Giorgio, who had been left fatherless and was looking after himself as best he could. So, as the cardinal wanted him to do well in painting, and also wished to have him near him, he ordered Tommaso de' Nerli, his commissary in Arezzo, that he should send him to Rome as soon as he had finished a chapel he was doing in fresco for the monks of St Bernard of the Order of Monte Oliveto in that city; and these instructions Nerli carried out immediately.

So having arrived in Rome, Giorgio went at once to find Francesco, who, beaming with joy, told him how greatly he was favoured by his lord, the cardinal, and how well placed to satisfy his urge to study, adding:

Not only am I enjoying myself now but I hope for even better things to come because besides seeing you, Giorgio, in Rome, and you're the closest of my young friends, whom I shall be able to talk to and confide in about everything to do with painting, I also live in hopes of entering the service of Cardinal Ippolito de' Medici, from whose liberality, as well as from the favour of the Pope, I shall be able to hope for even greater things than I have at present; and this is bound to happen, so long as a certain young man who is expected from abroad does not turn up.

Although he realized that this certain young man was himself, and that the place was being kept for him, Giorgio did not want to reveal himself yet, since some doubt had entered his mind as to whether the cardinal might have other plans in readiness; and also he did not want to say anything that might turn out otherwise. He had brought with him a letter from the above-mentioned commissary, Nerli, for the cardinal, which, after being in Rome five days, he had not yet presented.

Finally, Giorgio and Francesco went to the palace, and there, in what is now the Hall of Kings they found Messer Marco da Lodi, who, as said above, had formerly been with the cardinal of Cortona, but who was then serving the Medici. So having presented himself to him, Giorgio told him that he had a letter from the commissary at Arezzo, which was meant for the cardinal, and that he would like him to be good enough to pass it on; and then, just as Messer Marco was promising to do this instantly, the cardinal himself arrived on the scene. So Giorgio went up to him and, kissing hands, presented the letter, and was received very gladly; then a little later, Jacopone da Bibbiena, master of the household, was commissioned to arrange living accommodation for him and find him a place at the pages' table. Francesco felt it was strange that Giorgio had not confided in him; and yet he decided that he had done it with good intentions and all for the best.

So then, after Jacopone had allocated some rooms to Giorgio behind Santo Spirito, and near to Francesco, the two of them devoted themselves very profitably in company together all that winter to matters of painting, and they did not fail to draw all the notable things in the palace and elsewhere in Rome. And since they could not carry on with their drawing when the Pope was in the palace, as soon as his Holiness rode off, which he often did, to the Magliana, they entered those rooms to do their drawing, by means of friends, and would stay there from morning to night, eating only a piece of bread, and almost freezing with cold.

Then after Cardinal Salviati had ordered Francesco to paint in fresco in the chapel of his palace, where he heard Mass every day, some scenes from the life of John the Baptist, Francesco, and Giorgio along with him, devoted himself to studying nudes from life, in a neighbouring bath-house; and afterwards they did some anatomical work in the Camposanto. With the arrival of spring, when Cardinal Ippolito was sent by the Pope to Hungary, he arranged that Giorgio should be sent to Florence, where he was to execute some pictures and portraits to send to Rome. But the following July, what with all his labours during the winter and the heat of the summer, Giorgio fell ill and was carried in a litter to Arezzo, much to the displeasure of Francesco, who was also ill, and indeed came near to death.

Francesco, however, made a recovery and he was then, through Antonio dell'Abacco, a master woodcarver, commissioned by Messer Filippo da Siena,★ to paint in fresco in a niche over the door at the back of Santa Maria della Pace a figure of Christ speaking to St Philip, and in two angles the Virgin and the Angel of the Annunciation. These pictures so pleased Messer Filippo that for the same place he commissioned an Assumption of Our Lady for a large square space, which was not yet painted, on one of the eight sides of that church. Thereupon Francesco, reflecting that he had to do this work not only in a public place, but in a place where there were pictures by men of the rarest kind – Raphael of Urbino, Rosso, Baldassare da Siena, and others – with the utmost care and diligence executed it on the wall in oils; and this proved very successful and earned him great praise. Among the others, one figure held to be excellent was the portrait he did of Messer Filippo himself, with his hands clasped. And because Francesco lived, as was said, with Cardinal Salviati, and was known as his protégé, he began to be called and known by no other name but that of Cecchino Salviati, and he kept that surname till he died.

★ Filippo Sergardi, a Sienese Apostolic proto-notary.

After the death of Clement VII and the election of Paul III, Messer Bindo Altoviti had painted by Francesco on the façade of his house, on the bridge of Sant'Angelo, the arms of the new Pope with some large nude figures, which gave immeasurable pleasure. At the same time he painted Messer Bindo, and this was a very good figure and fine portrait; afterwards it was sent to his villa of San Mizzano in Valdarno, where it still is. Later, for the church of San Francesco a Ripa, he did a most beautiful oil painting of the Annunciation, executed with all diligence.

On the coming of Charles V to Rome in the year 1535, for Antonio da San Gallo Francesco executed some scenes in chiaroscuro which were placed on the arch made for San Marco, and these pictures, as said elsewhere, were the best in all the display. Then Signor Pier Luigi Farnese, who was made Lord of Nepi at that time, wanted to adorn that city with new buildings and paintings, and so he took Francesco into his service, giving him rooms in the Belvedere, where he executed for him on large canvases some scenes in gouache of the deeds of Alexander the Great, which were subsequently executed and woven into tapestries in Flanders. For the same Lord of Nepi he painted a large and very beautiful bath-house with many scenes and figures executed in fresco. Afterwards, when Pier Luigi was made Duke of Castro, for his first entry into the city, a rich and very fine festive display was arranged and devised by Francesco, with an arch at the gate all covered with scenes, figures, and statues, executed with great judgement by able men, and in particular by Alessandro, called Scherano, a sculptor from Settignano. Another arch, in the form of a façade, was made at Petrone, and yet another on the piazza, the woodwork for these arches being made by Battista Botticelli; and among other things in this display Francesco executed beautiful scene paintings for a play that was performed.

At that time, too, Giulio Camillo Delminio put together a book of his compositions to send to King Francis

of France; he had it all illustrated by Francesco Salviati, who put into it all the diligence such a work requires. Cardinal Salviati, having a desire to have a picture in tinted woods, namely in tarsia, from the hand of Fra Damiano da Bergamo, a lay brother of San Domenico, sent him from the hand of Francesco a drawing in red chalk to show how he wished it to be, and this drawing, which represented King David being anointed by Solomon, was the best and truly the rarest thing ever done by Cecchino Salviati. Now Giovanni da Cepperello and Battista Gobbo of San Gallo had caused Jacopo del Conte of Florence, a young painter at the time, to paint for the Society of the Misericordia of the Florentines of San Giovanni Decollato under the Capitol in Rome, in the second church where they have their meetings, a scene from the life of St John the Baptist, when the Angel appears in the temple to Zacharias; and afterwards, they commissioned Francesco to paint beneath this another scene from the life of the same saint, showing the visit of Our Lady to St Elizabeth. And this work, which was finished in the year 1538, was executed in fresco in such a manner that it is worthy to be numbered among the most graceful and best-conceived pictures that Francesco ever did, in its invention, in the composition of its scenes, in the attention given to method and rule in the gradation of the figures, in the perspective and architecture of the buildings, in the nudes, the garments, the gracefulness of the faces, and, in sum, in all its parts; so no wonder that all Rome admired it. Around a window, he also painted some little scenes that are marvellously graceful. And so as not to lose time, while he was employed on this work, he did many other exercises and drawings, and he did a coloured Phaethon with the horses of the sun, which Michelangelo had drawn.

Salviati showed these works to Giorgio, who had gone to Rome for two months after the death of Duke Alessandro, and he told him that, after he had finished a picture of the young St John for his lord, Cardinal Salviati, and a picture

on canvas of the Passion of Christ that he had to send to
Spain, and one of Our Lady, for Raffaello Acciaiuoli, then
he wished to make time to return to Florence, to see once
more his native place, his relations, and his friends, for his
father and mother were still alive, and he was always a great
help to them, especially in settling two sisters, one of whom
was married and the other a nun in the convent of Monte
Domini.

So Salviati came to Florence, where he was joyfully
received by his relations and friends; and he happened to
arrive just when the festive display was being erected for the
wedding of Duke Cosimo and Signora Donna Leonora di
Toledo. Therefore, he was commissioned to do one of the
scenes, already mentioned, for the courtyard, showing the
Emperor placing the ducal crown on the head of Duke
Cosimo, and this he very gladly accepted. But before he
had finished it, he decided he would like to go to Venice,
and so he left it to Carlo Portelli da Loro, who completed it,
following Francesco's design, which is in my book with
many others by the same master.

Having left Florence and arrived in Bologna, Francesco
came across Giorgio Vasari, who had returned two days
previously from Camaldoli where he had finished the two
panels that are on the screen of the church, and made a start
on the panel for the high altar; and Vasari also made arrange-
ments for three big pictures for the refectory of the fathers
of San Michele in Bosco, where he kept Francesco with him
for a couple of days. And during this time, some of his
friends strove to have him given the commission for an
altarpiece to be decided by the men of the Della Morte
hospital. But even though Salviati did a very fine drawing
for this, because they lacked understanding, those men failed
to recognize the opportunity the good Lord had given them
of obtaining for Bologna work by an able man. So Francesco
went away rather indignantly, leaving some beautiful de-
signs with Girolamo Fagiuoli so that he might engrave them
on copper and have them printed. Having then arrived in

Venice, he was courteously received by the Patriarch
Grimani and his brother Messer Vettor, with innumerable
kindnesses; and after a few days he did for the patriarch an
oil painting, in an octagon of eight feet, of a most beautiful
Psyche, to whom, as a Goddess, gifts are being made, on
account of her beauty, of incense and votive offerings. This
octagon was placed in a drawing room of the house of that
lord, where there is a ceiling with some festoons curving in
the centre, made by Camillo Capello Mantovano, an ex-
cellent painter of landscapes, flowers, leaves, fruits, and other
suchlike things; and in the centre where this octagon was
placed, as I said, it was surrounded by four pictures each five
foot square, showing, as was told in the *Life* of Genga, other
stories of Psyche painted by Francesco of Forlì.* The octagon
is not only beyond compare more beautiful than the other
four pictures, but the finest painting in all Venice. After
that, in a room where Giovanni Ricamatore† had executed
many works in stucco, he did some small figures in stucco
both nude and draped, which are very graceful. Likewise in
a panel picture for the nuns of Corpus Domini in Venice, he
painted with great diligence a Dead Christ, with the Marys,
and an angel in the air bearing the emblems of the Passion.
He executed the portrait of Messer Pietro Aretino, which,
as a rare work, was sent by that poet to King Francis
with some verses in praise of one who had painted it. For
the nuns of St Christina of Bologna, of the Order of
Camaldoli, at the request of Don Giovan Francesco da
Bagno, their confessor, Salviati did an altarpiece with many
figures, which is in the church of that convent, and is truly
very lovely.

Francesco then grew weary of living in Venice, as someone
who remembered the life of Rome, and feeling that it was

* The lives of Bartolommeo Genga and his father Girolamo, painters and
architects from Urbino, were recorded by Vasari along with details of the
architect Giovanni Battista of San Marino. Francesco of Forlì was Francesco
Manzochi (1502–74).
† Giovanni da Udine.

no home for designers, he left to return to Rome; and so, making the journey by way of Verona and Mantua, he saw in the first all the many antiquities to be found there, and in the other the works of Giulio Romano, and wended his way through the Romagna to Rome, where he arrived in the year 1541.

Francesco rested for a while, and then the first works he did were the portrait of Messer Giovanni Gaddi and that of Messer Annibale Caro, his closest friends; after these were finished, for the chapel of the clerks of the Camera in the Papal palace, he painted a very fine altarpiece and in the German Church he began a chapel in fresco for a merchant of that nation, painting on the vault above the descent of the Holy Ghost upon the Apostles, and in a picture half-way up the wall, Jesus Christ rising from the dead, with the soldiers unconscious around the tomb in various attitudes, all foreshortened in a bold and beautiful manner.

On one side he painted St Stephen and on the other St George, in two niches, and below he depicted St John the Almoner, giving alms to a naked beggar, with Charity on one side and on the other St Albert, the Carmelite friar, between Logic and Prudence. And finally in the large altarpiece he did a fresco painting of the Dead Christ with the Marys.

Having struck up a friendship with Piero di Marcone, a Florentine goldsmith, and having become quite a crony of his, he made for his wife, a bosom friend also, after her delivery, a present of a very beautiful design to be painted on one of those plates on which food is carried to a woman after childbirth. In this drawing, in a series of squares, with very handsome figures ranged above and below, he showed the life of man, namely all ages of human life, each one of which rested on a different garland appropriate to the particular age and season; and in this bizarre composition were accommodated, in two long oval shapes, the figures of the Sun and of the Moon, and, in the middle, Sais, a city of Egypt, standing in front of the temple of the Goddess Pallas

and asking for wisdom, as if wishing to show that for new-born children one should before anything else pray for wisdom and goodness. Piero, thereafter, always cherished this design as if it were, as indeed it was, a most precious jewel.

Not long afterwards, the above-mentioned Piero and other friends wrote to Francesco that he would do well to return to his native place, because it was regarded as certain that he would be employed by the Lord Duke Cosimo, who had no master craftsmen about him except those who were slow and irresolute; and so he finally decided (trusting also in the favour of Messer Alamanno, the brother of the cardinal and uncle of the Duke) to go back to Florence. Then, after his arrival, before he attempted anything else, for Messer Alamanno Salviati he did a very fine picture of Our Lady, which he executed in a room in the Office of Works of Santa Maria del Fiore kept by Francesco del Prato, who at that time, from being a goldsmith and master of tausia,* had turned to casting little figures in bronze, and to painting, much to his profit and honour. In the same place, then, where this person lived as the official in charge of the woodwork of the Office of Works, Francesco portrayed his friend Piero di Marcone, and also Avveduto del Cegia, a dresser of squirrel-fur and his very dear friend indeed. Along with many other things that he possesses from the hand of Francesco, Avveduto has a portrait of Francesco himself, in oils and from his own hand, which is very lifelike. When the above-mentioned picture of Our Lady was finished, being in the workshop of Tasso, the woodcarver who was then architect to the palace, it was seen by many people and praised beyond measure. But what made it regarded as even more rare, was that Tasso, who used to find fault with nearly everything, praised it to the limit; and moreover, he told Messer Pier Francesco, the major-domo, that it would have been best had the Duke given anything of importance

* Tausia, sometimes confused with tarsia (inlays in wood), is the art of inlaying one metal with another.

to Francesco to do. And then Messer Pier Francesco and Cristofano Rinieri, who had the ear of the Duke, influenced matters to such effect that when Messer Alamanno, in speaking to his Excellency, said that Francesco desired to be commissioned to paint the audience chamber which is in front of the chapel of the Ducal Palace, and that he was not worried about any other payment, his Excellency was happy for it to be conceded to him. So Francesco, having executed small drawings of the Triumph of Furius Camillus, and many other scenes of his life, set himself to settle the divisions of that reception chamber according to the spaces left by the windows and the doors, some of these being high and some low, and found no little difficulty in dividing up the space to be well ordered and not spoil the sequence of the scenes. On the wall containing the door by which one enters the chamber, there were left two large squares, either side of the door; and opposite to this, where there are three windows overlooking the piazza, but in another direction, there were three similar spaces, each about six feet; and on the end wall, on the left hand, opposite the other, what with the marble door leading into the chapel and the window with a bronze grating, there was left only one large space that could accommodate anything of consequence.

On the wall of the chapel, therefore, within an ornament of Corinthian columns supporting an architrave (with a recess underneath in which there hang two very rich festoons and two pendants of various fruits, counterfeited very well, with a naked *putto* seated above, holding the Ducal arms, namely those of the Houses of Medici and Toledo) Francesco painted two scenes as follows. On the right, he showed Camillus who is commanding that the schoolmaster should be handed over to the revenge of his young scholars, and on the other side, the same Camillus, while the army is fighting and fire burning the stockades and tents of the camp, puts the Gauls to rout. And beside this, where the same range of pilasters continues, he made a life-size figure of Opportunity,

who has seized Fortune by the hair of her head, and some emblems of his Excellency, with many ornaments executed with marvellous grace. On the main wall, where there are the two great spaces divided either side of the principal door, he did two large and very beautiful scenes. In the first are the Gauls who, weighing the gold to be paid as tribute, throw on a sword in order to increase the weight, and Camillus who, enraged, through the force of arms gets the tribute of gold taken away; and this scene is very beautiful, with copious figures, landscapes, and antiquities and vases very well counterfeited in various styles in imitation of gold and silver. In the other scene beside this, we see Camillus on the triumphal chariot, drawn by four horses, and on high the figure of Fame, who is crowning him; and going before the chariot are priests, very richly robed, carrying a statue of the Goddess Juno and various vessels, with some magnificent spoils and trophies. About the chariot are innumerable prisoners in diverse attitudes, and behind it the soldiers of the army in their armour, among whom Francesco portrayed himself so well that he seems alive. Then in the distance, where the triumphal procession proceeds, is a very beautiful depiction of Rome; and above the door is a chiaroscuro figure of Peace, with some prisoners, who is setting fire to the weapons. And all this was executed by Francesco with such diligence and zeal that there is no more beautiful work to be seen.*

On the wall facing the west he painted in a niche in one of the larger spaces in the middle an armed figure of Mars, and below this a nude figure simulating a Gaul, with a crest

* Marcus Furius Camillus, hero and elected dictator of the Roman Republic. The stories are told in Livy's *The Early History of Rome* (Penguin Classics, trans. Aubrey de Sélincourt). The Greek schoolmaster of Falerii treacherously led the children in his charge into the Roman camp and was repudiated by Camillus.

When the Roman Senate was buying off the besieging Gauls with gold tribute, on which the Gallic chieftain had scornfully thrown his sword to increase the weight, Camillus arrived in time to quash the deal.

like a real cock's comb;* and in another niche is Diana, with a skin round her waist, who is drawing an arrow from her quiver, and also a dog. In the two corners next to the other two walls are two figures of Time, one adjusting the weights of his balance, and the other tempering the water in two vases, pouring from one to the other. On the last wall opposite the chapel, which faces towards the north, in a corner to the right is the Sun represented as the Egyptians show him, and in the other corner the Moon represented the same way. And in the middle is a figure of Fortune, simulated by a nude youth at the summit of the wheel, with Envy, Hatred, and Malice on one side, and on his other, Honours, Delight, and all the other things described by Lucian.† Over the windows is a frieze covered with very beautiful life-size nudes in various attitudes, with some scenes likewise from the life of Camillus. And opposite the figure of Peace burning the weapons the river Arno, in possession of a most abundant horn of plenty, lifts a veil with one hand to reveal a figure of Florence, the greatness of her pontiffs, and the heroes of the House of Medici. Francesco painted in addition a base for these scenes, running all the way round, and niches with some terminal figures of women, bearing festoons; and in the centre are some oval spaces with scenes of people adoring a sphinx and the river Arno. Francesco executed all this work as carefully and diligently as he possibly could, and though he encountered many obstacles, he brought it to a happy conclusion, leaving in his native place a work worthy of himself and of a very great prince.

Francesco was melancholy by nature, and when he had to work, most times he did not care to have anyone near him; none the less, at the beginning when he started this project, almost doing violence to his nature and playing at being open-handed, with great friendliness he let Tasso and other

* *Gallus* in Latin (*Gallo* in Italian) means both Gaul and cock.

† Greek writer (AD 125–180) best known for his satires, which were influential in the Renaissance.

friends of his, who had done him some service, stay to watch him work, and he did all he possibly could to please them. But when later on he had, as they say, made his way at court, and he felt that he was in favour, then returning to his choleric and mordant nature, he paid no regard to them. Indeed, worse than that, using very biting words, as he once used to (which gave excuses to his enemies) he reviled and censured the works of others, and praised his own work to the skies. This behaviour of his which displeased most people, and certain craftsmen as much as others, acquired him so much hatred that Tasso and many others, who from being friends had become the opposite, started to give and tell him what for. So though they praised what excellence he did show as a painter, and the facility and swiftness with which he completed his works so well and perfectly, they did not fail on the other hand to blame him: and since if they had allowed him to gain a footing and establish his affairs, they would not then have been able to hurt and hinder him, they started early on to cause him bother and molest him. Thus many in the craft of painting, and others, banded together and, having formed a faction, they began to spread it around among leading people that the work for the audience chamber would not succeed, and that he put no study into what he did, but worked it out just as he went along. Yet here, in truth, they slandered him badly, for although he did not labour over his work as they did, it is not the case that he did not study, nor that his works did not have infinite grace and invention, nor that they were not put into execution supremely well. But, as his adversaries could not surpass his achievement in their works, they wished to bury it under their words and reproaches. In the end, truth and talent prevail. At the start, Francesco made a joke of all these rumours; but when he saw they were going beyond bounds, he complained more than once to the Duke. Then, however, when, by all appearances, it seemed that the Duke was not doing him the favours he would have wished, and it seemed he did not care about his grievances,

Francesco started to decline in such a manner that his adversaries were encouraged and circulated a report that his scenes in the hall were to be destroyed, and that they had given no pleasure, and were no good at all. All these things, which his adversaries were alleging with incredible envy and malice, had brought Francesco to such a state that, if it had not been for the goodness of Messer Lelio Torelli, Messer Pasquino Bertini, and other friends of his, he would have given in to them just as they wanted.

However, these friends, continually counselling him to finish the hall and the other works he had undertaken, managed to restrain him, helped by many others of his friends outside Florence, to whom he wrote about these persecutions. Among the rest, Giorgio Vasari, in answering a letter that Jacopo wrote to him about this, also counselled him to remain patient, because talent was refined by persecution as was gold by fire; and he added that the time would come when his talent and skill would be recognized, and that he had no cause to complain save of himself, for still not understanding people's humours, and how the men and the craftsmen of his own native land were constituted. Notwithstanding, then, all the contradictions and persecutions that poor Francesco suffered, he finished the chamber he was decorating, in other words, the painting he had undertaken to do in fresco on the walls, since on the ceiling or soffit there was no need to work at all, as it was so richly carved and all inlaid with gold that no more beautiful work of its kind could be seen. And to finish it all off, the Duke commissioned two new windows of glass with his emblems and coat of arms and those of Charles V; and nothing better could be done in this sort of work than these, which were executed by Battista Borro, a painter of Arezzo who was exceptional in that branch of the craft.

After this, Francesco painted for his Excellency the ceiling of the hall where he eats in winter, with many emblems and figures in tempera, and a very fine study opening out over the green room. He also did portraits of some of the Duke's

children; and one year, for the carnival, he executed in the great hall all the stage scenery for a play that was put on, so beautiful and so different in style from those which had been made in Florence before, that it was judged to be superior to them all. Nor is this surprising, since it is undoubtedly true that Francesco always showed great judgement in everything he did, was fertile in invention, and, moreover, mastered the techniques of drawing and had a more beautiful style than anyone else then in Florence; and he also handled colours with great skill and charm. He also did the head, or rather portrait, of Signor Giovanni de' Medici, father of Duke Cosimo, which was very beautiful, and is now in the wardrobe of the Lord Duke.

For Cristofano Rinieri, his very close friend, he did a picture of Our Lady, which is now in the audience hall of the Decima. For Ridolfo Landi, he did a picture of Charity, which could not be more beautiful; and for Simone Corsi, he did likewise a picture of the Madonna, which was highly praised. For Messer Donato Acciaiuoli, knight of Rhodes, with whom he had always enjoyed a unique friendship, he painted some most attractive little pictures. He also painted a panel with Christ showing to Thomas, who would not believe that He was newly risen from the dead, the marks of the wounds and blows He had received from the Jews; and this painting was taken by Tommaso Guadagni to France and put in the chapel of the Florentines in a church at Lyons. Also, at the request of Cristofano Rinieri and of Giovanni Rosto, the Flemish master of tapestry, Francesco depicted the entire story of Tarquin and the Roman Lucretia, in many cartoons, which, when subsequently put into execution in tapestries woven in gold, silk and ravelled silk, produced a marvellous work. When this came to the ears of the Duke (who at that time was commissioning similar tapestries in Florence from Master Giovanni for the Hall of the Two Hundred, all in gold and silk, and, as was said, had cartoons made of stories from the life of the Hebrew, Joseph, by Bronzino and Pontormo) he wished Francesco also to do

a cartoon for the hall, which was that of the interpretation of the dream of the seven fat kine, and seven lean. And let me say that Francesco attended to this cartoon with all the diligence that can possibly be devoted to such a work and is required for pictures that are to be woven. For fantastic inventions and varied compositions must be sought for in the figures, which need to stand out from each other, so that they may have clear relief and come out bright in their colours, and rich in their costumes and vestments. That tapestry and the others having come out well, his Excellency resolved to establish the craft in Florence, and had it taught to some young boys, who, having grown up, now create excellent works for the Duke.

Francesco also made a most beautiful picture of Our Lady, again in oils, which is now in the chamber of Messer Alessandro de' Medici, son of Messer Ottaviano de' Medici. For Messer Pasquino Bertini, he did on canvas another little picture of Our Lady with Christ and St John as little children, who are laughing at a parrot they are fondling, which was a fanciful and very charming work; and for another person, he also did a very fine drawing of a Crucifixion, about two feet high, with a figure of the Magdalen at the foot, in so novel and charming a style that it is a marvel. And after Messer Silvestro Bertini had lent this to his very good friend Girolamo Razzi, now Don Silvano, two pictures were painted from it by Carlo of Loro, who has since done many others, which are found throughout Florence.

Now Giovanni and Piero d'Agostino Dini had made in Santa Croce, on the right after entering by the centre door, a very ornate chapel of grey-stone, and a tomb for Agostino and for others of their family, and they commissioned the altarpiece for this from Francesco, who depicted in it Christ being taken down from the Cross by Joseph of Arimathaea and Nicodemus, and at the foot Our Lady in a swoon, with Mary Magdalen, St John, and the other Marys; and this panel was executed by Francesco with such intense care and

skill that not only is the nude figure of Christ extremely beautiful but all the other figures are also well grouped and executed with strong colouring and relief. And although, at the beginning, this picture was censured by Francesco's adversaries, it has none the less won him great fame in the world at large; and those who have tried to do the same in emulation of him, have not surpassed him.

Before he left Florence, Francesco painted the portrait of the above-mentioned Lelio Torelli, and some other things of no great importance, whose particulars escape me. But among other things he completed a drawing, which he had outlined a long time before in Rome, of the Conversion of St Paul, which is very beautiful, and which he then had engraved on copper by Enea Vico of Parma. And the Duke was content to provide for him in Florence, till that was done, with his usual stipend and allowance. And at that time, the year 1548, Giorgio Vasari being in Rimini in order to do his paintings in fresco and in oil, as recounted elsewhere, Francesco wrote to him a long letter, informing him in detail about all and everything and how his affairs were proceeding in Florence, and in particular about having made a design for the main chapel of San Lorenzo, which was to be painted by order of the Duke; but with regard to which no end of trouble had been stirred up for him with his Excellency, and, on top of all the rest, he was more or less sure that Messer Pier Francesco, the major-domo, had not shown his design, and so the work had been commissioned from Pontormo; and finally for these reasons he was returning to Rome, bitterly disgruntled with the men and the craftsmen of his own native place.

Having therefore returned to Rome, and having bought a house near to the palace of Cardinal Farnese, he was keeping himself by working on some works of no great importance, when through Messer Annibale Caro and Don Giulio Clovio, the cardinal commissioned him to paint the chapel of the palace of San Giorgio. And here he did a series

of very fine compartments in stucco and a vault in fresco
with many figures and scenes from the life of St Lawrence,
all very graceful, and on a stone panel, in oil, the Birth of
Christ; and in this very beautiful work he introduced the
portrait of the cardinal. After this, he was commissioned to
do another work in the above-mentioned Society of the
Misericordia,* where Jacopo del Conte had painted the
Preaching and Baptism of St John, in which, though he had
not surpassed Francesco, he had performed very well, and
where some other works had been done by Battista Franco
of Venice and Pirro Ligorio; and Francesco then did in that
part which is exactly beside his own scene of the Visitation,
the Birth of St John, a picture which, though excellently
done, is not equal to the first. Likewise, at the end of the
oratory, he painted for Messer Bartolommeo Bussotti two
figures in fresco, the Apostles St Andrew and St Bar-
tholomew, beautifully executed, one on either side of the
altarpiece, on which is a Deposition from the Cross by the
hand of the above-mentioned Jacopo del Conte, which is a
very good picture and the best work he had ever done up to
that time.

In the year 1550, when Julius III was elected as Supreme
Pontiff, in the display for the coronation, Francesco did
some very fine scenes in chiaroscuro for the arch erected over
the steps of St Peter's. And afterwards, he painted some
scenes and figures in grisaille on the sepulchre which had
been made, with many steps and rows of columns, that
same year by the Society of the Blessed Sacrament, in the
Minerva. In a chapel of San Lorenzo in Damaso, he painted
two angels in fresco, holding a veil; the drawing for one of
these is in my book. He also painted in fresco on the main
wall in the refectory of San Salvatore in Lauro at Monte
Giordano, the wedding feast at Cana in Galilee, at which
Jesus Christ turned the water into wine, with a whole host
of figures; and at the sides he depicted some saints and Pope
Eugenius IV, who was of that Order, and other founders;

* San Giovanni Decollato.

and over the door of the refectory inside he painted a picture in oil of St George killing the dragon, a work executed with great skill, polish, and charm of colouring. About this time, he also sent to Florence for Messer Alamanno Salviati a large picture, in which are painted Adam and Eve, who in the Earthly Paradise are eating the forbidden fruit, by the Tree of Life, and this is a very lovely work.

For Signor Ranuccio, Cardinal of Sant'Agnolo, of the Farnese family, in the chamber before the great hall of the Farnese, Francesco did some very beautiful and fanciful painting on two of the walls. On one, he showed the elder Signor Ranuccio Farnese receiving from Eugenius IV his baton as Captain-General of Holy Church, with figures of virtues; and on the other, Pope Paul III Farnese, who is giving the baton of the Church to Pier Luigi, while there is seen approaching from afar the Emperor Charles V, accompanied by Cardinal Alessandro Farnese and by other lords portrayed from life. And on this wall, as well as all the above and more, he painted a Fame and other figures, which are executed very well. It is true, all the same, that this work was not finished entirely by him, but by Taddeo Zuccaro of Sant'Agnolo, as will be related in the proper place; meanwhile he gave proportion and completion to the chapel of the Popolo, which Fra Sebastiano Veneziano had formerly begun for Agostino Chigi; but, as discussed in the *Life* of Fra Sebastiano, he had not finished it, so Francesco did.

For Cardinal Riccio of Montepulciano, he painted in his palace on the Strada Giulia a most beautiful hall, where he did a number of pictures in fresco containing scenes from the life of David, including Bathsheba washing herself in a bath, with many other women, while David stands gazing at her; and this scene is very well composed, graceful, and as rich in inventions as any to be found. In another picture is the death of Uriah; and in a third is the Ark, preceded by many musical instruments; and, finally, after many others, a battle being fought between David and his enemies, very

well composed. To be brief, the work done in this hall is all
full of grace, of superb ideas, and of very capricious and
ingenious inventions. The division of the various parts is
well conceived, and the colouring is extremely charming.
And to tell the truth Francesco, knowing himself to be bold
and fertile in invention, and having a hand obedient to his
brain, would have wished always to have grand and
extraordinary works on his hands; and the only reason he
was strange in his relations with his friends, was that being
variable and rather unstable in certain things, he would find
something that was pleasing one day, hateful the next; and
he also did few important works over which he did not, in
the end, have to contend about the price. For all these
reasons, many people shunned him.

After these works, Andrea Tassini, having to send a painter
to the king of France, in the year 1554, sought out Giorgio
Vasari, but in vain, for he replied that no matter however
rich the rewards or whatever hopes or promises were held
out, he did not wish to leave the service of his Lord Duke
Cosimo. Then finally, Tassini reached an agreement with
Francesco and took him to France, guaranteeing that he
would pay him what he was owed in Rome if he were not
satisfied in France. But before Francesco left Rome, in the
belief that he would never have to return there, he sold his
house, furniture, and everything else he had except the
offices he held. But the outcome was not what he had
promised himself. For after he had arrived in Paris, where
he was received benignly and with many favours by Messer
Francesco Primaticcio, abbot of Saint-Martin and the king's
painter and architect, he at once, so we hear, was recognized
for the difficult sort of man he was; for he saw no work
either by Rosso or any other master without censuring it
openly or in some subtle manner. Thereupon, with everyone
expecting some great work from him, he was commissioned
by the cardinal of Lorraine, who had brought him there, to
paint some pictures in one of his palaces at Dampierre; and
after producing many drawings he finally began the work,

painting some fresco scenes over the cornices of chimney-pieces and filling a small study with scenes, which are said to have been very workmanlike. But, for whatever reason, these works did not win him much praise. Besides this, Francesco was never much liked in France, because he had a nature completely opposed to that of the men of that country; because there, just as happy and jovial men, who live free and easy lives and adore parties and banquets, are loved and cherished, so equally those who are, as Francesco was by nature, melancholy, abstemious, sickly, and morose, are, I do not say shunned, but less well liked and not so fondly treated. For some things he might have deserved to be excused, seeing that his constitution did not allow him to indulge in big meals and eating and drinking too much, if only he could have been easier to get along with. What was worse was that whereas, according to the ways of that country and the customs of the courts, his duty was to show himself and to pay court to others, he preferred, and felt he deserved, to be courted by everyone else. In the end, as the king of France was occupied in some wars, and likewise the cardinal, and he was let down over payment and promises, Francesco resolved, after he had been in France twenty months, to go back to Italy.

So he made his way to Milan, where he was courteously received by the knight Lione of Arezzo * in a house he had built for himself, which is very ornate and chock-full of ancient and modern statues, and figures cast in gesso from rare works, as will be narrated elsewhere. Here Francesco stayed for a fortnight, having a rest, and then he came to Florence, where, having found Giorgio Vasari, he told him how well he had done not to go to France, recounting things that would rob anyone of the wish to go there, no

* Leone Leoni (1509–90), a sculptor whose life was also written by Vasari, who worked for the Emperor Charles V and was a keen house-builder. One of his copies was the famous equestrian statue of Marcus Aurelius.

matter how intense. From Florence, having then returned to Rome, Francesco started a lawsuit against those who had given guarantees for payments due from the cardinal of Lorraine, and he forced them to pay him in full. When he received the money, he bought some offices in addition to those he already had, being firmly resolved to look after his own life carefully, knowing he was sickly and had completely wrecked his constitution. Notwithstanding this, he would have liked to be employed on ambitious works; but he had no immediate success in this, and so for a while he occupied himself doing easel pictures and portraits.

Then Paul IV died, and Pius IV became Pope, and he showed his delight in building by employing Pirro Ligorio on his architecture; his Holiness also ordered that Cardinals Alessandro Farnese and Emulio should have the Great Hall, the Hall of Kings as it is called, finished by Daniele da Volterra, who had already begun it. * The Very Reverend Farnese made every effort to secure half of this work for Francesco, and through this there ensued a long struggle between Daniele and Francesco, especially as Michelangelo Buonarroti exerted himself in Daniele's favour; and for some while nothing was resolved.

Meanwhile Vasari had gone to Rome, with Cardinal Giovanni de' Medici, son of Duke Cosimo, where Francesco recounted to him his many misadventures, and especially those he was now experiencing, for the reasons just given; and Giorgio, who much admired that man's talent, showed him that he had hitherto managed his own affairs very badly, and should in future let him manage them, for he would contrive to ensure, one way or another, that it would fall to Francesco to do half the Hall of Kings, which Daniele could not do alone, since he was slow and irresolute, and even, perhaps, not as able and versatile as Francesco. With matters standing thus, and nothing more being done for the

* The Sala Regia, the Vatican Palace's main ceremonial centre.

time being, Giorgio was asked by the Pope, not many days later, to execute a part of the Hall; but he responded that in the palace of his lord Duke Cosimo he had to attend to a hall three times larger than that, and, moreover, that he had been so badly treated by Pope Julius III, for whom he had toiled on many works at the villa at Monte San Savino, and elsewhere, that he no longer knew what to expect from certain people. And he added that he had painted for the palace of the same Pope, without having been paid for it, an altarpiece showing Christ by the Sea of Tiberias calling Peter and Andrew from their nets (which had been removed by Pope Paul IV from a chapel which Julius had erected over the corridor of the Belvedere, and which was to be sent to Milan) and that his Holiness should decide either to have it given back to him or paid for. To all this, the Pope in reply said (whether it was true or not, who knows) that he knew nothing of that panel, and wished to see it. It was therefore brought to him, and when he saw it, in a bad light, he was content for it to be given back. Afterwards, resuming the discussion about the Hall, Giorgio told the Pope frankly that Francesco was the first and best painter in Rome, that his Holiness should rely on him, as no one could make better use of him, and that, although Buonarroti and the cardinal of Carpi were favouring Daniele, they did this more from a motive of friendship, and perhaps as prejudiced, than for any other reason. But to return to the altarpiece: no sooner had Giorgio left the Pope, than he sent it to the house of Francesco, who then had it taken from Rome to Arezzo, where, as we have related elsewhere, it has been deposited by Vasari, with rich and costly ornamentation, in the city's main church.

While the matter of the Hall of Kings rested as described above, when Duke Cosimo left Siena to go to Rome, Vasari, who had accompanied his Excellency thus far, recommended Salviati warmly to him, so that he might win him the Pope's favour; and he wrote telling Francesco all he had to do, once the Duke had arrived in Rome. And in this regard, Francesco

did not depart a jot from the advice Giorgio gave him, for he went to pay his respects to the Duke, and was looked upon kindly by his Excellency, who shortly afterwards intervened on his behalf with his Holiness to such good effect that he was commissioned to paint half of the hall. And setting his hand to the work, he destroyed a scene that had been begun by Daniele, and this stirred up much strife between them. Now, as said earlier, the reigning pontiff was served for his architectural needs by Pirro Ligorio, who from the start had greatly favoured Francesco and would have supported him; but Francesco paid no further attention to Pirro or to anyone else once he had begun to work, and so from being a friend, he became to some degree an adversary, and there appeared very clear signs of this: for Pirro began to say to the Pope that as there were many young and able painters in Rome, since he wanted to get the hall off his hands, it would be sensible to allocate a scene to each one of them, and to have it done with once and for all.

These moves of Pirro, with whom it was plain the Pope went along in this matter, so displeased Francesco that he scornfully withdrew from the work and all the strife, considering that he was held in little esteem. So having mounted a horse, without a word to anyone, he went off to Florence where, very oddly, without paying heed to any friend he had there, he lodged in an inn, just as if he were not in his own native place or had no influential friend on hand or anyone to side with him. Afterwards, having kissed hands with the Duke, he was treated so fondly that he could well have hoped for some good to follow, if only he had possessed a different nature and had attended to the advice of Giorgio, who counselled him to sell the offices he had in Rome and to return to Florence to enjoy his birthplace and his friends, and so avoid the danger of losing, along with his life, all the fruits of his unending toil and sweat. But Francesco, guided by impulse, by anger, and by the desire to avenge himself, resolved that he would return to Rome at all costs within a few days.

Meanwhile, at the entreaties of his friends, he moved from the inn and retired to the house of Messer Marco Finale, prior of Sant'Apostolo; and here, as if to while the time away, for Messer Jacopo Salviati he executed a Pietà in colours on cloth of silver, depicting Our Lady and the other Marys, which was very beautiful. He also repainted in colours a medallion with the Ducal arms, which he had executed on a previous occasion and placed over the door of the palace of Messer Alamanno, and for the same Messer Jacopo, he made a handsome book of bizarre costumes and various head-dresses of men and horses for masquerades; and as a result, he received innumerable expressions of loving-kindness from that lord, who grieved over the strange and fanciful nature of Francesco, whom he could never this time persuade to come into his house, as he had done on other occasions. Finally, when Francesco was about to leave for Rome, as a friend, Giorgio reminded him that being rich, elderly, of poor constitution, and not fit for more exertions, he should take care to live quietly and to shun all strife and contention; and this he would easily have been able to do, as he had acquired honour and property in abundance, if he had not been so avaricious and desirous of gain. Besides this, Giorgio advised him to sell many of the offices he had, and so to arrange his affairs that in any need or misfortune that might befall him, he could remember his friends and those who had served him so faithfully and lovingly. Francesco promised that he would watch his words and his behaviour, and confessed that Giorgio was telling him the truth; but as generally happens with men who are always marking time, he did nothing more. Then, when he arrived in Rome, Francesco found that Cardinal Emulio had allocated the scenes for the hall, giving two to Taddeo Zuccaro of Sant'Agnolo, one to Livio Agresti of Forlì, another to Orazio Sammachini of Bologna, another to Girolamo Sermoneta, and the rest to others. Francesco sent word of this to Giorgio, and asked him if he would do well to continue with what he had begun; and in reply he was

told that he would certainly do well, having executed so many small drawings and large cartoons, to finish one scene at least, notwithstanding that most of the work had been allocated to so many others, worth less than him, and that he should strive to approach as closely as he could in his work to the pictures by Buonarroti on the walls and vaulting of the Sistine Chapel, and to those of the Pauline. For then, when it was seen what his were like, all the others would be destroyed, and everything, to his glory, would be allocated to him. And he also warned him not to worry about profit or money, or any offence done to him by those in charge of that project, seeing that the honour was of much more importance than any other thing whatsoever. And of all these letters and proposals and responses, both the copies and the originals are among those we keep in memory of this great man, our very dear friend, and among those in our own hand that must have been found among his possessions.

After all this, Francesco was left indignant and not really sure what he wished to do, distressed in mind, sick in body, and weakened by the medicines he kept taking; and he finally succumbed to a mortal illness which in a short while brought him to his last extremity, without allowing him time to dispose of his possessions entirely. To one of his pupils, called Annibale, the son of Nanni di Baccio Bigio, he left sixty crowns a year on the Monte delle Farine, fourteen pictures, and all his drawings, and other things to do with painting. The rest of his belongings he left to Suor Gabriella, who was his own sister and a nun, though I understand that she did not receive, as the saying goes, even the string for the package. However, there must have fallen into her hands a picture on cloth of silver, trimmed with embroidery, which he had done for the king of Portugal, or perhaps it was Poland; and he left it to her to keep in memory of him. All his other possessions, such as the offices which he bought after all his crippling exertions, were lost.

Francesco died on St Martin's Day, November 1563, and

he was buried in San Geronimo, a church near to the house where he lived.

The death of Francesco was a grievous and damaging loss to the art of painting, for although he was fifty-four years old and in poor health, he never stopped studying and working, whatever the circumstances; and at the very last, he had begun to work in mosaic. He was evidently a capricious man, and he would have liked to do many things; and if he had found a prince who could have understood his temperament, and given him commissions after his own fancy, he would have done marvels. For he was, as I have said, rich, prolific, and copious in his inventions and in every detail, and versatile in every field of painting. He gave lovely grace to his heads of every style, and he mastered the nude as well as any other painter of his time. In handling draperies, he had a very soft and gentle manner, and he always arranged them to reveal the nude form underneath, where this was proper. He also continually clothed his figures with new fashions in dress, and he was fanciful and varied in his depiction of head-dresses, footwear and every other sort of adornment. He handled colours in oils, in tempera and in fresco so well that it can be affirmed that he was one of the most able, prompt, bold, and solicitous craftsmen of our age; and I, who have enjoyed knowing him over so many years, can well testify to this. Even though, from the desire all good craftsmen have to surpass each other, there has always been some honest emulation between us, our love and affection based on mutual friendship have never failed, although, to be sure, both of us have worked in rivalry in the most famous places in Italy, as can be seen in the countless number of letters that I have in my possession, as I said, from the hand of Francesco.

Salviati was by nature a loving but suspicious man, utterly credulous, yet sharp-witted, subtle and penetrating; and when he set himself to discuss some of the men practising our art of painting, either jokingly, or in earnest, he tended to give offence, and sometimes his words cut to the

FRANCESCO SALVIATI 305

quick. He liked to keep company with well-educated people
and great men, and he always held plebeian craftsmen in
detestation, even if they were talented in some field. He
shunned certain persons who are always speaking ill, and
when the conversation turned to them, he savaged them
mercilessly. But above all, he disliked the frauds that
craftsmen sometimes practise, and which he could talk about
only too well, having run into them when he was in France.
At times, in order to be less weighed down by melancholy,
he would mix with friends and force himself to be cheerful.
But in the end, his odd nature, so irresolute, suspicious, and
solitary, did harm to no one but himself.

A very close friend of his was Manno, a Florentine
goldsmith in Rome, of rare skill in his own field and of
impeccable behaviour and goodness; and because Manno
had the burden of a family, if Francesco had been able to
dispose of what was his own, and not spent all his hard-
earned income on offices, only to leave them in the hands
of the Pope, he would have left a large part of his property
to this worthy and excellent craftsman. * Avveduto dell'
Avveduto, the furrier whom we mentioned above, was
likewise very close to him, being the most affectionate and
faithful of all the friends he had; and if Avveduto had been
in Rome when Francesco died, he would perhaps have
settled his affairs more advisedly than he did. His pupil, also,
was the Spaniard Roviale,† who did many works with
him, and, by himself, painted a panel picture for the church
of Santo Spirito, showing the Conversion of St Paul.

Salviati also felt warmly towards Francesco di Girolamo
dal Prato,‡ in whose company, as was said, he applied him-
self to design while still a child. This Francesco was ex-
quisitely talented and drew better than any other goldsmith

* Manno Sbarri, a student of Benvenuto Cellini's who, Cellini alleges
in his autobiography, was scratched by Vasari's long nails when they once
shared a bed for the night.
 † Francisco Ruviales de Estremadura.
 ‡ Francesco Ortens di Girolamo dal Prato (1512–62).

of his time. Nor was he inferior to his father Girolamo,
whose work of all and every kind in silver-plate was better
than that of all his peers. It is said that Girolamo found
everything easy; thus he would beat the silver-plate with
some tools and then, having placed it on a length of
board, and put between the two a layer of wax, tallow, and
pitch, he produced a substance which was midway between
hard and soft; and then forcing it with his tools inwards and
outwards, he formed it into the shapes he wanted, whether
heads, breasts, arms, legs, backs, or whatsoever he wished or
was asked for by those wanting votive offerings to hang
before sacred images in places where they have been granted
favours or had their prayers heard. Francesco, then, not
only specialized in votive offerings, like his father, but also
worked in tausia and at inlaying steel with gold and silver
by the technique of damascening, producing foliage, pieces,
figures, and anything else he wished. For example, he made
a complete suit of armour, of great beauty, for a foot soldier
of Duke Alessandro de' Medici. And among the many
medals from the same craftsman's hand were those very
beautiful ones which were placed in the foundations of the
fortress at the Faenza gate, along with others, in which there
was on one side the head of Pope Clement VII, and on the
other a nude Christ with the scourges of His Passion. ★
Francesco dal Prato also loved sculpture; and he cast in
bronze some very graceful little figures which Duke Ales-
sandro acquired. He also polished and brought to perfect
completion four similar figures done by Baccio Bandinelli,
namely a Leda, a Venus, a Hercules, and an Apollo, which
were given to the same Duke.

Being dissatisfied with the goldsmith's craft, and unable
to devote himself to sculpture, which makes too many
demands, Francesco, as he was competent in design, gave
himself to painting; and since he was a person who mixed
little with others, and did not care for it to be known more
than it had to be that he was keen on painting, he executed

★ The Fortezza da Basso, built for Alessandro de' Medici, in 1534.

many works on his own. Meanwhile, as was said at the beginning, Francesco Salviati came to Florence and worked on the picture for Messer Alamanno in the rooms which this Francesco occupied in the Office of Works of Santa Maria del Fiore. So then, with this opportunity of seeing Salviati's way of working, Francesco threw himself into painting with more zeal than ever before, and finished a very fine picture of the Conversion of St Paul, which is now in the possession of Guglielmo del Tovaglia; and afterwards, in a picture of the same size, he painted the serpents raining down upon the Hebrews; and in another, he painted Jesus Christ delivering the Holy Fathers from Limbo. And these last two pictures, which are very beautiful, now belong to Filippo Spini, a gentlemen who takes great pleasure in our arts. And besides the many other little works that Francesco dal Prato executed, he did many very good drawings, as can be seen from some by his hand in our book of designs. He died in the year 1562, to the intense grief of all the Academy; for besides his being an able painter, there was never a worthier man. *

One of the pupils of Francesco Salviati was Giuseppe Porta of Castelnuovo della Garfagnana, who was called Giuseppe Salviati, out of respect for his master. This young boy, having been brought to Rome by an uncle of his, who was secretary to Monsignor Onofrio Bartolini, archbishop of Pisa, was placed with Salviati, under whom he learned in a short space of time not only to draw extremely well but also to colour superbly. Having then gone with his master to Venice, he formed so many connections with noble people that, when he was left there by Francesco, he resolutely set his mind to making Venice his own native city; and so, having taken a wife there, he still lives in Venice, and he has worked in few other places since. He once painted

* The Academy of Fine Arts – *Accademia di Disegno* – was founded by Vasari under the patronage of the Grand Duke Cosimo and Michelangelo in 1563, originally as a teaching institution, and chiefly to enhance the status of the artist.

the façade of the house of the Loredan family on the Campo Santo Stefano with scenes coloured in fresco, which were executed with great charm in a lovely style. Likewise, he painted that of the Bernardo family at San Polo, and another behind San Rocco, which is a very good work. He has also painted in chiaroscuro three other façades, very large and covered with varied scenes, one at San Moisè, the second at San Cassiano, and the third at Santa Maria Zobenigo. He has also painted in fresco at a place called Treville, near Treviso, the whole of the palace of the Priuli, a rich and grandiose building, both within and without, of which there will be a long account in the *Life* of Sansovino. At Pieve di Sacco, he has also painted a very fine façade. Then at Bagnuolo as well, a seat of the friars of Santo Spirito of Venice, he has painted an altarpiece in oils, and for the same fathers he has decorated the ceiling or soffit for their refectory in the convent of Santo Spirito, with a compartment filled with painted pictures and with a very fine Last Supper on the main wall. For the Hall of the Doge in the palace of San Marco, he has painted the Sibyls, the Prophets, the Cardinal Virtues, and Christ with the Marys, which have won him endless praise. And in the above-mentioned library of San Marco he painted two large scenes in competition with the other painters of Venice, discussed above.

Then after the death of Francesco, he was called to Rome by Cardinal Emulio and finished one of the larger scenes in the Hall of Kings, and began another; and afterwards, when Pope Pius IV died, he returned to Venice where the Signoria has commissioned him to cover a ceiling at the top of the new stairway in the palace entirely with oil paintings. The same master has painted six very beautiful panel pictures in oils, one for the altar of Our Lady in San Francesco della Vigna, the second for the high altar in the church of the Servites, the third for the Friars Minor, the fourth in Madonna dell'Orto, the fifth in San Zaccaria, and the sixth in San Moisè; and he has painted two at Murano,

which are beautiful and executed very diligently in a lovely style.

I shall say no more for now about this Giuseppe, who is still living and becoming an outstanding painter, save that, besides painting, he is a keen student of geometry; and by his hand is the volute of the Ionic capital that is seen in print today, showing how it should be turned according to the ancient measure; and soon there is to be published a work which he has composed on the subject of geometry. A disciple of Francesco, also, was Domenico Romano, who was of great help to him in the hall he executed in Florence and in other works, and who in the year 1550 engaged himself to Giuliano Cesarini; but he does not work by himself.

LIFE OF
JACOPO SANSOVINO*

——— · ———

Sculptor and architect, 1486–1570

THE family of Tatti is recorded in the books of the Commune for the year 1300, because after coming from Lucca, a most noble Tuscan city, it always had more than its share of industrious and honourable men who were highly favoured by the House of Medici. Jacopo, whom we shall now discuss, was born into this family, the offspring of Antonio, a very worthy person, and his wife Francesca, in the month of January in the year 1477. In the first years of boyhood, in the usual way, he was set to learn his letters, and after beginning to show in these a lively intelligence and eager spirit, not long after he began to draw of his own accord, giving some kind of evidence that he was more inclined by nature to this form of work than to letters. For indeed he went to school very reluctantly and learned the difficult rules of grammar only against his will. When this was observed by his mother, whom he greatly resembled and who encouraged his genius, she helped him by having him taught design in secret. For she fondly hoped that her son would become a sculptor, and perhaps even emulate the then rising glory of Michelangelo Buonarroti, who was still a young man, and she was also prompted by the fateful augury that both Michelangelo and her Jacopo had been born in the same street called Via Santa Maria, near to the Via Ghibellina.†

* The translation of the *Life* is abridged from the 1568 edition of the *Lives* with the addition of introductory and concluding paragraphs from the fresh version published by Vasari in 1570, after Sansovino's death.

† The birthplace of Michelangelo was Caprese in the Casentino, now Caprese Michelangelo.

Now after a while, the child was sent to learn the trade of merchant, and, finding this even less agreeable than learning his letters, he kicked up such a fuss that he obtained leave from his father to spend his time freely on what nature drove him to.

There had come to Florence at that time Andrea Contucci, from Monte Sansovino, a castle-town near Arezzo, which has grown illustrious in our days through having been the native place of Pope Julius III; and this Andrea, who had won the reputation in Italy and Spain of being, after Michelangelo, the most outstanding sculptor and architect in the craft, was staying in Florence to make two figures in marble.* And Jacopo was sent to him to learn sculpture. Andrea, then, recognized what an outstanding sculptor the young man was bound to become, and he did not fail to teach him scrupulously all those things which could make him known as his disciple. So he came to love the young man intensely, teaching him with warm affection, which was completely reciprocated; and thus all the people came to judge that he would come not only to equal his master in excellence, but to surpass him by a great measure. And the mutual benevolence and love of the two men was so much that of father and son, that Jacopo began in those early years of his to be called not Tatti but Sansovino, as he is now so known and always will be.

So then, as he began to apply himself to his work, Jacopo was so greatly assisted by nature that even though sometimes his way of working might lack care and diligence, none the less in what he did could be seen facility, sweetness, grace, and a certain kind of charm that is very pleasing to a craftsman's eye, inasmuch as his every rough study, sketch

* Andrea Contucci, now known as Andrea Sansovino (c. 1467/71–1529), is said by Vasari to have spent some years in Portugal. He is mentioned in the *Life* of Michelangelo as having wanted the marble block which was to become the great statue of David. He was most famous for his wall-tombs, notably those of Cardinals Sforza and della Rovere, commissioned by Pope Julius II in Rome.

or mark has always possessed a boldness and suggestion of movement which nature customarily allows to only a few sculptors. Moreover, the experience and friendship which Andrea del Sarto and Jacopo Sansovino shared in their childhood, and then in their youth, benefited both the one and the other a great deal; for following the same style in design, they had the same grace in execution, the one in painting and the other in sculpture; and so conferring together on the problems of their crafts, Jacopo made models of figures for Andrea, and they assisted each other tremendously. The truth of this is attested by the following, namely that in the altarpiece of San Francesco, belonging to the nuns of Via Pentolini, is a figure of St John the Evangelist, copied from a very fine clay model which in those days Sansovino executed in rivalry with Baccio da Montelupo. What happened was that the Guild of Porta Santa Maria wished to have a bronze statue, eight feet high, made for a niche at the corner of Orsanmichele, opposite to the Wool Shearers; but then, even though Jacopo made a more beautiful clay model than Baccio, the commission was more readily given to Montelupo, being an old master, than to Sansovino, even though, young as he was, his figure was better. This model is now in the hands of the heirs of Nanni Unghero, and is very beautiful. And as at the time Sansovino was a friend of Nanni, he executed for him some large clay models of *putti* and of a figure of St Nicholas of Tolentino; these were both made in wood, life-size, with Sansovino's help, and then placed in the saint's chapel in the church of Santo Spirito.

For these reasons, Jacopo became known by all the craftsmen of Florence, and regarded as a young man of high intelligence and excellent behaviour, and so, to his intense satisfaction, he was brought to Rome by Giuliano da San Gallo, architect to Pope Julius II. As a result, he was delighted beyond words by the ancient statues he saw in the Belvedere, and he set himself to draw them; in consequence Bramante, who was also architect to Pope Julius, holding the highest

position at that time and living in the Belvedere, having
seen this young man's drawings, and a recumbent nude in
clay, in full relief, made by Sansovino to hold a stand for an
ink-well, was so pleased with them that he took him under
his wing; and he told him to execute a large copy in wax of
the Laocoön, which he was also having drawn by others (to
have one cast subsequently in bronze), namely by Zaccaria
Zacchi of Volterra, the Spaniard Alonso Berruguete, and
Vecchio of Bologna.* And when they were all finished,
Bramante had them seen by Raphael Sanzio of Urbino, in
order to learn which of the four had acquitted himself best.
Thereupon it was judged by Raphael that Sansovino, young
as he was, had by a long way surpassed all the others; and
so, by the advice of Cardinal Domenico Grimani, Bramante
was ordered to make the bronze cast from Jacopo's copy;
and so the mould was made and the work cast in metal,
with considerable success. After it had been polished and
given to the cardinal, he held it as long as he lived no less
dear than if it had been an antique; and when he was near
death, he left it as a most precious work to the Most Serene
Signoria of Venice which, having kept it for ten years in the
wardrobe of the Hall of the Council of Ten, finally gave it,
in the year 1534, to the cardinal of Lorraine, who took it to
France.

While Sansovino daily acquired more renown through
his studies in Rome, and so became held in high regard,
Giuliano da San Gallo, who put him up in his home in the
Borgo Vecchio, fell ill; and when he left Rome in a litter for
a change of air in Florence, Sansovino was found a room by
Bramante, still in the Borgo Vecchio, in the palace of
Domenico della Rovere, cardinal of San Clemente, where
there was still living Pietro Perugino, who at that time
painted the vaulting of the chamber in the Borgia Tower
for Pope Julius. So then, when Pietro saw Sansovino's

* Vecchio of Bologna was Domenico Aimo, a sculptor, painter, and
architect.

beautiful style, he persuaded him to make him many models in wax, including a Deposition of Christ from the Cross, in the round, with many ladders and figures, which was a very beautiful work. This, together with other objects of the same sort, and models of various fantasies, were all subsequently collected by Messer Giovanni Gaddi, and are now at his home in Florence on the Piazza di Madonna.

These works, to be sure, were the reason why Sansovino became very familiar with Maestro Luca Signorelli, the painter from Cortona, with Bramantino from Milan, with Bernardino Pintoricchio, with Cesare Cesariano, who was then held in esteem for his commentary on Vitruvius, and with many other famous and very talented men of that age.

Bramante, therefore, desiring that Sansovino should become known to Pope Julius, ordered that some antiques should be restored by him; and having set his hand to the task, he showed in putting them right so much grace and diligence that the Pope and whoever else saw them judged that they could not have been done better. And these praises spurred Sansovino to surpass himself in such a manner that flinging himself into his studies, being also a little frail in his constitution, and suffering from some disorder typical of young men, he fell so seriously ill that to save his life he was forced to return to Florence; and there, profiting from his native air, the advantage of being young, and the diligence and care of the doctors, in a short while he made a full recovery. Now at that time Messer Pietro Pitti was arranging to have a marble statue of the Madonna made for the façade where the clock is, in the New Market of Florence; and it seemed to him that as there were many able young men in Florence, and also masters, the work should be given to the one among them who made the best model. Thereupon one was given to Baccio da Montelupo, another to Zaccaria Zacchi of Volterra, who had also returned to Florence that year, another to Baccio Bandinelli, and yet another to Sansovino; and when they came to be assessed, Lorenzo Credi, an outstanding painter and a man of

goodness and judgement, and likewise the other judges, craftsmen, and connoisseurs, gave the honour and the project to Sansovino. But although, because of this, he was commissioned to do the work, none the less there was so much delay in procuring and transporting the marble for it to him, through the envy of Averardo da Filicaia, who strongly favoured Bandinelli and hated Sansovino, that he was ordered by some of the citizens, who had become aware of how long it was taking, that he should execute one of the large Apostles in marble to go in the church of Santa Maria del Fiore. So, having made the model for a figure of St James, which (when the work was finished) came into the hands of Messer Bindo Altoviti, he made a start on it; and, continuing to work on it with all care and diligence, he brought the figure to such perfection that it is truly a miracle, and its every detail reveals that it was executed with incredible diligence and care, with the draperies, the arms and the hands undercut and completed with such skill and so much grace that there is nothing better to be seen in marble. Thus Sansovino showed the way in which to undercut draperies in sculpture, having made these so subtle and so natural, that in some places he has made his marble reliefs of the same thickness as natural folds of cloth, and the edges and hems of the borders of real draperies: a difficult technique, and one requiring time and patience, if one wishes to succeed in demonstrating how to produce perfection in sculpture. And this figure has remained in the Office of Works from the time it was finished by Sansovino until the year 1565, when in the month of September, to honour the visit of Queen Giovanna of Austria, wife of Don Francesco de' Medici, prince of Florence and of Siena, it was placed in the Church of Santa Maria del Fiore, where it is preserved as a very rare work, along with the other Apostles, also in marble, made in competition by other craftsmen, as related in their lives.

At this time also, for Messer Giovanni Gaddi, he executed a Venus in marble on a shell, of great beauty, as was the

model which was in the house of Messer Francesco Mon-
tevarchi, a friend of these crafts, but which came to an
unfortunate end when the river Arno overflowed in the
year 1558; and he also did a *putto* made of tow and a swan as
beautiful as could be, in marble, for the same Messer Gio-
vanni Gaddi, with many other things he keeps in his house.
And for Messer Bindo Altoviti he had constructed a very
costly chimney-piece, all in grey-stone, carved by Benedetto
da Rovezzano, which was installed in his house in Florence,
where Messer Altoviti also had executed by Sansovino
himself a scene of little figures to go in the frieze of the
chimney-piece, with Vulcan and other Gods, which was a
very rare work. But far more beautiful are two marble
putti, originally above the crown of this chimney-piece,
holding the coat of arms of the Altoviti family in their
hands, which have been removed by Signor Don Luigi di
Toledo, who lives in the house of Messer Bindo, and placed
about a fountain in his garden in Florence, behind the Servite
Friars. Two other *putti*, also in marble, of extraordinary
beauty, by the hand of the same master, who are also holding
a coat of arms, are in the house of Giovan Francesco Ridolfi.
And these works caused Sansovino to be regarded by all
Florence, including the craftsmen, as an outstanding and
most graceful master. Because of this, Giovanni Bartolini,
having had a spacious house built in his garden of Gualfonda,
wanted Sansovino to make for him a life-size statue of a
young Bacchus in marble; and when Sansovino had done
the model, it pleased Giovanni so much that he had him
supplied with the marble, and Jacopo began work so en-
thusiastically that his hands and mind flew to finish it. Indeed
to make it perfect, he studied it in such a manner that he set
himself to portray from the life, though it was winter, an
assistant of his, called Pippo del Fabbro, making him stand
naked a good part of the day.★ When the statue was finished,

★ Vasari rounds off this story, in the 1568 version of the *Life*, by noting
that the experience of posing naked in the cold as Bacchus apparently
drove poor Pippo mad, and till he died only a few years later he would

it was held to be the finest work ever made by a modern master, seeing that in it Sansovino solved the problem, never before explored, of making an arm detached from the rest of the body and raised in the air, holding between the fingers a cup carved from the same marble so delicately that the attachment is very slight. Besides this, the attitude of the figure is so well devised and balanced on every side, and the legs and arms attached to the torso are so beautiful and well proportioned, that, when seen and touched, it seems more like living flesh, and so much so that this statue more than justifies the fame it has from those who see it. So then this work, when it was finished, while Giovanni was still alive, was visited in the courtyard at Gualfonda by all and sundry, natives and strangers, and was much praised. But subsequently, when Giovanni died, his brother Gherardo Bartolini gave it to Duke Cosimo, who, for the rare work it is, keeps it in his apartments along with other very fine statues of marble in his possession. For the same Giovanni, Sansovino also made a very fine Crucifix in wood, which is in their house, along with many works of the ancient world, and of Michelangelo.

Then in the year 1514, a very lavish display had to be mounted in Florence, for the visit of Pope Leo X, and orders came from the Signoria and from Giuliano de' Medici that many triumphal arches should be erected, in wood, in various parts of the city; and so Sansovino not only made the designs for many of them, but also undertook in company with Andrea del Sarto to make himself the façade of Santa Maria del Fiore all in wood, with statues, and scenes, and architectural orders, exactly as one would like it to be in order to remove all its Gothic order and composition. Therefore, having set his hand to this (to say nothing just now of the cloth awning that on the feast day of St John and other solemn festivals used to cover the piazza of Santa Maria del Fiore and that of San Giovanni, since we have

often be found wrapped round with cloth, as if he were a clay model, striking attitudes as a prophet, an Apostle, or a soldier.

talked about it enough elsewhere) let me say that beneath
the hangings Sansovino had constructed the façade in the
Corinthian order, giving it the appearance of a triumphal
arch, and that he had placed, on an immense base, double
columns on each side, with some huge niches between them,
complete with figures in the round representing the
Apostles; and over this were some large scenes in half-relief,
made to look like bronze, with episodes from the Old
Testament, some of which can still be seen in the house of
the Lanfredini, along the Arno. Above came the architraves,
friezes, and cornices, projecting outward, and then varied
and very beautiful frontispieces. Then in the angles between
the arches, on the broad parts and below, were scenes painted
in chiaroscuro by the hand of Andrea del Sarto, all very
beautiful. And in brief, this work of Sansovino was so good,
that when Pope Leo saw it, he said that it was a shame that
such a work was not the real façade of the church by the
German, Arnolfo.*

Sansovino also contributed to this display for the visit of
Pope Leo X, besides the façade, a horse in the round, entirely
of clay and shearings, in the act of rearing up, and with a
figure underneath of eighteen feet, set on a base of bricks.
And this work was executed with so much *bravura* and
boldness that it pleased and was highly praised by Pope Leo;
and in consequence Sansovino was taken by Jacopo Salviati
to kiss the feet of Pope, who treated him very fondly.

After the Pope had left Florence, he held a conference at
Bologna with King Francis I of France, and then he decided
to return to Florence. So Sansovino was instructed to make
a triumphal arch at the San Gallo gate; and in complete
harmony with his own standards, he executed it like the
other works that he had done, and so it was marvellously
beautiful, and filled with statues and painted pictures of the
best workmanship. Then, after his Holiness had determined

* Vasari's prejudice against the German, or Gothic, shows itself; the
architect of Santa Maria del Fiore, Arnolfo di Cambio (*c.* 1245–1302) was
Tuscan.

to have the façade of San Lorenzo executed in marble, while he was waiting for Raphael of Urbino and Buonarroti to come from Rome, Sansovino, on the instructions of the Pope, made a design for it: and as this proved very pleasing, Baccio d'Agnolo was commissioned to make a model of it in wood, which was most beautiful. And in the meantime, as Buonarroti had made another model, both he and Sansovino were commanded to go to Pietrasanta. They found many blocks of marble there, but difficult to transport; and thus they lost so much time that, when they returned to Florence, they found the Pope had left for Rome.

Both of them, therefore, went after him with their models, each by himself, and Jacopo arrived just at the moment when Buonarroti's model was being shown to his Holiness in the Borgia Tower. But he did not achieve what he thought he would, for, whereas he believed that he would, under Michelangelo, make at least part of those statues going into the project, following the Pope's mention of this to him, and what Michelangelo told him was his intention, he perceived, when he arrived in Rome, that Buonarroti wished to do it on his own. However, having made his way to Rome, so as not to return in vain to Florence, he resolved to remain in Rome, and devote his time to sculpture and architecture. And thus he undertook to make a Madonna in marble, larger than life-size, for the Florentine Giovan Francesco Martelli, and he produced a very beautiful figure, with the Child in her arms, which was placed over an altar on the right after you enter the principal door of Sant'Agostino. He presented the clay model of this statue to the prior of the Salviati in Rome, who placed it in a chapel of his palace on the corner of the piazza of St Peter's, at the beginning of the Borgo Nuovo.

Not long afterwards, he then made, to go over the altar of the chapel which the Most Reverend Cardinal Alborense had commissioned for the church of the Spaniards in Rome, a marble statue of St James, eight feet high, lovely beyond praise, with a very graceful air of movement and executed

so perfectly and judiciously that it brought him enormous fame. While he was working on these statues, he did the ground-plan and model, and began to build the church of San Marcello for the Servite friars, an assuredly beautiful work. And still pursuing the practice of architecture, for Messer Marco Coscia he did a very fine loggia on the road that leads to Rome, at Pontemolle on the Via Flaminia. For the Society of the Crucifixion, of the church of San Marcello, he made a wooden Crucifix for carrying in procession, which was very graceful. And for Cardinal Antonio di Monte, he began a great fabric at his villa outside Rome, on the Aqua Virgine.* And possibly also by the hand of Jacopo is a very fine portrait in marble of that elder Cardinal di Monte, which is now in the palace of Signor Fabiano at Monte Sansovino, over the door of the principal chamber of the hall. He also had Messer Luigi Leoni's house built very commodiously, and in the Banchi a palace by the house of the Gaddi family, which was subsequently bought by Filippo Strozzi, and which is, to be sure, very beautiful and commodious, with many ornaments. And it was at that time, with the favour of Pope Leo, that the Florentines living in Rome,† in emulation of the Germans, the Spaniards, and the French, who had either finished or started to build their own national churches there, and then begun to hold solemn services in those already completed and adorned, had sought permission to build a church for themselves in that city. The Pope, having given instructions for this to Lodovico Capponi, then consul for the Florentine residents in Rome, it was determined that behind the Banchi, at the beginning of the Strada Giulia on the bank of the Tiber, should be built a very great church, dedicated to St John the Baptist, which should surpass those of all the other nations in magnificence, size, expense, adornment,

* The Villa Giulia was completed for Pope Julius III by Vasari, Vignola, and Ammanati. The Aqua Virgine, running through the villa, is the aqueduct first brought to Rome by Marcus Agrippa.

† Described by Vasari as the *Nazione Fiorentina*.

and design. Raphael of Urbino, Antonio da Sangallo, and
Baldassare da Siena and Sansovino competed in making the
designs for this work, and when he had seen all their
drawings, the Pope praised Sansovino's as best, since, besides
other things, he had made a tribune at each of the four
corners of the church, and a larger tribune in the centre, in a
way similar to the plan that Sebastiano Serlio put in his
second book on architecture.* Thereupon, at the behest of
the Pope, all the leaders of the Florentine people came to-
gether in agreement, and with great approval being shown
to Sansovino, work began on part of the foundations of the
church, to a length of 176 feet.† But as there was not enough
space, and yet they wished to make the façade of the church
in line with the houses on Strada Giulia, they found it
necessary to enter into the stream of the Tiber at least 170
feet. This pleased many of them, as both the expense and
the pride of the Florentines were increased by sinking the
foundations in the river. So the work was begun; and they
spent over 40,000 crowns on it, which would have been
enough to build half the brickwork of the church.
Meanwhile Sansovino, who was head of construction for
the church, as the foundations were being laid little by little,
had a fall and hurt himself badly; and so a few days later he
was carried off to Florence to recover, and left Antonio da
Sangallo, as was said, in charge of finishing the foundations.
But not long afterwards, when through the death of Leo
the Florentine people in Rome lost so great a support, and
so splendid a prince, the building was abandoned for the
lifetime of Pope Hadrian VI. Then with the election of
Clement, to pursue the same order and design, it was decreed
that Sansovino should return and continue the fabric in the
manner he had first designed it; and so the work began

* Sebastiano Serlio (1475–1554), an influential Bolognese architect and
writer who began publication of his planned sequence of seven books on
architecture in Venice, after leaving Rome when the city was sacked in
1527.

† Approximately: the measurement was twenty-two canne (and, below,
fifteen canne) or rods, which varied from region to region.

again. But meanwhile, he undertook to execute the tomb of the cardinal of Aragon and that of the cardinal of Agen; and already having started to have the marble cut for the ornaments, and many models made for the figures, he now had Rome in his grasp, and he was busy on behalf of all these lords, making most important works, having been acknowledged by three pontiffs, and especially by Pope Leo, who gave him a knighthood of St Peter, which he sold during his illness, fearing he would die; and then to chastise that city, and to humble the pride of the inhabitants of Rome, God allowed the Bourbon to come with his army on 6 May 1527, and to put all that city to the sack by sword and fire. In that disaster, among many other brilliant minds that came to a sad end, Sansovino was forced to his great loss to leave Rome and to flee to Venice, meaning to go from there to serve the king of France, to which country he had already been invited.

But while he lingered in Venice to put his affairs in order and provide for the many things he needed, for he had been despoiled of everything, it came to the ears of Prince Andrea Gritti, who was a great friend of talent, that Jacopo Sansovino was in the city. Thereupon he had the desire to speak to him, since at that very time Cardinal Domenico Grimani had given him to understand that Sansovino would have been the right man for the cupolas of their principal church, San Marco, which because of weak foundations, and old age, as well as being badly secured with chains, were all loose and threatening to collapse; and so he sent for him. And then, after warm greetings and lengthy conversation, he said to Sansovino that he wished him, and begged him, to find a way to stop the ruin of those domes, and Sansovino promised to do this and to find a remedy. So, having undertaken this task, he set his hand to it, and having arranged for all the scaffolding to be erected within, and having made a framework in the shape of a star, he shored up, inside the wooden framework, all the beams supporting the ceiling of the tribune, and made wooden ties inside; and

then, afterwards, he made iron chains to compress them from the outer side; and, rebuilding the walls with new foundations beneath and with pilasters to buttress them, he strengthened the building and made it secure for ever. By doing this, Sansovino caused all Venice to wonder, and he did more than give satisfaction to Gritti; indeed, far more than that, he gave to the most Serene Senate of Venice such brilliant evidence of his talent, that when, after the work was finished, the masterbuilder to the noble procurators of St Mark's died, they gave this post,* the most important these lords can bestow on their engineers and architects, to Sansovino, with the usual house and a very advantageous salary.

So Sansovino took up this office, and then began to perform its functions very scrupulously, both with regard to the buildings and in managing the policy papers and books held by virtue of his office, applying himself with all diligence to the business of the church of San Marco, to the commissions, which are very numerous, and to the many other transactions carried out in the procuracy; and he dealt with these lords with extraordinary solicitude, inasmuch as having turned all his attention to benefiting them, and to arranging their affairs to promote the greatness, the beauty and the adornment of their church, their city, and their public square (something never formerly done by anyone in that office), he then provided for them various benefits, proceeds and revenues through his ideas, with his shrewd mind and eager spirit, yet always at little or no cost to the lords themselves.

Among these initiatives was the following. In the year 1529, there were between the two columns in the piazza some butchers' stalls, and also between one column and the next many wooden huts for the convenience of people's natural needs, something foul and shameful for the dignity of the palace and the public square, as well as for strangers,

* The *Protomaestro* combined the jobs of chief architect and the superintendent of buildings.

who coming to Venice by way of San Giorgio saw on their arrival all that filthiness first of all. Because of this, Jacopo, after demonstrating to Prince Gritti the honourable and profitable nature of his intentions, had the stalls and huts taken away, and placing the stalls where they are now, and adding some outlets for the sellers of herbs, he obtained for the procuracy an extra revenue of 700 ducats, and at the same time embellished the piazza and the city. Not long afterwards, having seen that in the Merceria, which leads to the Rialto, near the clock, by removing a house that paid a rent of twenty-six ducats, a street could be built going into the Spaderia, whereby the rents from all the houses and shops around would be increased, he demolished the house, and increased their income by 150 ducats a year. As well as this, by placing on that site the Pilgrims' Inn, and another in the Campo Rusolo, he increased their income by 400 ducats. He gave them similar benefits from the buildings in the Pescaria, and, on various different occasions, from many houses and shops and other places belonging to these lords at various times; and as those procurators gained on account of him more than 2,000 ducats in revenue, they rightly felt able to love and cherish him.

Not long after this, by order of the procurators, he set his hand to the very beautiful and rich fabric of the library opposite the Palazzo, with such variety of architecture, since it is both Doric and Corinthian, and such an array of carvings, cornices, columns, capitals, and half-length figures throughout the whole work, that it is a marvel. And all was done with no expense spared, for it is covered with the richest of pavements, stuccoes, and painted scenes throughout all its halls, as well as public staircases adorned with various pictures, as discussed in the *Life* of Battista Franco; not to mention the rich adornments and conveniences that it has at the principal door of the entrance, which all endow it with majesty and grandeur, demonstrating Sansovino's talent. In that city, where till then no way of building had been established other than that of imposing a uniform order

on their houses and palaces, so that each one kept conservatively to the same measurements and old usages, and there were no variations according to convenience or location, in that city, let me say, Sansovino's method of building was the reason why public and private edifices began to be constructed with new designs and better order, and according to the ancient teaching of Vitruvius. And the library, in the judgement of knowledgeable people, who have seen many parts of the world, is without any equal.

Sansovino then, did the palace of Messer Giovanni Delfino, situated on the Grand Canal on the other side from the Rialto, opposite the Riva del Ferro, at a cost of 30,000 ducats. He likewise did a palace for Messer Leonardo Moro at San Girolamo, a very costly work, looking like a castle. And he did the palace of Messer Luigi de' Garzoni, wider by thirteen paces in every direction than the Fondaco de' Tedeschi, and so well accommodated that there is running water throughout the palace, which is adorned with four very fine statues by Sansovino, and is situated in the neighbouring countryside at Ponte Casale. But the most beautiful is the palace of Messer Giorgio Cornaro on the Grand Canal, which, undoubtedly surpassing the others for convenience, majesty, and grandeur, is reputed to be the finest perhaps in the whole of Italy. To finish with the private buildings which he did, Sansovino also built the Scuola of the Confraternity of the Misericordia, a very great edifice, costing 130,000 crowns which, when it is finished, will be the most superb building in Italy. Also one of his works is the church of San Francesco della Vigna, the seat of the Observant friars, an enormous and important edifice, though the façade was by another master. The loggia about the Campanile of San Marco, in the Corinthian order, was from his design,* with a very rich adornment of columns, and with four niches, in which there are four very fine bronze figures, a little less than life-size, from his hand, as well as various scenes and figures in low relief. This work

* The free-standing columns are composite, not Corinthian.

makes a very beautiful base to the Campanile, which has a width, on one of the sides, of thirty-five feet, all round corresponding to Sansovino's ornamentation; and its height, from the ground to the cornice, with the openings for the bells, is 160 feet; then from the level of that cornice to the level above, with the corridor, is twenty-five feet; and the other dado has a height of twenty-eight and a half feet. From the level of the corridor to the pyramidal steeple is sixty feet; at the summit of this spire, the little square, on which rests the Angel, is six feet high; and this Angel, which turns with every wind, is ten feet high: so the total height comes to 292 feet.*

But the finest, richest, and strongest of Sansovino's edifices is the Mint of Venice, all of iron and stone, for in order to safeguard it completely against fire, there is not a single piece of wood in it. The interior, moreover, is divided in such a well-ordered and convenient way for the sake of all its workmen, that there is nowhere in the world a better-ordered stronghold as a Treasury; and Sansovino made it something very beautiful, in the rusticated order. This method never having been used before in that city, its appearance greatly amazed the inhabitants. And then, also by Sansovino's hand may be seen the church of Santo Spirito, on the lagoons, which is of very charming and delicate workmanship. And in Venice, he did the façade of San Geminiano, which lends splendour to the piazza, and that of San Giuliano in the Merceria, as well as the very rich tomb of Prince Francesco Venier in San Salvatore. On the Grand Canal, at the Rialto, he likewise erected the New Buildings of vaulted bays which are so well designed that a very thriving market of the townsfolk and other people who flock into that city forms there almost daily. But altogether splendid and novel was what he did for the Tiepolo family at the Misericordia; for having a great palace on the canal with many regal apartments, they found the structure so badly founded in the water that it was thought very likely

* The height of the old Campanile, finished about 1514, was 323 feet.

to crash to the ground within a few years; and then San-sovino rebuilt all the foundations in the canal below the palace with huge stones, and kept the house standing with a marvellous arrangement of props, while the owner stayed at home safe and sound.

Nor, while Sansovino was attending to all these buildings, did he ever neglect to work every day, for his own pleasure, on large and beautiful sculptures, both in marble and bronze. Over the holy water font of the friars of the Ca'Grande, there is from his hand a statue made of marble, representing St John the Baptist, which is very beautiful and highly praised.

Then, in a chapel of the Santo at Padua, there is also from Sansovino's hand a large marble scene, with very fine figures in half relief, of a miracle of St Anthony of Padua, which is much esteemed in that place.

For the entrance to the stairs of the palace of St Mark's he has now been making in marble, in the form of two very impressive giants, each fourteen feet high, a Neptune and a Mars, signifying the strength of the Most Serene Republic both on land and at sea. He also executed a very fine statue of Hercules for the Duke of Ferrara; and for the church of San Marco he did six bronze scenes, in half relief, two feet high and three feet across, for placing on a pulpit, with stories from the life of that Evangelist, which are much prized for their variety. And above the door of San Marco, he has executed a Madonna in marble, life-size, which is held to be very beautiful. Again, by his hand is the bronze door leading into the sacristy of St Mark's which is divided into two very beautiful parts, and contains scenes of Jesus Christ, all in half relief and excellently crafted; and above the door of the Arsenal he did another very beautiful Madonna in marble, holding her Son in her arms.

These works have all not only adorned and shed lustre on the Republic of Venice, they have also day by day caused Sansovino to be known for the outstanding craftsman he is, and to be loved and honoured by those most liberal and magnificent of lords, as also by the craftsmen, who have

referred to him every item of sculpture and architecture carried out in Venice in his time. And in very truth, because of his excellence Jacopo is deservedly ranked in first place in that city among the artists of design, and his talent is loved and respected generally by both nobles and plebeians. For besides all the other things, he has, as said, with his knowledge and judgement caused that city to be made almost completely new, and to learn the true and good method of building.*

Three very beautiful stucco figures by Sansovino may also be seen in the possession of his son, one a Laocoön, another a Venus standing, and the third a Madonna surrounded by many *putti*; and these are of such quality that there is nothing else to be seen like them in Venice. This son also has drawings of sixty plans of temples and of churches of Sansovino's invention so outstanding, that from the time of the ancients till now it has been impossible to see any that are better conceived or more beautiful. And I have heard that his son will publish these for the benefit of the world, and already he has had some pieces engraved, putting along with them designs of innumerable illustrious projects organized by him in various parts of Italy.

For all this, although he was occupied, as said, in the management of so many public and private concerns, both in the city and abroad (for strangers also ran to him for models or designs of buildings, or for figures, or advice, as did the Duke of Ferrara, who obtained a Hercules in the form of a giant, the Duke of Mantua, and that of Urbino), Sansovino was always very prompt in the personal and particular service of each of the Lords Procurators. And they, availing themselves of him both in Venice and elsewhere, and doing not a single thing without his help and counsel, made use of him continually, not just for themselves

* At this point in the 1568 version of the *Life* of Sansovino, Vasari goes on to list some of his friends, such as Titian, pupils, notably Ammanati and Danese Cattaneo (who fled with him from Rome after the sack), and fellow artists from the Veneto, principally Palladio.

but for their friends and relations too, without any payment, since he was ready to put up with any fatigue or discomfort, just to satisfy them.

But above all, he was greatly loved and prized beyond measure by Gritti, lover of fine intellects, by Messer Vittore Grimani, brother of the cardinal, and by Messer Giovanni da Legge, the knight, all procurators, and by Messer Marc' Antonio Giustian, who came to know him in Rome. For these illustrious men of exalted spirit and truly regal minds, being experienced in worldly matters, and fully conversant with noble and excellent arts, soon recognized his worth, and how much he merited affection and esteem. And making the most they could out of this, they used to say (in agreement with the whole city) that the procurators never had nor ever would have at any future time another equal to him. For they knew very well how celebrated and famous his name was in Florence, in Rome, and throughout Italy, with the men and princes of intellect, and were all firmly convinced that not only he but all his posterity and descendants well deserved to be endowed for ever because of his unique talent.

Jacopo was physically of ordinary stature, not at all fat, and he walked in an upright posture. He was pale, with a red beard, and as a youth very handsome and graceful, and so much loved by women of some importance. Then, in his old age, he was of venerable appearance, with a fine white beard, but the walk of a young man; and so, having reached the age of ninety-three years, he was very healthy and vigorous, and even without his spectacles could see the tiniest object, however far off it might be; and when he was writing, he kept his head erect, not leaning forward, even a little, as others usually do. He loved to dress like a gentleman, and he was always very neat about his person, and into his ripe old age ever fond of women, and loved to talk about them. In his youth, because of his excesses, he was not very healthy, but as an old man he never experienced any illness; thus for the space of fifty years, however much he might

sometimes feel indisposed, he would never consult a doctor, and indeed when, at the age of eighty-four, he had an apoplectic stroke for the fourth time, he recovered simply by staying two months in bed in a very dark, warm place, and spurning medicines. His stomach was so strong that he was not worried about anything, and made no distinction between good and harmful food; and in summer he lived almost solely on fruit, very often eating up to three cucumbers at a time, and half a lemon, in his extreme old age. As for his qualities of mind, he was very prudent, and he used to foresee future events in present instances and weigh them against those of the past; and he was solicitous in his affairs, never being wearied by them, and never neglecting business for pleasure. He discoursed well, and with a flow of words, on whatever subject he understood, citing many examples with good grace. So because of this he was very pleasing to people great or small, and to his friends. And in his final old age, his memory was still very green, and he recalled in minute detail his childhood, the sack of Rome, and many things, both favourable and adverse, that he had experienced in his time. He was courageous, and from boyhood he delighted to strive with those greater than himself; because he used to say that if he strives with the great, a man grows, but if with the small, he shrinks. He valued honour above everything else in this world, and so in his dealings he was most loyal and a man of his word, and he possessed such integrity of soul that nothing however substantial could corrupt him, though he was more than once put to the test by the procurators who, because of this and his other qualities, treated him not as their master-builder and minister but as a father and brother, honouring him for his unfeigned and natural goodness. He was generous with everyone, and so affectionate towards his relations that, to help them, he deprived himself of many comforts, though he lived all the time honourably and in good repute, as someone who was observed by all. Sometimes he let his naturally fierce temper get the better of him,

but it soon abated; and quite often, a few contrite words would bring the tears to his eyes.

Sansovino loved the art of sculpture beyond all measure, and indeed so passionately that, so that it could spread as widely as possible in many parts of the world, he trained a host of disciples, more or less founding a seminary for sculpture in Italy. Prominent among these were Niccolò Tribolo and Solosmeo, both Florentines; the Tuscan Danese Cattaneo from Carrara, of supreme excellence in poetry besides sculpture; Girolamo da Ferrara; the Venetian Jacopo Colonna; Luca Lancia of Naples; Tiziano da Padova; Pietro da Salò; the Florentine Bartolommeo Ammanati, the present masterbuilder and sculptor of the Grand Duke of Tuscany; and finally Alessandro Vittoria of Trento, a rare master of portraits in marble, and Jacopo de' Medici of Brescia. And these men, renewing the memory of the excellence of their master, have used their skill to create many noble works in various cities.

Sansovino was highly esteemed by princes, among whom Alessandro de' Medici sought his judgement in building his citadel in Florence. And Duke Cosimo, in 1540, when Sansovino had returned to his homeland to see to his affairs, not only asked his opinion concerning that fortress but endeavoured to engage his services, offering a fat salary. Again Duke Ercole of Ferrara, when Sansovino was returning from Florence, kept him by him and put forward various proposals, making every effort to detain him in Ferrara; but Sansovino absolutely refused to consent, having grown used to Venice, being very comfortable there, where he had lived a large part of his life, and having exceptional fondness for the procurators, by whom he was treated so honourably. He was also likewise sought after by Pope Paul III, who wanted to put him in charge of St Peter's, in place of Antonio da San Gallo, and in this matter, Monsignor della Casa, who was then the Papal legate in Venice, became very involved; but it was all in vain, for Sansovino said that he was not intending to exchange his condition of life in a

republic for that of again being under an absolute prince. And King Philip of Spain, on his way to Germany, treated him very affectionately in Peschiera, where he had gone to see him.

Sansovino had an immoderate longing for glory; and for this reason, not without notable loss to his descendants, he spent much on others from his own resources, to ensure some remembrance of himself. Those who are knowledgeable say that however much he had to cede to Michelangelo, in some things he was his superior; because in executing draperies, little children, and the expressions of women, Jacopo had no equal. For indeed his marble draperies were most delicate, well executed, with pretty pleats and folds revealing the nude under the clothing; and his little children he made tender and soft, without those muscles that adults possess, and with little arms and legs like flesh so that they seemed really and truly alive. The expressions of his women were sweet and charming, and as gracious as could be, as can be seen in many public places from the various Madonnas which he did, of marble and in low relief, and from his Venuses and other figures.

Now this man, having become so renowned in sculpture and so unique in architecture, having lived in the grace of mankind and of God, who conceded to him the talent which made him brilliantly famous, as has been described, and having reached the age of ninety-three years, feeling a little weary in body, took to his bed in order to rest; and having lain without suffering at all (though he strove to get up and dress himself as if well) for the space of a month and a half, weakening little by little, he wished to receive the sacraments of the Church; and having had them, still keeping up the hope that he would live a few more years, he sank into death on 2 November 1570. And although he had come to the end of his natural course through old age, yet his death grieved the whole of Venice.

He left behind him Francesco, his son who was born in Rome in the year 1521, a man who was learned both in the

law and in the humanities, from whom Jacopo saw three grandchildren born, a male child named Jacopo after his grandfather, and two girls: one named Fiorenza, who died, to his tremendous grief and sorrow, and the other Aurora.

His body was carried with great honour to his chapel at San Geminiano, where his son erected the marble statue, made by Jacopo himself while he was alive, with this epitaph given below in memory of his great talent:

IACOBO SANSOVINO FLORENTINO QVI ROMAE IVLIO II.
LEONI X. CLEMENTI VII. PONT. MAX. MAXIME GRATVS,
VENETIIS
ARCHITECTVRAE SCVLPTVRAEQVE INTERMORTVVM DECVS
PRIMVS EXCITAVIT, QVIQVE A SENATV OB EXIMIAM VIRTVT-
EM LIBERALITER HONESTATVS, SVMMO CIVITATIS MOER-
ORE DECESSIT. FRANCISCVS F.
HOC MON. P. VIXIT ANN. XCIII. OB. V. CAL. DEC. MDLXX.*

His funeral was similarly celebrated in public at the Frari by the Florentine people in Venice, with a ceremony of some importance, and the oration was delivered by the Admirable Messer Camillo Buonpigli.

* To Jacopo Sansovino at Florence – who at Rome was mightily pleasing to the Popes Julius II, Leo X, and Clement VII; who first revived for the people at Venice the dormant glory of architecture and sculpture; and who, having been highly honoured by the Senate for his outstanding merit, passed away to the great grief of the city – this memorial was erected by his son Francesco. He lived ninety-three years, and died on 27 November 1570.

NOTES ON THE ARTISTS

by Peter Murray

—— · ——

IN these notes I have tried to record major surviving works with their present location and, occasionally, their condition. For works which are lost but are known from copies I have tried to list the copies. These notes are not intended to be complete, and in some cases of disputed attribution or identity I have come down flatly on one side without attempting to argue. A further problem is that many works, especially frescoes which have been taken off the wall, are frequently moved about. The Belvedere Fort in Florence is a temporary resting-place for such works, but I have tried to be as up-to-date as possible in giving locations. Names of towns – Vienna, Berlin – imply the major gallery there, but I have also frequently given the name of the gallery – Louvre, Uffizi, Pitti – without adding Paris, Florence, etc., on the grounds that anyone reading these notes is likely to be familiar with them. There is now a tendency to refer to the Galleria Palatina for what has always hitherto been called the Pitti, but I have retained the old name.

NICOLA AND GIOVANNI PISANO

Vasari was right, as we see it, to begin his account of the new art with the painter Cimabue, the architect Arnolfo, and the sculptors Nicola and Giovanni Pisano. He was wrong, however, in the order, since Arnolfo di Cambio was the pupil of Nicola Pisano. We see things this way because Vasari did, but there is no evidence whatsoever to suggest that some other, unknown, geniuses were really responsible for the great changes in Italian art in the years after about 1260. He was also surprisingly well informed about their works, although it is vital for us to remember that when he was writing, before 1550, he was recounting events that had happened almost 300 years ago – as if we were to write about the events of the 1680s – the Restoration, say.

He is also obviously right in his opening paragraphs about the

influence of Roman art on Nicola Pisano, since the sarcophagus he records as being in Pisa is still there (although it is now thought to represent Phaedra rather than Meleager), and the influence of the figures in it is obvious in Nicola's pulpit in the Pisa Baptistry. The account of Nicola's early career, however, is another matter: the current view is that Nicola may well have come from Apulia rather than Pisa, and that he was born *c.* 1220–25 and trained in South Italy, where a classical revival was being fostered by Frederick II Hohenstaufen for political reasons of his own. Certainly, Nicola is first documented in 1258, so Vasari's account of his visit to Bologna is suspect, especially as the *Arca di S. Domenico* there is known to have been commissioned from him in 1264 rather than 1225 – in any case, it was almost certainly executed by pupils of his – Arnolfo, Lapo and others – and not by him. Similarly, Vasari lists a number of buildings which he attributes to Nicola or Giovanni, but which actually date from anywhere between the early thirteenth century to the late fourteenth. Nevertheless, both Nicola and Giovanni were active as architects, as well as sculptors.

From the confusing list of works given by Vasari we may concentrate on the few which are certainly by one or the other, or by both, starting with Nicola's pulpit in the Baptistry at Pisa, which, as Vasari correctly says, is signed and dated in an inscription of 1260 (in fact, this should be read as 1259, since the Pisan year was different from most of the rest of Europe as we now reckon years). The next pulpit, in Siena Cathedral, gets scanty attention from Vasari, but is documented as 1265–8, and the records give the names of Nicola's assistants: his young son Giovanni, Arnolfo, Lapo and Donato.

Vasari's account of the work at Orvieto is an example of his 'expansionism', since the reliefs of the cathedral façade are certainly much later, even though there is disagreement about the artists responsible.

The Fountain in the piazza outside Perugia Cathedral is his last known work and is signed and dated by him and by his son in 1278: this is the last reference we have to Nicola until, in March 1284, he is referred to as dead.

It is generally thought that there are two distinct styles in the Perugia Fountain, and that the upper part is by Giovanni. He was certainly born in Pisa, probably about 1248, and is last documented in 1314.

His style is markedly less classical than his father's and much

closer to French Gothic models. This has led to the supposition that he actually went to France and had first-hand knowledge of the great sculptural cycles on the cathedrals there. There is no evidence for such a journey, and present opinion is that he derived his undoubted knowledge of the Gothic style from portable works such as ivories. He was responsible for the sculptural programme of Siena Cathedral, where he was working between about 1284 and 1296, and the disposition of the façade figures is quite different from those of the great French cathedrals. Most of his figures for Siena are now in the Cathedral Museum there, but a fragmentary piece came to light recently and is now in the Victoria & Albert Museum, London.

The pulpit in Sant'Andrea, Pistoia, is closely based on the one in Pisa by his father, but the style is much more Gothic. It is signed and dated 1301 and, according to Vasari, took four years to make.

His masterpiece is another pulpit in Pisa, in the Cathedral, finished half a century after his father's in the Baptistry. For some reason Vasari is highly critical of it, perhaps because of its Gothic tendency. He says that it was finished in 1320, but he misread the inscription which gives Giovanni's name and the date 1311 (i.e. 1310): a second inscription, in very obscure Latin, seems to complain about Giovanni's hard life and lack of recognition. The pulpit was dismantled in the seventeenth century and was only reconstructed in 1926, minus several pieces (some now in Berlin and the Metropolitan Museum, New York). His last work, the Tomb of Margaret of Luxembourg, is also dismantled, but various pieces survive (e.g. in Genoa) – Giovanni was in Genoa in 1313 and is last heard of in 1314. Vasari may therefore be correct in giving 1320 as the date of his death, since he may have seen the grave in which, he says, Giovanni was buried along with his father.

DUCCIO DI BUONINSEGNA

Duccio di Buoninsegna (c. 1255/60–1315/19) was the first, and arguably the greatest of Sienese artists, comparable with Cimabue and Giotto. It is therefore surprising how badly informed Vasari was concerning him, and the *Life* clearly demonstrates the difficulty he had in getting reliable information outside Florence. In fact, as he admits, he was almost totally dependent on the few lines in Ghiberti's *Commentarii*, written about 1450. Ghiberti's notes were

not chronological and Vasari was therefore misled from the beginning in thinking that Duccio was 'about 1350', which makes him the follower of Simone Martini and the Lorenzetti brothers instead of their teacher. Ghiberti's note on Duccio, in full, reads: 'In Siena there was also Duccio, who was most noble; he retained the Greek manner; by his hand is the main altarpiece (*tavola maggiore*) of the cathedral of Siena; and on the front of it the Coronation of Our Lady and on the back the New Testament. This picture was most excellently done and with great skill. It is a magnificent thing and he was a most noble painter.' The *Maestà* is indeed a magnificent thing, and Duccio's masterpiece. It was painted between 1308 and 1311, when it was taken in procession to the High Altar of Siena Cathedral (Vasari managed to relate the triumphal procession to the Rucellai Madonna in Florence, almost certainly actually by Duccio (1285), but attributed by Vasari to Cimabue). The *Maestà* was moved from the High Altar in 1506, as Vasari says, and was later broken up; nevertheless most of it is still in Siena (Cathedral Museum), although some of the smaller panels are now in London, Washington, New York (Frick), Fort Worth and Mount Holyoke, Mass. Probably as many as fifteen others have gone missing. The huge painting, some sixteen feet wide, was still in the cathedral when Vasari complained that he could not find it, in spite of the utmost diligence. This was almost certainly because he was looking for a picture of unknown size representing the *Coronation of the Virgin* – a different subject – and, above all, because he had no idea of Duccio's style, since he thought the Rucellai Madonna was Cimabue's and he was looking for something painted about 1350. In any case, he was handicapped by thinking that Duccio did the earliest parts of the famous marble inlaid floor of the cathedral, which was not begun until forty-odd years after Duccio's death. The only other painting he mentions is an *Annunciation* in Sta Trinita, Florence, which is either lost, or, more likely, is the *Annunciation* still there but by Lorenzo Monaco and painted in 1422–5.

Finally, Vasari pads out the account with a piece on Moccio, who was Moccio da Perugia, active in Siena in 1340–45, and some motley attributions such as the Loggia de' Mercatanti, which dates from 1454–9.

LUCA DELLA ROBBIA

The *Life* of Luca della Robbia and his family in the first edition (1550) of Vasari's book is very short and not at all accurate, but in the second edition he specifically claims to have information from members of the family, and the *Life* is consequently much longer. Oddly enough, however, it is not much more accurate and there are several strange mistakes, beginning with the fact that Luca's birth and death dates are placed far too early: he says that Luca was born in 1388 and implies that he died about 1461, which is in line with the statement in the first edition (not repeated in the second) that he was seventy-three when he died. In actual fact, his father's tax return says that Luca was twenty-seven in 1427, so he was born in 1399–1400, and he died in 1482. Vasari also implies that he got information about the family from Andrea, Luca's nephew, who 'died in 1528', aged eighty-four, but who actually died in 1525 at the age of ninety, when Vasari himself was barely fourteen. He could well have heard a confused old man reminiscing about things that happened almost a century before, but Vasari also introduces Girolamo della Robbia, who had returned to Florence from France in 1553, and was therefore not mentioned in the 1550 edition. It is also interesting that, in the first edition, Vasari mentions Andrea, but does not claim to have spoken to him.

We start, therefore, with the statement that Luca went to Rimini in 1403 at the age of fifteen to work for the Malatesta: he was then three years old, and the Tempio Malatestiano was not actually begun until 1447, by Matteo de' Pasti, and it has no connection with Luca. After this, Vasari continues, Luca was recalled to Florence to work on the Campanile (actually commissioned in 1437), and, 'in 1405', on the Organ Loft of the cathedral. This, the so-called Cantoria or Singing Gallery, is Luca's masterpiece and was actually made between 1431 and 1437, a little before the companion by Donatello (as Vasari correctly observes). Luca's Cantoria was dismantled in 1688 and most of it is now reconstructed in the Cathedral Museum. The nude angels in bronze mentioned by Vasari are almost certainly those now in the Musée Jacquemart-André, Paris. The other major commission for Florence Cathedral, the bronze doors of the sacristy, is still there. The doors were commissioned in 1446 from Michelozzo (q.v.), Luca, and Maso di Bartolommeo, but were carried on by Luca alone, 1464–9. Vasari

mistakes the panel of S. John Baptist for the Resurrection, but otherwise his description is accurate, as is that of the two accompanying glazed terracotta panels, of the *Resurrection* and the *Ascension* (commissioned in 1442 and 1446 respectively). At this point Vasari asserts that glazed terracotta sculpture was invented by Luca and used for the first time in these panels: by and large he is right – glazed earthenware pottery is, of course, of great antiquity, but the use of the technique for sculpture does seem to have been invented by Luca, and was carried on by the family workshop well into the sixteenth century. It is likely that Luca made some experiments in the 1430s, a few of which have survived, but the two reliefs in the cathedral seem to be the first of his major works in this new medium.

Other glazed terracottas are the *Twelve Months*, now in the Victoria & Albert Museum, which are very probably the works for the Medici Palace recorded by Vasari. Others, still in place, are the tomb of the cardinal of Portugal and that of Bishop Federighi, partly in marble, recorded by Vasari as in 'S. Brancazio' (i.e. S. Pancrazio), but which has been moved to S. Trinita. The terracottas in the Pazzi Chapel are the subject of controversy; although most are by Luca the dates are disputed and some of the figures have been attributed to Brunelleschi or Donatello – presumably executed in the della Robbia workshop. The marble tomb for the Infante, brother of the Duke of Calabria, made in Florence and sent to Naples, seems either to have been lost or never to have existed.

MICHELOZZO MICHELOZZI

Michelozzo (1396–1472) was active both as a sculptor and as an architect, and Vasari begins by associating him with Donatello in sculpture and ranking him after Brunelleschi in architecture, both of which are reasonable assessments, although much the greater part of the *Life* is devoted to his work as an architect. In sculpture Michelozzo was closely associated with all three of the leading Florentine sculptors of the fifteenth century, so that his own personality is somewhat submerged. He was working on the first of Ghiberti's bronze doors for the Baptistry in 1417, and was later renowned for his skill as a bronze-worker; by 1425 he was sharing a studio with Donatello, with whom he collaborated on such

major works as the tombs of the Anti-Pope John XXIII and of Cardinal Brancacci in Naples, the Aragazzi Monument (largely by him) and the Prato Pulpit. This collaboration ended about 1433 and Michelozzo later worked again for Ghiberti on the second doors, and later still for Luca della Robbia.

Most of these works are mentioned by Vasari, but he ends with a *S. John*, which is probably by Antonio Rossellino, and he omits Michelozzo's important contribution to the Silver Altar of the Baptistry (1452).

His work as an architect began in the 1430s and was crowned by his commission to build the new palace for Cosimo de' Medici and by his appointment to succeed Brunelleschi as chief architect of the cathedral in 1446. Michelozzo's connection with Cosimo de' Medici goes back at least to 1433, when he accompanied Cosimo in his exile to Venice. There he built the library for S. Giorgio Maggiore, as Vasari says, but it was burned down in 1614. This would have been a predecessor of the famous library, which still exists, for the convent of S. Marco in Florence, another of Cosimo's commissions. Before coming to this, however, Vasari devotes a long passage to Michelozzo's work for the Signoria of Florence, taking the occasion to point out how he himself had worked there in 1538 for Duke Cosimo. He then turns to the work at S. Marco, most of which still exists, although the chapel was rebuilt in the seventeenth century. His citation of the inscription recording the consecration by Eugenius IV in 1442 (1443 in our reckoning) is a rare example of his care to give exact dates whenever possible. The noviciate at Sta Croce, and the Medici villas at Caffagiolo, Trebbio, Careggi, and Fiesole all exist, but with alterations – the villa at Fiesole was rebuilt in the eighteenth century, and the church and convent there have been rebuilt. Nothing seems to be known of the Hospice in Jerusalem. Perugia is an example of Vasari's dependence upon earlier writers: the so-called Anonimo Magliabechiano has a note referring to Michelozzo's work in 'Raugia', which Vasari misread as 'Perugia' instead of 'Ragusa', the city now in Yugoslavia and renamed Dubrovnik. In the fifteenth century Ragusa was a Venetian possession, and Michelozzo is known to have worked there.

The Palazzo Tornabuoni, now Corsi, had its façade altered in the nineteenth century. Considerable parts of S. Miniato, especially the Cappella del Crocefisso, and of SS. Annunziata remain as he

built them, although the tribune of the Annunziata was much altered by Alberti and again later.

The important palace in Milan, built for the Medici Bank, is now known only from a drawing by Filarete (mid fifteenth century) and a doorway in the Museo Sforzesco, Milan. The decorations by 'Vincenzio di Zoppa', i.e. Vincenzo Foppa, have been lost except for a charming fragment, *The Young Cicero Reading*, now in the Wallace Collection, London.

Vasari gives no date for Michelozzo's death, saying only that he was sixty-eight when he died. In fact, he was seventy-six (1396–1472), but the portrait by Fra Angelico as Nicodemus in his *Deposition* (now in S. Marco) is generally accepted: if it was painted about 1440 Michelozzo would have been forty-four, which seems reasonable.

ANDREA DEL CASTAGNO AND DOMENICO VENEZIANO

The joint *Life* devoted to Andrea del Castagno and Domenico Veneziano is often cited as an example of Vasari's general untrustworthiness and his love of moralizing and melodrama. He begins with one of his characteristic homilies, pointing out that Castagno's art was forceful to the point of brutality and proceeds to the rash assumption that Castagno himself must have been harsh and brutal in his life, as was shown by his cold-blooded murder of Domenico Veneziano. The truth was established by Milanesi in the 1860s, when he demonstrated conclusively that Castagno died, probably of the plague, in August 1457 and Domenico did not die until 1461. Nevertheless, it is equally rash to blame Vasari for apparently making it all up, since we also now know that he was dependent upon an earlier writer, perhaps active in the fifteenth century, who was the common source of the *Libro di Antonio Billi* and the so-called Anonimo Magliabechiano, both of whom have the story. Indeed, it seems certain that, about 1448, a painter called Domenico was murdered by another painter called Andreino, so it is hardly surprising that Vasari could not resist so good a story, especially as Castagno's art is undoubtedly characterized by forceful draughtsmanship, dramatic foreshortenings, harsh colour, and general *terribilità*. The problem is to avoid falling into the same trap, particularly as Domenico's art is very unFlorentine in its emphasis on light and colour rather than line.

The date of Castagno's birth is still controversial, but it is now agreed to have been 1419 or 1421 (later than used to be thought), so that he was at most thirty-eight when he died. We have no evidence for the date of Domenico's birth, or even for the place: his name implies that he was a Venetian, but it is also possible that he was the son of a Venetian, born in Florence. In any case, we first hear of him in Perugia in 1438, when he wrote a letter to Piero de' Medici asking for work, in terms which show him to be aware of what was happening in Florence. He was certainly there in 1439, when he was working on some frescoes, along with Piero della Francesca, in Sant'Egidio, which was part of the great hospital of Sta Maria Nuova. Vasari wrote the lives of Castagno and Domenico as a single unit not only on account of the apparent connection by murder, but also because these frescoes were being worked on at various times between 1439 and 1460 by both of them, as well as Piero della Francesca and Alessio Baldovinetti. Unfortunately, they have been almost completely destroyed and the few pathetic fragments which do survive give us no idea of their original appearance, although they must have been one of the most important fresco cycles of the mid fifteenth century. Nevertheless, there are several works described by Vasari which can still be identified, although some are in a damaged state: on the other hand, the recently invented process by which a fresco can be removed from a wall, leaving the under-drawing (*sinopia*) behind has more or less doubled the number of works known to us, especially in the case of Castagno. Unfortunately, these frescoes, once removed from the wall and mounted on canvas, can be transported and have no permanent home. There is a Castagno Museum at Sant'Apollonia in Florence, but several of the most famous works mentioned by Vasari are still being moved about and it is not clear whether they have found permanent homes. For example, the frescoes in S. Maria degli Angeli were removed from the wall, but were damaged by fire in 1952; they are now said to be in the administrative offices of the Hospital of Sta Maria Nuova. Castagno's major surviving work, the series of *Famous Men and Women*, is recorded twice by Vasari, once at the beginning of the *Life*, as in the villa at Legnaia, and again at the end, as in the Villa Carducci: they were removed from the wall in the 1950s and are now in the Uffizi, pending a more permanent home. The frescoes in SS. Annunziata (the Servi) are still there, although somewhat damaged.

The fresco of *SS. John Baptist and Francis* is now in the Museo di Sta Croce, but current critical opinion gives it to Domenico Veneziano under Castagno's influence rather than, as Vasari and the early sources say, to Andrea himself. The *Flagellation* is lost, but is known from a contemporary engraving and seems to have been an influential work. The fresco portrait of Niccolò da Tolentino, painted in 1456 as a companion to Uccello's *Hawkwood* of 1436, is his last known work and is still in the cathedral. The *Assumption* painted for San Miniato fra le Torri is datable 1449–50 and is in Berlin: it is unusually soft and warm in colouring for Castagno and is sometimes thought to represent a 'Second Gothic' style, characteristic of the mid fifteenth century. The defamatory fresco of the hanged men, however, seems quite different, but we have no knowledge of what it looked like. It cannot have represented the Pazzi conspirators, since Castagno died before the conspiracy of 1478; it may, however, have been commissioned in connection with one of the plots of the 1440s.

Domenico Veneziano's *Famous Men* in Perugia are lost, but they must have been painted about 1437 and it would be interesting to know what relationship they bore to Castagno's. There are now only two certain, signed, works known to be by Domenico, and Vasari records both. They are the very damaged *Carnesecchi Madonna*, now in the National Gallery, London, which Vasari correctly records as an early work, and the great altarpiece for Sta Lucia de' Magnoli, Florence, which Vasari says was painted shortly before his death 'aged sixty-five' (in 1461). This, which is one of the great masterpieces of Italian art, is now dated at about 1440–45 (which may well be too early), and is divided between the Uffizi (the main panel, representing the Madonna and Child with SS. Lucy, John Baptist, Francis, and Zenobius), and the five *predelle* in Berlin, Cambridge (Fitzwilliam Museum), and Washington (N G). The very beautiful, but extremely puzzling, tondo of the *Adoration of the Magi*, now in Berlin, was for many years reasonably considered to be by Pisanello, but is now generally agreed to be by Domenico Veneziano; if so, the dating is difficult, but a recent suggestion that it may be a commission arising from the letter of 1438 to Piero de' Medici is very attractive, and allows the *S. Lucy Altarpiece* to be dated later, as Vasari suggests.

JACOPO, GIOVANNI, AND GENTILE BELLINI

In the first edition of 1550 Vasari had a fairly long life devoted to the leading Venetian painters of the fifteenth century, and his visit to the city in 1566, while his second edition was in preparation, gave him an opportunity to see more works. We know, for example, that during this visit he met Titian and talked with him about the great painters of the previous generation. The disastrous fire of 1577, which destroyed the Sala del Gran Consiglio in the Doge's Palace, means that we have a huge gap in our knowledge of monumental painting in Venice from the fourteenth century right up to the time of the fire. Vasari's descriptions of the works are therefore extremely important.

Right at the beginning of the *Life* Vasari puts in a claim for Florentine superiority, when he points out that Jacopo Bellini was a disciple of Gentile da Fabriano, who was working in the Doge's Palace in the early years of the fifteenth century. He was, says Vasari, influenced by Domenico Veneziano until Domenico left Venice, leaving Jacopo as the leading painter there. This implies that Domenico was active in Venice – and, presumably, had been born there – before his arrival in Florence in 1439. By 1429, however, Jacopo Bellini was married and his wife was expecting her first child. It is probable, but not certain, that the child was either Gentile or Giovanni, but we do not know which was the elder – in his first edition Vasari says that Gentile was the younger, but he omits the statement in the second edition. Both seem to have been born around 1430, and it has even been suggested that Gentile was either illegitimate or the son of a previous marriage. It is reasonable to suppose that he was named after his father's teacher, as Vasari says.

Few paintings by Jacopo now survive, although he left two very important books of drawings (now in the British Museum and the Louvre); the portrait of Giorgio Cornaro is lost, but that of the Queen of Cyprus may be the picture now attributed to Gentile in Budapest. The Passion scenes in Verona are known to have been destroyed in the eighteenth century.

The paintings in S. Giovanni Evangelista were certainly by both Gentile and Giovanni, but only three signed ones, by Gentile, of the story of the Relic of the True Cross have survived in the Accademia, Venice. Two are dated 1496 and 1500, and one of

them is the one described by Vasari, of the rescue of the relic from a canal.

The list of works by Giovanni is quite long and includes several that are known to have been destroyed, but they are not in any kind of order. The first, the portrait of Doge Loredano, is certainly the picture now in the National Gallery, London, painted about 1501. It is followed by a description of the altarpiece for SS. Giovanni e Paolo which was burnt in 1867, but of which poor copies are known: it was an extremely important work since it was one of the earliest large compositions of the type known as a *Sacra Conversazione*, representing the Madonna and Child with Saints and other figures in a unified spatial setting. Three major examples of about 1475 are known: this one; the San Cassiano Altarpiece by Antonello da Messina, also formerly in Venice (fragments now in Vienna); and the altarpiece by Piero della Francesca, now in Milan (Brera). The S. Giobbe Altar by Giovanni Bellini, mentioned next, developed the theme and was painted in the early 1480s (it is now in the Accademia, Venice). After a long description of the lost works in the Sala del Gran Consiglio Vasari returns to altarpieces with a description of the one in Pesaro (correctly said in his first edition to be in S. Francesco, wrongly changed to S. Domenico in the second). It is now divided between the Pesaro Museum and the Vatican Gallery. The S. Zaccaria Altar, dated 1505, is still in the church. The pictures described as being in the Ca' Grande (Sta Maria de' Frari) and in Murano are both still *in situ*, except that the Murano picture has been moved to S. Pietro Martire: both are signed and dated 1488. The *Dead Christ* which was reluctantly given to Louis XII (not XI) of France, may perhaps be the picture now in Stockholm, but there is a signed *Madonna and Saints* of 1507 still in S. Francesco della Vigna and it is hard to see why Vasari said it was by Mocetto, unless there is a confusion with some other picture. The *Christ with Cleophas and Luke* was burned, as was the painting of the Pope in the Sala del Gran Consiglio.

Returning to Gentile, Vasari relates the story of the Grand Turk sending to Venice for a portrait painter. The letter arrived in 1479 and the Signoria sent Gentile for just over a year, until November 1480. The portrait of the Sultan is almost certainly the very badly damaged picture now in the National Gallery, London. After this Vasari says that Gentile, 'nearly eighty', died in 1501: he actually died in 1507, but if he were almost eighty then his birth would

have taken place about 1429. Giovanni continued to paint, as Vasari says, and in 1506, Dürer wrote of him that he was 'very old, but still the best in painting'. He died in 1516. The *Life* rather tails off, with an odd list of pupils, including Giorgione, and a mention of a portrait of Bembo's mistress, which Burckhardt rather romantically identified with the *Lady at her Toilet* in Vienna (the identification is not now generally accepted) and the *Pietà* which is still in Rimini (Museum).

ANTONIO AND PIERO POLLAIUOLO

The Pollaiuolo brothers ran one of the most successful and diversified workshops in Florence in the second half of the fifteenth century, providing designs for gold and silversmith's work, embroideries, engravings, paintings and sculpture, including two papal tombs. As Vasari points out at the beginning, they rose from humble origins, their father being a poulterer (*pollaiuolo*), who had a stall in the Old Market of Florence.

Antonio was born about 1431–2 and died, in Rome, in 1498; Piero was much younger (and, as Vasari points out, much inferior to Antonio as an artist); he was born about 1441 and died, also in Rome, in 1496.

According to Vasari, Antonio was trained as a goldsmith under Bartoluccio Ghiberti, the father of the famous Ghiberti – but Bartoluccio died in 1422, so it must have been some other member of the family. In any case, Lorenzo Ghiberti certainly employed Antonio on the frame for his second door for the Baptistry, and the quail is there to prove it. This would have been in the early 1450s. Piero, according to Vasari, was a pupil of Andrea del Castagno (*d.* 1457), and taught his brother the technique of painting. This may well be right, although artistically Piero was his brother's pupil. Antonio opened his own workshop about 1459, and at this point Vasari introduces the almost mythical figure of Maso Finiguerra, whose drawings Vasari owned. Finiguerra's exact status is a matter of controversy, and the large book of drawings in the British Museum, once attributed to him, is no longer accepted as his.

Antonio was commissioned as early as 1457 to make the candelabra (now altered and restored, in the Cathedral Museum, Florence), and he was commissioned to make the *Birth of the Baptist* for the Silver Altar in 1478, but Vasari seems to have been misled

about other subjects – for example, the figure of S. John was made by Michelozzo in the 1450s.

Vasari says that much of Antonio's work in gold and silver was melted down (as was often the case), and he therefore decided to switch to painting and sculpture: certainly he and Piero worked closely together for the rest of their lives. They collaborated on the chapel of the cardinal of Portugal in S. Miniato, painting the altarpiece, dedicated in 1466 (now in the Uffizi, with a copy in S. Miniato), and on the frescoes where Antonio painted two Angels pulling back curtains.

The *Archangel Raphael and Tobias*, recorded by Vasari as on canvas and in Orsanmichele, is now thought to be the picture – on panel – in Turin, Galleria Sabauda.

The history of the *Virtues*, painted for the Mercatanzia, a commercial tribunal, is rather strange. All seven were commissioned from Piero in 1469, but the series (now in the Uffizi) shows that one, *Fortitude*, is by Botticelli, while another, *Charity*, painted by Piero, has a drawing by Piero or Antonio on the back of the panel. The drawing is of much higher quality than the painting, which is why it is often ascribed to Antonio. These documented works by Piero, together with the *Coronation of the Virgin*, signed and dated 1483, in San Gimignano, are much weaker than Antonio's known works and confirm Vasari's assessment of the two brothers.

The *S. Sebastian* painted for the Pucci family chapel is clearly identifiable with the altarpiece now in the National Gallery, since the description of the crossbowman straining to wind up his weapon is quite obviously based on the picture in London. Since Vasari knew the picture, his date (1475) – which is stylistically highly probable – is always accepted, and it is generally thought that the original frame must have had the date on it. The *S. Christopher* in S. Miniato fra le Torri, which was ten braccia (about nineteen feet) high, is lost, but there is a fresco now in the Metropolitan Museum, New York, attributed to Ghirlandaio, which may give some idea of the original composition. Similarly, the three large paintings of the *Deeds of Hercules*, once in the Medici Palace and recorded in the Medici Inventory of 1494–5, are also lost but may be preserved in two very small panels in the Uffizi. These panels were stolen during the Second World War and not recovered until 1963, in America. One of them represents

Hercules and Antaeus, and a small bronze in Florence (Bargello) of the same subject is consequently attributed to Antonio. There seems to be no record of the third subject, Hercules and the Lion.

A very damaged *S. Michael* in the Museo Bardini, Florence, may be the remnants of the banner recorded by Vasari as painted for Arezzo. What was certainly far more famous and influential was the engraving, signed by Antonio but not dated, of the *Battle of the Nudes*. This is thought to be contemporary with the *S. Sebastian*, i.e. 1475, and the two are regarded as the most important examples of the study of anatomy by an artist before Leonardo da Vinci.

The last, and perhaps greatest, commissions received by the brothers were those for the tombs of Popes Sixtus IV and Innocent VIII, both in the precincts of St Peter's. Sixtus IV died in 1484 and his tomb is signed and dated 1493. The tomb of Innocent VIII (*d.* 1492) was completed in 1498, shortly before Antonio's death. Dismantled in the seventeenth century and later reconstructed, it was notable for having a recumbent effigy of the dead Pope and also one of him alive, seated and giving a blessing, which led to developments in funerary sculpture in the sixteenth century.

Vasari was correct in saying that the brothers died at about the same time (1496 and 1498), but his dates are wrong. The low-relief by Antonio, casts of which were owned by every craftsman in Florence, is not now known, but a terracotta in the Victoria & Albert Museum, London, very like the *Battle* engraving, probably gives an idea of it. The two drawings for the projected Sforza Monument in Vasari's own collection are now thought to be those in Munich and the Metropolitan Museum, New York.

Right at the end of the *Life*, almost as an afterthought, Vasari mentions the designs for embroidered vestments, twenty-seven of which (out of thirty) exist in the Opera del Duomo, Florence. Payments for them are recorded between 1469 and 1487.

BERNARDINO PINTORICCHIO

According to Vasari's estimate of Pintoricchio he was praised beyond his deserts, since he was not as good as Perugino, let alone Raphael, even though he had plenty of work and many assistants. It is fair to point out, however, that Vasari does not seem to know two of Pintoricchio's best works, the frescoes in the cathedrals of Spello and Orvieto.

He certainly began his career in Rome, where he worked for Perugino on the frescoes in the Sistine Chapel painted in 1481–2, and his hand can be seen in such works as the *Circumcision of the Sons of Moses*, commissioned from Perugino. Vasari then turns to the frescoes in the Piccolomini Library in Siena Cathedral, painted between 1503 and 1508, a jump of over twenty years. Here, Vasari says, Pintoricchio was assisted by no less an artist than Raphael, already emerging as the leading painter in Central Italy. The cartoon by Raphael which Vasari says was still in Siena, as well as the drawings in his own book, have been lost, but there are still a few drawings — including two *modelli* for scenes in the series — which are agreed to be by Raphael and were used by Pintoricchio. Vasari's description of the ten frescoes with scenes from the life of Pius II is very full and includes a mention of the classical statue of the Three Graces, which is still there, and was, as Vasari says, one of the earliest antiquities to be highly esteemed — for example, by Ghiberti.

We then go back to the time when Pintoricchio was working in Rome with Perugino, when he got various jobs including a mysterious series of landscapes in the Belvedere in the Vatican painted 'in the Flemish manner', which must have been something like the work of Memling. Unfortunately, the few fragments of these frescoes give no clue to their original appearance. The *Madonna* now in the Vatican Gallery, however, is probably the one mentioned by Vasari. Of the two chapels in Sta Maria del Popolo that of the Cibo family has been entirely destroyed, save for a single fragment now in Massa Carrara; the della Rovere chapel is, however, preserved.

The rooms in the Vatican include the Borgia Apartment, painted for the notorious Alexander VI (1492–1503): Vasari comments that the ruined state of many of these decorations was due to ignorance of the proper method of stucco-working and he also sharply criticizes the old-fashioned idea of mixing painting and low relief in the same composition. His love of a good story leads him here into conflating two frescoes, one with the undoubted portrait of Alexander himself adoring the Risen Christ, with the *Madonna* in the next room, so getting Alexander adoring Giulia Farnese, who was rumoured to be his mistress.

The frescoes with portraits of the Borgia family, in the Castel Sant'Angelo, were destroyed soon after they were painted.

The *Assumption* in Monte Oliveto is now in the Museum at Capodimonte. At the end of the *Life* Vasari mentions the frescoes in the Bufalini chapel in the Aracoeli in Rome, which are among his earlier works (*c.* 1486).

The *Birth of the Virgin* in S. Francesco, Siena, was burned in 1655, but Vasari says that it was done when he was fifty-nine and that he died soon after, his works dating from about 1513. In fact, Pinturicchio died in 1513, so if we accept that he was about fifty-nine when he died, he must have been born about 1454; which is, for lack of other evidence, now accepted as his birth-date.

Other Umbrian contemporaries mentioned by Vasari are Benedetto Bonfigli of Perugia, who was of an older generation. He died in 1496, and there are works in Perugia, e.g. frescoes in the Cappella de' Priori and the *San Bernardino* of 1473, perhaps done from a design by Perugino, now in the gallery there. Gerino Gerini (1480–after 1529) painted a fresco at Poggibonsi and is represented by works in Pistoia. The most interesting of these artists, Niccolò Alunno da Foligno (*c.* 1430–1502), whose *Pietà* was so admired by Vasari, is represented by works in Foligno and the banner in Assisi Pinacoteca: the *Pietà* itself, unfortunately, is lost.

The *Life* concludes with a final jibe at Pinturicchio because he finished and delivered his works on time, which princes and lords like, even if the work is not as good as it might be: coming from Vasari this is close to the pot calling the kettle black.

PIETRO PERUGINO

Vasari describes how Perugino, who was born poor, went to Florence, the capital of the arts, to learn how to make himself a successful career; and at various points in the *Life* Vasari refers to Perugino's avarice and lack of religious feeling (there seems to be other evidence that Perugino was not a very pleasant character). He was certainly in Florence by 1472, when he was a member of the Company of S. Luke, a painters' guild, and was referred to as 'Master'. He probably studied originally under Piero della Francesca at about the same time as Signorelli, whom he certainly knew, and later in Florence with Verrocchio. The first known signed and dated work, a damaged fresco of *S. Sebastian* in Cerqueto, near Perugia, is of 1478, when Perugino was probably about thirty and had been active for at least six years. His earlier

works are unknown, but it is often said that he had some part in a series of eight scenes from the life of S. Bernardino (now in Perugia, Galleria Nazionale), one of which is dated 1473: these have little in common with his mature style, which is most clearly shown in his frescoes in the Sistine Chapel of the Vatican (1481–2).

Vasari begins his account with a description of the *Lamentation over the Dead Christ* painted for the nuns of Sta Chiara in Florence (now in the Pitti Gallery, Florence): it is signed and dated 1495, and is a good example of his mature style, with an extensive landscape very much influenced by Flemish painters such as Memling, which may account for Vasari's criticism that the landscape seemed very beautiful to those who saw it, because the modern manner of painting landscape was not then known.

Because it was destroyed in the siege of 1529–30, Vasari describes the church of the Gesuati in some detail. Three of the panels – the *Agony in the Garden*, the *Pietà*, and the *Crucifixion* – have survived and are now in the Uffizi and Pitti Galleries in Florence.

The *S. Sebastian* sent to the king of France cannot now be identified; although there is a *S. Sebastian* now in the Louvre it did not come from the French Royal Collection. The painting done for the Certosa of Pavia is now divided between the National Gallery, London, and the Certosa itself, which has the original upper part with *God the Father*.

In Rome, with his assistants including Don Bartolommeo della Gatta and Pintoricchio, he was the leading artist working in the Sistine Chapel for Sixtus IV. The *Giving of the Keys* is universally ascribed to him, with a minimum of assistance, but the other frescoes recorded by Vasari are either lost or largely by assistants. The *Nativity* and the *Birth of Moses* are lost, and the *Circumcision of the Sons of Moses* and the *Baptism of Christ* were largely the work of Pinturicchio and Bartolommeo della Gatta, though probably designed by Perugino. The *Assumption* on the altar wall was, as Vasari says, destroyed to make room for Michelangelo's *Last Judgement*, but the composition is known from a drawing now in Vienna, and from a very similar picture of the Assumption, mentioned by Vasari as painted for the Carafa Chapel in Naples and now in the cathedral there.

Most of the works listed by Vasari as done after his return to Perugia are still there, but the *Marriage of the Virgin* ('*Lo Sposalizio*'), painted for Perugia Cathedral, is now in Caen, having been stolen

by the French during the Napoleonic occupation and never returned.

The frescoes in the Sala del Cambio, or Exchange, in Perugia are probably Perugino's best-known works: they were painted between 1497 and 1500, the date inscribed on Perugino's self-portrait there. The programme is known to have been supplied by a local humanist, Francesco Maturanzio. It is rare to know the name of such a provider of an iconographic programme, but it must have been quite common to supply such programmes. During these years Raphael was in Perugino's shop, and he may well have worked on some of the frescoes.

The *S. Bernard* painted for Cestello is very probably the famous picture now in Munich, but the *Crucifixion*, also painted for Cestello, is lost. These were painted in the 1490s, and Vasari is right in saying that most of Perugino's works were already being painted by rote, justifying Michelangelo's contempt for him. Because of this, he left Florence and returned to Perugia, where, for example, he painted the fresco in San Severo begun by Raphael about 1505 but left unfinished: Perugino finished it about 1521, in a very old-fashioned manner. Vasari tells us that Perugino died in 1524, at the age of seventy-eight: in fact he died in 1523, of the plague, and was buried in a field, but, in 1524, he was exhumed and given honourable burial, as Vasari says. The list of his pupils is interesting to the historian of Umbrian painting, but, with the exception of Raphael, they were not very inspired. As Vasari perceived, with Michelangelo a new age had dawned.

PIERO DI COSIMO

Vasari's *Life* of Piero di Cosimo is largely taken up with tales of his oddity and with the description of his *Triumph of Death*, probably made for the carnival of 1511, which is important as a description of one of these events, now otherwise lost to us. He begins, however, with a mention of Correggio and Giorgione as contemporary leaders of Emilian and Venetian painting, thus apparently placing Piero di Cosimo on a higher plane than he would now occupy. He was a pupil of Cosimo Rosselli, perhaps the least imaginative of the leading painters in Tuscany at the end of the fifteenth century; yet Rosselli had the sense to see that Piero was not only superior technically, but also had qualities of imagination that he himself

lacked. Vasari tells us that they worked together on the frescoes in the Sistine Chapel (1481–2), with Piero painting the landscape and some portraits in the *Sermon on the Mount*: modern critics tend to deny this, but it is difficult to see how Vasari could have been wrong, given the importance of the birds – a typical Piero motif – in the background. He was certainly a good portrait painter, as his San Gallo family portraits testify, but we have few other examples, as the 'Duke Valentino', i.e. Cesare Borgia, is lost, as it was in Vasari's own day.

The altarpiece for S. Marco is lost, but the one for Sto Spirito, with S. Antony's spectacles and the metal spheres of S. Nicholas, is now in the National Gallery, Washington. The altarpiece for the Tedaldi Chapel in SS. Annunziata (the Servi) is now in the Uffizi, but the predella, with S. Margaret and the dragon and other scenes is unfortunately lost, as is the *Sea-Monster* once in the collection of Duke Cosimo.

The 'scenes with little figures' painted for Francesco del Pugliese present a problem as there are several pictures of this type attributed to Piero di Cosimo but which cannot be securely identified with these. The lovely and pathetic *Battle of the Lapiths and Centaurs* in the National Gallery, London, is one, and it may be associated with others in Hartford (Connecticut), New York (Metropolitan Museum), Ottawa, and Oxford. The *Mars and Venus* is lost, but the *Mars and Venus* which Vasari himself owned is undoubtedly the picture now in West Berlin. The Strozzi *Perseus and Andromeda* is now in the Uffizi, Florence, and the picture in the Innocenti is now in the museum there.

The S. Piero Gattolini painting is lost, but the altarpiece in S. Francesco at Fiesole is still there: it is inscribed with Piero's name and the date 1480, but this inscription is believed to be false.

The *Bacchanals* painted for Giovanni Vespucci, like the *Fables* for Francesco del Pugliese, cannot be identified with certainty, but pictures in Cambridge, Mass., and Worcester, Mass. are probably those mentioned by Vasari.

The date of Piero's death, 1521, is given only by Vasari, who says that he was then nearly eighty – in fact, Piero was born in 1461–2, so he was no more than sixty in 1521. His pupils included Andrea del Sarto (*q.v.*).

At the end of the *Life*, Vasari mentions Francesco da San Gallo, a member of the Florentine family of architects, who supplied

him with the portrait of Piero used to illustrate the *Life*, and
who also owned a 'head of Cleopatra, with an asp wound round
her neck', and two family portraits: of his father, the architect
Giuliano da San Gallo, and his grandfather, Francesco Giamberti.
The *Cleopatra* must be the picture now in Chantilly, which is
inscribed with the name of Simonetta Vespucci, but this inscription
is now thought to be apocryphal. The two San Gallo portraits are
now in Amsterdam (Rijksmuseum), having been transferred from
The Hague.

FRA BARTOLOMMEO OF SAN MARCO

According to Vasari, Fra Bartolommeo's career as a painter was
divided into two sharply separated parts; the period from his appren-
ticeship to Cosimo Rosselli *c.* 1485 up to 1499–1500, during most
of which time he worked with Mariotto Albertinelli; and the
period from *c.* 1504 to his death in 1517, with a four-year gap
from 1500 to 1504 when, under the influence of Savonarola, he
became a Dominican friar and ceased to paint for more than four
years. If this is so, the influence of Leonardo da Vinci, stressed by
Vasari, must have been on his later works, since Leonardo's cartoon
for the *Battle of Anghiari* was not begun before 1503.

The shutters made for the Donatello relief owned by Pugliese,
later in the collection of Duke Cosimo, where Vasari would have
seen them, are now in the Uffizi (the *Madonna* relief is very
probably the one now in Boston). The *Last Judgement* for the
ossuary in Sta Maria Nuova was begun about 1499, abandoned by
Fra Bartolommeo when he entered the Order of Preachers at
Prato in 1500, and completed by his friend and partner Mariotto
Albertinelli, in 1501. It is a fresco in very bad condition, transferred
to canvas, and moved to the museum at San Marco, Florence, Fra
Bartolommeo's own convent, which contains many of his works.

The second period of his career begins about 1504, when he
began the *Vision of S. Bernard*, completed in 1507 and now in the
Accademia, Florence. As Vasari says, 'at that time' (i.e. 1506)
Raphael came to Florence and Fra Bartolommeo certainly learned
from him: he also went to Venice in 1508, and many of his altar-
pieces show the influence of Giovanni Bellini's great *Sacre Con-
versazioni* in the music-making child angels below the Virgin's
throne. The panel sent to the king of France is now in the Louvre,

signed and dated 1511, and the replacement is probably the *Marriage of S. Catherine*, of 1512, now in the Accademia, while the one opposite to it is still in S. Marco and dates from 1509.

The journey to Rome took place in 1514 and the two paintings of S. Peter and S. Paul, both dated 1514, are now in the Vatican Gallery; as Vasari says, the *S. Peter* was completed by Raphael. Unfortunately, the *S. Sebastian* painted on his return, which so agitated the ladies of Florence that it had to be moved, eventually went to the king of France and has been lost. It seems to have been in a French private collection about 1903, but has since disappeared. The *S. Vincent* is still over the sacristy door, but the *S. Mark* is now in the Accademia. The large *S. Mark*, five braccia (nearly ten feet) high, is in Florence (Pitti), which also has the *Saviour with Evangelists and Putti* (1516), but the two *Prophets*, also signed and dated 1516, are now in the Accademia. The pictures painted for Lucca are still there, the *Madonna and Child with SS. Stephen and John* (1509) in the cathedral, and the *Madonna della Misericordia* (1515) and *God the Father with SS. Catherine of Siena and Mary Magdalen* (1509) in the Pinacoteca. This last painting is one of the masterpieces of the Florentine High Renaissance, comparable with the Sistine Ceiling and the Stanze of the Vatican.

The passage on the importance of Fra Bartolommeo's drawings is interesting, since many have survived and forty of those once in Sta Caterina were sold in London in 1957. The invention of the lay figure, too, was of great importance in the development of academic art of the next four centuries. The picture for the Compagnia dei Contemplanti of Arezzo, formerly in Berlin, was destroyed in 1945, but the *Purification* (actually the *Presentation in the Temple*), painted for the noviciate of S. Marco (signed and dated 1516) is in Vienna, which also has the *Rape of Dinah*, although it is dated 1531 and is considered to be by Bugiardini, who also completed the *Pietà* for S. Gallo, now in the Pitti.

The commission for the Council Chamber, the *Madonna and Child with S. Anne and other Saints*, is now in S. Marco and is an unfinished work in chiaroscuro, begun in 1510 and left unfinished at his death in 1517. Vasari gives the date correctly, but says that he was forty-eight years old, whereas he was probably about forty-five, i.e. born in 1472.

ANDREA DEL SARTO

For a short time, about 1525, the fourteen-year-old Vasari was apprenticed to Andrea del Sarto. He does not seem to have got on at all well with Lucrezia, Andrea's wife, and in the first edition he disparaged her and her family even more severely than in the later edition, although she was still alive in 1550 and living in Florence. This contact with Andrea is undoubtedly the reason why the *Life* is so long – three times longer than that of Fra Bartolommeo – although much of it is in fact taken up with anecdotes about Andrea in France and his marital difficulties. Nevertheless, there is still an exceptionally full list of works by Andrea, many of which have survived. This note will give only the most important losses and survivals.

Andrea was certainly born in 1486, not 1478 as Vasari says, and he died of plague in September 1530. The memorial stone which Vasari mentions is lost, but it must have been wrong in giving his age as forty-two, since he was actually forty-four. Practically nothing is known of the Barile who was said to have been Andrea's first teacher, but there is a difference of opinion over his second and far more important master: Vasari says he was Piero di Cosimo, but the contemporary Anonimo Magliabechiano gives Raffaellino del Garbo, and modern critical opinion supports him. In any case, the formative influence was, as Vasari implies, the study of the cartoons by Leonardo and Michelangelo in the Sala del Papa about 1504–6. His first significant works were the frescoes of scenes from the life of S. Filippo Benizzi in the courtyard of SS. Annunziata (the Servi), painted about 1509–10. The first of the frescoes in the Scalzo, the *Baptism*, was painted *c.* 1511, but the series was not finished until 1526. In the same way, he began work in San Salvi on the *Last Supper* and other frescoes in 1511, completing them just before his death. The *Birth of the Virgin*, signed and dated 1514, in SS. Annunziata was probably the most famous of all his early works and is often considered to be the exemplar of the High Renaissance in Florence, a parallel to the Sistine Ceiling and the Stanze in Rome. It was a particular favourite of nineteenth-century writers such as Wölfflin.

The S. Gallo *Annunciation*, also of about 1514, is now in the Pitti Gallery. Vasari says that the predella was by Pontormo, Andrea's pupil, and he repeats this in the *Life* of Pontormo himself; un-

fortunately, the predella is lost, but it would have been of great interest as an early work by Pontormo still in the workshop of Andrea. About 1518 Andrea married Lucrezia del Fede, and just before then he completed the so-called *Madonna delle Arpie* (signed and dated 1517, now in the Uffizi). What Vasari called harpies are in fact sphinxes, but the name has stuck. Soon after his marriage Andrea went to France, remaining about a year (1518–19). Vasari mentions several works of this period, including the portrait of the sculptor Bandinelli, sometimes identified with the portrait in the National Gallery, London, and sometimes with one in the Uffizi, but neither is very likely. The *Pietà* for the Puccini family is lost, but the engraving by Agostino Veneziano is known and hardly deserves the strictures Vasari records. The *Madonna* painted for the king of France is very probably the *Madonna and Child with SS. Elizabeth and John Baptist* now in the Louvre, which also has the *Charity*, signed and dated 1518. The panels painted for Borgherini have been dispersed, but the two by Andrea are in the Pitti and others by Pontormo and Bacchiacca are in the National Gallery. Still others are elsewhere.

The fresco at Poggio a Caiano is still there, and the drawing for it, in Vasari's possession and twice mentioned by him, is now in the Louvre. In 1523, plague drove Andrea and his family to the Mugello, where he painted the *Lamentation*, the main part of which is now in the Pitti. The story of the copy made by Andrea of Raphael's portrait of the Medici Pope with Cardinals Medici and Rossi seems to be true, since the picture from the Medici collection is now in the Uffizi and the copy sent to Mantua is now in Naples (Capodimonte). The *Madonna del Sacco*, the fresco of S. Joseph leaning on a sack and looking at the Madonna and Child, one of his finest works, is dated 1525 and is still in the Annunziata. The *Madonna* for the Scala family is now dispersed, the *Madonna and Child with Eight Saints*, dated 1528, is now in Berlin, but the *Annunciation* which was originally over it is now in the Pitti. What is believed to be the self-portrait painted on a tile is now in the Uffizi, but has been much restored. The *Abraham and Isaac*, of about 1529, exists in three versions; one signed one in Dresden and two others in Madrid and Cleveland, Ohio.

Andrea's importance as a teacher is shown by the list of pupils, all of whom were major painters in Florence in the mid sixteenth century.

GIOVANNI BATTISTA ROSSO

Rosso, so called from his red hair, was born in Florence in 1495 (1494 Florentine style) and died in Paris on 14 November 1540, apparently from natural causes. Vasari's date, 1541, is therefore wrong and so is his dramatic account of Rosso's suicide; yet he was writing less than ten years after the event and must have had some grounds for his belief, particularly since he is careful to state that he has been informed about Rosso's work at Fontainebleau and this information is reliable.

Like most other young artists around 1505, Rosso was profoundly influenced by Michelangelo's cartoon for the *Battle of Cascina*, which was then on public view in Florence. He seems also to have been, with Pontormo, in Andrea del Sarto's shop *c.* 1512. Nothing is known for certain of his early works before 1517, the date of the *Assumption* in the court of the Annunziata, which has the over-prominent draperies criticized by Vasari. The *Madonna and Child with Saints*, the cartoon for which so upset the Director of the Hospital of Sta Maria Nuova, was painted in 1518 and is now in the Uffizi: the figure of S. Jerome is certainly fearsomely gaunt. The *Dead Christ* painted for the Signor di Piombino, the first of several recorded by Vasari, is lost, but an idea of it can be gained from the masterpiece of his early period, the *Deposition from the Cross* painted for Volterra and now in the gallery there, which is signed and dated 1521. Vasari's account of the commission for the Dei family altarpiece is substantially correct, since the original picture, begun by Raphael but abandoned by him in 1508, is now in the Pitti Gallery, having been finished rather badly by someone else: Rosso's new version, signed and dated 1522, is also in the Pitti, but has been enlarged at the top and sides to the detriment of the composition. In the following year, he painted the *Marriage of the Virgin* for the Ginori family, which is still in S. Lorenzo, and late in 1523 he went to Rome. About this time he painted the *Moses Slaying the Egyptian*, which Vasari says was sent to France: it is now in the Uffizi, having come from the Medici collection. The manifest influence of the nudes in Michelangelo's Sistine ceiling makes it likely that it was painted in Rome rather than Florence. Vasari mentions it along with a *Jacob at the Well*, which he says was sent to England: if it was, it has now disappeared.

The frescoes in Sta Maria della Pace in Rome, so severely criticized by Vasari, were painted in 1524 and are still there, but in a

very bad state. The *Dead Christ* painted for Bishop Tornabuoni was long believed lost, but it has recently been identified with a very fine picture of that subject, signed by Rosso, which is now in the Museum of Fine Arts, Boston. Vasari noted that there were two angels in the Tornabuoni picture, but the Boston one has four although only two are really prominent. About twenty-six Caraglio engravings are known from Rosso's drawings. After his misfortunes in the sack of Rome in 1527, he went to Perugia and Borgo San Sepolcro: the *Deposition* (1528) is still in San Sepolcro, but in S. Lorenzo. In Arezzo the work for the Madonna delle Lagrime is known only from a drawing in the Musée Bonnat, Bayonne, and the *Madonna della Misericordia* from Vasari's own collection is now in the Louvre. The *Transfiguration* for Città di Castello is datable 1528–30 and is in the cathedral there.

Late in 1530, Rosso went to France and remained there for the rest of his life. He was very successful and became a formative influence on Northern painting of the mid sixteenth century. On his way, he stayed in Venice with Pietro Aretino, and the drawing he made for him of *Mars and Venus* is known from another engraving by Caraglio. The *Leda* presents problems, since it is known that Michelangelo had treated this subject. The painting now in the National Gallery, London, though in poor condition, is accepted by most Italian scholars as being the Rosso mentioned by Vasari (although they always confuse things by locating it in the Royal Academy): the National Gallery itself catalogues the picture simply as 'After Michelangelo'. Part of the Gallery at Fontainebleau survives, although, as Vasari tells us, part was destroyed by Primaticcio soon after Rosso's death. What remains is in a poor state and much of the work, both in fresco and in stucco, is clearly by some of the assistants listed by Vasari. One drawing, in the Louvre, is all that remains of the Pavilion. Nothing is known of the *S. Michael*, but the last version of the *Dead Christ*, once at Ecouen, is now in the Louvre. It is deeply tragic and has livid and unexpected colouring, including the red hair of Christ, like Rosso's own.

FRANCESCO MAZZUOLI (PARMIGIANINO)

Mazzuoli (Mazzola), known as Il Parmigianino, was born in 1503 (not 1504, as Vasari says) and died in 1540, at the same age, thirty-seven, as Raphael. His earliest work, which Vasari says was painted

when he was sixteen (i.e. *c.* 1520), was a *Baptism of Christ.* This may be the picture now in East Berlin (Bode Museum), but many critics (including the present writer) find it hard to accept. On the other hand, the frescoes in S. Giovanni Evangelista in Parma, which cannot be much later, certainly include some by him, although it is unlikely that the seven chapels ascribed to him by Vasari are in fact all his. The *SS. Francis and Chiara* for Viadana is lost, but the *Mystic Marriage of S. Catherine* is probably the painting now in Sta Maria at Bardi, Parma. The *Madonna and Child with S. Jerome and Bl. Bernardino da Feltro* is lost, but is known from an engraving by Bonasone and a partial copy in Parma, Pinacoteca.

Vasari omits the frescoes of *Diana and Actaeon* in the Rocca at Fontanellato, near Parma, of about 1523, but these were almost unknown until the present century and show the influence of Correggio to a marked degree. When Parmigianino went to Rome in 1523 he took three paintings with him, which can be identified as the *Self-Portrait in a Convex Mirror,* now in the Kunsthistorisches Museum, Vienna; the *Holy Family,* now in the Prado, Madrid; and a third which may be the *Circumcision,* painted for Clement VII, known from a picture in Detroit which may be the original, but is often regarded as a copy of the lost original. The *Cybò* in Copenhagen has an inscription with Cybò's name and a date, 1523, which is unlikely, since the picture must have been painted in Rome about 1525. The *Madonna* for Città di Castello is evidently the large picture, sometimes called *The Vision of S. Jerome,* now in the National Gallery, London, which Parmigianino was prevented from finishing by the incursion of the Germans during the sack of Rome in May 1527. It seems, however, to have been finished later. When he fled to Bologna, Parmigianino painted several pictures there, including the *S. Rocco* for S. Petronio, which is still in the church. The *Conversion of S. Paul* is probably the picture in Vienna, although it is often attributed to Niccolò dell'Abate, and the *Madonna,* 'turning to one side', may be the picture now in the National Gallery (formerly Lord Normanton's). The *Madonna* for Count Manzuoli is the *Madonna and Child with SS. Mary Magdalen, John Baptist, and Zacharias,* now in the Uffizi, Florence. The portrait of 'some count or other of Bologna' is not identifiable, but the *Madonna* with the Child holding a globe is clearly the so-called *Madonna della Rosa* now in Dresden. Vasari says that there were at least fifty copies of it – one is in the Royal Collection at Hampton Court, having been bought by Charles I from Mantua. Another

altarpiece, painted for the nuns of Sta Margherita in Bologna, is the *Madonna and Child with SS. Margaret, Jerome, and others*, finished in 1529 and now in the Pinacoteca, Bologna. The sketch for a *Madonna,* bought by Vasari in Bologna, is not now identifiable, but the allegorical portrait of the Emperor Charles V is certainly the picture once in the Cook Collection, Richmond, and now in America: the attribution is, however, much disputed.

After his return to Parma he was commissioned to paint frescoes in Sta Maria della Steccata (1531), but he did very little painting and was more interested in the gilded copper rosettes, so that the exasperated commissioners had him imprisoned and excluded from the work (1539), although some figures by him are still in the church. The *Cupid Cutting a Bow* is now in Vienna, and the *Madonna* for Sta Maria de' Servi is the famous *Madonna del Collo lungo*, commissioned in 1534 and signed although never finished: it is now in the Uffizi, Florence. After his flight to Casalmaggiore, he painted the *Madonna and Child with SS. Stephen and John Baptist*, now in Dresden and datable to 1540. Vasari says that his last painting was a *Lucretia*, which is doubtfully identifiable with one in Naples (Capodimonte). The *Nymphs* and the cradle with children are both lost.

At various points Vasari mentions Parmigianino's drawings for engravers and woodcutters, and it is true that he was one of the first Italian artists to design specifically for reproduction.

Finally, Vasari gives the correct date of Parmigianino's death and the bizarre details of his funeral. These details almost certainly came from Girolamo Mazzola-Bedoli (1500–69), who married Parmigianino's cousin and provided Vasari with information – Vasari was in Parma in 1567. Works by Mazzola-Bedoli are easily confused with Parmigianino's, but there are pictures recorded as his by Vasari, e.g. the *Immaculate Conception* of 1533 in the Gallery at Parma, which has other works by him.

JACOPO PALMA AND LORENZO LOTTO

Vasari's artistic sympathies were characteristically Florentine and his enthusiasm for Venetian art was very moderate, as is clearly seen in the faint praise of Palma in the introduction to what is in fact four *Lives* taken together. One of them, Lorenzo Lotto, is by our standards a major artist, but Vasari seems to treat them as much the same although Rondinelli and Francesco da Cotignola were rather pedestrian followers of Bellini.

Jacopo Palma, called Palma Vecchio to distinguish him from his grand-nephew Palma Giovane, was probably born about 1480: Vasari says that he died at forty-eight, which we know happened in July 1528. Most of the works cited by Vasari still exist: the *Magi* for Sant'Elena is now in the Brera, Milan; the *S. Barbara* for Sta Maria Formosa is still there; the *Madonna and S. John* for S. Moisè is now in the Accademia, Venice; and the *Tempest at Sea*, so fully described by Vasari, is still in the Scuola di S. Marco, although it is possible that it was finished by Paris Bordone. The problem is to identify the *Self-portrait in a Mirror* with a camel-hair garment, which Vasari praised as by far the best of Palma's works and which he never again equalled. It is most likely to be the picture now in Munich, which has been attributed to Giorgione himself, as well as to Palma and to several other Venetians of the early sixteenth century. If it is indeed by Palma then Vasari's enthusiasm is understandable.

Lorenzo Lotto was also born about 1480, but he lived until 1556–7, working little in Venice and wandering round north Italy until he finally settled as an Oblate in the Holy House at Loreto in 1552. The origins of his complex art are obscure, but Vasari's description of him as the friend and companion (i.e. fellow worker) of Palma, who began by imitating Bellini and then Giorgione, may very well be right. The first work mentioned by Vasari, the *Odoni*, is in the Royal Collection and is signed and dated 1527, so it is a fully mature work and shows Lotto as well able to keep up with Titian. The *Nativity by Night* is possibly to be identified with one in the Gallery at Siena; but it can hardly be an early work. The *S. Nicholas* in Sta Maria del Carmine, Venice, is still there and is signed and dated 1529. The *S. Antoninus* for SS. Giovanni e Paolo is also still in the church, and is signed and datable to 1542, so Vasari is clearly giving works in Venice before going on to the rest of Lotto's career, rather than placing them in chronological order. He specifically says of the Recanati altarpiece that Lotto painted it when he 'was still young' and it is in fact signed and dated 1508: it is now in the Gallery at Recanati, but the predella which was praised by Vasari is lost except for one panel, recognized from the description, which is now in Vienna. The *S. Vincent* is still in the church. Also in the Galley at Recanati is the *Transfiguration* from Sta Maria di Castelnuovo, but again the predella has been separated: one panel is lost, but the others are in Leningrad and Milan (Brera).

The *Madonna and Child with Angels* is now in the gallery at Ancona, and some of the paintings from the choir of Loreto are now in the Palazzo Apostolico there.

Niccolò Rondinelli also worked in the Romagna in a Bellinesque manner, but the picture in the cathedral at Forlì is by Palmezzano, as Vasari himself recognized when he mentions it in his *Life* of Palmezzano. There are works by Rondinelli in Ravenna and in Milan (Brera). Francesco Zaganelli da Cotignola was a follower of Rondinelli and also worked in Ravenna. The National Gallery, London, has a *Baptism of Christ* by him, signed and dated 1514.

GIULIO ROMANO

Of all the major artists working in Rome between 1481 and 1527 only Giulio Pippi, called Giulio Romano, was Roman-born. He was very precocious, but the exact date of his birth is unclear: he died on 1 November 1546, and Vasari, who knew him well, says that he was fifty-four, i.e. born in 1492; the Mantuan Hospital records, however, say that he was forty-seven, i.e. born in 1499. The earlier date is probably correct, because he was certainly working in an important capacity as Raphael's assistant on the great works in the Vatican while still very young, and he was Raphael's heir, along with Penni, in 1520. Vasari begins with the works executed under Raphael's direct supervision, starting with the frescoes in the Loggie of the Vatican, certainly finished by 1519, and he continues with the *Fire in the Borgo* fresco, painted between 1514 and 1517, and those in the Villa Farnesina (1515–17). These were major works and hardly likely to be entrusted to a boy still in his teens, however precocious. The panel of the *Madonna of Francis I* (with S. Elizabeth) is in the Louvre, as is the portrait of the Vicereine of Naples. The *S. Margaret* is also in the Louvre, but in a very bad state. From Raphael Giulio also learned architecture (as is evident in his buildings) and Vasari says that he was responsible for most of the Villa Madama, although he says elsewhere that Raphael was the designer, and Antonio da San Gallo is also known to have had a hand in the building.

The Sala di Constantino in the Vatican was begun under Raphael in 1517 but was not finished until 1524, four years after his death, and it is clear that the *Victory of Constantine* owes more to Giulio than

to Raphael. With Penni, Raphael's other chief assistant, he completed the *Coronation of the Virgin* for Monteluce, near Perugia, which had been commissioned from Raphael in 1505 but was abandoned by him a few years later. It is now in the Vatican. At this time – 1520–24 – Giulio also painted the *Madonna with the Cat*, now in Naples, and the *Stoning of S. Stephen* for Sto Stefano in Genoa (the cartoon is in the Vatican). For the German church of Sta Maria dell'Anima in Rome he painted the *Madonna* which is still there, although, as Vasari says, it has become very dark.

As an architect, he built the Villa Turini (now Lante) on the Janiculum, which was much altered in the nineteenth century. Some of the interior decorations are now in the Biblioteca Herziana in Rome. The Palazzo Alberini (now Cicciaporci) may be his, although the attribution to Raphael has much to recommend it, and the palace in the Piazza della Dogana (Maccarani) is also probably Giulio's.

In 1524 Vasari tells us that he was persuaded to go to Mantua, where he spent the rest of his life, but in his *Life* of the engraver Marcantonio, Vasari has the story of a set of engravings by Marcantonio made from drawings by Giulio to illustrate the sonnets by Pietro Aretino which discuss the various positions of copulation. There are sixteen of these sonnets, but there were said to be twenty engravings: however, the Pope got to hear of them, Marcantonio was imprisoned, the engravings were destroyed, and Giulio was lucky to have gone to Mantua. By 1525 he had made a design for the Palazzo del Te, later revised and enlarged, and he was in the favour of Federigo Gonzaga, Duke of Mantua, who was Giulio's faithful patron for the rest of his life. The very full description of the palace obviously derives from a conducted tour by Giulio himself during Vasari's four-day visit in September 1541. The descriptions of the Palazzo Ducale and of the villa at Marmirolo also come from the same source. Marmirolo was destroyed in the eighteenth century.

In Sant'Andrea the frescoes of the *Crucifixion* and the *Discovery of a Relic of the Blood of Christ*, executed by Rinaldo Mantovano, are still there, but Giulio's altarpiece is now in the Louvre. The *Madonna Bathing the Child* is now in Dresden, the *Nativity*, with a portrait of Isabella Buschetta, is lost, and the *Lovers on a Bed* is probably the picture in Leningrad. The *S. Jerome* is lost, but the *Alexander* is now in a private collection in Geneva. The frescoes of

Vulcan and Venus, the *Lamentation* for S. Domenico and the other picture of the *Dead Christ*, as well as the portrait of Giovanni de' Medici, are all lost. Giulio's own house survives, but has been enlarged and the frescoes are only partially preserved. The work at S. Benedetto Po was begun in 1539 and was completed after Giulio's death. He also remodelled the old cathedral of Mantua and made a design in a 'Gothic' style for S. Petronio in Bologna (in the Museum of S. Petronio), dated 1546. Perhaps fortunately, he died before being appointed to St Peter's in Rome, and Michelangelo (very unwillingly) took on the task. The drawing by Dürer, so enthusiastically described by Vasari, is lost, but the one by Raphael sent in return to Dürer is preserved in Vienna (Albertina).

JACOPO PONTORMO

Pontormo was about seventeen years older than Vasari and was arguably the greatest Florentine painter of his generation, often referred to as the First Mannerists. Vasari's account of him is based not only on personal knowledge, but also on two trustworthy witnesses, his own friend and adviser Don Vincenzo Borghini, head of the Foundling Hospital, and Bronzino, his own contemporary, who was virtually Pontormo's adopted son. There was also Battista Naldini, who had been brought up in the Foundling Hospital, had been Pontormo's apprentice, and became one of Vasari's closest collaborators. With so much information available it is not surprising that the *Life* contains a very full list of Pontormo's works, most of which have survived and are identifiable: the only major omission appears to be the strange but haunting *Visitation* painted for the church at Carmignano, near Florence, and still there. It probably dates from about 1530 and is one of the masterpieces of early Florentine Mannerism.

Pontormo's neurotic character seems to have been difficult for the rather stolid Vasari to understand, but it is clear from the diary which Pontormo kept during his last years that Vasari did not exaggerate his odd behaviour. He was born at Pontorme in 1494 (not 1493, as Vasari says) and died on New Year's Eve 1556–7. His training seems to have been rather sketchy, first with Leonardo and, soon afterwards, with Albertinelli, and finally (1512) for a short time with Andrea del Sarto, later to be Vasari's own master.

The *Dead Christ* painted as a predella to Andrea's altarpiece now in the Pitti Gallery used to be identified with some panels now in Dublin, but it is not likely that these are as early as 1512–14. The frescoes painted for the Servi, *Faith* and *Charity*, have survived in a ruinous state (1513: in deposit in the Florentine Galleries). Vasari correctly says that these were painted when he was nineteen and he goes on to say that Michelangelo himself praised them. Some of the frescoes painted for the Papal visit have survived in Sta Maria Novella and in the Annunziata (ex-San Ruffillo). The *Visitation* for the Servi was finished in 1516 and is still there. Pontormo's first masterpiece was the *Madonna and Child with Saints*, dated 1518, which was painted for S. Michele Visdomini and is still there. This is the altarpiece which Vasari thought was the best he ever painted. The Dublin predella panels have also been connected with this painting, but again probably wrongly. The altarpiece painted for his native Pontorme is now in Empoli (Museo della Collegiata), and the gruesome *S. Quentin*, repainted for his pupil, is in the Gallery at Borgo San Sepolcro. The double portrait may be the one now in the Cini collection, Venice, but the *Dead Christ* painted for a church at Porta San Gallo in Florence is lost.

The Borgherini panels are now in the National Gallery, London, including the *Joseph in Egypt* with the portrait of Bronzino as a boy seated on the steps, which Vasari describes as the best thing he ever did. The National Gallery also has the two panels by Andrea del Sarto which belonged to the same decorative scheme. The *Magi* for Benintendi is now in the Pitti, and the portrait of Cosimo the Elder is in the Uffizi.

According to Vasari, Pontormo was commissioned to paint both ends of the hall at Poggio a Caiano, but only one fresco, finished in 1521, was actually done. It is probably Pontormo's masterpiece of secular decoration, quite different from the emotional intensity of most of his religious works or the nervous restraint of his portraits. Both the *S. Augustine* and the *Pietà* for the Ragusan merchants are lost – it would have been interesting to see the landscape based on a Dürer engraving in the latter. The *Madonna* in the Neroni collection may be the one now in Washington or the one in Rome (Corsini), but the one bought in a second-hand shop on Bronzino's advice is not identifiable.

The frescoes in the Certosa del Galluzzo outside Florence, begun in 1522 when he went there to escape the plague, have now been

taken off the walls and are still there, but in a very damaged state. They are, however, quite clearly derived from Dürer and are also simplified in form and pale in colour: Pontormo was obviously striving after new emotional effects and Vasari's strictures are beside the point. The portrait of the 120-year-old lay brother, and the *Nativity*, again in the 'German manner', are both lost, but the *Christ at Table* is the *Supper at Emmaus*, dated 1525, which is now in the Uffizi. The Capponi chapel in Sta Felicità, begun in 1525, is preserved except for the vault, destroyed in the eighteenth century. The *Evangelists* are rather damaged, but the *Annunciation* and, above all, the altarpiece of the *Deposition*, which were censured by Vasari as being less good than the vault, are now reckoned to be among the greatest works of the period. The *Madonna*, also for the Capponi family, is still in their possession.

The *Madonna* for the nuns of Sta Anna can be identified with the painting in the Louvre on account of the unusual scene of the Signoria in procession, which Vasari describes as a predella although it is actually painted at the base of the main panel. The three portraits next mentioned present problems: the *Alessandro de' Medici* is the picture now in Lucca, but the *Ippolito* is lost; the portrait of Bishop Ardinghelli may perhaps be the picture also called Mgr. della Casa, now in the National Gallery, Washington. There are similar problems of identity in the case of Francesco Guardi as a soldier, which has been reasonably identified with the *Halberdier* in the Stillman collection, New York, although the *Pygmalion* which Vasari says was by Bronzino and served as its cover (Palazzo Vecchio, Florence) is somewhat smaller. The two versions of the *Eleven Thousand Martyrs* are in the Pitti and Uffizi respectively. The *Christ Appearing to the Magdalen*, for which Davalos got Michelangelo to provide a cartoon, is not certainly identifiable, but there are two derivatives in the Casa Buonarroti in Florence; similarly, there are many versions of the Michelangelo cartoon of *Venus and Cupid*, one being in the Uffizi.

The small portrait of Duke Alessandro is lost, but the large one made from it has been identified with the picture in Philadelphia (Johnson). The last works have suffered greatly – the decorations at Carreggi and Castello have perished; the two tapestries are in the Quirinal, Rome, and the Palazzo Vecchio, Florence; and the ten years spent on the works in S. Lorenzo have left no trace other than the numerous drawings for the figures. Bronzino actually

finished the scenes in 1558, but they were not liked and were finally destroyed in 1742.

FRANCESCO SALVIATI

Francesco de' Rossi, known to his contemporaries as Cecchino Salviati, was born in 1510 and died in 1563. He was known as Salviati because he was a protégé of Cardinal Salviati, but his own pupil, Giuseppe della Porta, was also known as Salviati, after him. Francesco was an exact contemporary and close friend of Vasari, who, nevertheless, makes it clear that most of his misfortunes were due to his own moody and vain temperament. Their friendship dated back to 1523, when Salviati was thirteen and Vasari twelve, so it is generally accepted that Vasari's account is correct in all essentials – certainly the surviving works confirm him. The story of their exploit in salvaging the broken pieces of Michelangelo's *David* in 1527 is evidently correct, since the breaks are clearly visible in the left arm below the wrist. Salviati's work confirms the influence of both Andrea del Sarto and Bandinelli in his early years, although very little is known of it before about 1533. His great chance came in 1531–2, when he was able to go to Rome under the patronage of Cardinal Salviati, where he was soon joined by Vasari. Nothing seems to be known of the work in Sta Maria della Pace, which must have been an important commission, and the earliest surviving work of his first Roman period seems to be the *Annunciation* (*c.* 1532–5) still in S. Francesco a Ripa. Soon afterwards he began a connection with the Farnese family, and there is a tapestry of the *Deeds of Alexander* in Capodimonte, Naples. What Vasari describes as his best drawing, the cartoon for a *David*, is lost, but a *Visitation*, dated 1538, in S. Giovanni Decollato, was, according to Vasari, better than the later *Birth of the Baptist*, of 1551, in the same church. Both still exist.

About 1539 he went to Venice. His *Psyche*, which Vasari rather optimistically called the best painting in Venice, is lost, but there is an engraved copy in the British Museum. The *Dead Christ* for the nuns of Corpus Domini has been rediscovered and is now in the Madonna del Rosario at Viggiù, near Milan. The portrait of Aretino, sent to France, is lost, but the altarpiece for Sta Cristina in Bologna is still there.

He returned to Rome in 1541, which Vasari implies is the date

of the work in the Brandenburg chapel in the German church of Sta Maria dell'Anima; these frescoes, much damaged, are still there, but they are generally dated several years later. In 1543 he returned to Florence, seeking work from the Grand Duke Cosimo. This he got in the Sala dell'Udienza of the Palazzo Vecchio (c. 1543–5), and Vasari gives a long description of the Camillus frescoes, which are a complex political allegory. He also painted the ceiling of the dining room and portraits of the Duke's children, one of which survives in the Pitti. The *Charity* is probably the picture now in the Uffizi, but there are many copies of it, including a small one in the National Gallery, London. The *Incredulity of S. Thomas*, sent to Lyons, has been in the Louvre since the eighteenth century. The tapestry of Pharaoh's dream is now in the Palazzo Vecchio, Florence, and other tapestries are in the Uffizi and elsewhere. The *Deposition from the Cross*, painted for the Dini Chapel in Sta Croce, is now in the Museum there. The engraving by Enea Vico of his *Conversion of S. Paul* is dated 1545 and the original drawing is in the Uffizi.

Back in Rome in 1548, he began work on frescoes in the Palazzo di S. Giorgio (i.e. the Cancelleria), which still survive, although the *Nativity* is in bad condition. The *Cana* in the refectory at S. Salvatore in Lauro is still there, but the others have perished. The *Adam and Eve* may be the picture now in the Colonna Gallery, Rome.

The frescoes in the Farnese Palace, called the *Fasti Farnesiani*, painted between c. 1549 and his death in 1563, are still there although at least two are by Taddeo Zuccaro, and the frescoes of the *David* cycle in the Palazzo Ricci-Sacchetti (c. 1553) are still in the palace: they are often regarded as his most Mannerist works.

Vasari tells us that in 1554 he himself was invited to go to France but refused, and Salviati went instead for some twenty months (c. 1555–6): the Dampierre works are lost, and when he returned to Rome he got a major commission for the Sala Regia in the Vatican, but began by quarrelling with Daniele da Volterra. In the event, he painted only one fresco and even that was finished by his pupil Giuseppe Porta. Salviati died on 11 November 1563. Giuseppe della Porta, called Salviati, (c. 1520–after 1573) became his pupil in 1535 and went to Venice with him, remaining there after 1541. Apart from finishing Salviati's fresco in the Sala Regia and painting another one of his own, Giuseppe worked entirely in Venice, where many of his works remain, e.g. in the Library of S. Mark, Sta

Maria della Salute, S. Francesco della Vigna, the Frari, churches in
Murano and elsewhere.

JACOPO SANSOVINO

When the Florentine sculptor and architect Jacopo Sansovino died
in Venice in 1570 Vasari celebrated his countryman's achievement
in Venice by producing a separate *Life* of him, revised from the
one in the 1568 edition of his book. There are several thousand
words more than in the earlier edition, including, naturally, an
account of his death and funeral, as well as an appreciation of his
character which might not have pleased his subject when alive.
There are also many details concerning his works which are
obviously derived from Sansovino's son, who wrote several guide
books to Venice, including the best of all the pre-twentieth-century
ones, the *Venezia Città Nobilissima . . .* of 1581. Early in the *Life* of
Sansovino, Vasari establishes the rivalry between him and Mich-
elangelo, and Michelangelo was the only other artist who has a
separate *Life* by Vasari; even then, it was no more than a separate
off-print of the 1568 edition, since Michelangelo had died in 1564,
whereas the *Sansovino* contains new material brought up to date in
1570. The text of the 1570 version is partly used here.

Like Michelangelo, Sansovino had a very long life, but not as long
as Vasari (Sansovino himself?) makes out: he was not born in 1477
(which would make him a near-contemporary of Michelangelo)
but in 1486, so he was not ninety-three when he died in 1570, but
only eighty-four, even though his tombstone gives the wrong age.
Like so many other Italian artists of the period he took his name
from his master, Andrea Contucci of Monte Sansovino, under
whom he studied from 1502 and whom he accompanied to Rome
about 1505–6. There he soon met Giuliano da San Gallo, Bramante,
Raphael, and other great artists and his wax copy of the *Laocoön*
(discovered in 1506) was praised by Raphael and cast in bronze. It
seems to be lost, although there is a version in the Bargello, Flo-
rence, which may perhaps be his. The wax model of the *Deposition*,
now in the Victoria & Albert Museum, is much more likely to be
his, and the one made for Perugino.

In 1511 he returned to Florence, where he was commissioned to
make the statue of the Apostle James, since Michelangelo had
failed to produce the projected series of Apostles, and had left

Florence. His next major work, the *Bacchus*, obviously inspired by Michelangelo, was made in 1511–12 and is now in the Bargello (the curious story about his unfortunate model Pippo, who went mad as a result of posing in the winter, is omitted from the 1570 version).

In 1514 he worked on the decorations for the Entry of Pope Leo X Medici, and a stucco relief in the Victoria & Albert Museum may be related to this; but far more important was the model for the S. Lorenzo façade, which occasioned a bitter dispute with Michelangelo, whom Sansovino accused, in a well-known letter of 30 June 1517, of wanting to keep everything for himself. Sansovino decided to stay in Rome, and his over-life-size *Madonna del Parto*, commissioned in 1521, is still in Sant'Agostino. The *S. James* for the Spanish church is now in Sta Maria di Monserrato, and at this time he was also active as an architect, making the plans for S. Marcello and various private buildings. Later, he worked on the plans for the Florentine national church in Rome which came to nothing because of grand ideas which proved ruinously expensive. In the 1520s he was working on the tombs of two cardinals, of which only the one in S. Marcello survives, but the sack of Rome in 1527 drove him, like many other artists, out of the city. He went to Venice (where he may already have been in 1523), apparently intending to go on to France to work for King Francis I, but in Venice he was given the difficult job of repairing the foundations of St Mark's and succeeded so well that he was given other commissions and spent the rest of his life there. He was made Protomaestro – chief architect – on 1 April 1529, in succession to Bartolommeo Bon, and from then on his career was more concerned with architecture and town-planning than with sculpture, although he continued, with the help of several skilled assistants, to produce sculpture into extreme old age.

His major State commissions were the Mint (*La Zecca*), begun in 1537, with a third storey added in 1558, and his masterpiece, the Libreria Sansoviniana or Library of St Mark, also begun in 1537. This was the major Venetian State commission of the century and brought lasting fame to Sansovino and to Venice, but that did not save him when, in 1545, some vaulting collapsed: he was imprisoned and only released after his friends Titian and Pietro Aretino appealed on his behalf, and even then he had to pay the cost of repairs himself. Nevertheless, as he told Vasari, he would

rather work in the comparative freedom of Venice than for an absolute ruler. Another State commission, from 1540, was the Loggetta at the base of the campanile of S.Marco, richly decorated with sculpture by him and his assistants, especially Tiziano Aspetti and Danese Cattaneo. The whole campanile collapsed quietly on the morning of 14 July 1902, doing remarkably little damage, and was reconstructed from the fragments so that most of the sculpture has survived. At this time Sansovino also built several Venetian palaces, including the Palazzo Corner on the Grand Canal for the Cornaro family. This is the first truly High Renaissance palace in Venice (1533–7 onwards). From 1534 he also built the church of S. Francesco della Vigna, although, as Vasari says, the façade was by Palladio (1562–72).

Of the sculpture mentioned by Vasari after this, the following are among the most important: the *Baptist* in the Frari is still there, and so is the *Miracle* in the Santo at Padua. The *Neptune* and *Mars* (1554–67) at the top of the staircase in the Doge's Palace, are among the most famous works in Venice, and the works in S. Marco include the pulpit reliefs, the bronze doors to the sacristy, and the *Madonna* now in the chapel of the Doge's Palace. The *Madonna* for the Arsenale, though signed, is now thought to be the work of assistants.

After the life of Sansovino, Vasari took the opportunity to add some details about his assistants and about other Venetian artists. Of the assistants by far the most important were Vittoria, Ammanati, and Cattaneo. Vittoria (1525–1608) worked mostly in Venice and the Veneto. His caryatids for the Library (1553–5) and the Contarini Tomb in Padua are still in place, but he is perhaps now better remembered as a splendid portraitist. Bartolommeo Ammanati was a Florentine who, like Sansovino, worked as architect and sculptor. He also worked on the Library, but he went to Rome and worked with Vasari (1550) on the Villa Giulia before returning to Florence, where he made the huge *Neptune* which still stands in the Piazza della Signoria. He worked on the enlargement of the Pitti Palace, making it a suitable residence for the Grand Duke (1558–70).

Danese Cattaneo (*c.* 1509–73) was the last of Sansovino's disciples. He was his pupil in Rome and then accompanied him to Venice, where he worked for the rest of his life. His portraits of Bembo and Contarini are still in the Santo in Padua and he worked

on the Library and Loggetta in Venice. His Fregoso Chapel in Verona (signed, 1565) exists but is not complete.

By far the most significant artist in the list was Andrea Palladio (1508–80), whose architecture was the most important formative influence in Britain and America in the eighteenth century. Vasari gave a long list of buildings by him, almost all of which still exist, and he concluded with a reference to Palladio's forthcoming book, with two books of ancient buildings and a third one of his own works: this is the *Quattro Libri dell' Architettura* of 1570, one of the most important architectural treatises ever published.

FURTHER READING

—— · ——

Vasari on Technique, by Louisa S. Maclehose and G. Baldwin Brown (Dent, 1907; Dover Publications, paperback, 1960): an accurate translation, with useful notes and illustrations, of Vasari's Introduction to the *Lives*, his technical treatise on architecture, sculpture, and painting.

Artistic Theory in Italy 1450–1600, by Anthony Blunt (Oxford University Press, first edition, 1940; also in paperback): an illuminating commentary on Renaissance art theory from Alberti to the later Mannerists.

Classic Art, by H. Wölfflin (Phaidon Press, 1952): first published in 1899, this classic of art history has had a major influence on subsequent art historians and in this illustrated translation makes a very stimulating introduction to the period.

The Art of the Renaissance, by Peter and Linda Murray (Thames and Hudson, 1963; also in paperback).

An Index of Attributions made in Tuscan Sources before Vasari, by Peter Murray (Leo S. Olschki, Florence, 1959): lists the sources that Vasari drew upon.

The High Renaissance (1967), and *The Late Renaissance and Mannerism* (1967), by Linda Murray, both reprinted and revised as one volume (Thames and Hudson, 1977).

The Architecture of the Italian Renaissance, by Peter Murray (Thames and Hudson, 1986).

Introduction to Italian Sculpture, by Sir John Pope-Hennessy, three volumes (Phaidon paperback, 1986).

Giorgio Vasari: The Man and the Book, by T. S. R. Boase (Princeton University Press, 1979), based on a series of (A. W. Mellon) lectures, is readable and scholarly, fairly well illustrated, critical, but sympathetic to Vasari, and the best general introduction to him in English.

Vasari Pittore, by Paola Barocchi (Milan, 1964): a reasonably well-illustrated essential first book for the study of Vasari as an artist.